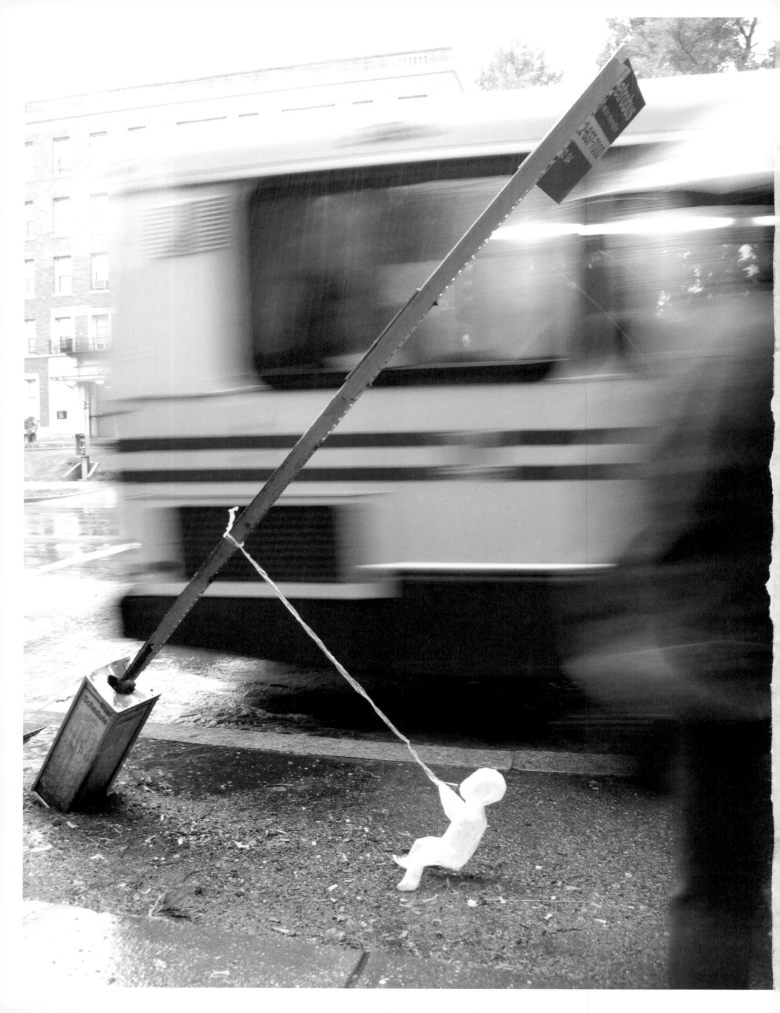

Hi-Fructose

Collected Edition 2

Edited by
Annie Owens
and Attaboy

Last Gasp ✦ Hi-Fructose

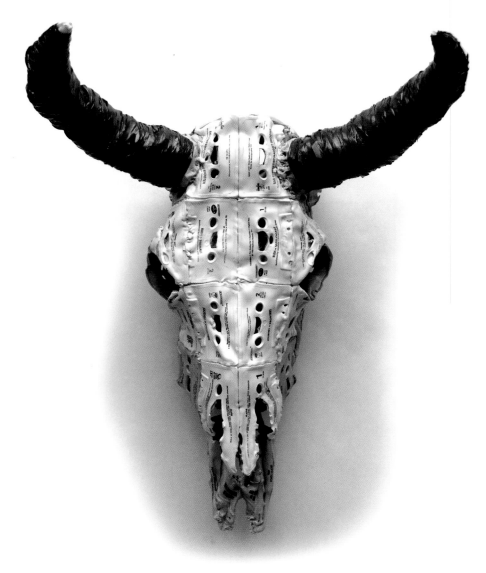

(previous)
"Stoker Project: Metro"
Mark Jenkins
(left)"Bull Skull"
Brian Dettmer
(right) "Anti Lemming"
Chris Mars

Hi-Fructose Collected Edition
Volume 2
Annie Owens and Attaboy, Editors in Chief

Published by Last Gasp of San Francisco
Ronald E. Turner, Publisher
Colin S. Turner, Associate Publisher

777 Florida Street
San Francisco, California 94110
www.lastgasp.com

For more information about Hi-Fructose, *including current issues,*
videos and art events from around the world please visit
Hi-Fructose *Online at www.hifructose.com.*

Originally published as Hi-Fructose Magazine, *Volumes 5-8*
Annie Owens and Attaboy, Editors and Publishers

All Layouts by: Annie Owens and Attaboy
First Edition printing: 3,500 copies, 2010
Regular Edition ISBN 978-0-86719-744-0
Special Edition ISBN 978-0-86719-745-7
Special Edition limited to 3,000 copies

All artwork, photos and writing copyright © 2010 respective
artists, photographers, and authors.

Book and box set design copyright
© 2010 Ouch Factory Yum Club and Last Gasp.

Book cover image by Audrey Kawasaki
Photo by Matt Whitaker (Static Medium)
Title page: "Black Mass" by Robert Hardgrave

Hi-Fructose *endpaper logo by Hydro 74*

Copy editing by Evan Rosa

Printed in China

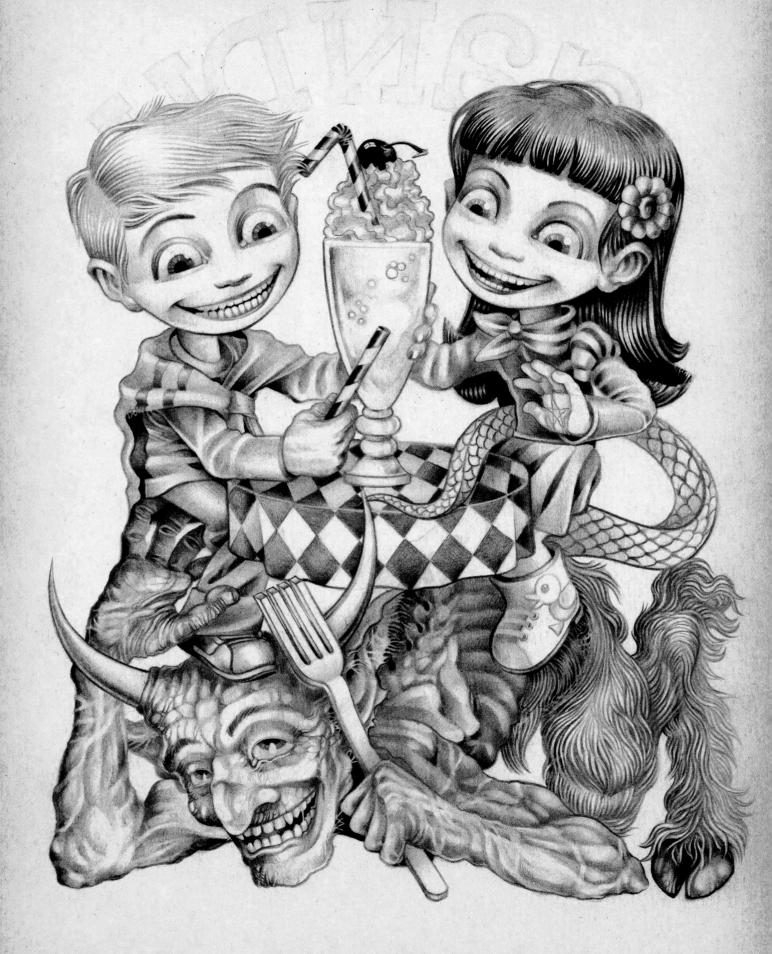

INSIDE:

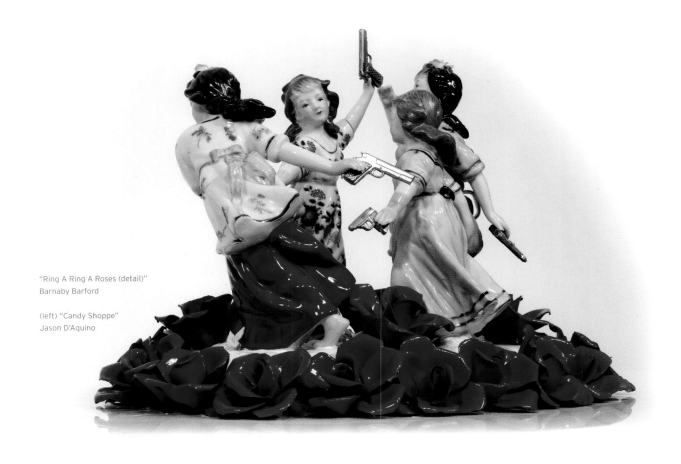

"Ring A Ring A Roses (detail)"
Barnaby Barford

(left) "Candy Shoppe"
Jason D'Aquino

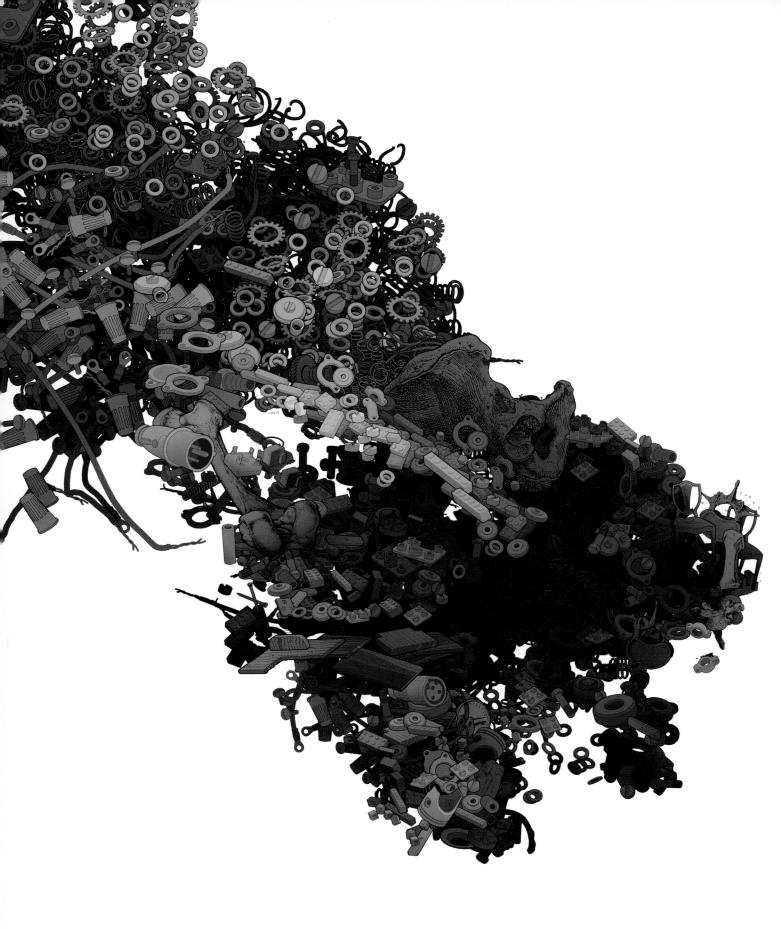

An Introduction
by Long Gone John

"You don't love me, you love magazines"
—Tomata du Plenty, The Screamers (1978)

I have a short attention span...
Brief articles with lots of images are ideal for me...

I love magazines...I always have and since the day I could afford them (before that, I shoplifted) I have bought them voraciously for all the right and wrong reasons...I don't buy magazines unless I intend to keep them, and I covet them with an unhealthy zeal...

I am, by nature, a cautious soul and I keep my magazines far removed from careless hands; and when maximum absorption has been fulfilled I file them away with religious precision...

Before I developed my severely anal reverence for magazines, they provided decoration for my walls...I carefully removed prized images and would then create frames using construction paper...That teenage makeshift gallery was my cherished personal art collection decades before I began amassing the hard stuff...

These days there aren't many magazines to get excited about, unless of course you have an interest in useless rock/rap rags, endless volumes of pierced/tattooed girls with Betty Page hairdos, or periodicals by daytime talk show hosts attempting to force-feed their banal, biased rhetoric into any receptive mushy gray matter they can find...

Hi-Fructose is ahead of the curve...Following paths others have traveled down is safe, predictable and ultimately redundant...Hi-Fructose instinctively follows its own sensibilities and has a distinct and unique approach in creating a magazine... Most current magazines are rife with mediocrity and there are rarely visible renegades or deserving contenders for magazine stardom...Hi-Fructose has been a glorious noticeable exception...It was evident with the very first issue that Hi-Fructose was going to be something very special...

I knew it and I wondered how long it would take till it was recognized as such and on its merry way to publishing infamy...

Turns out it didn't take long at all...

Hi-Fructose has continually spotlighted the obvious heavy hitters as well as untold upstarts, which they present with equal importance out of a genuine desire to educate as well as illustrate...the selection of artists featured has always been sublime (is stellar a better word??) and although not all of what appears is always right up my proverbial alley, I do enjoy seeing all of the work and welcome being constantly apprised of art outside of my immediate snobby realm...I could tell you what I like and don't like, but it would just encourage artists to gang together and form my class-action execution, so I won't...

Citing individual artists in this introduction is also difficult, as those omitted might somehow feel less deserving of attention…And as brutal and heartless as I've often been portrayed, that is not something that I care to be responsible for...Everyone is a star, everyone is more talented than me, and I'm just clever enough to know when to pull my punches...Just flip through these pages and you will find the best, most innovative

(left) Collage Series from instruction manuals by Freek Drent
(above)" Fishing With Fox" Xiao Qing Ding

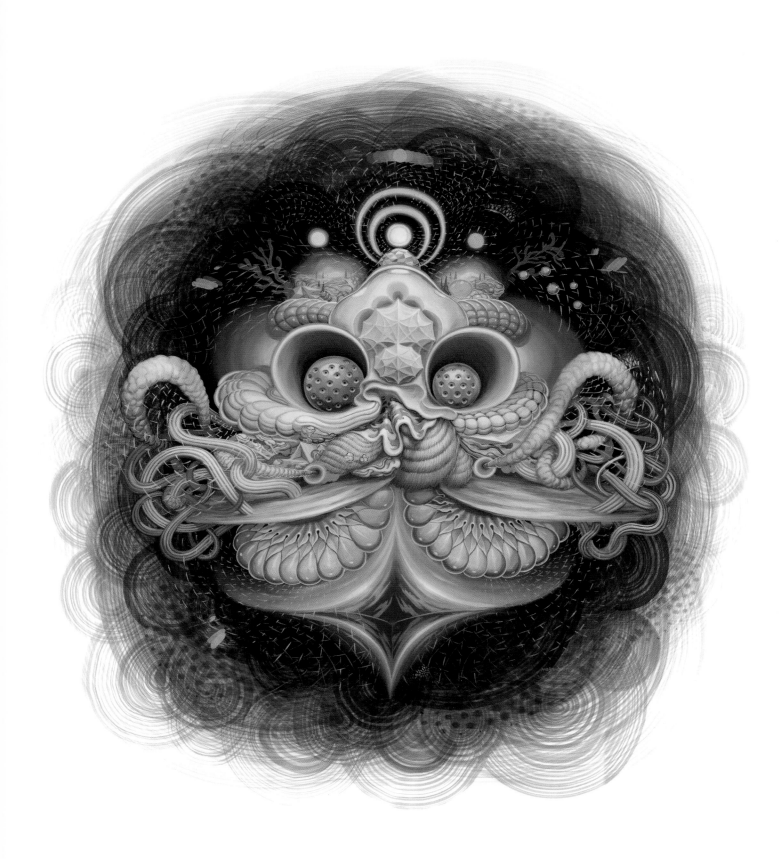

and genuinely talented artists, creating tomorrow's treasured masterpieces today...

The editors of *Hi-Fructose*, Annie Owens and Attaboy, are both important artists in their own right, yet they've resisted filling the pages with their own art, as other artist/editors have shamefully done...Another thing they've resisted is even more admirable...They have side-stepped the lure of corporate bucks and benefits associated with sullying their pages with ads for cigarettes and tacky leisure footwear...The temptation must be overwhelming and I admire them immensely for "just saying no"...It appears *Hi-Fructose* is a tome with admirable principals...

Content aside, I'm impressed with their usage of a higher-quality paper for their pages as well as the covers...It shows that they really care...It shows that cutting corners is not an option, and it shows that they think that their efforts deserve to withstand the ravages of time...They are, of course, right...

I am consistently in awe at the depth of the coverage they tastefully squeeze into every issue and it is no surprise that *Hi-Fructose* continues to increase in circulation and popularity with each new appearance...

A gracious and resplendent nod must also go to Last Gasp, who have just celebrated 40 years as a distributor and publisher...They have spared no expense in producing this second beautiful collection...

In time these precious pages will serve as a textbook of the evolution of the revolution as it is glaringly apparent that no current

art of any real merit and substance will escape an audience and notoriety within the pages of *Hi-Fructose*...

Hi-Fructose is a believer in the non-believers... And what they offer is beautiful, intoxicating, hideous, dreamlike, strange, emotional, nostalgic, blasphemous, elegant, mysterious, and sometimes magical, but what they offer most importantly is undying optimism for a readership that will continue to spawn gifted artists for many years to come...

Nearly sincerely,
Long Gone John XX
May 2010

..

Long Gone John is a swapmeet denizen and an unapologetic packrat...He collects celebrity prescription bottles, rusty cutlery, religious artifacts and well-worn stuffed animals...He is a self-professed anti-mogul and accidental CEO for his ventures, Sympathy for the Record Industry and Necessaries Toy Foundation...In 22 years of business he has never had an employee and has always worked from his home...He watches a minimum of 14 hours of tv a day and goes to movies as often as possible...He began buying art sometime in the 80s and has amassed a staggering collection...He has two daughters and a granddaughter who basically think he's a nice guy...

in 2007 he moved to an undisclosed waterfront location in Olympia, Washington where he takes daily walks through the forest to reflect on his many blessings in life...Long Gone John lives a relatively solitary existance with his best friends hiro, trilby, dickens and bronte' (his cats)... His dream is to travel to Volga, Russia to visit the land of his ancestors...

California born and bred Long Gone John is many things, but he is not a writer...He fumbles his way through attempts when enlisted for projects he supports or for people he admires.

(opposite)
"Tulpa Series #5" Mars-1
(left) "Thirsty Animal"
Victor Castillo

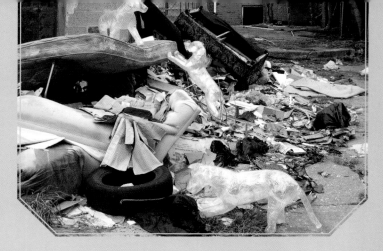

Mark Jenkins

Invasion of the Tape Babies

Redefinition is a funny thing—the simple leverage of context giving one the ability to totally change the idea of something with a small addition of one's own. It's almost like riding a horse or walking a big dog, in that a slight tug can cause the whole beast to turn. One of my personal favorites is when folks make some minor, tiny-yet magical change in the urban landscape that totally reorients your experience of it, and maybe even makes you rethink the things you just take for granted about how it's supposed to work.

So it's pretty easy to dig the work of sculptor Mark Jenkins. Like those other urban trickster sculptors, such as Brain Goggin and the Rebar group, his work reinvents, reinterprets and redefines our public spaces. Yet it's also a hit-and-run, a sculptural graffiti, with rapidly made, site-specific pieces made of clear tape, old clothes, and trash installed right into our urban fabric.

Such as his *Storker* project—little translucent ghostly babies made of clear tape, left behind by a mystical stork, inserted into various settings around the globe, looking to be adopted so as to grow up to become tape men and women. Or his clear tape giraffe, delightfully born to pluck plastic bags caught in trees for its nourishment. There's also his somewhat darker work of strange, impossible people made of old clothes, convincingly blending into a stone wall or looking to have been throw away, legs and all, in a NYC trashcan. And, finally, the gleeful simple prank: a old folk's walker, complete with split tennis balls on the legs, u-locked to a street post like a bike. Much better than a flashing light-bright of a Mooninite, his delightful and disturbing creations are something I really hope to stumble across someday. +

-TOAST

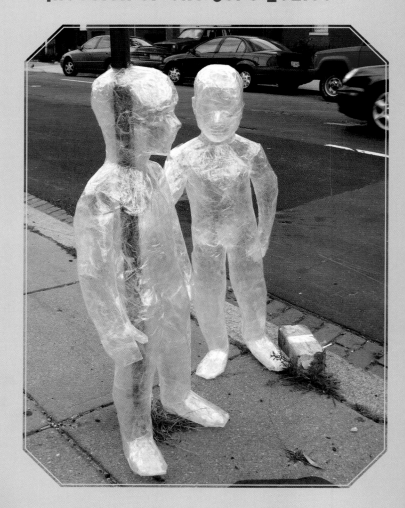

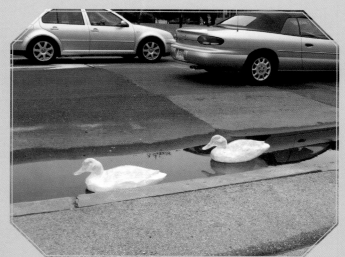

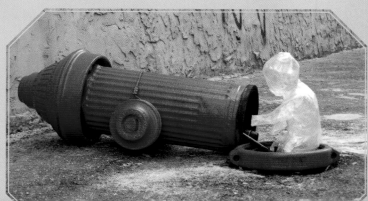

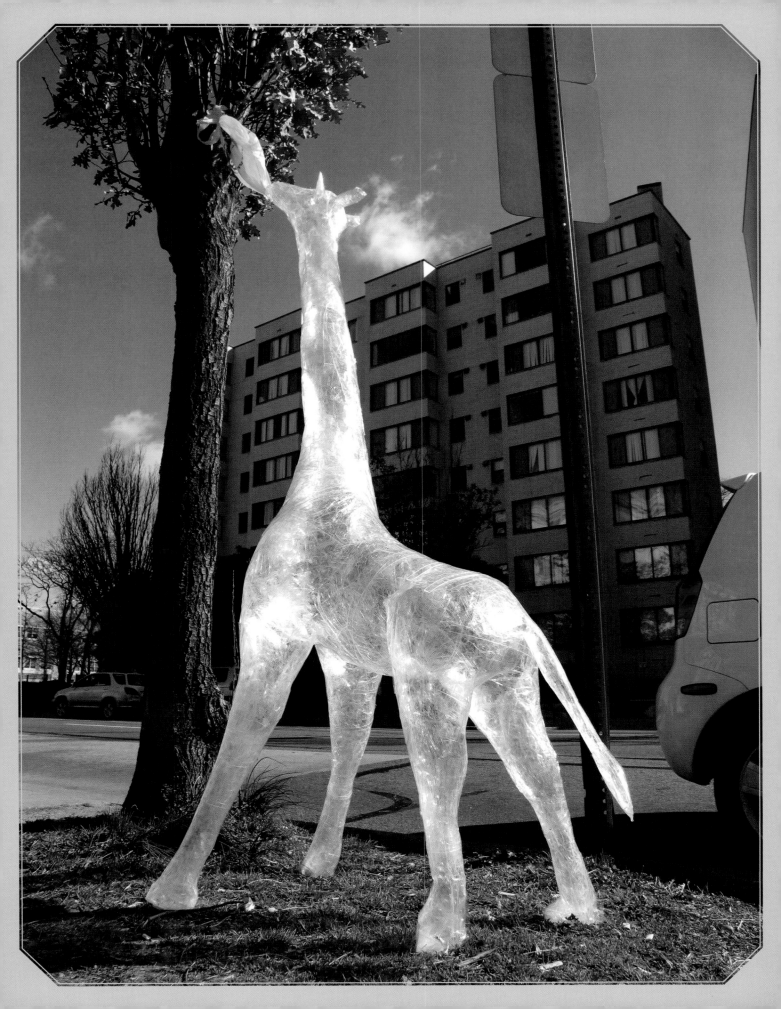

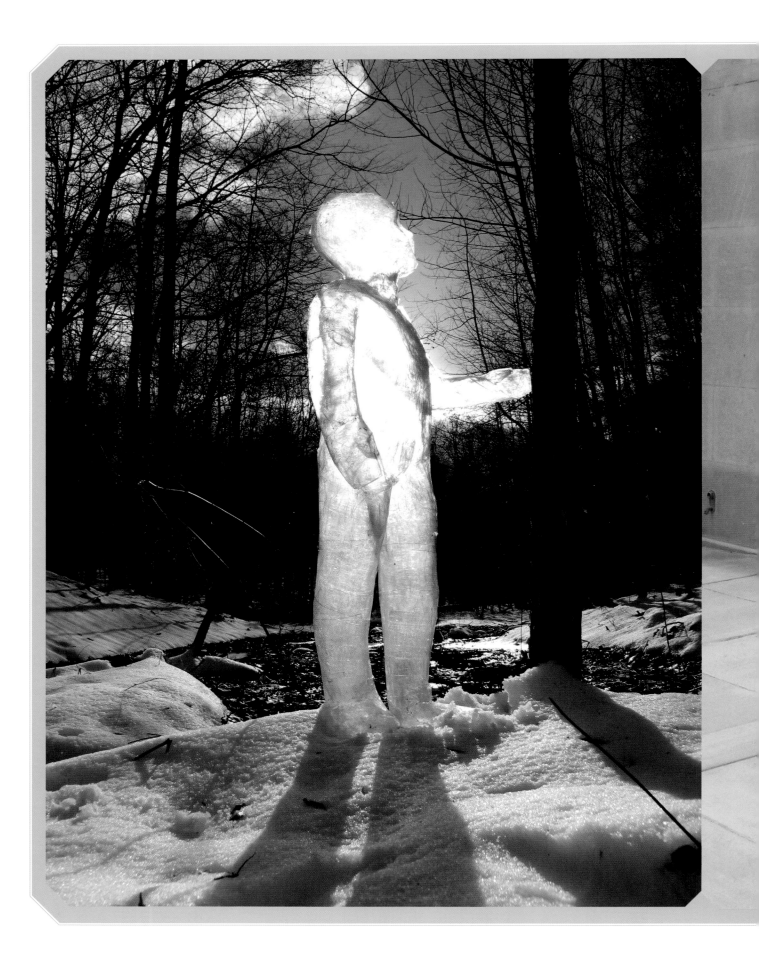

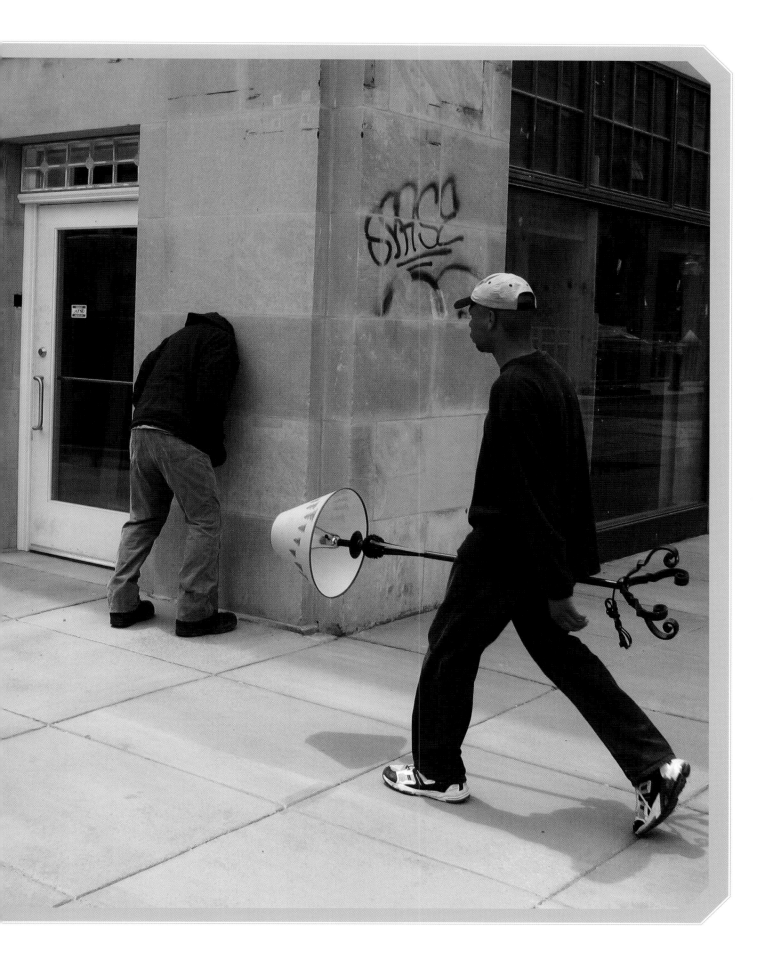

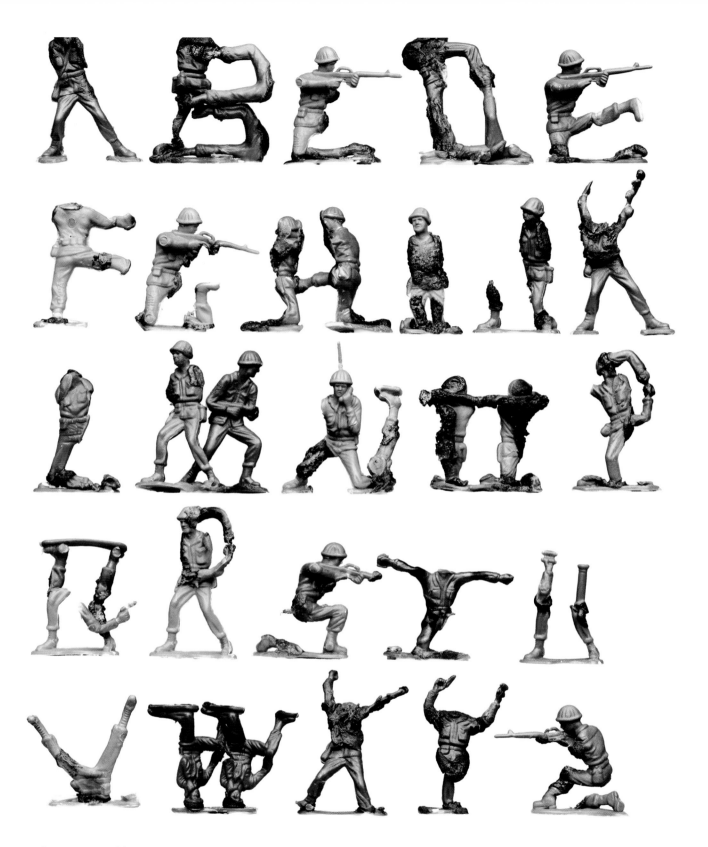

OLIVER MUNDAY

Somehow, the simple melding of the English alphabet with plastic toy soldiers, makes us laugh, but hits us in the marrow of our bones. Perhaps it's because taking a lighter to them is every little boy's sadistic secret. We instantly remember how the rush of our first pyro experience made our eyes wide, regardless of the consequences. It's fun to watch things burn. Or perhaps it's the realistic action-movie nature of the wounds a lighter makes on the plastic. I'm not certain. But Oliver Munday, a student at Maryland Institute College of Art, created this bold typeface, which speaks to the brutal realities of war; any and all wars, with the most basic elements we use for speaking, our ABC's. —Atta

BRENDAN TANG

There's a wave of classical kitbashing and historical remixing going on lately. There's the return of Steam Punk artists obsessed with alternate sci-fi tangents on Victorian England and the unsettled Wild West of America. And recently, a solid interest in pop reinterpretations of porcelin heirlooms. It's as if the space-time continuum *was* disrupted by Marty McFly back in 1985 and we're only now seeing the reformatted effects of the reshuffled time cards.

Brandan Tang pushes the bar further with his batch of mutated time spawn. Tang's impressive **Manga Orolu** series of sculptures collides ornamental ceramics from yester-year with pop-inspired Mecha. Says Brendan:

"Manga Ormolu enters the dialogue on contemporary culture, technology and globalization through the relationship between ceramic tradition (using the form of Chinese Ming dynasty vessels) and techno-Pop Art. The futuristic update of the Ming vessels recalls the 18th century French gilded *ormolu*, where historic Chinese vessels were transformed into curiosity pieces for aristocrats. But here, robotic prosthetics inspired by *anime* (Japanese animation) and *manga* (the beloved comics and picture novels of Japan) subvert elitism with the accessibility of popular culture."

Put that in your damn museum and smoke it.

—Atta

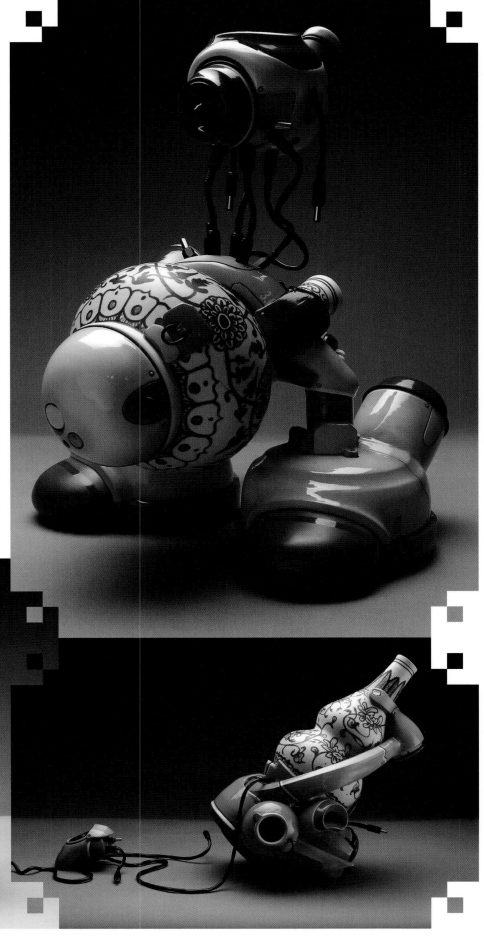

Travis Louie's PictureBook OF BiPEDS.

Interview by Annie Owens

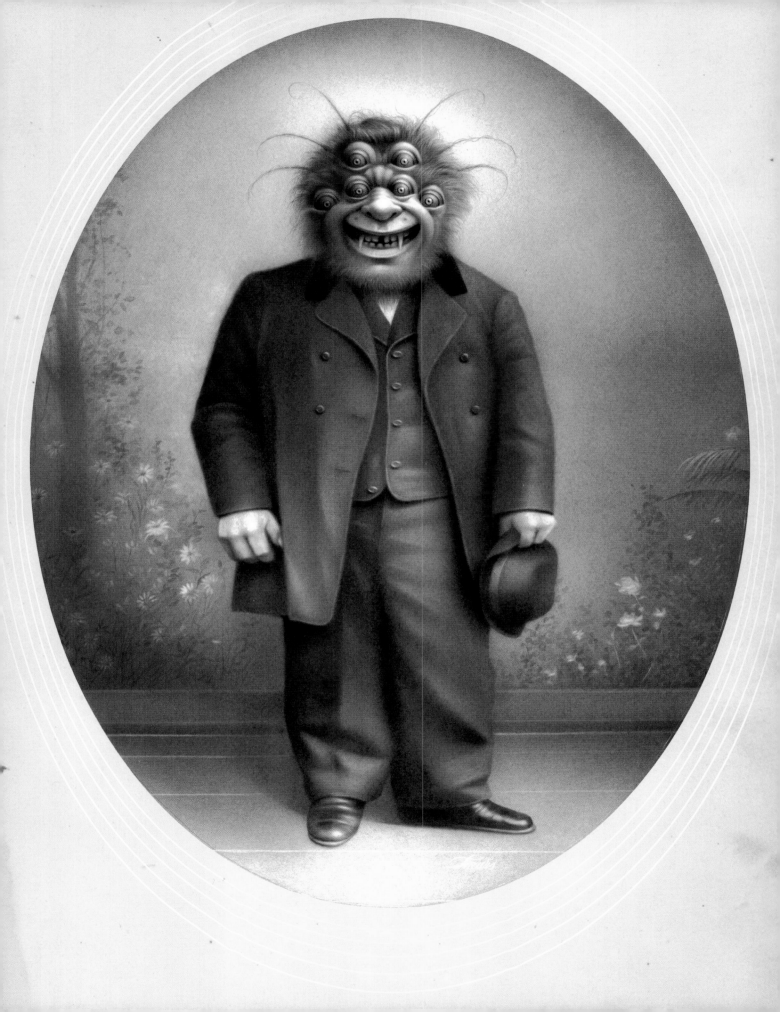

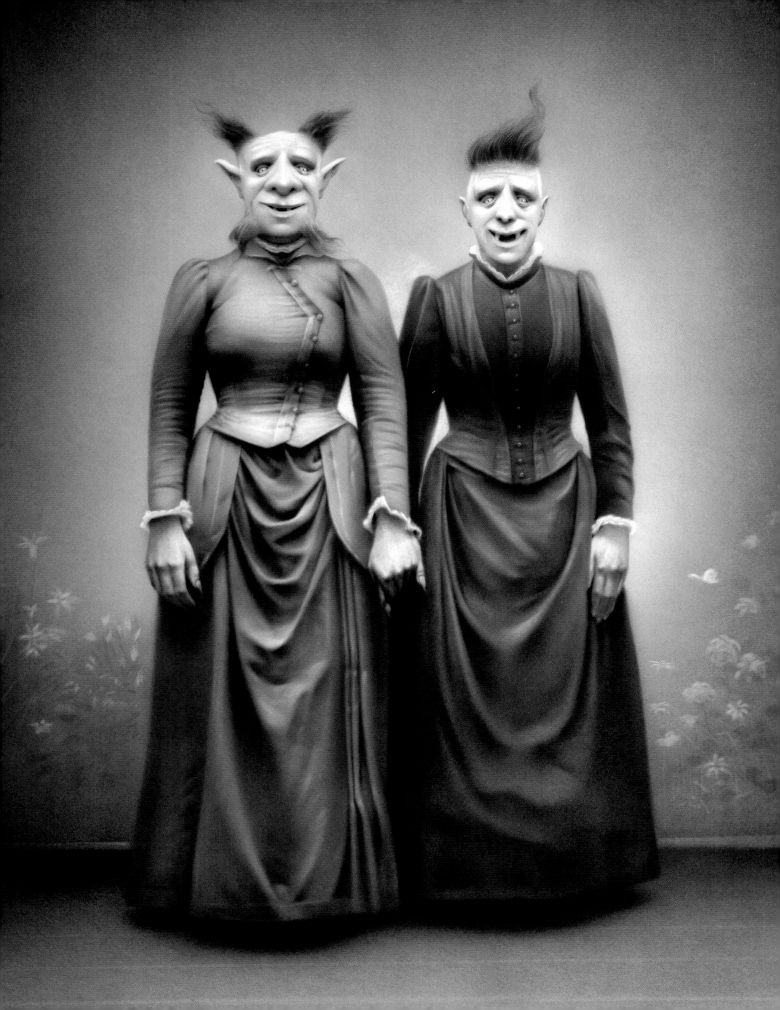

T he work of Travis Louie is arresting for many reasons, but one of the two most notable qualities of Louie's work is the realistic rendering of his subjects—so much so that the artist has often been accused of doctoring vintage photographs. Actually, layers of painstakingly blended acrylic paint over a fully rendered pencil drawing perfectly reproduces shadow and light as seen in the glowing haze of the imperfect 19th-century photograph.

The way Louie mimics the behavior of light as it's bounced off the subject or how he subtlety recreates the vignetting that used to occur within the "frame" of old land cameras elevates the tonal ranges to an almost heavenly glow, creating a soft romantic background for his otherwise unseemly subjects. This leads us to another other notable area of extreme interest.

But first let's back up for just a minute.

Before photography, visual documentation including portraiture was much more labor intensive for both the artist and the subject.

The arrival of photography introduced another option for portraiture. It was much faster than sitting for hours waiting for a picture to be painted. Hence, more pictures of more people and more types of people than ever before. Not just the rich and the noble, but the middle class, the poor, and the otherwise less fortunate. All walks of life, you could say, were more easily documented on glowing silver plates.

Fast-forward to now. Some lucky few possess antique photos of their old, dead relatives. Others can only covet the faded sepia-toned proof of their ancestry. Because Louie's work is so convincingly real, this is possibly part of what makes his work so compelling.

As I look upon the portrait of Karl the Humanzee, my first thought isn't, "a chimp in a cool suit" (even though he is) it is more like, "he must be someone's great, great grandfather." To be sure, despite the fact that Karl is an anthropoid, his dignified and genteel posture and sweet, intelligent gaze speak of a higher order of species, possibly surpassing us lowly *Homo sapiens*.

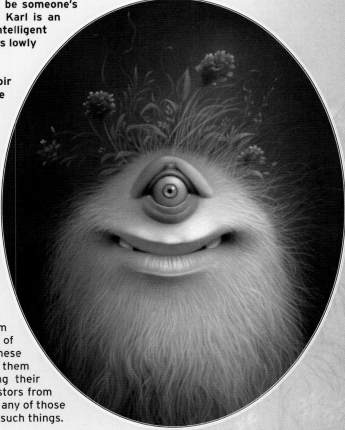

Travis Louie's aesthetic is highly influenced by the Film Noir genre; the cinematic phenomenon that took place between the 1940s and the late 50s and his work captures the atmosphere of that bygone era. Much of his work also exudes the quality of the silent film age as seen in "Pals"—two outwardly ugly "women" with kind eyes, affectionately holding hands. Presumably, by the title, they're old friends. What must they have experienced together to bond them so closely? Wondering at their story overrides their appearance. Louie's imagination and skill produces much more than beautifully rendered, two-dimensional paintings of sideshow freaks.

Even though the characters you paint are of the more conspicuous variety, not a single one looks truly menacing. Even the ones with huge fangs, and it's not just the dapper clothing. There is (or I imagine) a kindness in the eyes. Is that conscious or accidental?

It's definitely a conscious effort to make the characters seem to have a kind or gentle soul, and to paint them with a kind of dignity; creating my own alternate little universe filled with these mythical characters. To make them seem more realistic I paint them as if they were old 19th-century photographs, documenting their existence the way some of us may have pictures of our ancestors from that era, in a closet or attic somewhere. That said, I don't have any of those kinds of photos of my family... I'm envious of people who have such things.

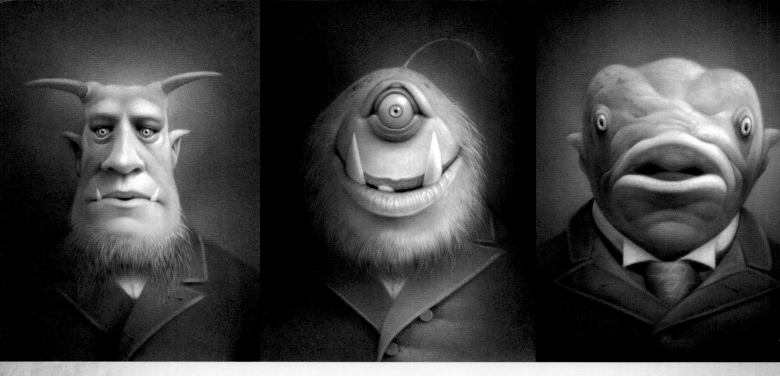

What was it like transitioning from freelance to doing only personal work? That's something I think a lot of artists aspire to, being able to do just personal work and survive that way.

It's something I always wanted to do. For me it was a confidence issue. I felt my work wasn't as polished as I wanted it to be and in the 1990s I started to experiment with different imagery. I didn't want anyone to see my work if I didn't think it was up to spec. For a long time, nobody but my friends saw my personal work, and I continued to freelance at art studios. I finally made the transition a few years ago and am grateful that it's worked out so far. I still pick up a freelance job every now and then, but I survive on private commissions and gallery sales for the most part.

How long does one your pieces take to finish?

It varies from piece to piece. It can take as short as two to three weeks or as long as two months.

If you could have a sit-down drink or meal with one or two of these folks, who would they be and why would you choose them? Personally, I'd like to hang out with Karl the Humanzee. He looks like he's got great stories to tell and would offer me tea and cake. No?

Yeah..."Karl" would be a cool character to have at a brunch... he's modeled after my late grandfather, but I'd like to catch a ballgame with "Gill." I don't get to catch too many games these days.

Outside of art, what is important to you?

My family is very important to me. I try to spend as much time with them as I can. I like to cook for them.

I could see thousands more portraits from you and always be surprised, but do you see yourself getting into doing other compositions like landscapes or scenes?

I intend on doing more scenes in my future work. I don't want to give anything away so it's a "wait and see."+

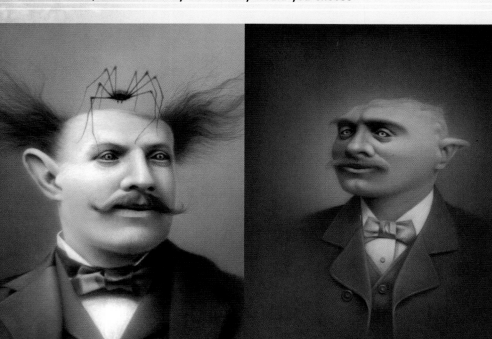

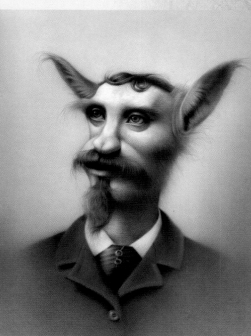

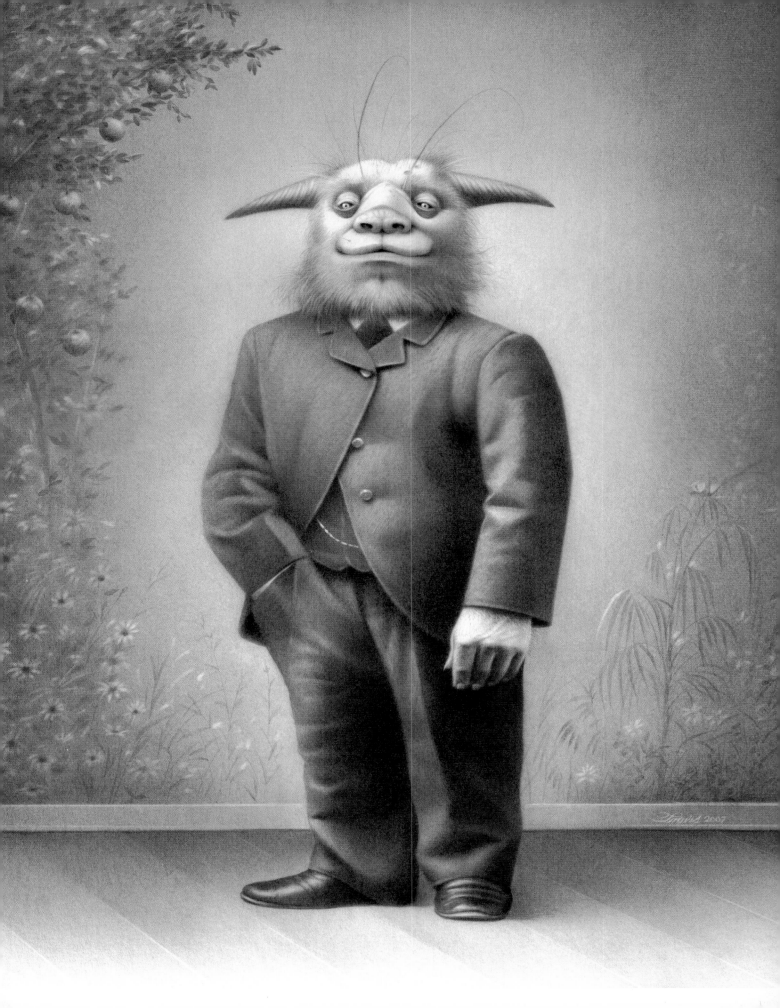

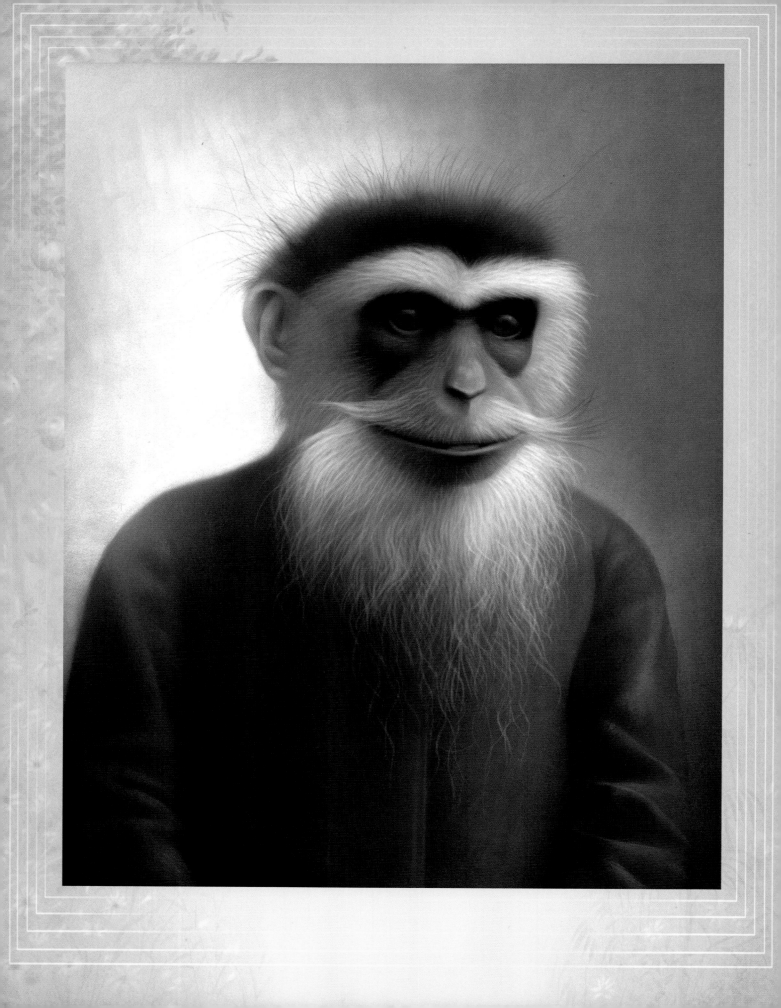

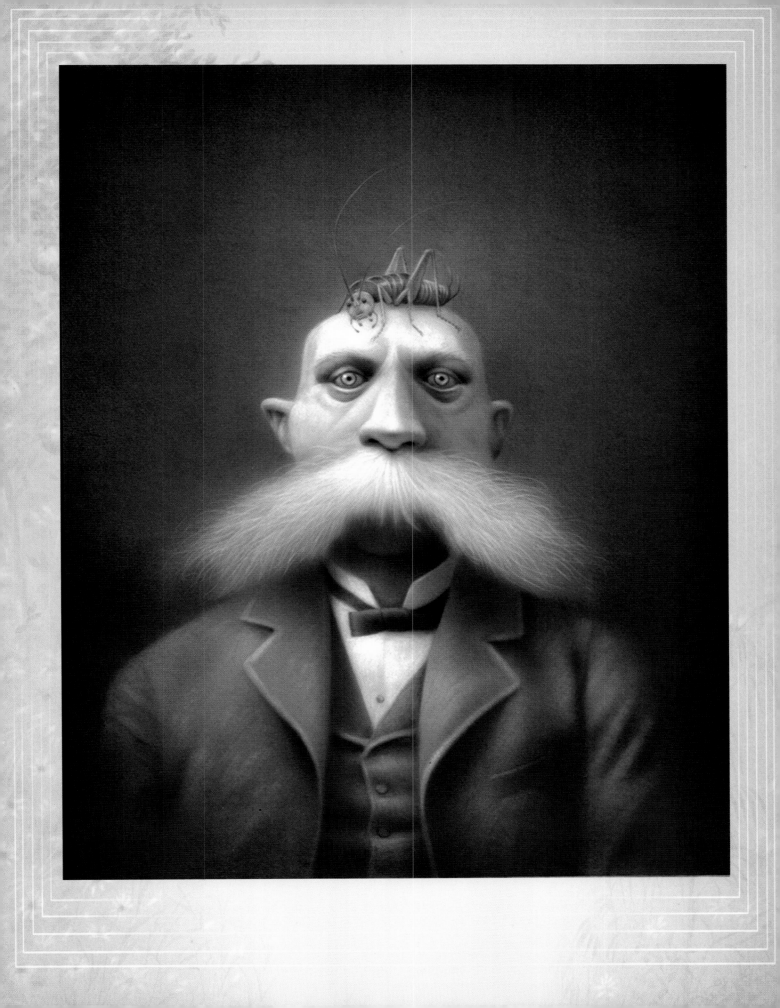

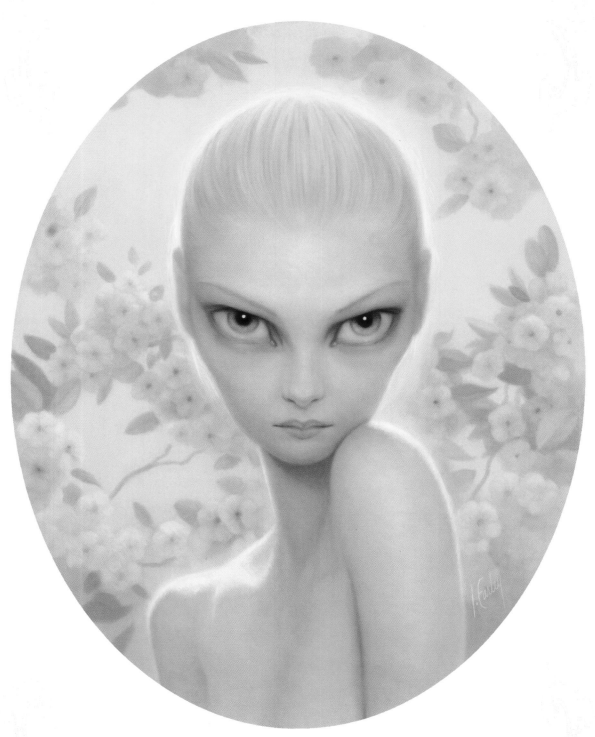

LORI EARLEY

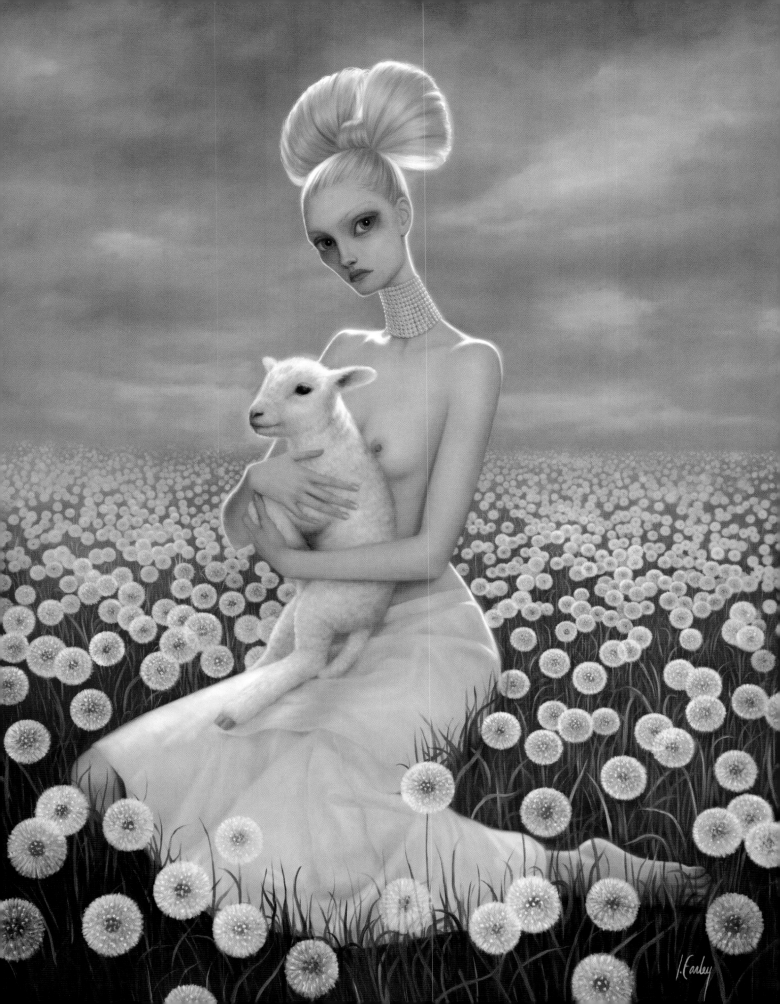

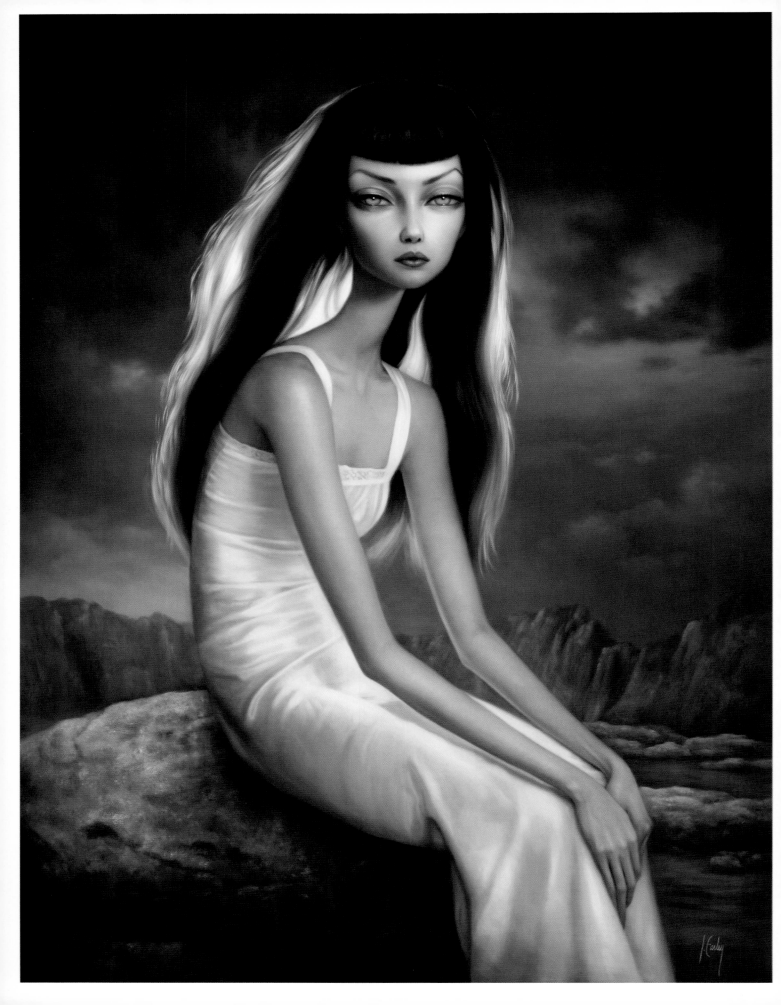

Bewitched: The Art of Lori Earley

Written by
Kirsten Anderson

In an art movement that has managed to juggernaut to such size and scope that it encompasses a virtual golden age of artistic talent, it takes a lot for a particular artist to stand out as a shining star of an art scene, yet that is what painter Lori Earley has managed to do in a relatively short time.

In 2005 while looking through *Juxtapoz Magazine*, I came across a tiny image of a painting by Lori Earley, no more than an inch square. I sat bolt upright and grabbed my laptop and looked her up. Instantly captivated by what I saw on her website, I emailed her immediately and booked her for her first solo show at my gallery, Roq La Rue. I just happened to jump the gun faster than my contemporaries, for Lori's work has had the same effect on dealers and avid art collectors all over the country. What I saw in that teeny photograph was the painting "Abolition," featuring a postmodern Venus with cream toned skin, an almost freakish swan like neck, and impossibly large limpid eyes staring warily out, backlit to create a fiery halo around her enigmatic countenance.

It was both subversive and classical at the same time, owing as much to Margaret Keane as to the elongated forms of El Greco, yet the staggering technique and sheer force of beauty in the image propelled it out of the kitsch arena into something much more. Lori's subsequent show (which sold out immediately) was a parade of icily alluring beauties, elongated to impossibly elegant proportions, wrapped in diaphanous, sexy gowns, if anything at all. Each painting, awash in Lori's rich trademark colors of caramel grey, cobalt blue, and shades of blush pink and fuchsias, was then set aglow by Lori's mastery of capturing light in skin tones and hair, rendering melancholy and serene emotions in the faces of her subjects.

Since that show, Lori's career has exploded into a whirlwind of shows and press, one that the artist is just now able to stop and reflect on. Of her phenomenal success she says "I haven't stopped painting since 2005, so I haven't had time to really think about what has happened." What has happened is galleries and collectors the world over are now clamoring for her work, and she recently opened a highly successful sold out show in New York at Opera Gallery, with her canvases fetching astronomical prices that place her in a playing field most of her contemporaries can only dream of.

Despite her recent and rapid ascent in the art world, Lori's story stretches back to when she was little, growing up in Rye, New York. "I did not grow up in an artistic family. I didn't go to museums or anything like that. I didn't really know that world existed. I just liked to draw." She spent hours in front of the TV, drawing people and made up landscapes. Despite a lack of immediate influences, she says, "I always knew I would be an artist… I just never questioned it."

In high school, an art teacher suggested she take outside art classes to hone her talent, and she went on to attend the School Of Visual Arts. After graduation, she started doing commercial illustration to support herself." I

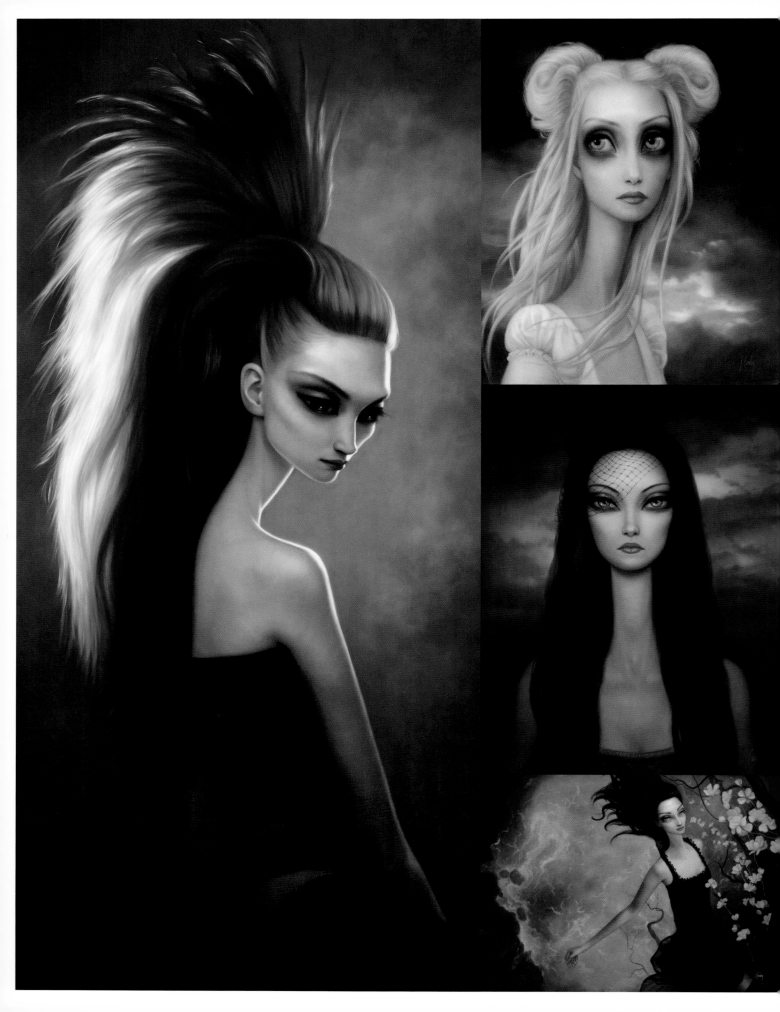

didn't like it very much, being told what to do, but it was a way to support myself while still doing art, and I really saw it as a way to practice my drawing and painting skills."

Successful as an illustrator, Lori's real interest lay in the fine art world. Her first foray was a group show at Fuse Gallery in NY, which *Juxtapoz* covered. The issue featured that tiny image of "Abolition," but the next issue of *Juxtapoz* to feature Lori, just a few months later, placed her squarely on the cover. Not bad for an emerging artist. Since then she's had solo shows at Roq la Rue, Copro Nason Gallery and Opera Gallery.

Now finally taking a break before her next show, at New York's Jonathan Levine Gallery, Lori has been able to think about her career.

"I paint all day, everyday, I have no social life at all!" she laughs ruefully. "It takes me so long to do these paintings and I'm such a perfectionist that it's all I can focus on. Now that I can look back on the reception my work has gotten, I'm really amazed and grateful."

Lori is not kidding about being a perfectionist. Due to a grueling technique and shorter than desired deadlines for shows, Lori is at her easel for up to 14 hours a day. Her technique is an arduous process, far more complicated than most people might realize.

The creation of a single painting takes months. The inspiration comes from an emotion or feeling Lori wants to capture. "Most of the paintings are essentially self portraits of things I am going through at a specific time." She says. "If it's not a painting of someone I know well in which I'm trying to convey something about them, 95 percent of the time it's about me, but using someone else as a model." Lori will hire a model and set up a photo shoot, which helps her with figuring out lighting as well as composition. After that, Lori takes the photographs and creates a distorted version of it in a drawing. This hallmark distortion is what Lori uses to tweak the realism she employs into a more fantastical realm, preferring to focus on her version of beauty rather than the mundane world.

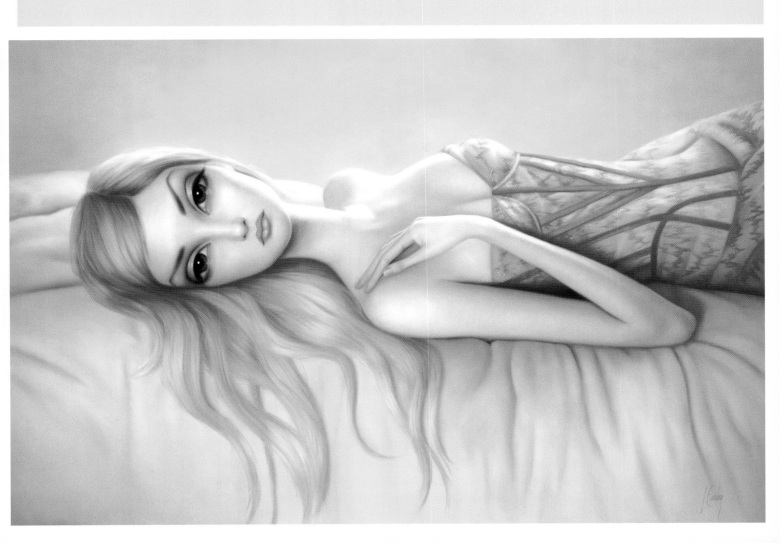

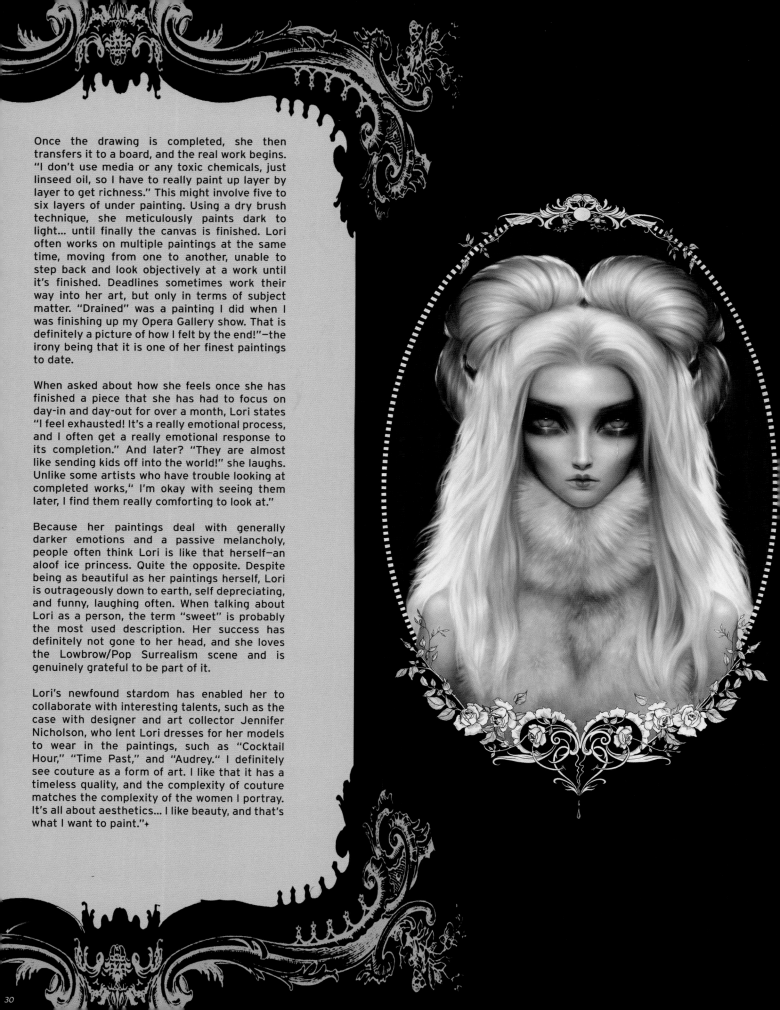

Once the drawing is completed, she then transfers it to a board, and the real work begins. "I don't use media or any toxic chemicals, just linseed oil, so I have to really paint up layer by layer to get richness." This might involve five to six layers of under painting. Using a dry brush technique, she meticulously paints dark to light... until finally the canvas is finished. Lori often works on multiple paintings at the same time, moving from one to another, unable to step back and look objectively at a work until it's finished. Deadlines sometimes work their way into her art, but only in terms of subject matter. "Drained" was a painting I did when I was finishing up my Opera Gallery show. That is definitely a picture of how I felt by the end!"–the irony being that it is one of her finest paintings to date.

When asked about how she feels once she has finished a piece that she has had to focus on day-in and day-out for over a month, Lori states "I feel exhausted! It's a really emotional process, and I often get a really emotional response to its completion." And later? "They are almost like sending kids off into the world!" she laughs. Unlike some artists who have trouble looking at completed works," I'm okay with seeing them later, I find them really comforting to look at."

Because her paintings deal with generally darker emotions and a passive melancholy, people often think Lori is like that herself–an aloof ice princess. Quite the opposite. Despite being as beautiful as her paintings herself, Lori is outrageously down to earth, self depreciating, and funny, laughing often. When talking about Lori as a person, the term "sweet" is probably the most used description. Her success has definitely not gone to her head, and she loves the Lowbrow/Pop Surrealism scene and is genuinely grateful to be part of it.

Lori's newfound stardom has enabled her to collaborate with interesting talents, such as the case with designer and art collector Jennifer Nicholson, who lent Lori dresses for her models to wear in the paintings, such as "Cocktail Hour," "Time Past," and "Audrey." I definitely see couture as a form of art. I like that it has a timeless quality, and the complexity of couture matches the complexity of the women I portray. It's all about aesthetics... I like beauty, and that's what I want to paint."+

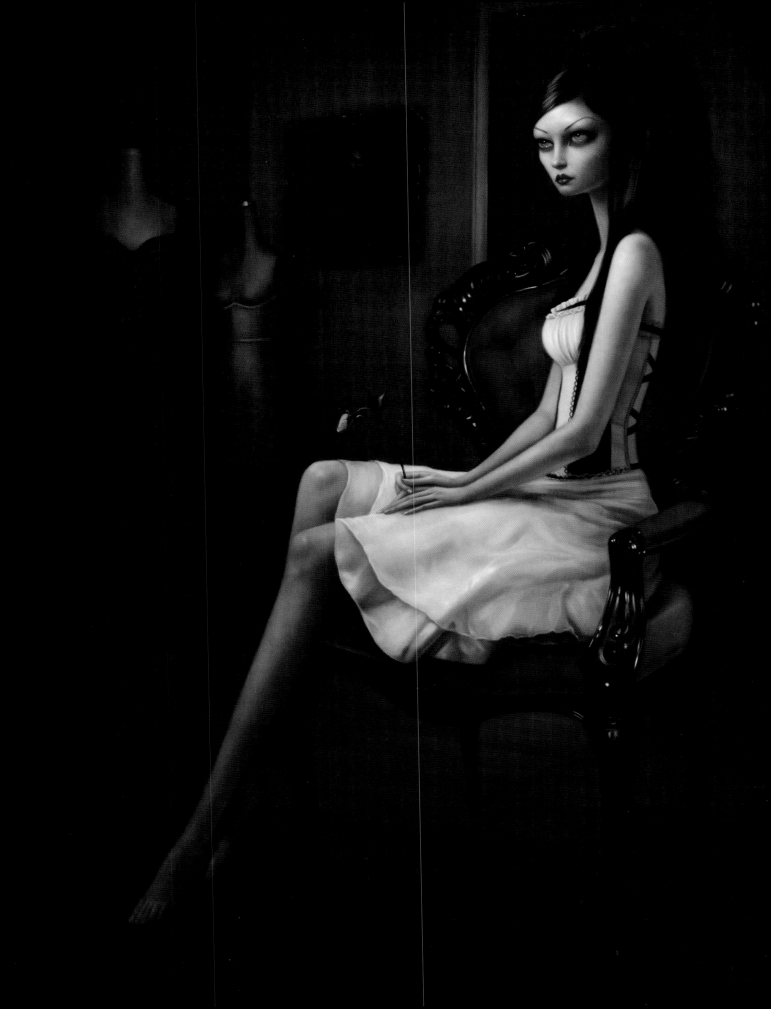

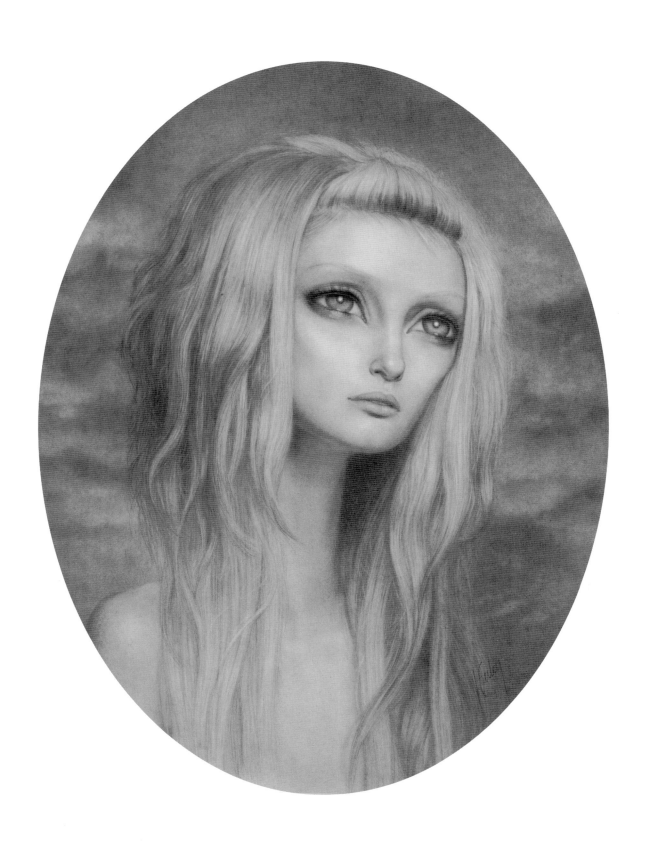

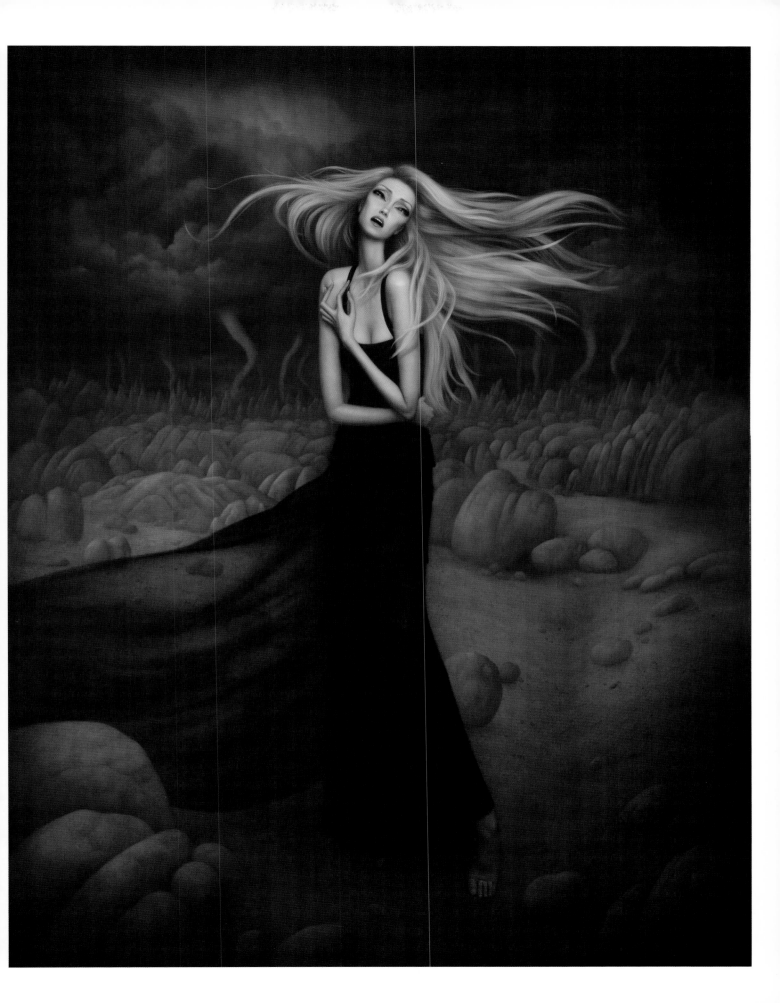

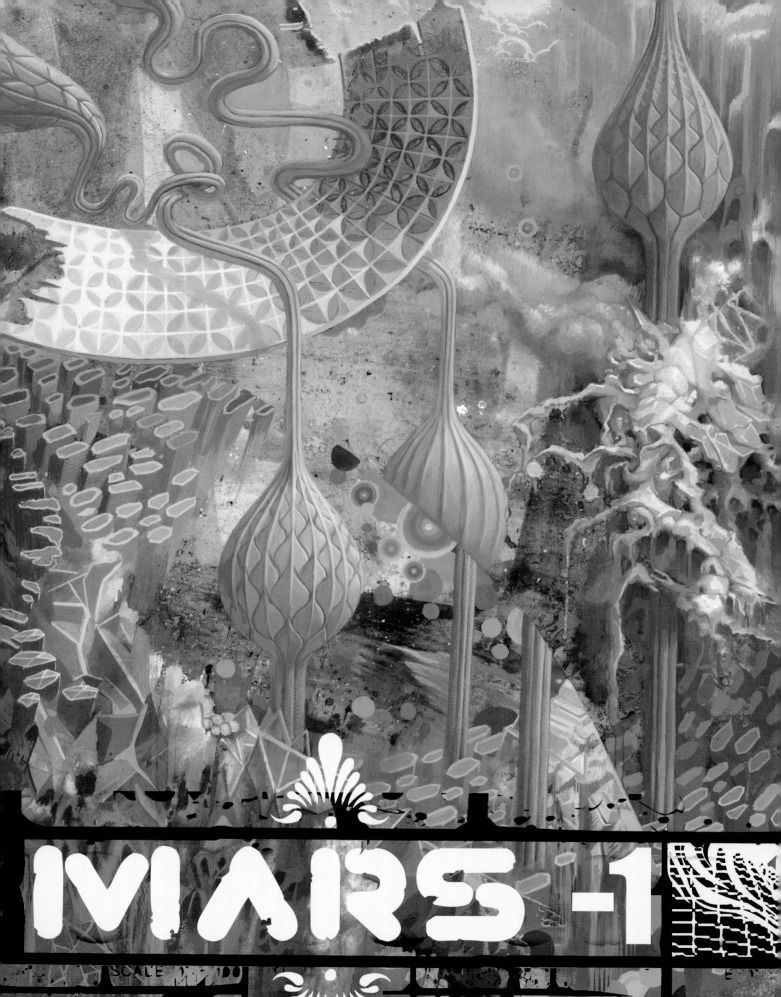

MARS-1

SCALE 1 : 10

Undisclosed Locations
Interview by Attaboy

Mars-1 creates fantastical worlds—his body of work is an always-evolving Petri dish. In his recent paintings, buildings or building-like structures grow from the ground seamlessly. It's as if nature became fed up with angles and posts and responded by fabricating her own plant-like structures. Growing, breathing buildings—which multiply like viral outbreaks. Mars' work has been shown in sold out gallery shows, vinyl effigies and in numerous publications. I visited Mars-1 (a.k.a. Mario Martinez) at his San Francisco studio to talk about his work.

There was something different about Mars' basement studio; it had an indescribable aroma, somewhere between the smell of fruit roll-up and blood. Even the hallway had an uncomfortable feeling, with warm spots and cold walls, but perhaps that's normal in San Francisco. Parts of the basement studio were finished off with stacked debris, Styrofoam sculptures in geometric shapes, dusty books... But elsewhere, parts of the earth stuck out in unlikely places, sharp rocks and roots made shelves for jars. Add a sneaky orange cat to the equation and it creeped me out! Our photographer for this piece, Joe Reifer had had a history of exploring odd trouble spots; from airplane graveyards to abandoned hospitals, but a look and a nod back from Joe confirmed my disconcerting feelings.

Throughout the interview the hallway lights flickered. Mars-1 suggested that we were to bring a flashlight for this very reason, but I thought he was joking. He solves this problem by a series of multi-purpose halogen lanterns hanging from his workspace. He gives a thinly veiled explanation about the electrician coming next week and wishes "it was fixed," but he really doesn't seem too bothered. Throughout the interview he answered questions through his bent coathanger smile when he wasn't speaking through the slit of a cheap rubber Creature from the *Black Lagoon* mask.

Attaboy (AB:) You visualize distant worlds, which appear as if they're undergoing great change. It's as if we're seeing them in the midst of their own Big Bang.

Mars-1 (M-1): Yes, you could say that. When you put it like that I am starting to wonder what things will look like when the dust settles.

AB: Is this civilization more intelligent that ours?

M-1: I'd say they were alien, at least in the way we know the term "alien."

AB: Is it devoid of technology?

M-1: I suspect this civilization is intelligent. I wouldn't necessarily say "more" intelligent but "different" in the abstract sense.

AB: Do the same laws of gravity, time and space apply here?

M-1: I am not totally convinced our thoughts are completely following these same laws of time and space. I believe my work reflects this possibility. One way of saying how it exists is as a collage of thought-forms defiantly open for interpretation. I want the viewer to be immersed in the creative process and to let their thoughts breathe—free to roam. No need to get too caught up in what it means to me, but it's symbolic of the imagination and creativity.

AB: I've been following your work for the past six or so years and I admire the way your work keeps evolving—changing dramatically from year to year.

I like to focus on new bodies of work all at the same time, like ten or twelve pieces. This way, it keeps things moving at a nice, productive pace. If I get stuck on one piece, I just set it to the side and start working on another one. Sometimes, I think of the process of working on my paintings as trying to solve **riddles or puzzles. So**

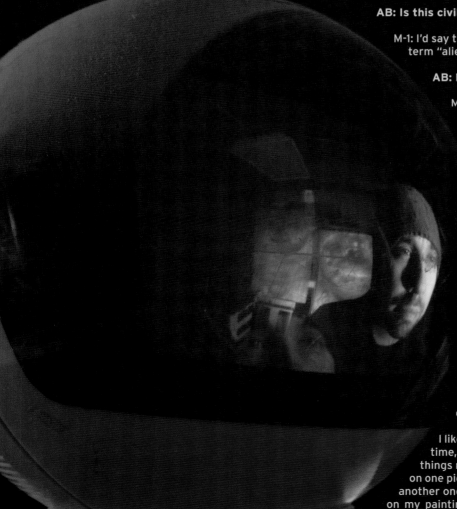

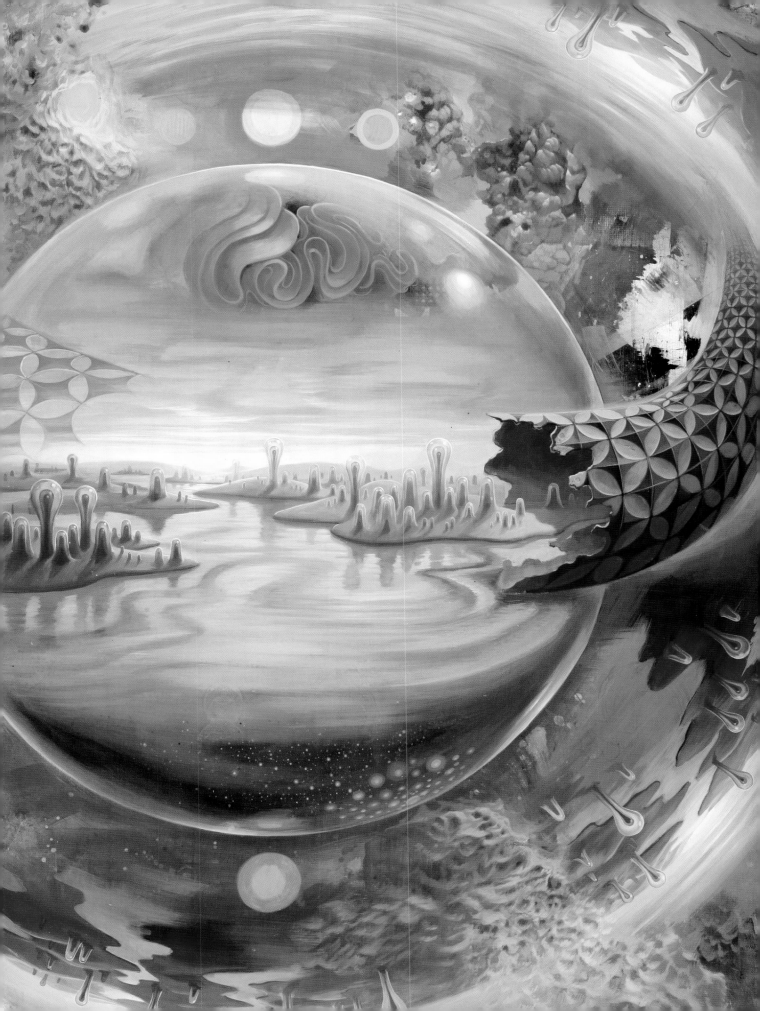

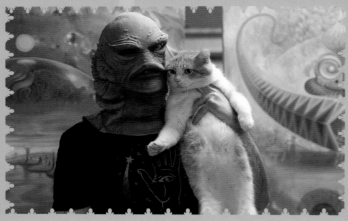

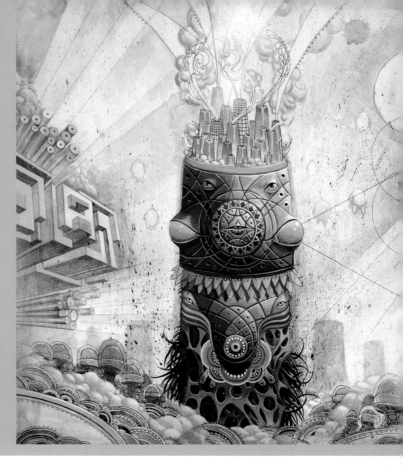

as I work on one riddle, it gives me time to ponder others lurking in the background! This method is also interesting to me because it allows a series of work to evolve together. An idea that may occur in one painting can spark an idea for another in-progress painting, letting new ideas incubate and playfully bounce around from piece to piece. What I find is that after I work through and finish a body of work like this (it takes about six months to complete) a few things happen by the end of the process. Namely, I experience a lack of sleep and vitamin D, over-work, and a longing for some R and R. Then, I usually won't pick up a paintbrush for at least a month. I use this time to catch up e-mail and miscellaneous things that I have neglected over the last several months. I draw in my sketchbook, travel, and just hang out with friends and family. I also take a dive back into the creative swimming pool to finish up whatever current toy project may be waiting for me. But, I have to make time to relax and unwind. Without, the stress can keep building up, crippling creativity and taxing my soul. It is mandatory for my creative process to take time to ponder, reflect and climb a far distant mountain of your mind, looking out over the horizon, across the valley of thoughts for a perspective besides the metaphorical maze that has already been wandered, over and over, day after day.

After the reset button has been pushed, the batteries get recharged and the creative cycle repeats. It's time to start working on the next series of paintings. Upon returning, it changes somehow from the last series; it is similar, yet different; keeping it interesting, allowing room to explore new creative terrain.

AB: Do you do a great deal of research?

M-1: Well, the only way I can explain it is in the sense of a mostly subconscious, all encompassing (to various degrees) "references" of all the things that have ever fascinated, interested and inspired me.
Maybe the simple answer is, "No." I don't consciously research

for any specific painting. The extent of my research is referencing my sketchbook, loosely, with a capital "L."

AB: Do you draw inspiration from science fiction books, movies or artists? If so, whom?

M-1: I do have an interest in science fiction, but I mostly draw a lot of inspiration from subjects that inspire a lot of science fiction—ufology, theoretical physics, etc. Artists who inspire me? Heck, I'm not even going down that road. The list goes on and on. Lately, I'm digging some of the fellows from the Hudson School of Art; landscape painters from the 1800s. In the movie department, I would say film writer and director Alejandro Jodorowsky's *Holy Mountain* and *El Topo* are my favorite movies of all time, guaranteed to drum up some creative juices.

AB: When I fly in an airplane and look out the window, I often think that every ten minutes I've just passed someone's routine; you can measure space by minutes. I love the idea that an entire world can exist in a tiny space, like the universe of civilizations that inhabited a locker in that movie *Men in Black*. It reminds us how small we are compared to the universe, and that our lifetime is barely a hiccup. It's hard to get a sense of scale. Are these microscopic or sub-atomically minute places?

M-1: About 6.5 inches—maybe six on a cold day. Wait what are we talking about again?

AB: Do you agree with the philosopher George Carlin who states that the world will be here long after we're gone? That it's not the earth that needs saving but the humans. Perhaps we are but the latest outbreak in the earth's pubescent stage.

M-1: Yeah man, I could see that point of view. It's like we are a bad case of chicken pocks!

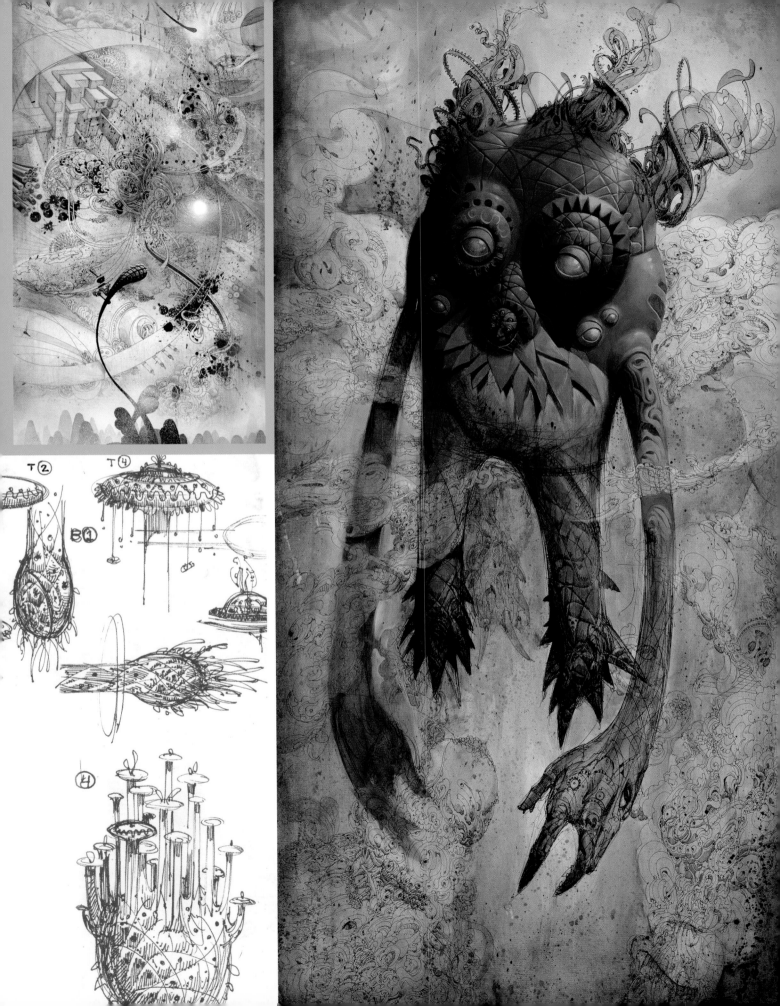

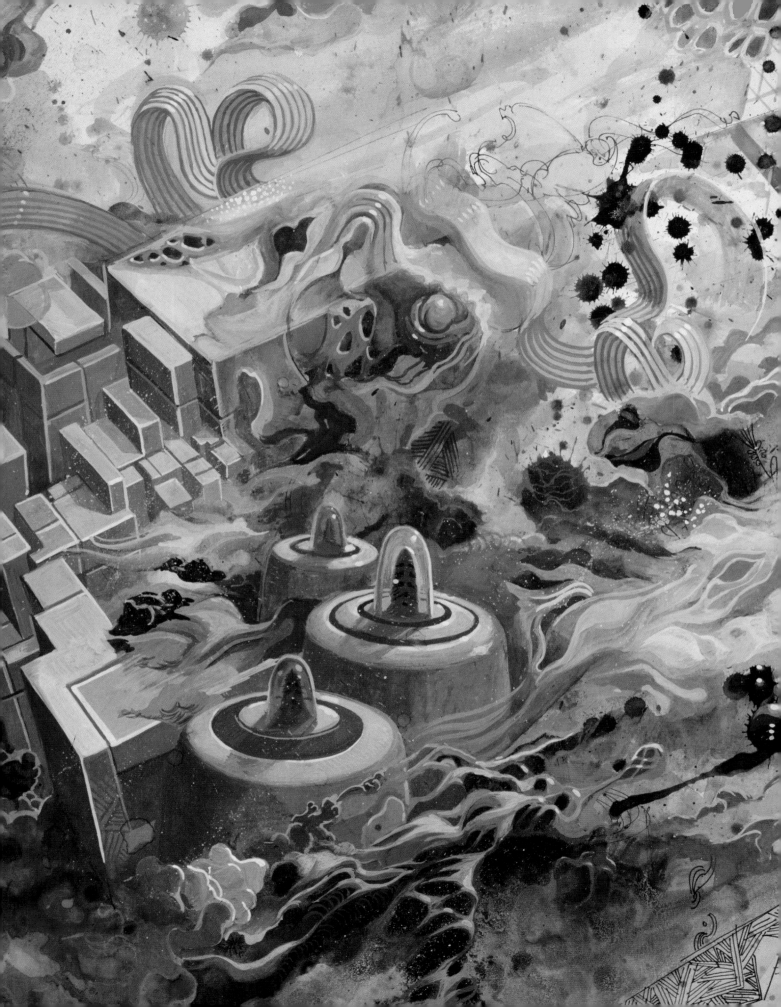

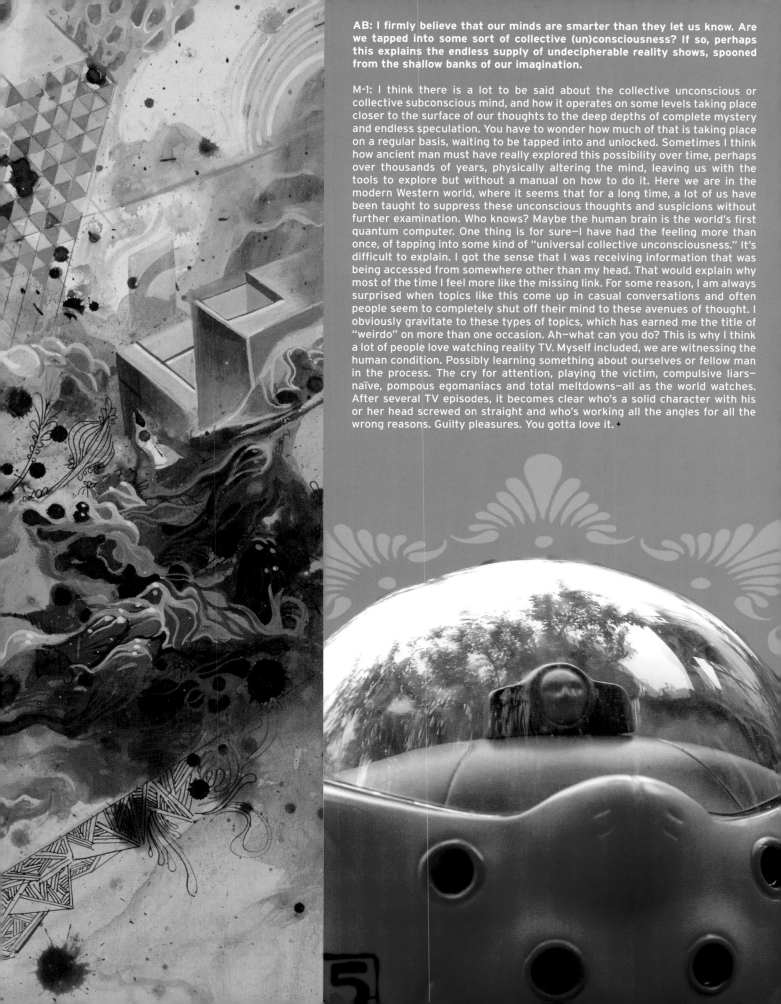

AB: I firmly believe that our minds are smarter than they let us know. Are we tapped into some sort of collective (un)consciousness? If so, perhaps this explains the endless supply of undecipherable reality shows, spooned from the shallow banks of our imagination.

M-1: I think there is a lot to be said about the collective unconscious or collective subconscious mind, and how it operates on some levels taking place closer to the surface of our thoughts to the deep depths of complete mystery and endless speculation. You have to wonder how much of that is taking place on a regular basis, waiting to be tapped into and unlocked. Sometimes I think how ancient man must have really explored this possibility over time, perhaps over thousands of years, physically altering the mind, leaving us with the tools to explore but without a manual on how to do it. Here we are in the modern Western world, where it seems that for a long time, a lot of us have been taught to suppress these unconscious thoughts and suspicions without further examination. Who knows? Maybe the human brain is the world's first quantum computer. One thing is for sure—I have had the feeling more than once, of tapping into some kind of "universal collective unconsciousness." It's difficult to explain. I got the sense that I was receiving information that was being accessed from somewhere other than my head. That would explain why most of the time I feel more like the missing link. For some reason, I am always surprised when topics like this come up in casual conversations and often people seem to completely shut off their mind to these avenues of thought. I obviously gravitate to these types of topics, which has earned me the title of "weirdo" on more than one occasion. Ah—what can you do? This is why I think a lot of people love watching reality TV. Myself included, we are witnessing the human condition. Possibly learning something about ourselves or fellow man in the process. The cry for attention, playing the victim, compulsive liars—naïve, pompous egomaniacs and total meltdowns—all as the world watches. After several TV episodes, it becomes clear who's a solid character with his or her head screwed on straight and who's working all the angles for all the wrong reasons. Guilty pleasures. You gotta love it. ✦

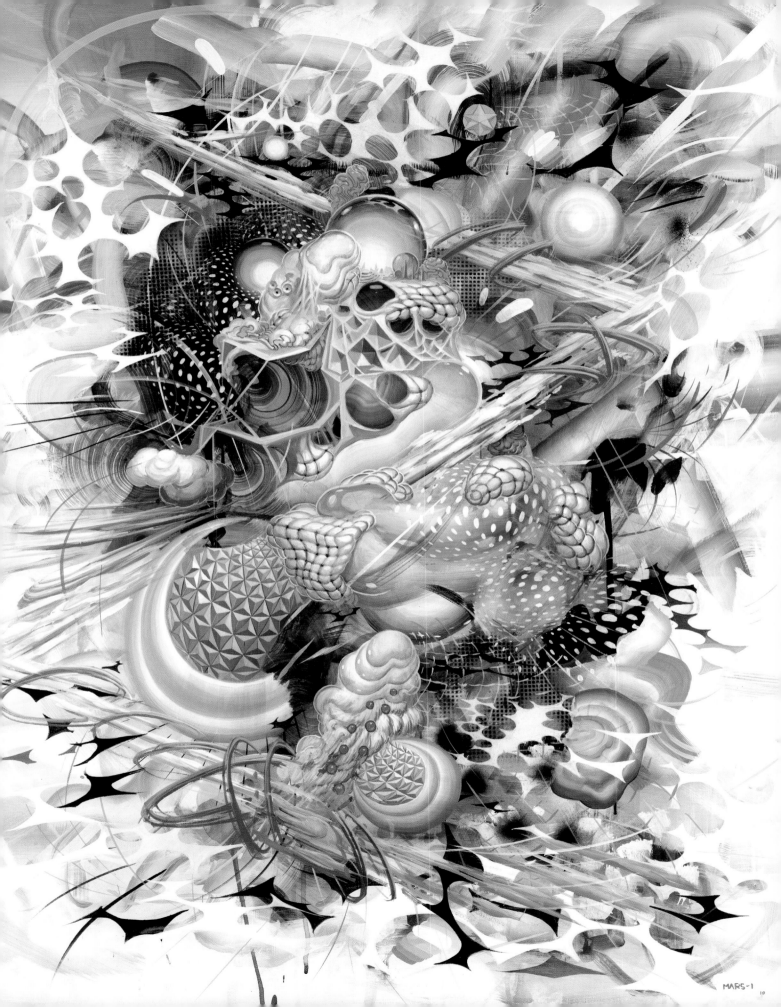

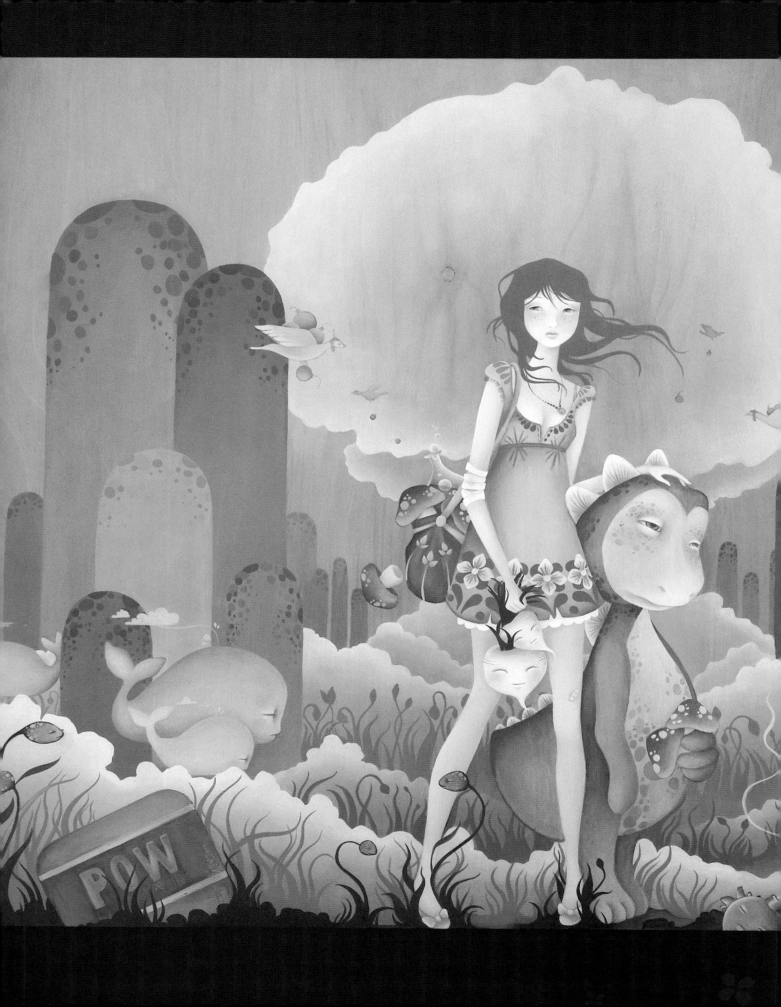

AMY SOL

"Dreamland": The Art of Amy Sol
by Kirsten Anderson

To look at an Amy Sol painting is to gaze into a tranquil, fantastical wor[ld] populated by a rarity in contemporary art: the gentle being. Each paintin[g] is a scene of a peaceable kingdom where humans and animals exist [in] fairy tale harmony, a sharp contrast to most work in the Pop Surrealis[m] art scene, which thrives on the cute/evil dichotomy. With only a handf[ul] of shows under her belt, Amy has gone from being a veritable unknow[n] to becoming one of the more highly sought after artists, with a legion [of] fans waiting patiently for each show to quickly buy up her work.

Amy's paintings are on wood panels with the grain allowed to sho[w] through, which harkens back to the natural themes in the work. Layere[d] over the top, painted in muted colors, lovely young women stand ale[rt] amongst flora and fauna that looks recognizable, even though it's n[ot] based on anything that exists in real life. The gentle beings in the work[s] are the pillowy, peaceful creatures that resemble elephants, whales, [or] bears, yet have a cartoonish distortion and frankly, look very cuddly. Lik[e] living versions of childhood toys, the are comforting and warm rathe[r] than threatening, and there is never any suggestion of aggressivenes[s.] The animals in her paintings all seem to be just waking up, hazily walkin[g] around, or about to drop into a deep slumber. Sometimes they are carrie[d] by the girl, and sometimes they carry her. "The faces of the animals [I] paint are actually often based on memories of old pets I had or animals [I] knew," Amy says thoughtfully, as if realizing this for the first time. "The[y] are sort of jumbled impressions, and even include people I know."

Landscapes are often more suggested than fully fleshed out, as if see[n] through a haze. Highly stylized, the backgrounds, decorative aspect[s] (such as the patterns on the girls dresses), and plant life are evocativ[e] of Art Nouveau period fluidity, but also of the graphic simplicity an[d] streamlined beauty of the Arts and Crafts movement. However, eve[n] though the paintings are soft, they are removed from being fluffy du[e] to an underlying tension viewing these visions provoke. A slight whiff [of] melancholy permeates the serenity, as neither the creatures nor the girl[s] are ever depicted as overtly smiling even though the sense of the bon[d] between the animals and girl is palatable. It's as if the characters know[,] as well as we do, that these are dreamlands, and that harsh reality mus[t] inevitably intrude and break the spell.

Amy adds, "I haven't really talked about this before, but my father use[d] to own a beef farm in Iowa. I spent every summer there and I reall[y] remember being with all horses, cows, all manner of animals. I was to[o] young to really realize these animals would be killed and made into foo[d.] I just loved animals and saw distinct personalities and intelligences i[n] them. I think they are much smarter than people give them credit for, an[d] that goes into my work somehow. Although," she adds, "I haven't reall[y] analyzed it [the motivation behind her imagery] much."

That's because Amy prefers to work intuitively, without speculatin[g] beforehand what each painting will be about. "I imagine looking int[o] another world, or universe. The female character sort of just appears[."] Rather than using the female figure as a self-portrait, Amy says that the[y] are more like an embodiment of a concept. "She might metaphorical[ly] represent Mother Nature... she is young but wise." Despite th[e] characters gentle and calm demeanor, she often looks like she is guardin[g] the creatures that stay close to her side, "but sometimes they are th[e] guardians, connecting humans to the environment."

The main thing Amy strives for in each painting is a sense [of] amorphousness. "I like them to be between extremes" she says, and tha[t] extends to her distinctive color palette.

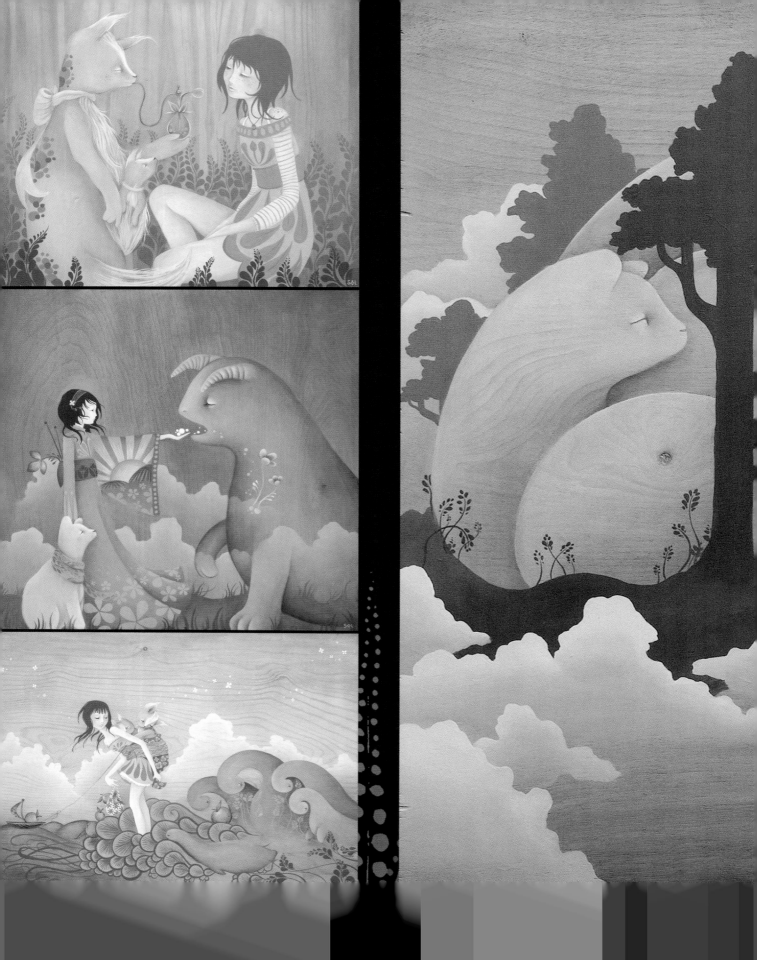

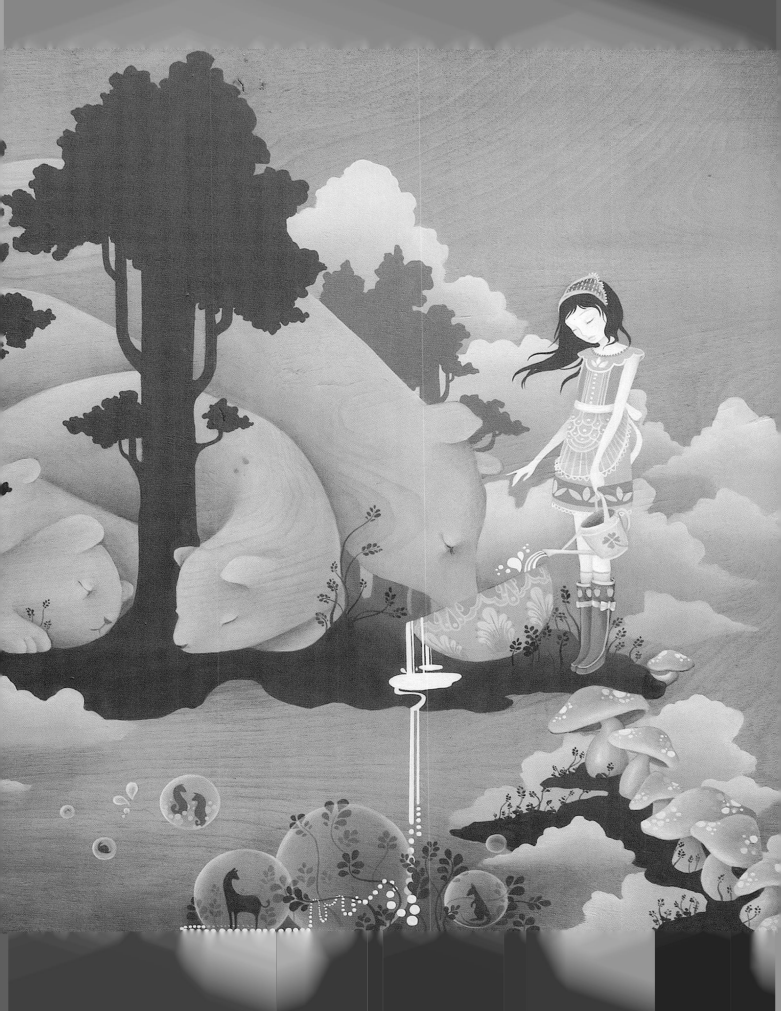

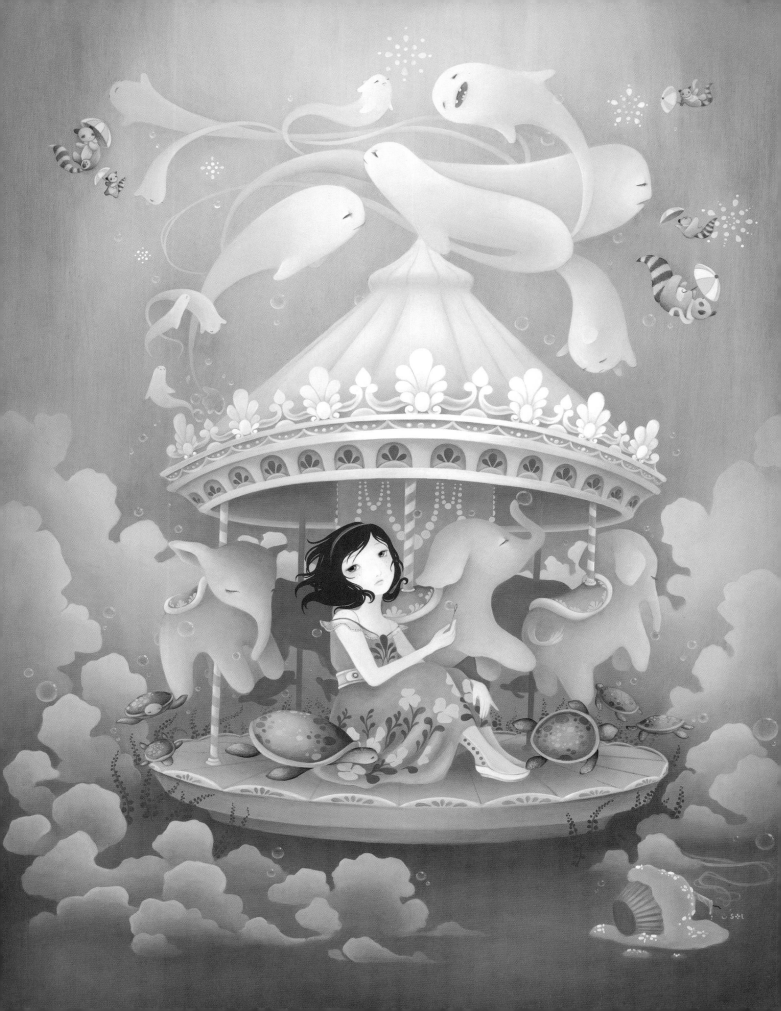

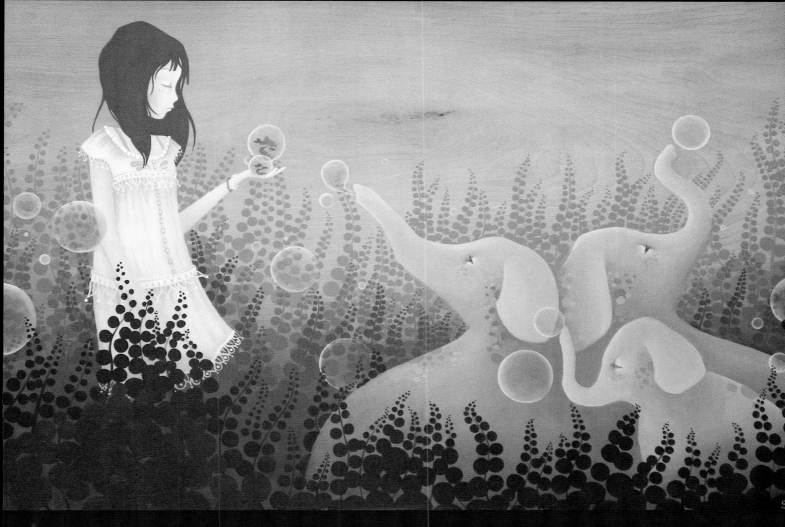

"I spent a lot of time in the past purely experimenting with motifs, design and color," she explains. "I really got into trying to create the colors I had in the back of my mind, even though I didn't really know consciously what they were! I knew I wanted a sense of ambiguity in my colors as well—I didn't want a blue, or a grey, but something in between.

As a result I now mix all my own pigments and create all my own colors rather than using standard paint recipes. I use almost every color pigment in each color I create. I finally realized the palette I was seeking was that of a forest at night." This palette she uses to great effect, using shades of brown, ochre and blue that heighten the languorous tone of her subject matter, and it's often hard to tell in her work if a scene is in the evening or during the day, which only adds to the nebulous aura of each piece.

Amy herself seems thoughtful and somewhat subdued. Born to a Korean mother and an American father, she was born in the U.S., but spent some time growing up in Korea, and then moved to Las Vegas. Her artistic start is one common to many artists. She is self taught, and started drawing at an early age. "I did lots of things, like play music, but drawing and painting is one thing I really stuck with and developed fully. My mom has saved stacks of drawings I did when I was little... I always drew girls and animals. I would hang out at home and draw stories. I did this sort of obsessively through junior high!" she laughs.

After her stint experimenting with design and color mixing, Amy returned to drawing the things she liked best. "I guess I developed my style about three years ago, incorporating the new techniques I learned to the subjects I always liked to paint." Her first big break in the art world came when Gary Pressman of L.A.'s Copro Nason Gallery found her Myspace page and contacted her with an offer of a show. Only a little more than a year ago, that first show led to a host of offers of exhibitions amongst most of the Lowbrow/Pop Surrealism galleries as well as a plethora of interviews and magazine profiles. "I get a lot of emails asking for work," she says, "and in fact, I've had to cancel some shows, which I feel really bad about. But I feel it's important to offer quality over quantity. I feel better having a lot of time to work on a piece, rather than show something I can barely stand to look at later because I had to do it so fast." That said, Amy is also grateful for the attention her work has received. "I can do art full time which is something I always dreamed of but did not expect."

Amy's most recent show was at L.A. gallery Thinkspace with some of her contemporaries such as Audrey Kawasaki, Kukula, Stella Im Hultberg and Brandi Milne. Her work quickly sold out, as it does in all her shows. When asked about her thoughts on moving to the underground art mecca of Los Angeles, she says, "I was tempted, but I always returned to Las Vegas. I like the energy of Las Vegas, but particularly the outskirts where it is actually very slow. There is not much to do, so I can really focus on work. It's sort of like my own little cubbyhole."

Upcoming projects include more shows at galleries such as Copro Nason, Roq La Rue, Lineage and Gallery 1988, and she has a full-length animated film currently being created based on her artwork.

Plus she jokes, "I'd like to have my own line of paint!"

"I never run out of ideas," Amy says. "I feel lucky that I'm so busy because then I can use those ideas. I get to go into the studio and make the same things I did when I was little, only more sophisticated. It makes me really happy." ✦

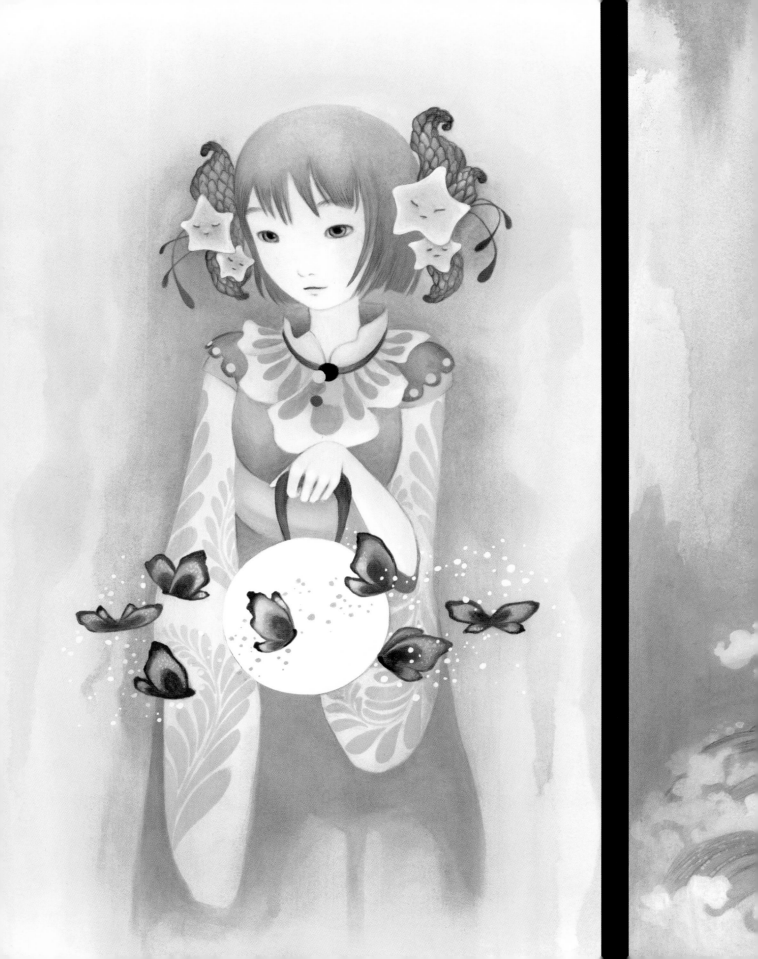

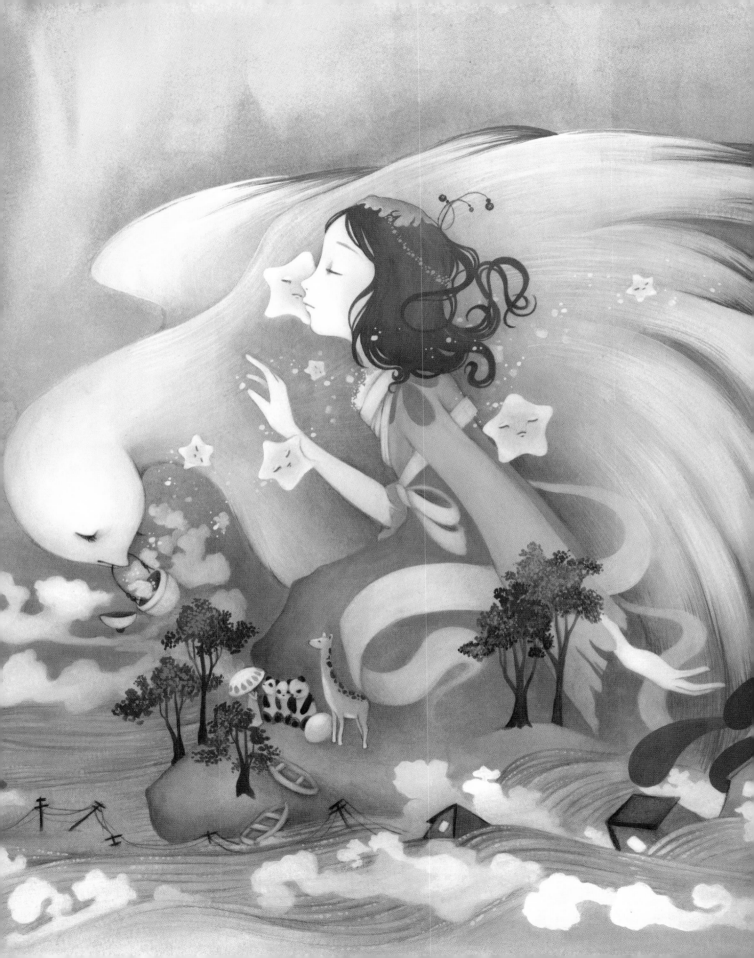

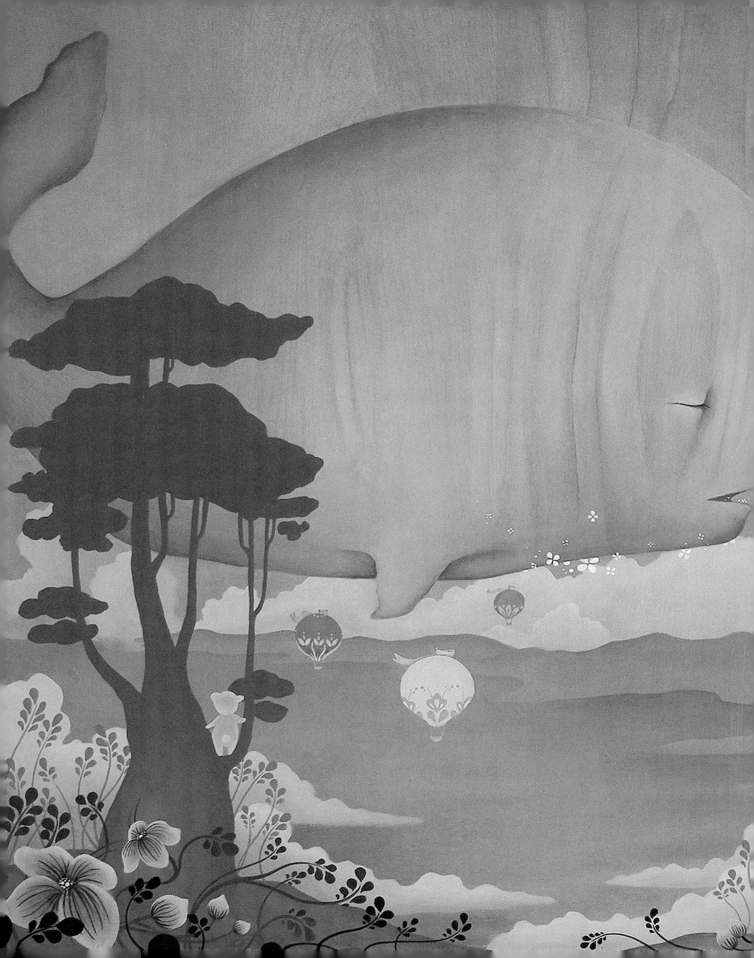

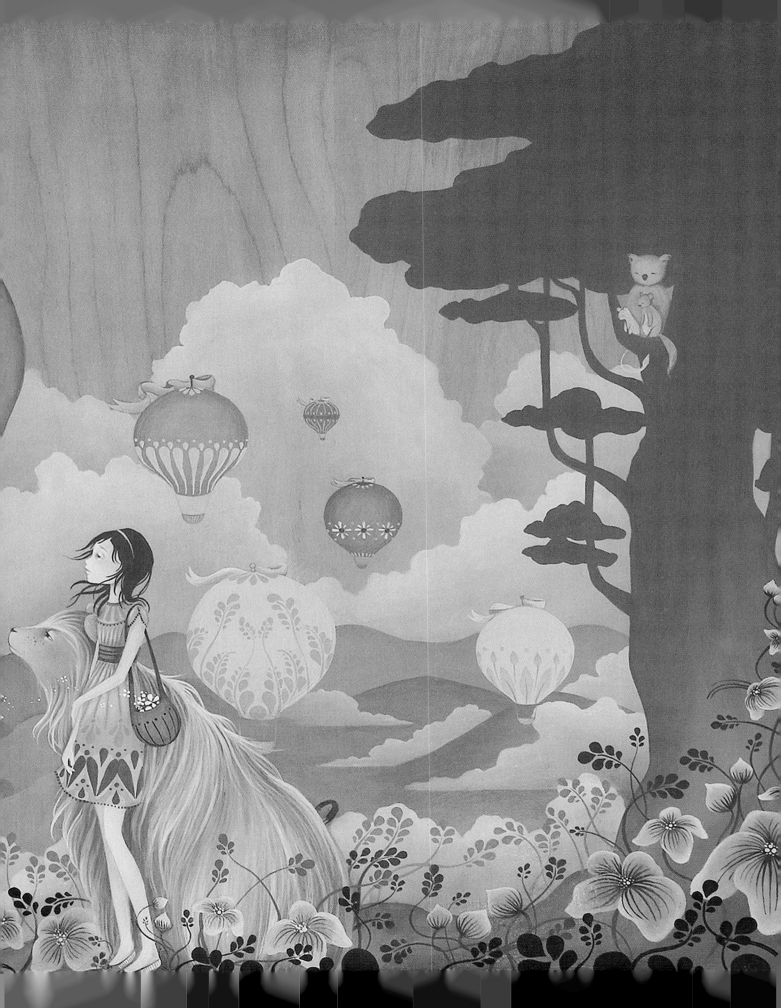

Interview by Annie Owens

Parskid is cute when he's angry. The irreverent and mysteriously hooded character, created by the artist of the same name, has multiplied and grown slightly more mature since the first time we spotted the swaddled boy-bushka back in 2003. Since then Parskid has put a long list of art shows under his belt. His brand of illustration, painting, plush and Digital art crosses over the invisible lines of many of the art scene's sub-genres.

I noticed the themes in your work have changed from when I first came across your art in 2001. The character has multiplied from one to many, and some of them have grown antlers (or did they always have antlers?) The landscapes have changed too from mostly urban, to environments that are more um... I'm not sure earthy is the word but there are lots of beautiful trees and mountains with a softer quality. Did you move?

A lot has changed since then. My characters have definitely taken on new identities. They are in different hordes and clusters. Things like antlers and horns separate their purposes and who they are. Their environments have changed too. I think I've come to appreciate nature and I'm surrounded by a lot of lush trees and forest where I live. I try to focus on that more and its influence. The themes are roughly based on different things I've experienced or thought about. I try to tell a small fraction of a story or tale with each piece.

Would you mind talking about Parskid please?

Parskid is just the name that's developed over the years that I use for my art. I came up with using the name 'Pars' in 1999 when I was looking for a name to write on things. I would divulge where I got the name Pars from, but it would be giving away too much information I think. It's basically just a first or last name that I go by, you could say. [So-called journalist hangs head in shame for not researching artists last name.]

The 'Kid' was added a couple years later. I was looking for a name for marketing purposes and to differentiate my street work from my gallery work. I decided on adding the 'Kid' because I like to think my characters are mostly children or at least have the views of children. So people would hopefully make that association when they saw the name. I don't think about it too much to tell you the truth, it's basically just the moniker I go by now.

I read that your earlier work is a little bit reflective of your childhood and of childhood in general. It's nice to see this natural progression from early work to now. Did you or do you ever worry over about what you'll do next? Or do the pieces come without too much forethought?

I'm always trying to evolve and progress. I'm constantly thinking of different ways I can change things up and explore new ideas. It's mostly so I personally don't get bored painting similar things over and over. Process has been a big thing for me lately. Creating one that feels really natural for me and I can call my own. It's an ever evolving thing with me though. I never really think too far ahead.

Are you really a vandal? I've heard the stories.

I won't admit to anything specific but I've been known to vandalize things—catching tags, painting freights, breaking windows... it's all good fun!

Could you tell me what it's like doing live art at shows like what you did at *Dodge and Burn*? How does it feel to have a bunch of people taking pictures and watching you as you paint?

You know, it's pretty strange for a person like myself who isn't too outgoing. I always get a little nervous someone's going to tap on my shoulder and want to start some shit over some graffiti or something like that, but that usually doesn't happen. To tell you the truth I really don't like talking about my art, so when someone comes to me in person and starts asking me twenty questions about my work, I want to go hide. (No offense or anything.)

None taken.

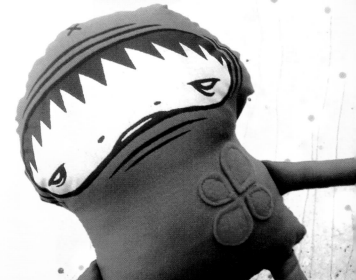

"I'M CONSTANTLY THINKING OF DIFFERENT WAYS I CAN CHANGE THINGS UP AND EXPLORE NEW IDEAS."

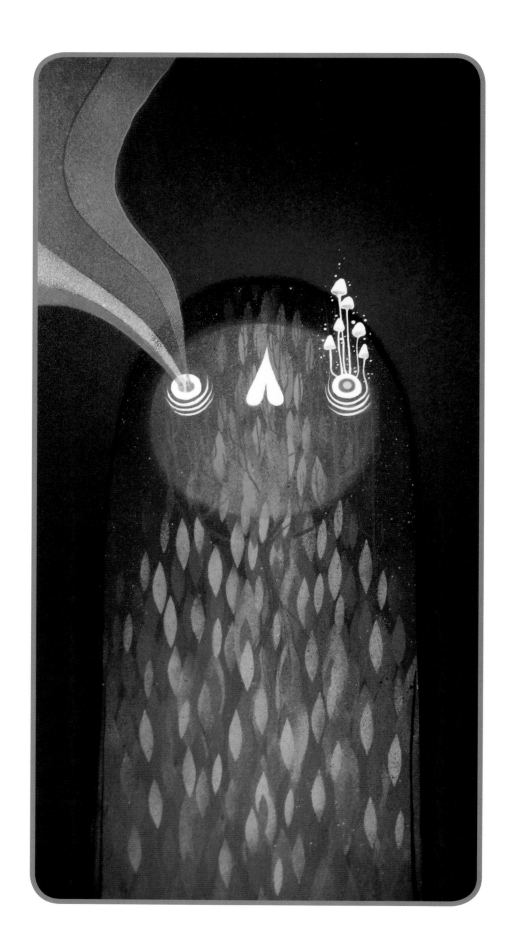

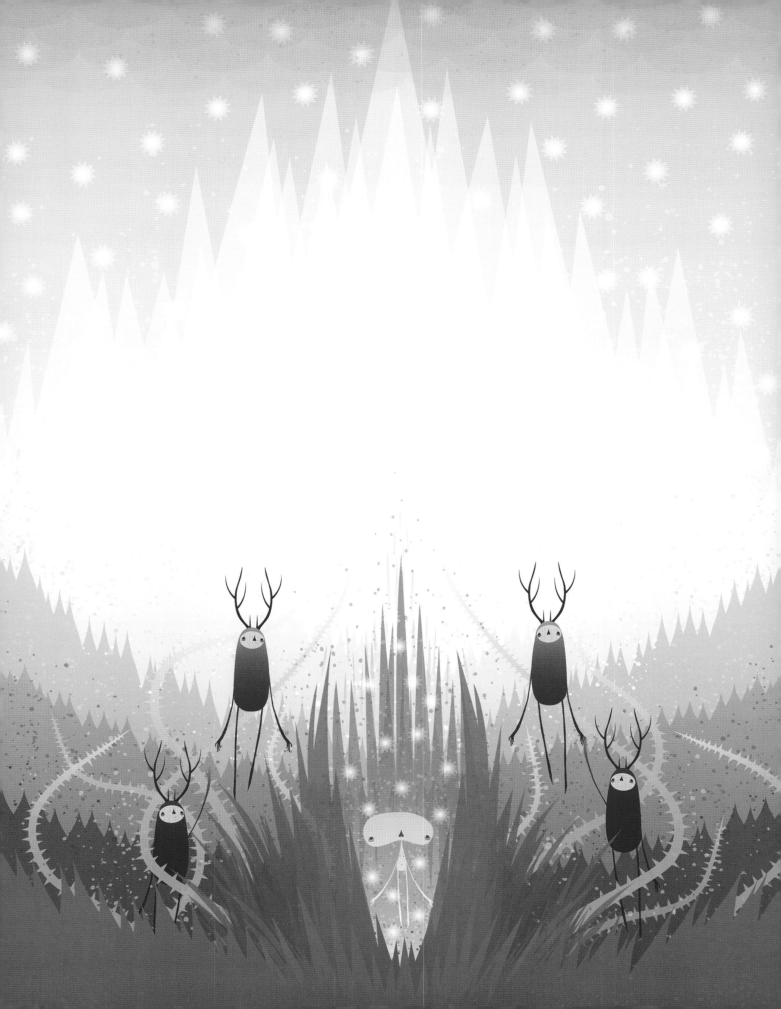

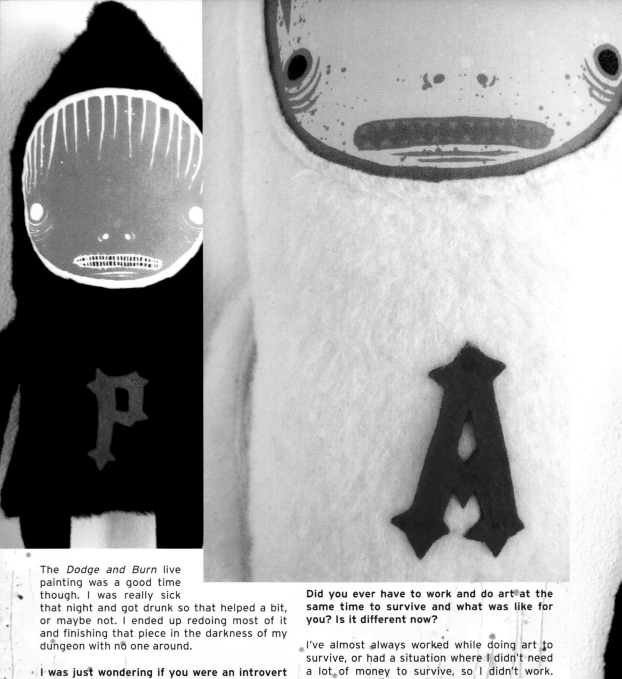

The *Dodge and Burn* live painting was a good time though. I was really sick that night and got drunk so that helped a bit, or maybe not. I ended up redoing most of it and finishing that piece in the darkness of my dungeon with no one around.

I was just wondering if you were an introvert or an extrovert.

Usually I'm pretty introverted but at times it can be the other way around. We don't want to talk about those times though.

Did you ever have to work and do art at the same time to survive and what was like for you? Is it different now?

I've almost always worked while doing art to survive, or had a situation where I didn't need a lot of money to survive, so I didn't work. Lately I've been not working as much and doing art mostly but I wouldn't say I'm doing really well. Let's just say I've looked through your magazine, but never have had the money to buy it. +

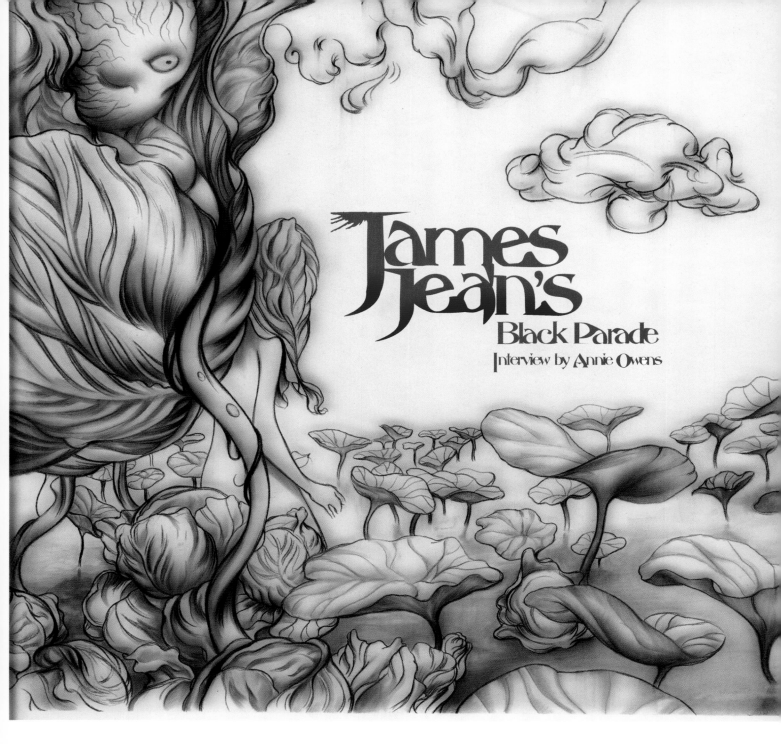

James Jean's Black Parade

Interview by Annie Owens

The open-ended art movement that we're lucky enough to be a part of has allowed many artists the ability to jump the old boundaries of categorization. One such illustrator whose captivating work, both personal and commercial, has earned him countless awards in the area of comic and book illustration, has also established himself as one of the most talented and prolific artists of our time.

If there were standards to be set in the world of art, James Jean would certainly have set some new ones. His beautifully executed images are complex in both content and concept. Never repetitive, his work evades the generalities of popular themes.

You will recognize some of his recent work on the CD art for the band My Chemical Romance's, *Black Parade*. At the time of our interview, James was in hiding, working intently on a batch of fresh work; but he took a break long enough to let us annoy him.

Annie Owens (AO): There's an ethereal quality to your work and objects/areas are darkened or blurred as if looking at it peripherally. Is this intentional... why?

James Jean (JJ): Creating pictures is great because it's so manipulative: you can direct a viewer's eye, lift them up into the sublime or drag them down into the profane. Technically, it's much like dodging and burning a photograph, pushing and pulling elements in the surface to create a sense of thrust or interest in a composition.

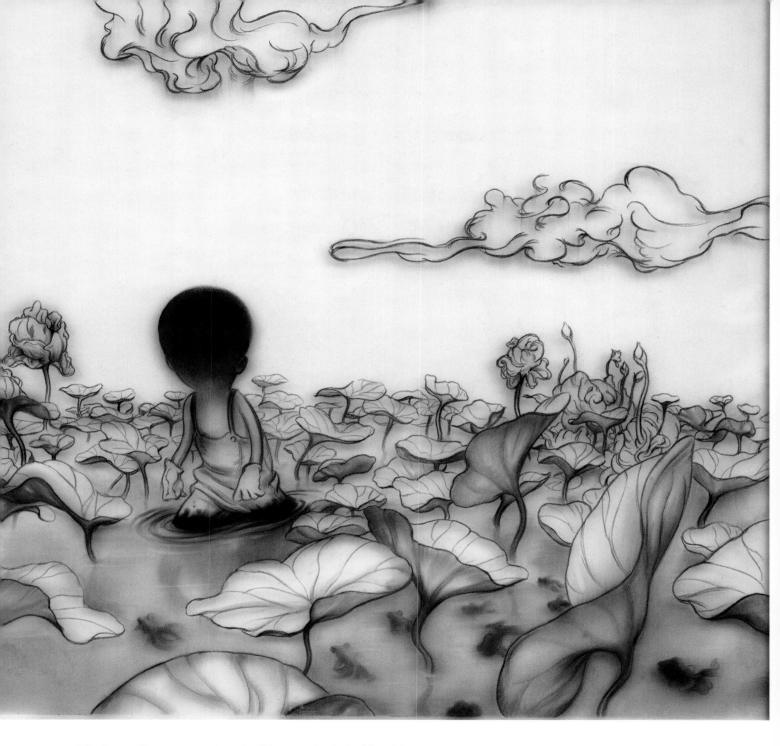

AO: Some figures are viewed with a sort of double vision appearing multiple ways in the same frame. It reminds me of the way Winsor McKay would compose his borderless comics.

JJ: That comes from drawing from observation, which developed from sketching on the subways when I lived in NYC. The train would shake, people would move, and I'd desperately try to keep my line true to whatever I was looking at, just trying to capture the moment. Hence, there was a lot of drawing over drawings, a layering of time and perspective.

AO: Do you, like Miyazaki, incorporate Shintoism into your works?

JJ: Not specifically... I'm attracted to the imagery and ideas, but

it's not something I grew up with culturally or claim to really appreciate. I'm still searching for an honest expression of whatever it is that's haunting me intellectually and spiritually.

AO: An enormous amount of planning and assessment must go into your images. Do you ever wind up rejecting any of them once you've already begun to lay down the paint? Do you keep the rejects like ugly children you still love or do you throw them out?

JJ: Very few are disavowed, many are nourished. As an "ugly child" myself, I know what it's like to be marginalized, to suffer the cleated heels of beautiful bullies. Actually, the most interesting part of the process is to wriggle oneself out of a mistake.

AO: Would you talk about the frustrations involved in creating your work?

JJ: Unpredictability is the most rewarding and frustrating part of a piece. Lately, color has been a particular struggle—after years of composing images in Photoshop, it's difficult to go back to painting with its physical constraints. My older paintings used to be more vibrant, and lately, they've been the color of earth and storm clouds.

AO: Would you talk about the satisfaction you feel after completing a piece?

JJ: I feel most satisfied when I look back over a body of work, rather than a piece on its own. I like to see the progression of ideas and the surprises along the way. The arc of experience from its verdant beginnings, to it's glorious apex, and to its desiccated shit-streaked ruin.

AO: I fell in love with your work immediately because of the awesomeness (for lack of a better word) and sheer volume of what you've produced, I thought you were... well I thought you were seventy. Possibly because of the comics background but I also think because your work is very unlike the art of a lot young artists currently. Certainly not to knock anyone else, but your work isn't trapped by trend and seems to be produced from a wholly original mind. (I swear I'm not trying to win favors.) But the old white man misconception: Has that happened to you a lot? It took me about a week to adjust to the fact that you were only twenty-seven, so young to have accomplished so much.

JJ: Old white men enslaved and emancipated the uncivilized world. Just because I look like a pasty raisin doesn't mean there isn't a young, diminutive Asian man waiting to bust through this alabaster shell.

AO: Alrighty. You must have begun working immediately after finishing school. Were you working as an illustrator also during school?

JJ: During the last year and a half of art school, the internet bubble was inflating, and I worked at a Flash animation company on Wall St. Other than that, I had a hard time finding illustration work. After 9-11, a magazine cancelled my first editorial illustration job, but I almost immediately received a regular cover gig at Vertigo/DC Comics the following month. As I kept doing the covers, the editorial and advertising work started coming in, and it slowly built up over the years.

AO: I wonder what you think of the use of the word talent in the context of great art or music. Some people would say there isn't such a thing and that great art comes purely from hard work, diligence and practice. Some would disagree and say it's something you're born with and cultivate. What's your take?

JJ: Obviously, you need both talent and diligence, and maybe a little luck as well. In my case, I certainly wasn't born into an artistic environment or groomed to be an artist. I wasn't groomed at all. Deeply stained, an artist through and through.

AO: Your work stands out and cannot be pigeon-holed by style, category or genre and this all seems to be very natural. Is it difficult not getting caught up in the sceney art scene?

JJ: I'm currently trying to get back into painting... the work has always found its own place, it breathes and reaches out to the right people, and I can hide in it's shadow.

AO: Do I see a Suehiro Maruo influence? Your nightmarish images are more cerebral and introspective, but the subtlety in your approach produces very strong imagery.

JJ: I have five or so volumes of his work from Japan—I love the weird mashup of European and Japanese imagery, and Georges Bataille's *Story of the Eye*.

AO: In terms of the subjective and objective, which do you feel your personal work is most?

JJ: I suppose it's mostly subjective, though I also enjoy creating drawings from life with an objective mind, that is, removing self-awareness and letting intuition take over.

AO: Do you ever *not* want to do a commission based on what and how someone wants something?

JJ: During my illustration career, I was able to find some moment of interest in a project, no matter how mundane. However, I've been less tolerant lately as I struggle to get back to my personal work.

AO: From the other room just now, I heard

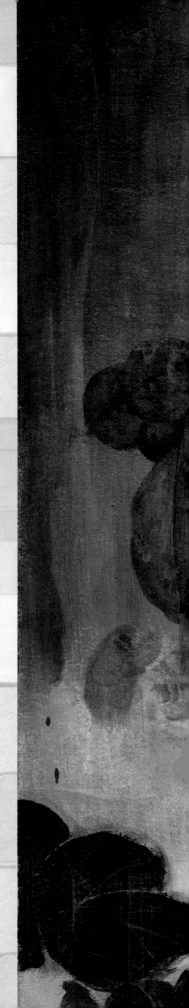

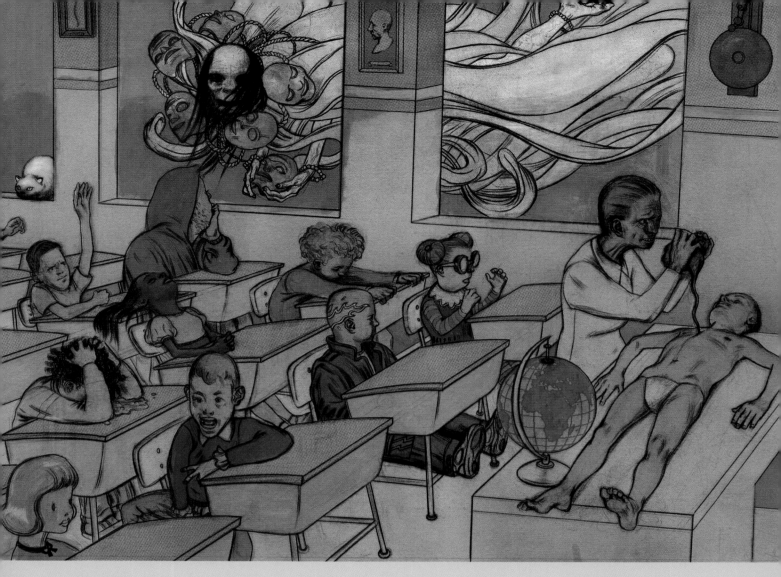

Attaboy say, "Oh there you are… my SWEEEEEEET." Thank goodness I know better and realize he is talking to his favorite paintbrush. Do you get like that? Favorite brushes or a specific way things need to be when you're working?

JJ: I adapt well to changes in environment, and I'll use whatever is at hand. I don't rely too much on any one brush or tool, though I do have favorites—the best brushes are usually battered and worn down to a weird shape and create amazing, unexpected shapes.

AO: This is a totally irrelevant question but kind of one I tend to want to ask very skilled artists but never do. Did you ever draw your own porn as a kid?

JJ: I was never turned on by my own drawings as a kid, but it had an amazing effect on others. When I was in the second grade, I drew a hermaphrodite for a friend of mine. He wanted to see me draw a naked lady, and then I drew a peepee to top it off. We died laughing, but the lunch monitor confiscated the drawing and I got in trouble.

AO: I imagine you to be totally immersed in your work. This makes me wonder at how much time you get to spend out of doors! Is time management an issue and what do you do when you are overwhelmed with demands like, for instance, demanding magazine editors?!

JJ: I have so much love to give, Annie. That's what people need to understand about me. A love that will undo and screw me in the end.+

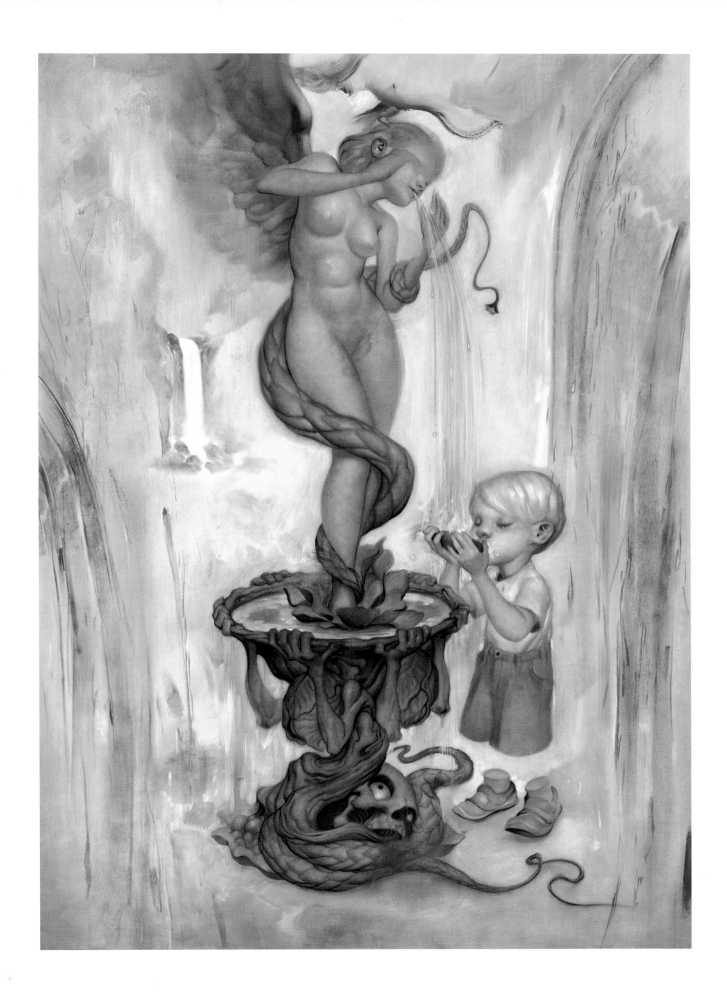

Brendan Danielsson

Interview by Attaboy

The people in Brendan Danielsson's awe-dropping drawings and paintings seem to be undergoing major medical problems, perhaps some degree of jaundice or at the very least they suffer a damaged thyroid that results in crossed and dilated yellowed eyes, eyebrow growth, large foreheads and the nastiest vein-erupted boxer's noses. Many figures have neck issues, either from another being growing from their neck. Our eyes draw us closer to them for their lush rendering, but soon after our brains kick in and the story quickly changes. Attaboy interviewed this Georgian artist in two sessions via modern telegraph stenotype machines.

In one of your paintings we're showcasing a clawed Neanderthal embraces (or is that chokes?) a red nosed woman in a romance novel pose. Can you tell us a little about this image?

This is one of the rare illustrations that I've done the last couple years. I created it based around the theme of "horror" for the Horror issue of *Vice Magazine*. So coming up with an idea, I asked myself "what is horrifying to me?" One of the scariest things for me is the fear of the unknown. It's the not knowing the outcome of a situation, and the seconds leading up to it, which can be frightening. Take death, for instance. It's not that the idea of being dead is such a scary thing... we all are going to die one way or another, it's the fear of how we are going to die and not knowing when it'll happen, that's what's scary. And I wanted to put some of that into this piece. I wanted to create a situation that was uncomfortable for both the female character in the painting and the viewer. And I wanted to include an element that would lead you to question the outcome... Is he about to kiss her or kill her?

Are you attracted/fascinated with the grotesque?

Anything that breaks away from the monotony of sameness that surrounds us every day interests me. Everywhere we look we are flooded with someone else's generic ideal of beauty that is so boring and uninspiring that I'd rather gouge my eyes out than look at it. I find people who are unique with their own flaws or faults much more beautiful than the typical norm. But that's not to say that I'm necessarily fascinated with grotesque things. I just am turned off by normalcy.

Why all the attention to punch drunk enflamed noses in your work?

That's probably a leftover element from back in my art school days when I was trying to find myself as an illustrator. It seems like a lot of the artists I was looking at back then had each done a shiny red nose at one point in their work. Artists like Skip Liepke, C.F. Payne, Rick Sealock and Brad Holland. And I think that it's something I picked up on early on and it just sort of stuck with me. I think it's just a way to add another element of detail and interest to a piece.

I've heard that you actually despise the process of creating a painting. Does this stem from a want to get the image to match a mental picture you may have? Is it a constant struggle?

This is generally true, but not always. I definitely have a love/hate relationship with my work. There are times when I'm as high as a kite while I'm painting and then there are the times when I'm looking for the nearest window to smash it through. So yes, it is a bit of a struggle. All I can do is try and make sure the painting doesn't get the best of me.

Your sketches are so lush and detailed, with scary nuances, can you describe your sketching process a bit?

The best way I've found to describe my drawings are that they are not much more than glorified doodles. When I sit down to draw, there is very little forethought put into it. I just get out my clicky pencil and start sketching. I usually begin with the face and then branch out from there. As the drawing progresses, I come up with elements that would create interest or maybe even a small narrative. But they pretty much just sort of draw themselves.

You are the founder of the Art Dorks Collective, a community of artists which

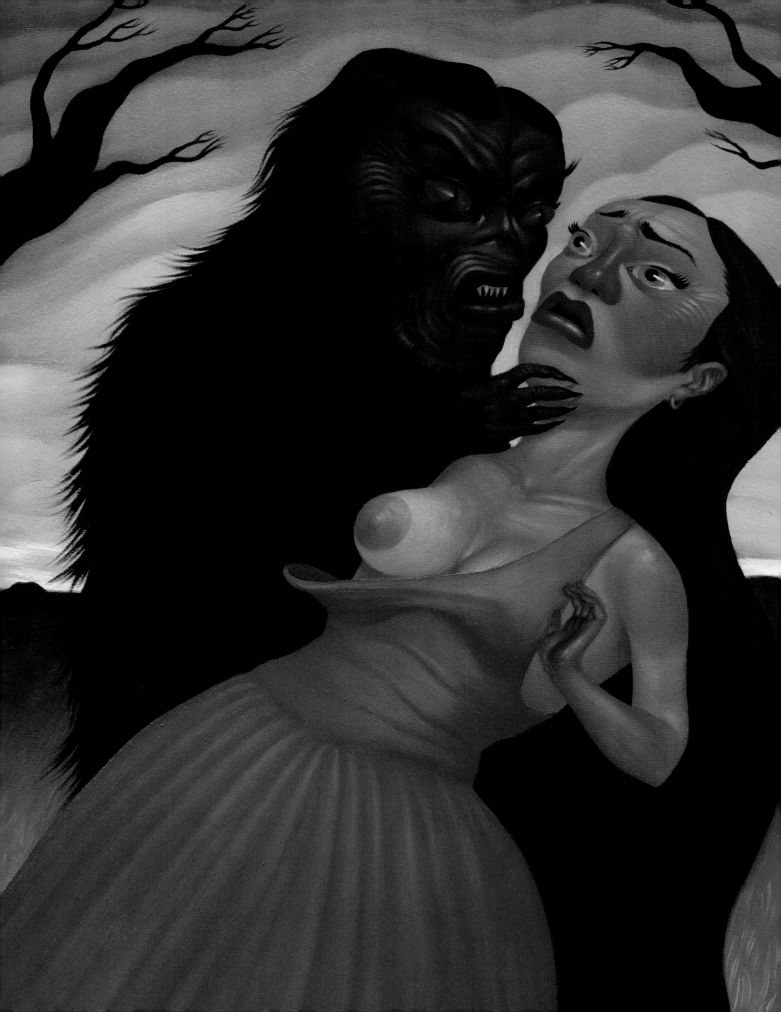

includes fellow featured artist Travis Louie as well as painters Chris Ryniak, David Chung, and even the paper cut art of Half Japanese singer Jad Fair. It's a great diverse group—did you all know each other or share a common bond/mantra or sorts?

Nearly half of us attended the Ringling School of Art and Design, but I think that's more of a coincidence than anything... I don't know. Maybe there was some word of mouth action happening early on. But with the exception of a few of us, I think most of the other members met on the Art Dorks website.

And whether there's a common thread that ties us all together... yeah, I think so. Most of us have backgrounds as illustrators, have similar attitudes towards art and life and I think that most of us were probably outcasts growing up. I love the work that everyone does and I'm proud that I've been able to be a part of something like this.

All the artists in the Art Dorks Collective use traditional means to do both gallery and commercial work. There seems to be a resurgence of this type of illustration. Any thoughts on this new wave?

I like it.

Thematically your paintings remind me of German folk lore and realistic fairytales like Strumpweiller (Shock Head Peter), where dire things happen when moral consequence rears its ugly head. Have you read any of these?

That's interesting... not the theme part of what you said exactly. I don't really think all that much about themes when I'm working, but maybe you're on to something with the German part. I've always been fascinated with the history, the design, and the culture of Germany. My grandmother was from Germany and my father was

from Iceland so I've always been interested in where I've come from. Maybe I'm tapping into some old thing or thang or something... I don't know.

Can you share with us artists whom you admire or influence your work?

Too many and not enough. I'm always excited when I find someone new who blows me away. Some of my early influences (and inspirations) still carry through to this day with artists such as George Tooker, Mauricio Lasansky, Antoni Tapies, Robert Rauschenberg, Phil Hale, Robert Crumb and other stuff like *Garbage Pale Kids* and *Ren and Stimpy*. And some current artists like Xiaoqing Ding, Alex Gross, Walton Ford, Sam Weber, Ronald Kurniawan, Femke Hiemstra, Stéphane Blanquet, Creoman, Zeloot and, of course, the Art Dorks... especially my wife, Meagan. There are aspects of her work that scream genius.

I love the wooden "Neighborwood" figure you painted. It looks like a Fisher Price Little People serial killer. Any plans to take your work into limited run vinyl or perhaps sculpture?

No plans to do any vinyl, although I've thought about it. I just haven't pursued it much beyond the idea phase. If a company approached me with the means to make it happen, sure, I'd probably do it. Other than that, I do have plans to do some wood and possibly bronze sculptures beginning sometime later this year. I won't say much more than that... just because it seems the more I talk about doing something, the less likely it is that it actually gets done.

I'd love to see those eyebrows of yours in the third dimension!

I guess I could shave them off for you. Maybe we could work out some sort of trade.

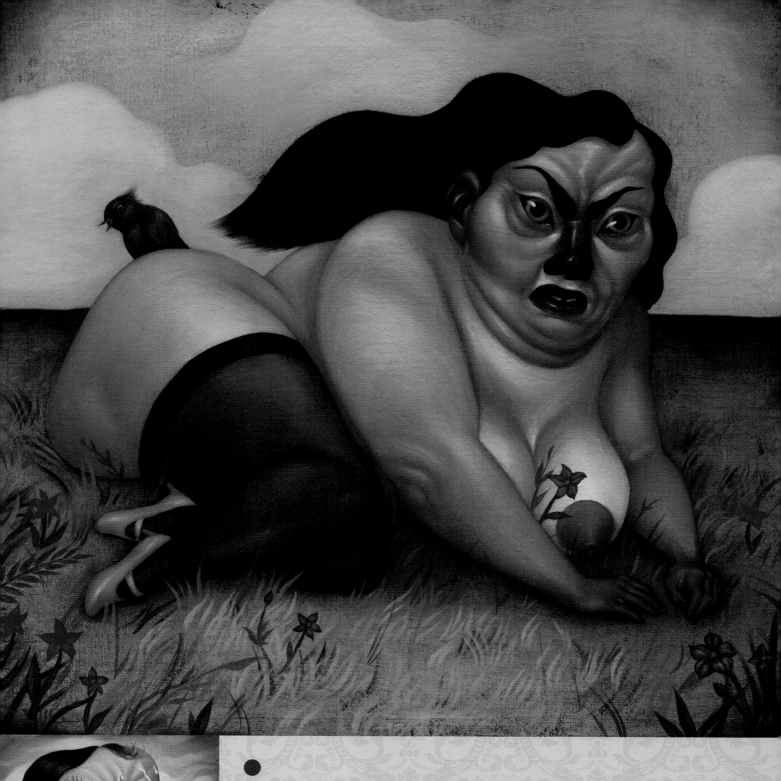

What's the art climate like in Georgia?

Sluggish. Like a wet sponge.

But have you ever been to folk artist Howard Finster's house/museum/theme park in Georgia? I hear it's amazing.

No. I should. I used to live a half hour from the Dali Museum for six years and never made it there either. I don't get out much.

What's up next for you Mr. Brendan Danielsson?

I'll be in a few shows coming up between now and the end of the year. One called *Crazy for Cult* at Gallery 1988 in Los Angeles. Then I'm in an H. P. Lovecraft exhibit at the Maison d'Ailleurs in Yverdon-les-Bains, Switzerland. And finally I will be in the *Don't Wake Daddy* II show curated by Heiko Müller at the Feinkunst Krueger Gallery in Hamburg, Germany.

After that, I'll probably just relax, drink some mayonnaise and make babies.+

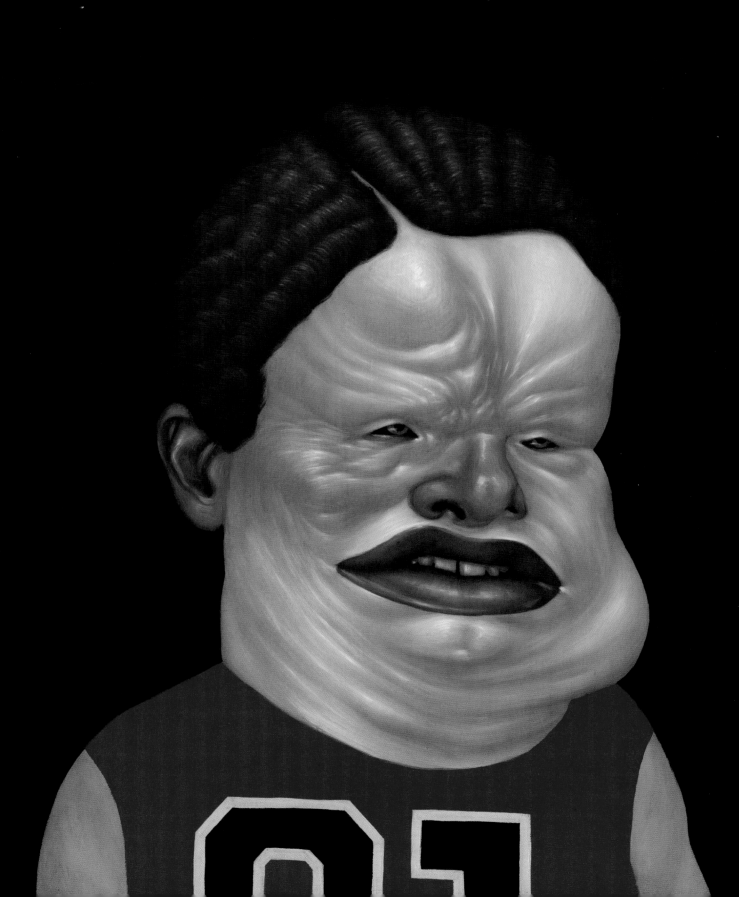

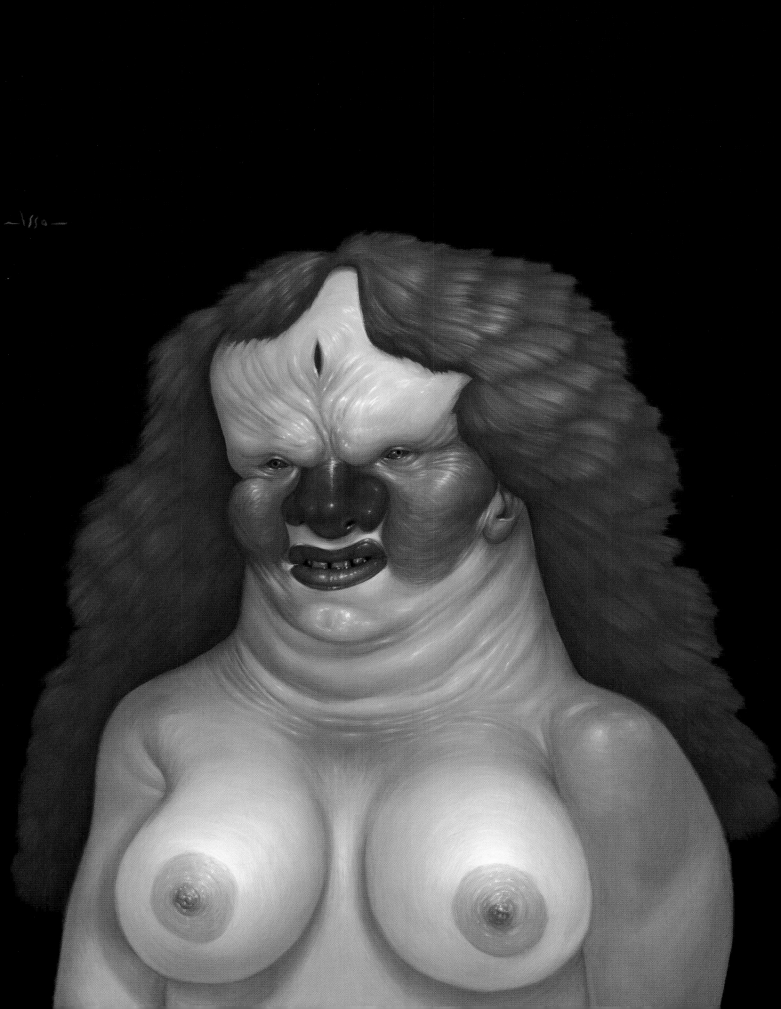

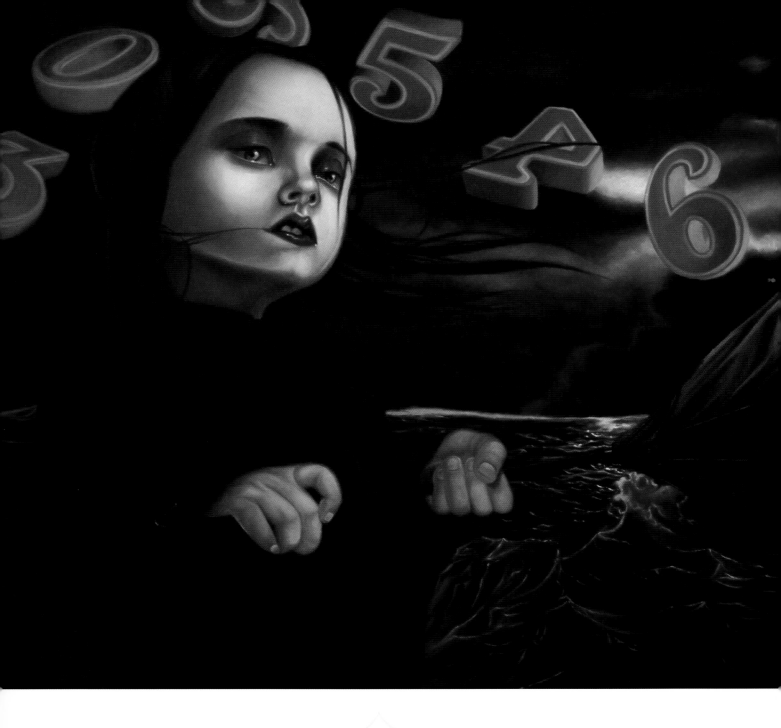

David Stoupakis

Interview by Annie Owens

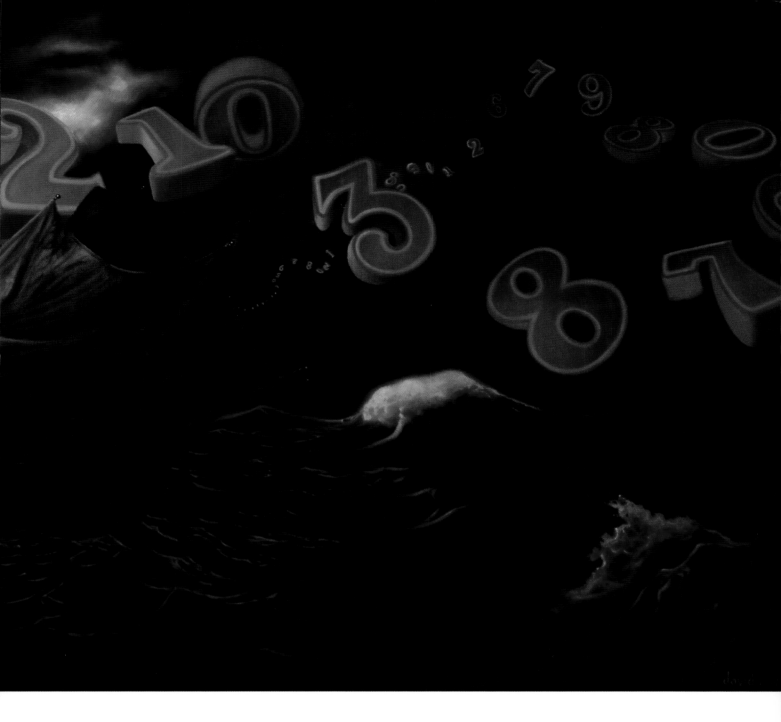

he hypnotic work of David Stoupakis has earned him international recognition profoundly talented painter. His powerful images tell stories of children who bear the scars of abuse or pain but who often gain empowerment through the damages inflicted upon them.

His newest works were recently on display at the Corey Helford Gallery in his show entitled, *Sheep Will Follow*. The stunning show, with red ribbons streaming floor to ceiling, customized musical score by Geoff Gersh and three elaborate life-size music boxes that played the music completed what could be described as a lovely nightmare fairy tale come to life.

The very affable and generous Stoupakis took time out of his grueling schedule to speak with *Hi-Fructose* about his work, his inspirations and life in general.

You said the red ribbon theme at your show, *Sheep Will Follow*, was based around the children's story of the *Girl with the Red Ribbon*; the one where her head falls off when her lover can't resist the urge not to untie the ribbon around her neck. Are you inspired by any other pieces of written work?

There is a lot of written work that I am inspired by. Some are Poe, Heinrich Hoffmann, Lewis Carroll, Grimm's Fairy Tales and most of all L. Frank Baum's works. I can never get enough of *The Wizard of Oz*. I will never forget the first time I saw that movie. That movie owned me! [laughs] I can remember when my parents could finally afford to buy a VCR. That year Santa Claus brought me *The Wizard of Oz* on VHS for Christmas and I would watch that movie over and over and over again. *The Wizard of Oz* has to be my favorite story. I feel like all my paintings are reflections of these fairy tales I grew up on.

Speaking of lovers who can't leave well enough alone, did you see the short silent film about the woman who couldn't

stop picking at her boyfriend's back-hair?

No I have not, but now I will be looking into it! Sounds nasty.

Could you please talk about the theme of the *Sheep Will Follow* series?

Sheep Will Follow began with the painting, *The Messenger*, which deals with the end of something so there can be a new beginning. When I started this series I thought the theme was going to be something different but the more I painted the more it seemed like these characters were on this quest to find this new place where they became the Sheep and the painting, *The Messenger* was the sheepherder/reaper. So in the end I just felt it needed to be titled. *Sheep Will Follow* .

Does music and sound help to inspire the mood or tone of your work?

Yes it does. I listen to music all the time when I work. I also listen to lots and lots of audio books; they're making me go broke [laughs]. It's really for me, the best time to take in a book due to me not having much time to sit and read. I feel when I can get into a good book as I work it helps me to not over think what it is that I am doing. I feel like when we are too aware of our own creations we leave them no place to grow.

Can you talk about the process of collaboration with Geoff Gersh and the music he wrote for your show *Sheep Will Follow*?

This was the second time Geoff and I worked together. As I begin to build the work I start giving him the drawings, paint studies and

writings to look at. Then I let him just do his thing. I don't get involved in his composing other then talk about what the paintings are about. As Geoff builds the structure of the musical score he gives me the parts to listen to as he goes, and then I can hang out with those music parts as I paint and let the music effect what I am painting. It's a really cool process. This time round for the "Sheep Will Follow" show Geoff and I had one score running throughout the gallery and then three different music pieces playing separately in three music boxes that I built to interact with the over all music score. I am very fortunate to be working with Geoff; he is amazing.

There's a lot of mean weather juxtaposed with very delicate china in some of your scenes. When I first saw *Balance*, after my initial amazement I thought "How horribly stressful! All those tea cups in that tornado!" To me, it's one of the most thought-inspiring pieces I've ever seen.

Life throws us lots of obstacles that we need to work through and they can be very challenging at times. When *Balance* was created I was working out an obstacle of my own and painting the piece was one of my ways of working through it. The tornado represents the obstacle and the teacups are the fragile details that need to be handled with care, but at the same time held out in the open. That one means so much to me that I had Josh Glantz, one of my best friends, tattoo it on my arm.

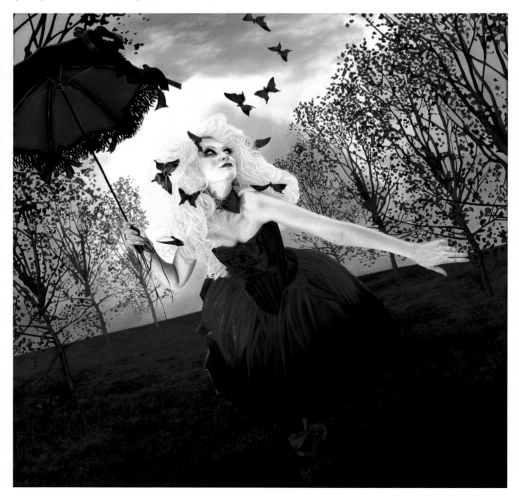

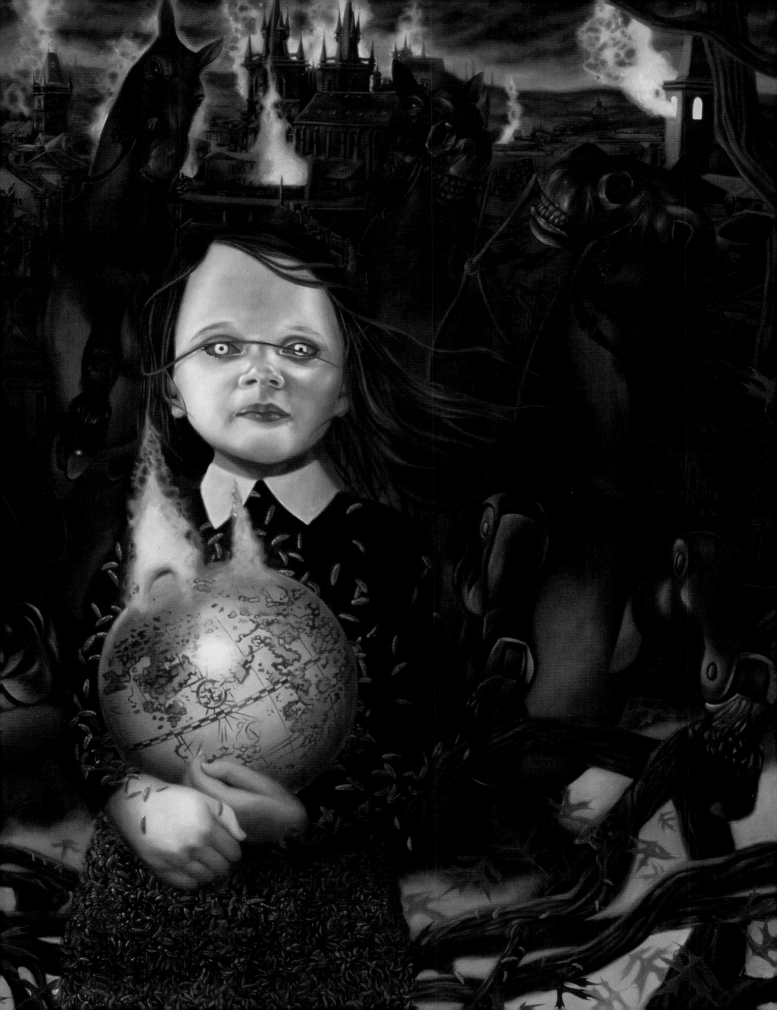

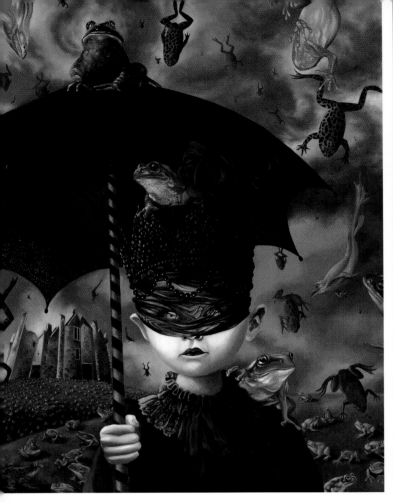

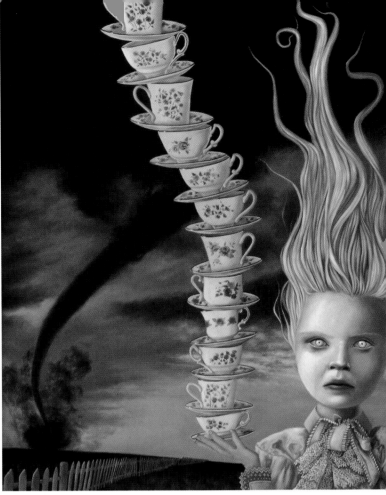

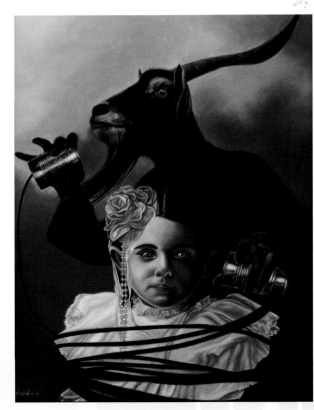

Your work does invite a level of wanting to figure it out or to decipher your thoughts or inspirations for what's in the scene. Could you please talk about "Flood"? The numbers?

I feel sometimes we allow numbers to rule our lives. Be it time or money, the more numbers you have the higher you are respected on the status quo. And some people have allowed the numbers to control them. I used the numbers in "Flood" to represent the race of time and used them as a stone path to journey down from the rising danger.

Aprella, your ladylove, models for you often. How much of her personality do you think is infused into the artwork?

All of her and every bit. I wouldn't have it any other way. My studio is in our home and both of our careers allow us to work from home so we spend a lot of time together. She is one of my best critics and she helps me see and think of things I normally don't see in my paintings. She points out the strong parts and trusts me, when I am doing something crappy she helps me see that as well. I am a very lucky person

to be able to paint her. Her beauty is breathtaking and who wouldn't want to paint her? Many of the great artists out there today already have and continue to. I have to share her as a muse but, you know, I'm pretty sure she loves me best [laughs].

What does your studio look like? Are you messy or neat? What frustrates you, if anything, when you are painting?

When I am working it's messy and I am always working so that makes it pretty much always messy and as it gets closer to one of my shows, it turns into a disaster. I try to set a day aside to tidy it up a little just so I can find things. But if it's too clean then I know there is a problem because it means I am not working enough. I would say the thing that frustrates me the most is that Aprella and I live in New York City and where I paint is right by a window to the main street. So when the rush hour hits, it's car horn-mayhem but that is part of the symphony of NYC and it reminds me I live here and I love it here so I wouldn't change a thing.+

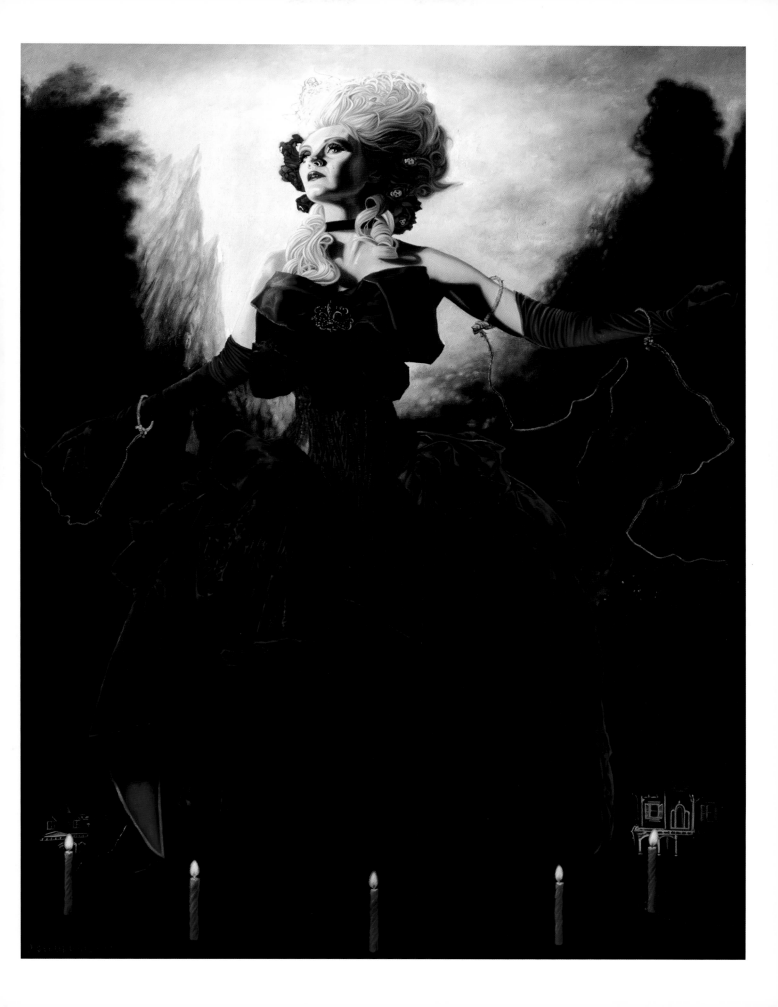

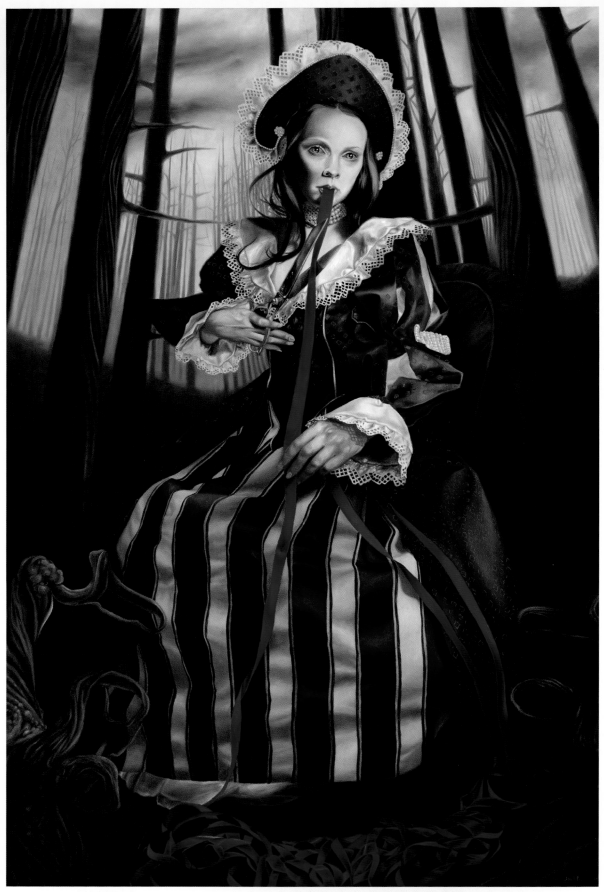

 "**I** feel like all my paintings are reflections of these Fairy tales I grew up on."

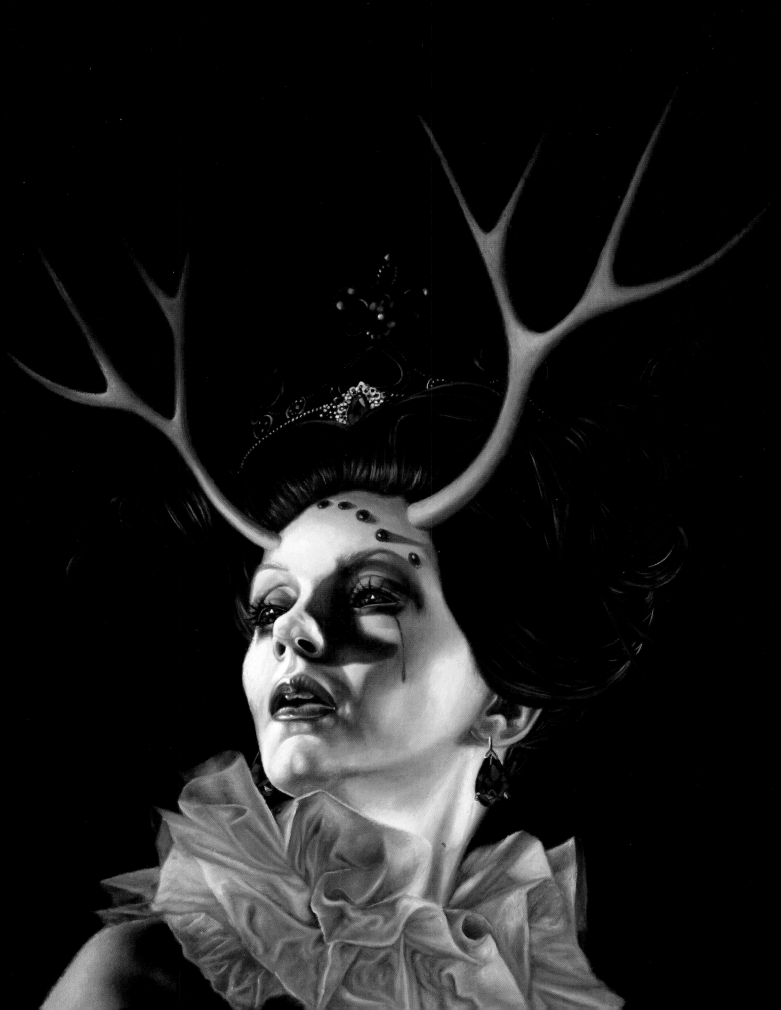

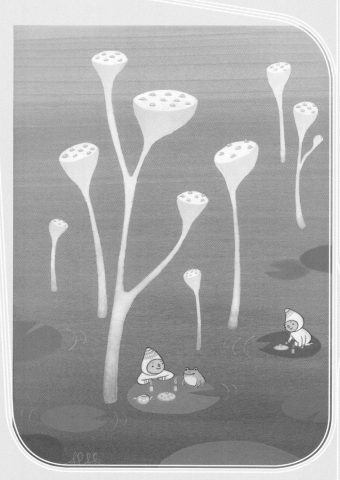

APAK

Ayumi Piland and Aaron Piland, individual artists on their own separate terms become the fabulous APAK when their wonder-twin powers activate.

Their exotic visual vocabulary of happy animals, often ridden by Oompa Loompa-looking, dwarf-like creatures (in footy PJs) set against lush organic environments are a refreshing breath of, well... optimism in our otherwise usually surly fair. The oxygen drifting off of their paintings is irresistible.

The harmonious nature of APAK's work leaves one hard pressed to imagine they were born of two creators. $1 \wedge 2$ or $1,000,000,000$ for that matter is still magically, 1.

Hailing from Portland, previously from Japan, APAK has a list of commission requests stretching miles through 2009.

APAK's work will be on exhibit in the Giant Robot Biennale at the Japanese American National Museum in Los Angeles, November 2007. +

-Ponce de Leone

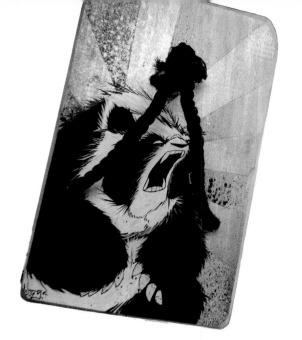
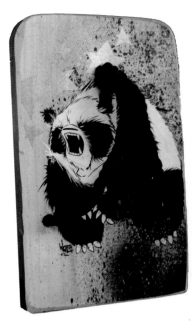

ANGRY WOEBOTS

Everyone loves pandas. What's not to love? So why not take the most loved creature ever, throw in a vicious temperament, and all the other emotions you may associate with a cuddly little panda. Yes, all the ones we humans feel: love, hate, fear, passion; then make sure to incorporate totally ripping style. It is only then that you begin to scratch the surface of the work of Aaron Martin, a.k.a. "Angry Woebots."

Angry Woebots is a huge plush fan and can customize vinyl with best of them. He has been known to throw up in a room full of heads, rock the sickest piece around, and do it in a record time. But Angry Woebots is not just another plush pedaling, vinyl painting, canvas splashing artist. His work is brazen, bold, powerful and provocative. Implementing painting techniques many artists reserve for ink, he has developed and refined a cross hatch style that is unmistakably his own. Aaron is the founder of the art crew "Pocket Full of Monsters" where he shares the spotlight with fellow art power houses, Peekaboo Monster and Mainframe—believing in power by numbers, and the numbers are taking notes.

Aaron has shown his talents and work in various ways all over the globe. You can find him jumping from his native land of Hawaii to the western states, across the globe and back again, without skipping a beat, but definitely spinning a few. In a world where garbage art is running amock and stick figures are being praised as masterpieces, it is refreshing to see a guy like Aaron "Angry Woebots" Martin getting down as hard as he does. This guy has some serious skills and deserves to steal some of the art world thunder.✦

—Manuel Bello

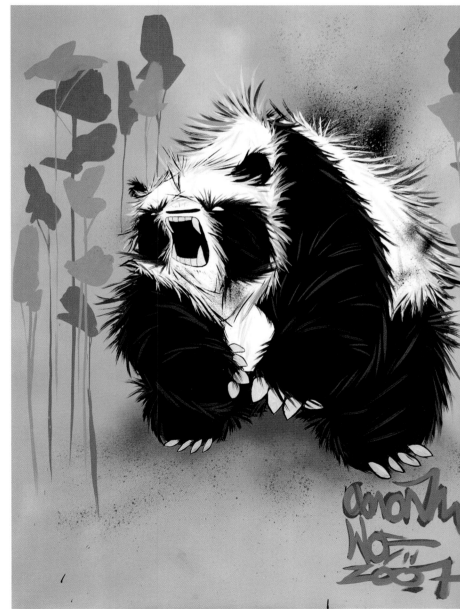

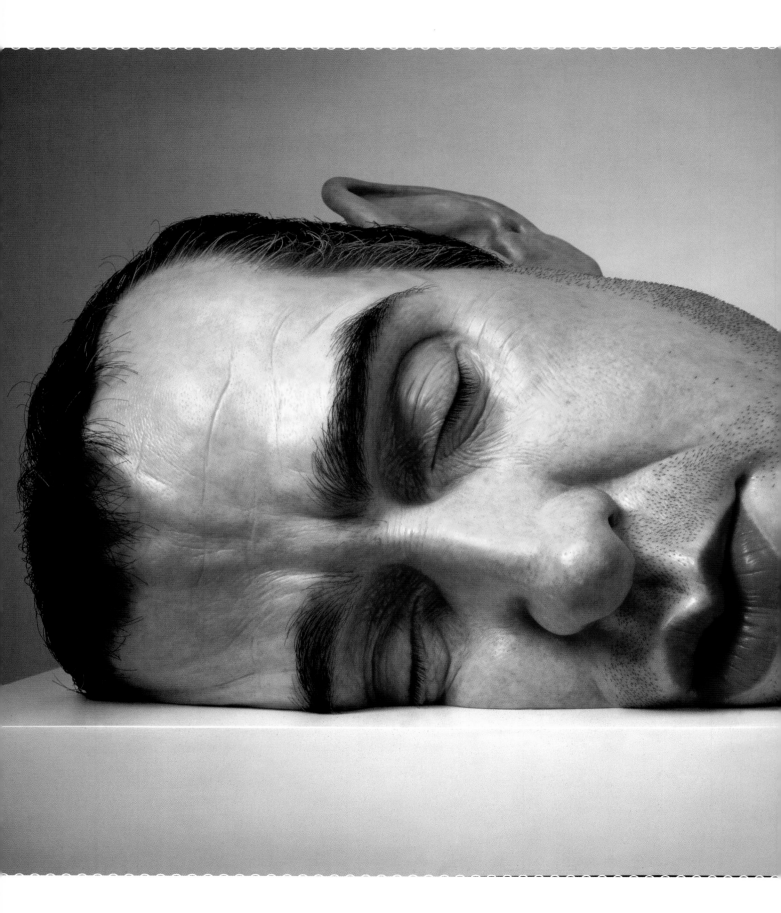

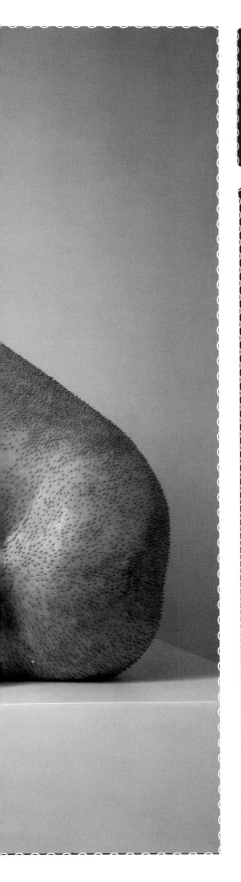

RON MUECK

Imagine if someone found a huge man. Or a slightly tiny, three-foot tall, very old woman. What would they do? Someone would probably put them in a museum for us to stare at, simultaneously captivated, horrified, bewildered, amazed, and feeling slightly queasy at how raw and overpowering the whole thing is. While they stare back wildly, or proudly, or timidly, or even just lay their sleeping. Or, perhaps, dead.

A self-trained artist with toy-maker parents, Ron Mueck started out as a puppet maker for children shows. The Australian-born, now London-based artist later moved into more complex models, puppets, and animatronics, for both commercials and movies. Working on the movie *Labyrinth,* he was even the voice of Ludo, the howling Yeti that can summon huge rocks to do battle. But in 1996 he moved into fine art, and everything changed with his "Dead Dad" sculpture.

Laid out, naked, and very dead, it was a hyper-realistic and haunting fiberglass and silicone sculpture of his father. Dead. Every pore, every hair, is perfectly rendered, and with all the impact and gut-punching reality therein. Scaled down to a demure three-feet long, and laying on the floor where people almost tripped over it, the sculpture still hit with the full impact of the humanity, humility, and well... plain ugliness of a naked, dead body. The incredible detail mixed with the scaling had made the sculpture, somehow, that much more powerful.

Other sculptures, such as nine-foot tall, chair-sitting, crazed "Wild Man," or his enormous "Ugly Man," a bald, belligerent-looking man filling the entire corner of a gallery he sits in, scale up that humanity to somewhat-frightening and disquieting proportions. Ron Mueck has found a new race of people. And he's putting them on exhibit, just as they would with us.✛

Photos courtesy of the Dallas Ft. Worth Art Museum, who hosted the Ron Mueck exhibition

–Toast

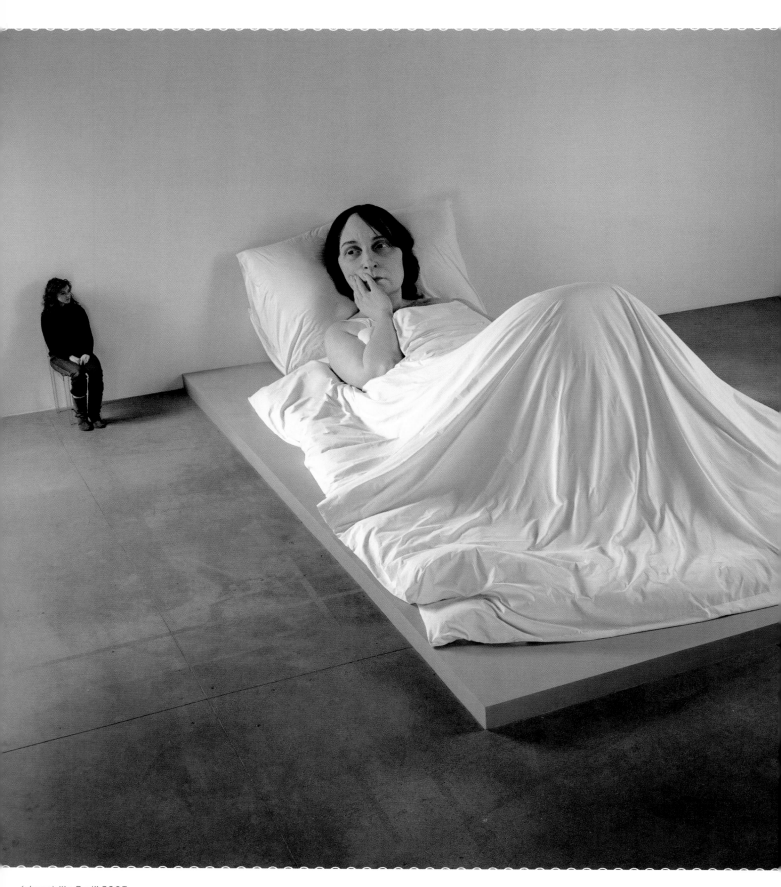

(above) "In Bed" 2005
(previous) "Mask II" 2001-2002
(right) "Two Women"

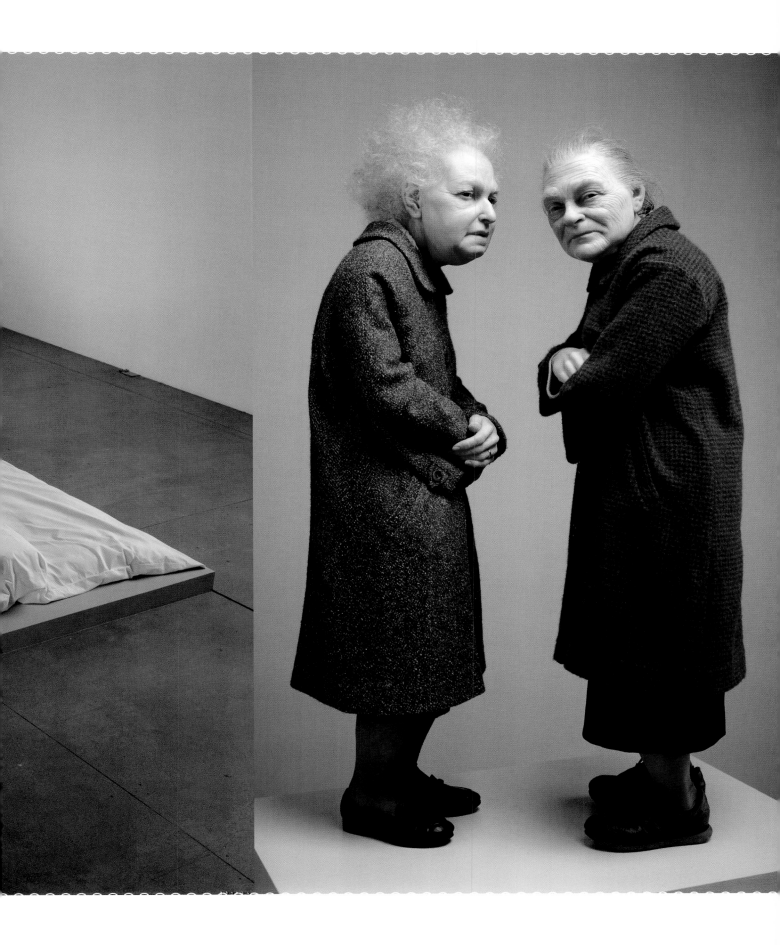

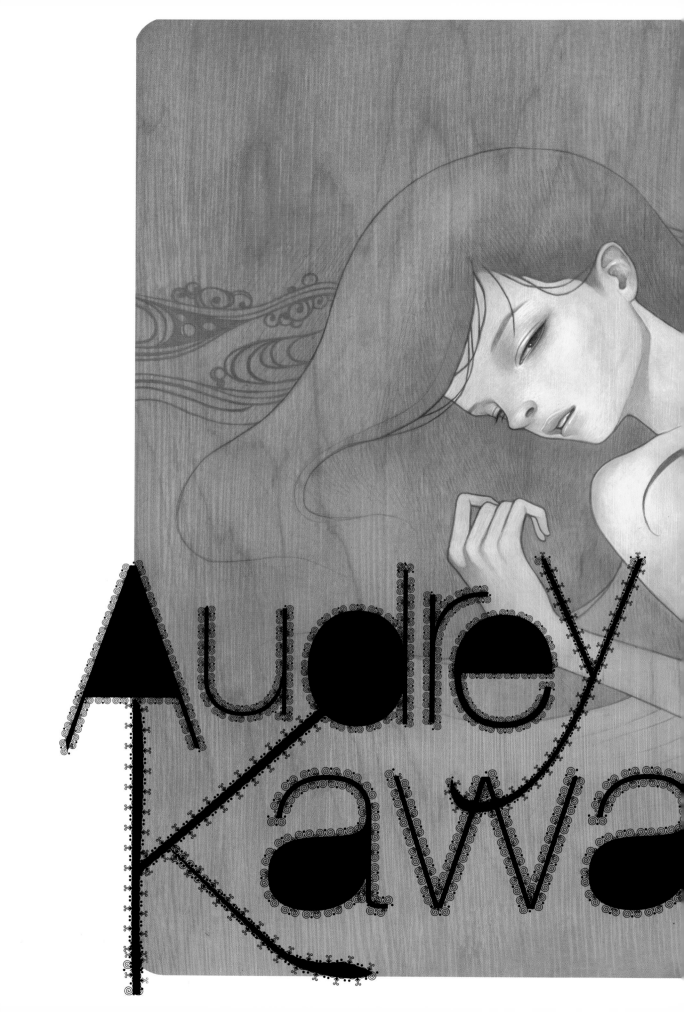

saki

interview by Annie Owens

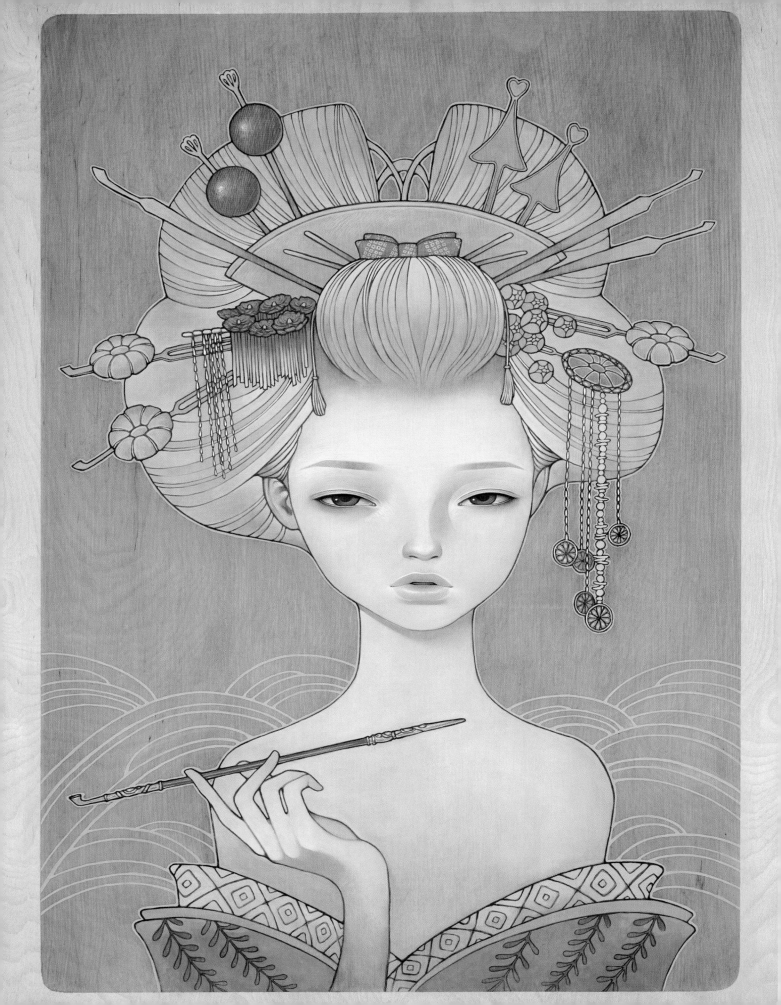

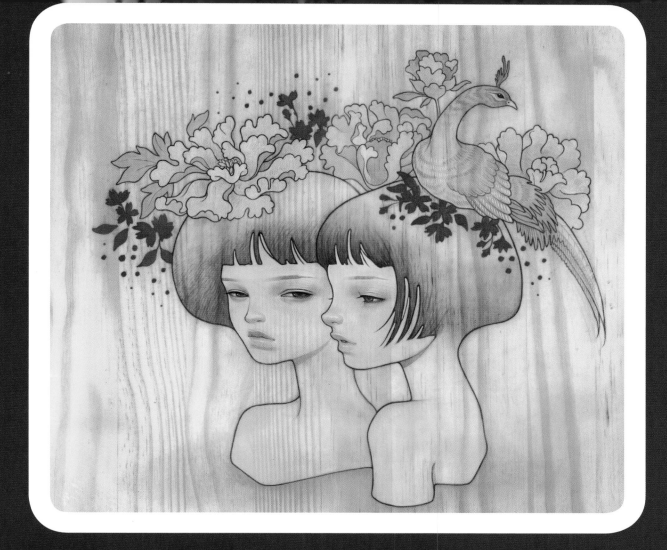

You can almost feel the heat rising off the skin of these young, nubile nymphs, the main subject of artist Audrey Kawasaki. Elegant, sexy and stylish—these breathtaking oil paintings on wood are the embodiment of femininity to its umpteenth degree.

Audrey is revered as an artist for her trance-inducing works of art through the delicate application of oil paint on wood, layer by layer—her color palates perfectly harmonious to each composition.

Complimenting her abilities are the thoughts, ideas and emotion beneath the paint. Captivating as these images are, they present a refreshing and much needed challenge for many.

The sultry pout and alluring gaze of her subjects are familiar and comforting because they mirror those same instincts that most all of us harbor inside. Yet others of us become squeemish when faced with such open emotion and raw sensuality, and so come the questions and critiques.

In her 25 years, Ms. Kawasaki has acquired a comfort level of the human condition that most 99 year-olds could never conceive of. She moved from New York to Los Angeles to more freely cultivate her art and her ideas, and in so doing, actively left behind the rigid and inflexible stogy art world. This understated irreverence and a steely resolve becomes apparent in the interview the shy artist granted us as she talks about her creative approach.

I noticed you've been doing some work on canvas that you've added beautiful backgrounds to your pieces. Can you talk what got you going in that direction?

Working back on canvas is really refreshing. I love being able to be loose and less precise in the beginning (and then more refined later). With the wood pieces, I like to have the wood grains show through, and to keep that transparency I need to stay pretty thin, and have the paint build up only where it needs to, and less in the background and such. But with canvas, I'm allowed to paint thicker, and to make mistakes and play around a bit more. I'm hoping to paint on canvas once in a while as a reminder to loosen up a bit.

Have you ever been approached to have your work licensed for things like clothing or other products?

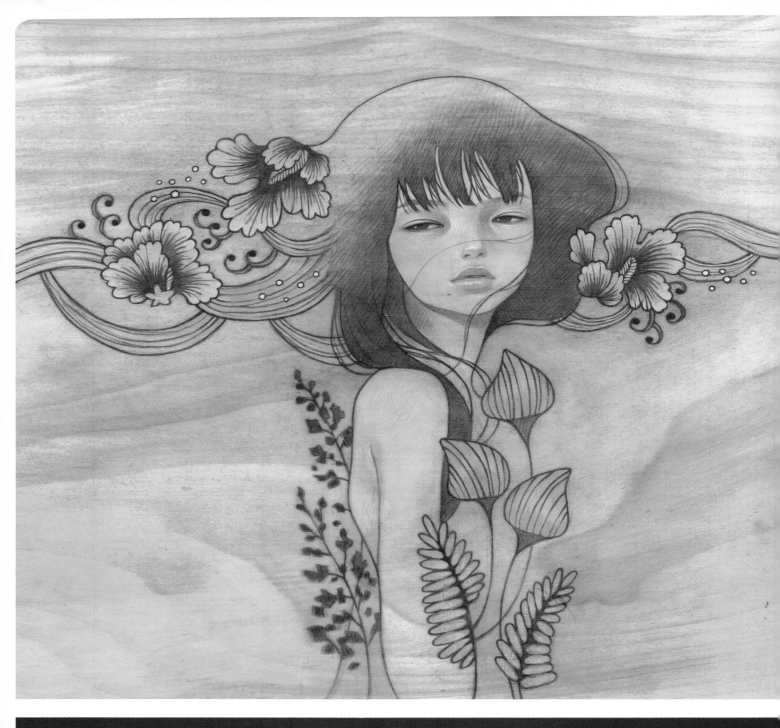

I have but it's not my current focus. And if I were ever to be involved in apparel and other products, I'd want to be very selective, so I'm holding off for the time being. I do plan to make postcard sets soon. Something that is more accessible for people. Possibly a book too, but that's not for a couple of years I think.

Any plans for a 3-D figure any time soon or do you have interest in that at all?

There has been some discussion to make a 3-D figure and I am aiming towards it. Something more official will be set soon.

I read that a couple of your professors told you not to paint your nudes the way you do after showing them some pieces. I'm guessing their ideas came from a very high brow point

of view but I'd still love to hear what they had to say. How did it strike you?

I was only in college for two years, and during that time I never had a chance to dive into my personal work. Everything was for class: life drawing and painting from real props and models, and learning the basics of creating an image. During the summer breaks I started on a couple of my girl pieces on wood. At the time it felt so good to step away the traditional way of painting, and explore the wood panel surface, use ball point pen to carve in solid bold lines, with subject matter I've always been attracted to. (These slowly developed into what they are right now.) I was hesitant to show my professors since they only knew my in-class work. When I showed them they seemed confused and perplexed. A "why would you be doing this!?," sort of look. They had very little to say, except suggesting I stay away from this.

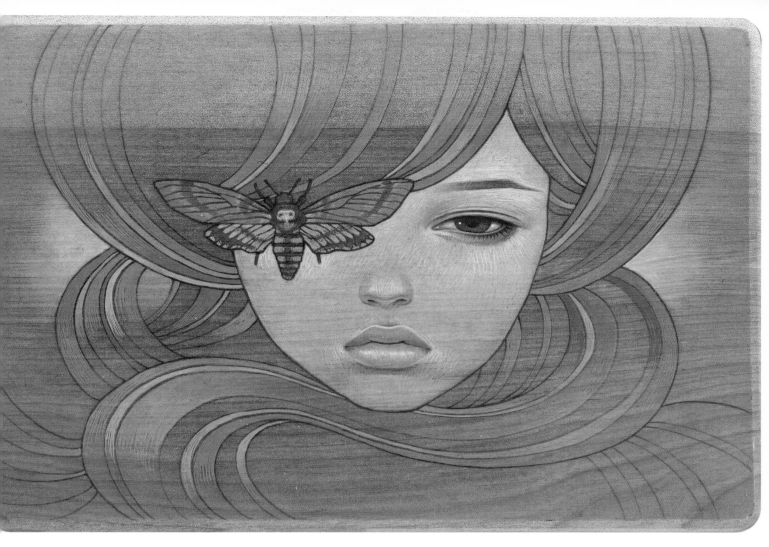
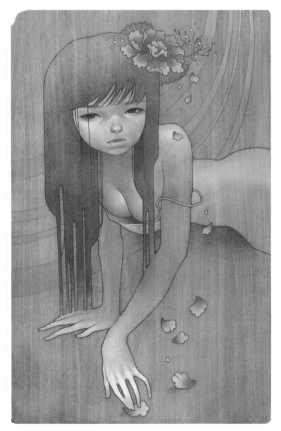
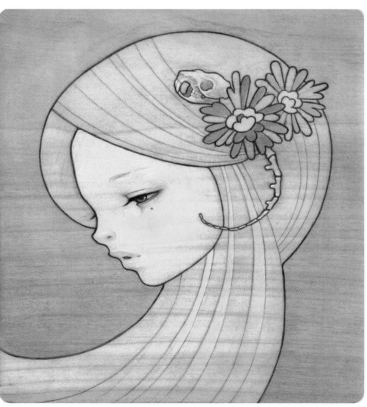

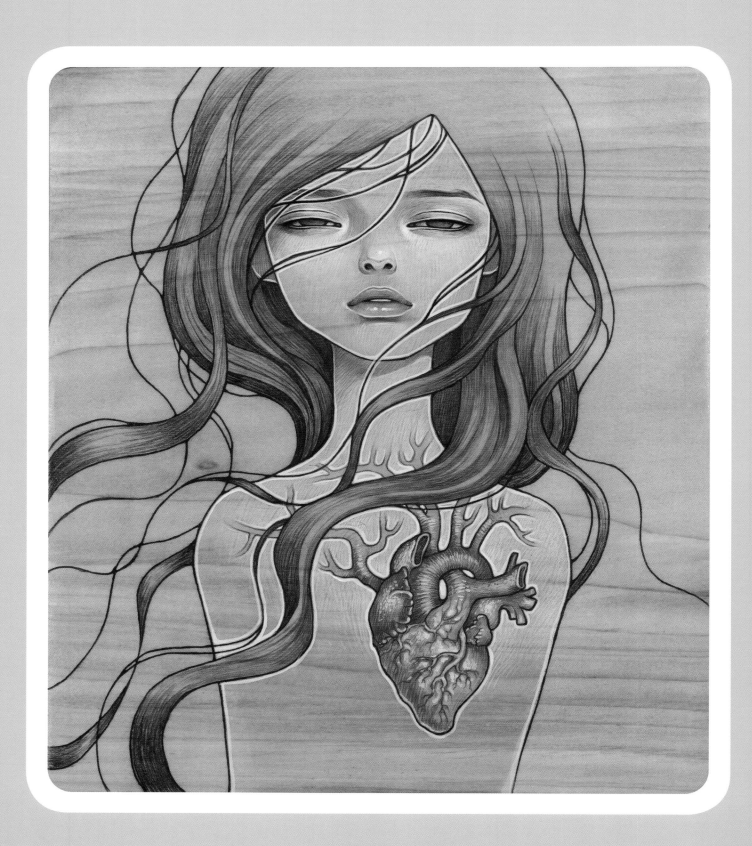

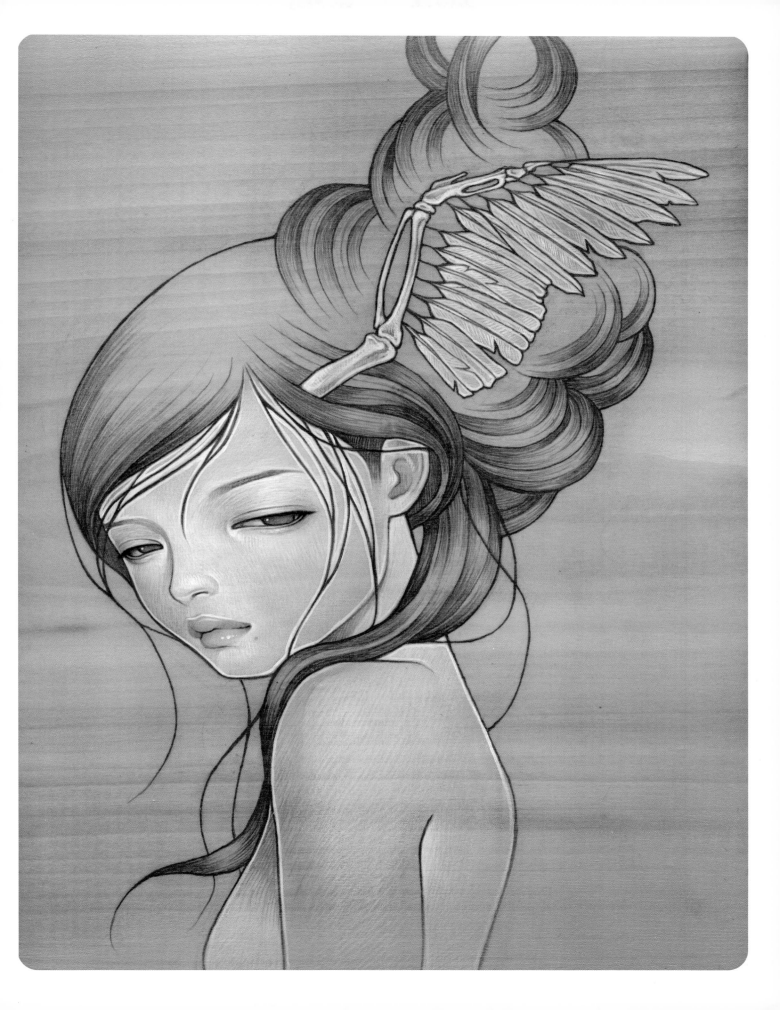

That it was too illustrative. (I can't remember the exact words.) This didn't come as a shock to me though. I expected it. Standards of high brow "fine art" is pretty clearly defined, it seems, and my pieces surely didn't fit in. Their criticism isn't the reason why I decided not to go back for my third year. School and NY just didn't fit right with my skin, and I'm glad I stayed in Los Angeles to pursue my wood pieces.

You seem to incorporate two-dimensional shapes with realistically rendered faces and body parts in a way that is reminiscent of the Art Nouveau artists like Klimt and Alphonse Mucha. Have you studied their work?

I do love Klimt and Mucha. The merging of realistically molded faces and bodies against the contrast of flat colors and lines and patterns is so stimulating to me. I've done a few studies of their work. I love Mucha's lines and monotone colors, and I admire Klimt's painterly style.

Your paintings have a strong stylized view of nature and because you paint so subtly on wood, they seem to almost grow from the grain. Do you factor this into your work; do you consciously factor in certain wood grains with particular paintings before starting?

I'm very picky when choosing the wood panels to work on. I choose by the quality of flow and lines of the wood-grains, but when I actually start to work on the piece, I don't think too much about the grains. It's just there and I treat it as a translucent fog or mist in the background. When I paint, I leave some parts with barely any paint, so the grains are still visible. Using thin layers of color is the key to keeping the organic warm feel of the wood.

Many of them are missing forearms, and other parts vanish or get swallowed by flat shape. Do arms just get in the way?

Yes I emphasize lines a lot. The flow is very important to me, and if an arm or leg interrupts that flow, I take it out. I sometimes like to choose what is compositionally pleasing to my eye, rather than being anatomically correct.

The figures in your work seem to be posing for us, perhaps that's what makes them so alluring (and disconcerting). Are they aware that we are looking at them? Do you use reference for the faces or pose models?

Most of my girls are definitely aware that they have an audience. She knows she is being looked at. Watched. And most of them directly stare back. I like being able to create that feeling of confrontation (and a bit of voyeurism). It's like she has so much to say to you, but never will. And yes, I use a good amount of reference images when I need a certain pose or a figure or a new face

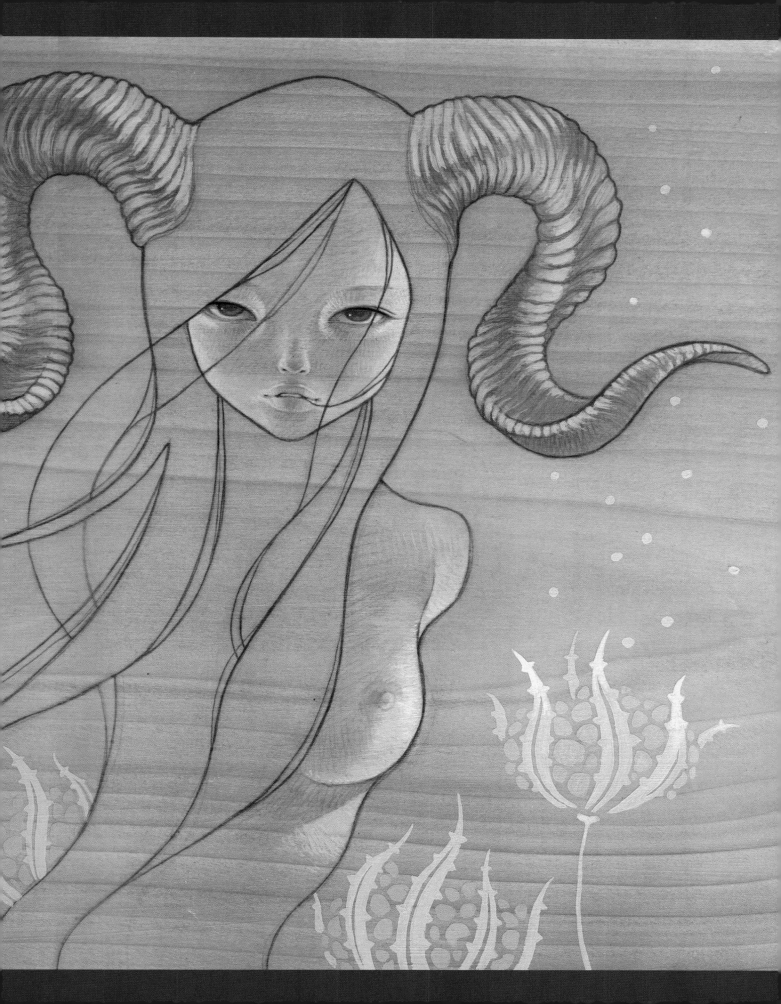

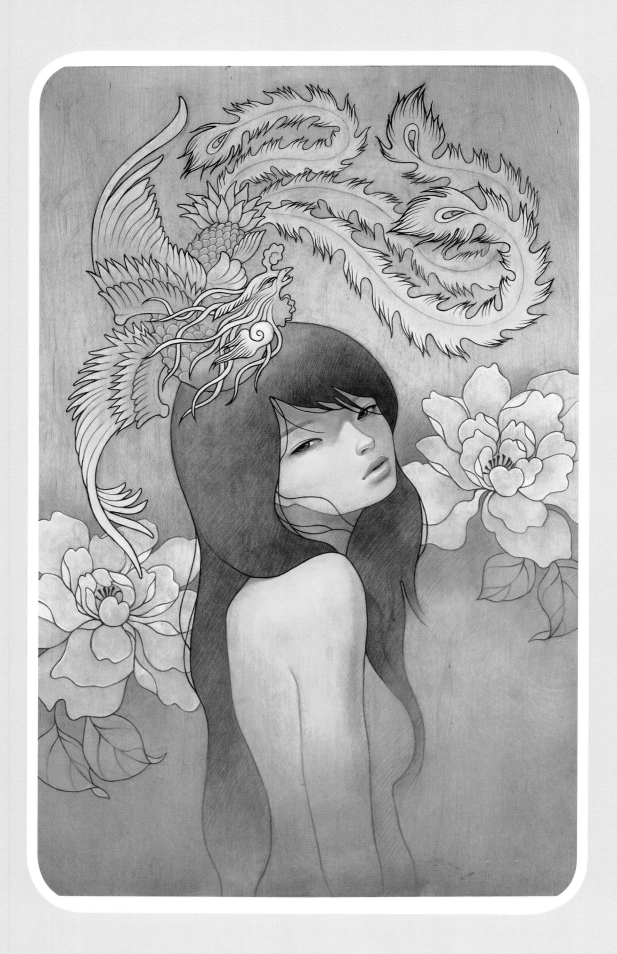

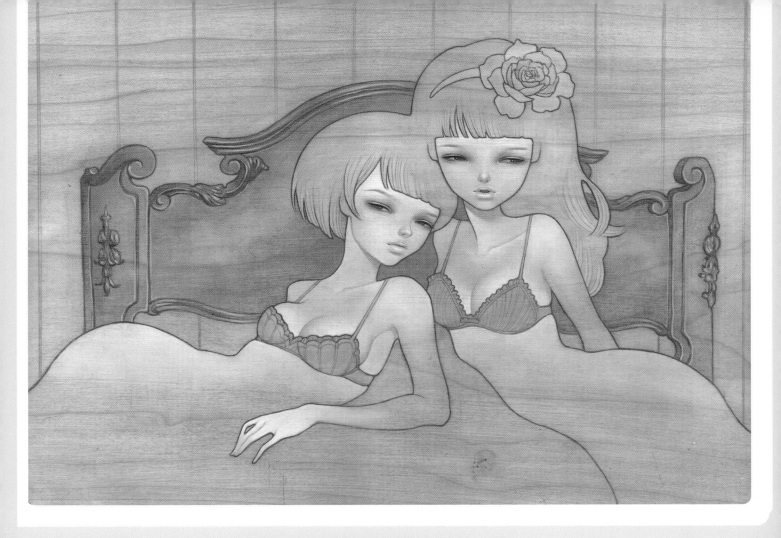

"She knows she is being looked at. Watched. And most of them directly stare back. I like being able to create that feeling of confrontation..."

or a set of eyes and lips. I am constantly looking online or through magazines for images to keep things new and stimulating.

There are hardly enough words to describe how beautiful and captivating your work is. I could go on but I am more interested in understanding what the work means to you.

The sexually provocative nature clearly strikes a chord with people. It's a base instinct hardwired into all of us.

I'm curious about the feedback you get from admirers of your work and if you ever get any criticism.

It has always felt natural for me to draw or paint women with sultry expressions and a suggestive hint at something lustful or naughty. In person—in real life—it's becoming increasingly more difficult for me to be carefree. Worry and self-

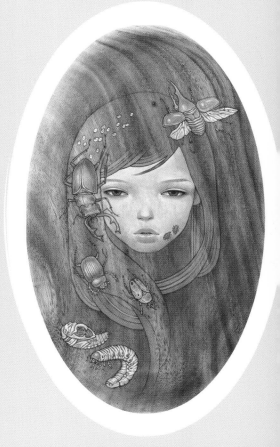

consciousness make me quiet and awkward and withdrawn. But my girls—my painted nymphs—have no inhibitions. They are free to be what they are. Free to feel and act upon their wants and needs and desires, and I think the people who like my work feel a connection with them. Perhaps liberating to visually see what they themselves feel and relate to.

But yes, on the other hand, I've gotten quite a few negative responses, that my work is pornographic. I think it's natural that out of the many viewers, some are bound to take offense or see it as disturbing. Sexuality is always a touchy subject and some people feel uncomfortable being confronted by it. When I make my more sexual pieces, my intentions are not really to design an image that would arouse lust in the viewer, as would porn would do. I simply enjoy the aesthetics of a nude female body or a sensuous facial expression, and it's gratifying to be able to freely express it.+

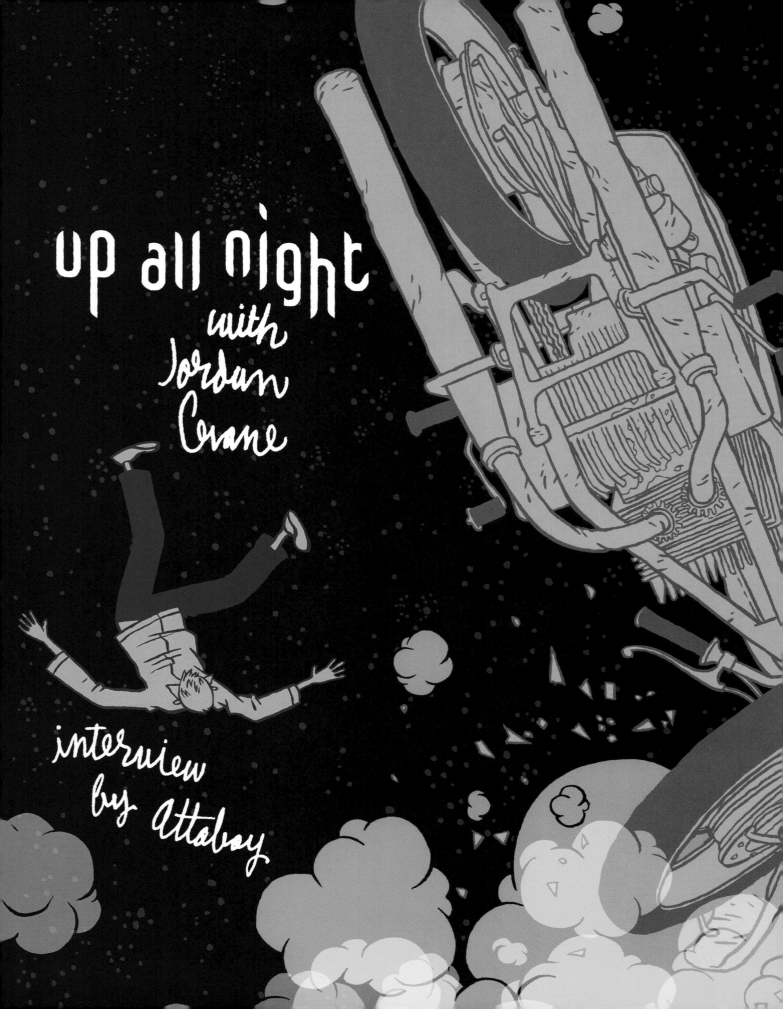

up all night
with
Jordan
Crane

interview
by Attaboy

Jordan Crane's art puts a spotlight on the subtleties of life. Crane's numerous graphic novels, masterly produced hand-pulled serigraphs, and thoughtful comics expose us to the little things and moments we take for granted in new, more powerful ways. They can be sucker punches for the uninitiated, producing human empathy from a two-color drawing of a cassette tape, moving our eye through a movie's worth of narrative in a single frame with a masterful use of color. There's a writer's mind behind Crane's imagery that is refreshing and scary at the same time.

When I saw your new collection of postcards and notebook set from Chronicle books I was amazed that they had the exact same feel as your early handmade books with hand-pulled silkscreen covers. They almost beg to be touched. How involved are you with the nuts and bolts of producing and designing them?

When I was a little kid, I took piano lessons from a very old lady named Claire. One afternoon, as I was plinking my way through "Fur Elise," we got to talking about art and she delivered up a pearl: even the most highly skilled draftsman cannot draw, freehand, a straight line. It's kind of an obvious truth but it's a good one. I forgot about it for years, but it stayed with me, and it's caused me to look very closely at lines made by hand, to appreciate their humanity.

I don't like straight lines. I use the computer only for layout and pre-production, never to create anything. I chafe at straight lines made by a computer. At least with respect to my own work. Edges, borders, keylines, type, I want it all to come from the hand. It pulls things together, creates an internal visual logic.

So, it's by necessity, to get it right, that I do every single aspect of the book by myself. When it leaves my hands, it's as an inalterable, high-resolution, print-ready PDF.

Additionally, when something gets screwed up I've only got myself to blame. It takes the guesswork out of what went wrong. With print there's so many things that can go wrong, and the more people that touch the work, the more probability of screw-ups. So it's just me.

With silkscreening and old printing methods when a color overprints another, it makes an unexpected yet related result, like a mutant family relative with familiar earlobes. A bright cadmium orange will pop out like a prom pimple, bringing to the picture that something extra. You capture this perfectly in your work.

Oh, god, I love overprinting. When I first grasped the idea, it seemed like magic to me. It's one of those cases of the total being greater than the sum of it's parts. Overprinting, when it works, is thrilling because all the colors in the image are relating to each other, in fact, composed of each other's parts, yet distinct. Composing an image of overprinted lines and colors will give it a whole internal logic that just can't exist otherwise. A couple of years ago, my brain started seeing everything in terms of overprints. I was looking at a sunset one day, and I realized that I could print it beautifully, perfectly, in two colors, and I just about had a stroke. Since then I've got this little print guy with a green visor and a dirty smock, living in a messy shack at the back of my head, and he's always there making separations out of the things I'm looking at.

Do you consciously experiment with or notice odd or "wrong" combinations that breed new results in your work for print?

That's the part that takes the longest when I'm making a print. Cutting it up, and layering the colors, figuring what emphasis I want and where, and then trying to get it down to as few colors as possible. Ideally all of my prints would be three colors... usually they end up around four or five colors though. Making a complete image is different than just separating colors for one object. In an image there's the overall flow and emphasis that must be considered. When one color is turned up, it impacts all the rest, and adjustments must be made.

Do you do a great deal of experimenting with printing techniques to create your patterns?

Not so much technique as color arrangements. Layering the colors, dropping out, reversing certain lines, I try to have as much movement as possible in a pattern, while using as few colors as possible.

You must have a huge library of patterns and swatches that you harvest from.

Yes and no. I don't need a palette of color swatches,

internal palette, I think is limited to about six colors that resonate with me. Everything I do is a variant on these colors, they're not even conscious colors—every time I set out to do something I fool and fool with the colors until I find something that resonates, and, as I've discovered the hard way, over years and years, it's always about the same six colors. Even the walls of my house are painted in these colors. As far as the patterns themselves go, I often draw shapes and turn them into patterns, and usually I'll work out new patterns for things I'm working on. But, if the new pattern doesn't fit, then I'll look through the older patterns that I've drawn, and see if there's anything usable. Sometimes I mash them together and see what happens, turn it sideways, flip it. New things emerge from old shapes. It's more of an iterative process than it is an imaginative one.

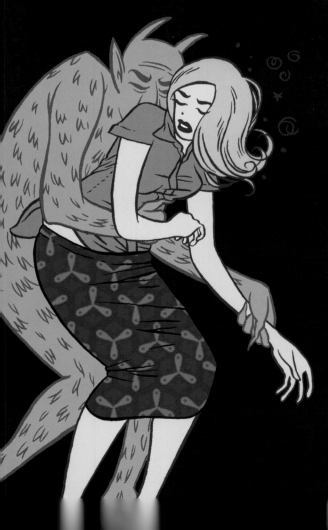

You've just begun a new comic series entitled _Uptight_, which hosts contained and ongoing short stories. The subject matter, thus far, deals with adult characters as subject matter more than your previous stories... and the books are affordable and portable, almost like a Jack Chick Tract in feel. Correct me if I'm wrong but there's an old pulp feel to them that's different than your previous narrative outings.

Yes, I want to make the book as cheaply as possible. I like inexpensive beauty. That way the value arises not from the materials or form, but what is contained within them.

They're like short bursts rather than the longer graphic novels we're accustomed to seeing from you.

Within the context of _Uptight_, I'm working on some longer stories—_Keeping Two_ is the continuing narrative in the comic right now. That will be collected as a graphic novel when I wind it up in a few years. Everything else is short story though. I've been wanting to do short stories for a long time now, but was put off by the idea of having to actually _end_ something. It's easy to go on and on, but ending, it's hard to end. It's just so final. But I braced myself, and finally started doing short stories. I love short stories.

Can you tell us what you are after with _Uptight_ and where we as readers are headed with the new series?

More of the same in terms of format. I expect that I'll grow as a writer though. One or two short stories per issue, and an ongoing one. I want to get out two issues a year. Right now, that's not happening. I have a lot of other crap work that's getting in the way of drawing comics, and I'm not sure how I can, or even if I can eliminate the crapwork.

For someone with such an original use of color, design and pattern, does working

completely satisfy you?

Well, no it doesn't, and that's why I do the prints. I think in an idea world, the only things I would do would be comics and prints. After I've been working on comics fo a long time, doing prints is like vacation. It's a totally differen thought process, more intuitive in many ways than narrative drawing I look at comics like drinking coffe and doing prints like drinking bee Both are necessary, and for me, need to drink a lot more coffee than I drink beer. But I do need to drin beer.

How do your stories take shape? Are all the details and dialogue mapped out with words first?

Stories take shape slowly, a pane or two at a time. I never see the whole thing laid out in front of me It usually starts with just one thing usually a feeling some sort that I'm able to capture in a couple of panels Those panels usually sugges something that comes ahead o behind of it, and it grows from there

Think of a story like twine buried in the ground. One day, I'm taking a walk, and notice a little bit o twine laying on the ground. I have to consciously look for these bits of twine though, because they're about the same color as the dirt tha they're laying on. I try to pick up the twine, but one end of it's stuck in the ground. I pull on it, and more of i comes out. Sometimes the twine i very short, and that will be that. Bu if the twine is long, at a certain point I can't pull anymore, and need to ge a shovel to dig it out. I have to be careful with the blade of the shove though, because if I'm rough, I'll slice the twine right through, and that's it end of story. But if I'm careful, I can through a combination of digging and pulling and getting down in the hole and following where the twine goes, emerge with a complete story whole and usable.

Do you read a lot of books?

Mostly fiction, a combination o modern and classic. What I've go on my table right now are _Collected Stories_ by Roald Dahl, _The Complete Stories_ by Flannery O'Connor, The _Collected Stories_ of Eudora Welty

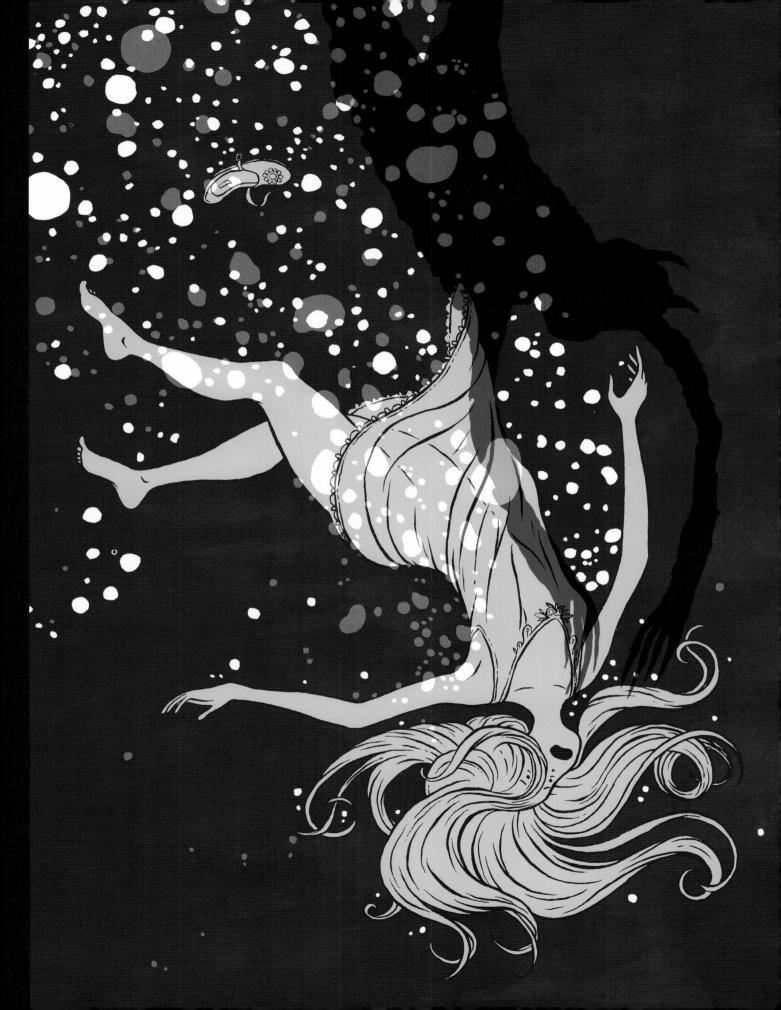

The Ghostly Tales of Henry James, and *What is the What* by Dave Eggers. I don't read many comics these days, but that usually goes in waves. With comics, if you read nothing but that for a month, you usually get all caught up with the last two years of output from all the best cartoonists. If there were more actual comic books that came out regularly, I'd probably read comics more often. As it is, I always read the new *Love and Rockets* and *Angry Youth* whenever they come out.

Who or what inspires you? What do you draw from visually?

Visual inspiration for me comes all at once, and usually from the corner of my eye. I'll see something off to the side, and it will be properly blurred and the impression swift enough that my brain will misconstrue it into something that has incredible resonance with me. It's usually something simple: the interaction of two colors, how to shapes touch each other, a reflection. It's always messy and nonspecific. I'll then think on it, and usually I see the separations for the specific thing in my head. Then I go from there, drawing the image on paper. Sometimes this is all it takes, and the image loses its resonance entirely, and that's it. But if it retains its resonance, then I turn it into a print.

I have a lot of books that I've bought for inspiration. shelves upon shelves of them. I've never actually used anything from these books though. I want to, I feel like I ought to, but I really have no idea how to incorporate any of the things into my own work. This hasn't stopped me from buying books of images. Hope springs eternal in my breast, but I've never found anything to look at, ruminate over, that actually inspires me in a way that will lead to an actual image. When I make a print I'm always trying to articulate something non-visual in an image. It's these non-visual things— lyrics, states of mind—from which I can draw direct lines to my images. If I set out to find some inspiration from a book or at the museum, I end up being more confused than when I start.

You had an early interest in animation, then realized the brutal truth of animation—that very little actual animating goes on in America and that animators rarely create the stories. Now that several years have passed, do you see yourself ever directing an animated series or bring your stories to film in any way?

The right situation needs to come along, and maybe I'd do it. But, I'm terrible with collaboration. It seems like it's better to ignore the Hollywood honeypot and focus on the things that I can actually do. If something happens to drop into my lap, I'll consider it at that point. But I'm not holding my breath. Honestly, Hollywood seems like more of a pain in the ass than it's worth.

Can you tell us about how your involvement with the infamous Fort Thunder artists who lived in a condemned art house of clutter and amazement in Rhode Island?

Actually, I lived in Boston. There was this event called the Cambridge Comics Circus put on by Highwater books, and I met Brian Ralph there. He invited me to the fort to print a poster, and I had never printed on paper before, just shirts, so I wanted to go. He told me how to do the separations, and I did them and got on the bus went to the fort and learned how to print. Brian pulled all the colors on my first print, and I just stacked them on the floor to dry. I printed a couple more things at the fort over the next year, and finally my friends Tom and Brooke got together and made our own little print studio in Boston which we dubbed Cuckoo Corral. The fort was very influential primarily in the attitude they took toward making their prints. It's a very public and inclusive attitude about making and showing their work. There's no pretense about their work—it's paint on paper, and anyone who wants one can pull it off the wall or post that it's stuck to.

I remember seeing your first *Non* anthology. It was so refreshing and when I look back they came at a pivotal time, when comics seemed at a stand still. I had personally just started self publishing and seeing *Non* was proof that it not only could be done, but done right. It was refreshing.

It's funny because I set out to just publish my own work. But then when I got the printing quote, it was so damn expensive that I thought that as long as I'm doing my own work, I ought to include the work of a few people that I knew who should have more readers. It turns out that the more involved in comics that I became, the more amazing work I saw that was being done by people who the big publishers were totally ignoring. It was a weird time in comics, where the visual and narrative structures were widening, and the publishers were only interested in seeing what they were familiar with. So I had many great artists to choose from. It was, in many ways, a very *easy* anthology to put together.

So many of the artists in that book went on to create great art and stories in their own right.

I was lucky to have them. I just happened to be at the right place at the right time. Nobody knew who these great artists were, so I got to show them to the world in my book. Two more years, and the world would have known these people already, I just got lucky enough to have the scoop.

Col-Dee, **a pocket-sized graphic novel you created, is a simple story about a kid really wanting a soda but not having the pocket change to get it. The panels and drawings are economical, but tap directly into some seriously deep feelings of childhood hard to describe.**

While reading it, long forgotten memories instantly came into mind. It is disconcerting that you have this strange ability to conjure up such feelings in just a few panels, or just how important a damn can of soda can be to a kid. That kind of power is fucking scary,

> "The act of writing and drawing tends to be, when it's really happening, a fully immersive state. So writing about drowning will put me under the water, drowning."

man. I mean, when I opened the book I didn't know you were going to have me remembering awkward parts of my adolescence through some sort of psychological Nyquil prism. That's really not fair.

Ahh, sure it is.

You do that sorta thing with your other single images as well, evoking feelings of being alone in a crowd of people and of impending tradgedy with only line, flat pattern and color. Are these images based on personal experiences?

Well... I can't do anything that isn't based on my own experience in one respect or another. And the "one respect or another" is the part where it starts to get fuzzy. The act of writing and drawing tends to be, when it's really happening, a fully immersive state. So writing about drowning will put me under the water, drowning. In my mind, I guess this state is being composed of what I know about drowning, and the act of drowning as I'm living it by the act of writing it.

Do you consciously work at creating such empathy or do you just like fucking with us that way?

Neither, really... although, if I had to pick one, I'd say that I consciously work at creating empathy. I definitely am not fucking with the reader. I'm trying to make fully and truthfully realized characters and situations. Truth is very powerful, truth alone can create a great deal of empathy. Stacked truths create a story. But if something rings false, then the whole dream dissolves and the reader is forcibly ejected from the story. So it's important to be true. I think if I set out to consciously create empathy or to fuck with a reader, then I'd lose sight of the more important thing, which is to write truthfully. But, of course, writing truthfully creates empathy, or even fucks with, the reader.+

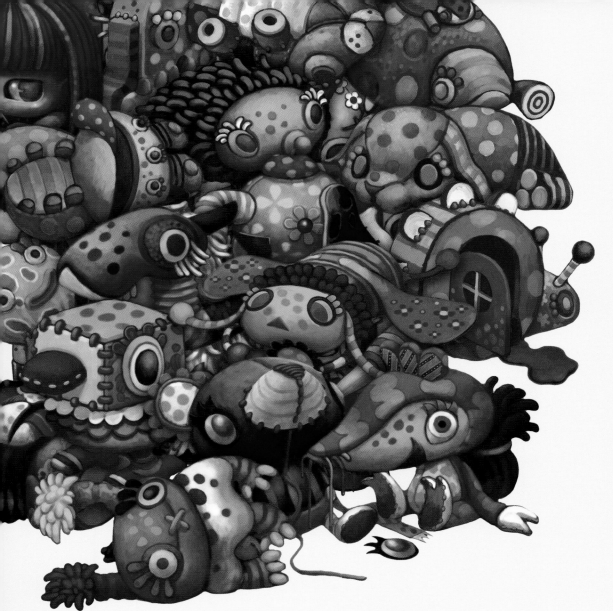

Butterflies on the Brain

the art of Yoko d'holbachie

by mikl-em

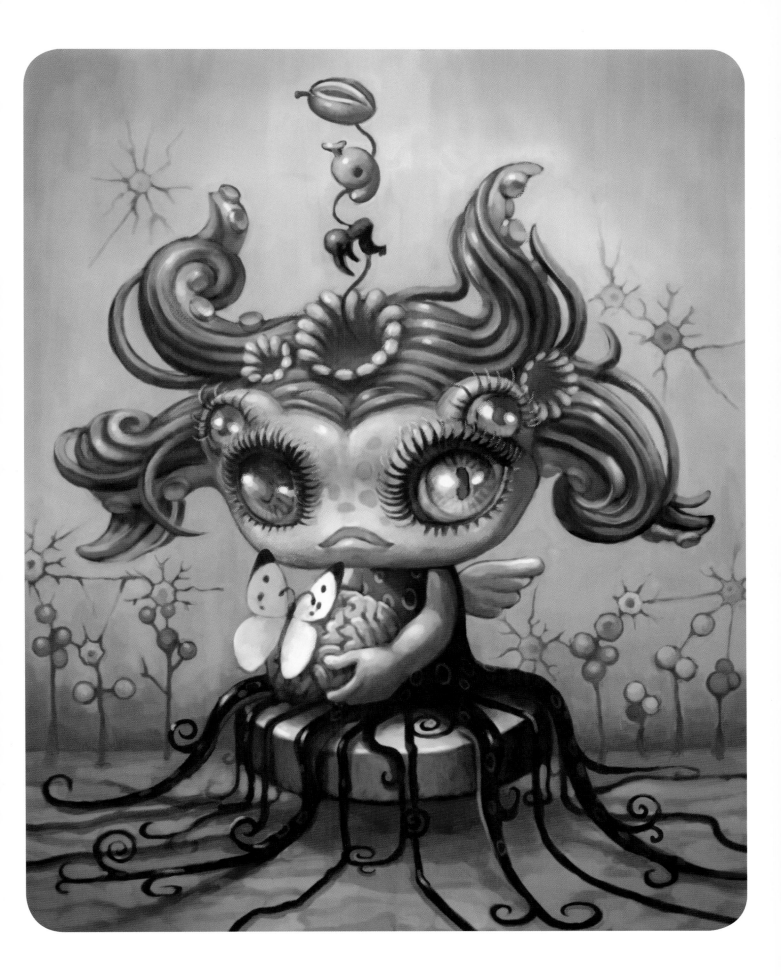

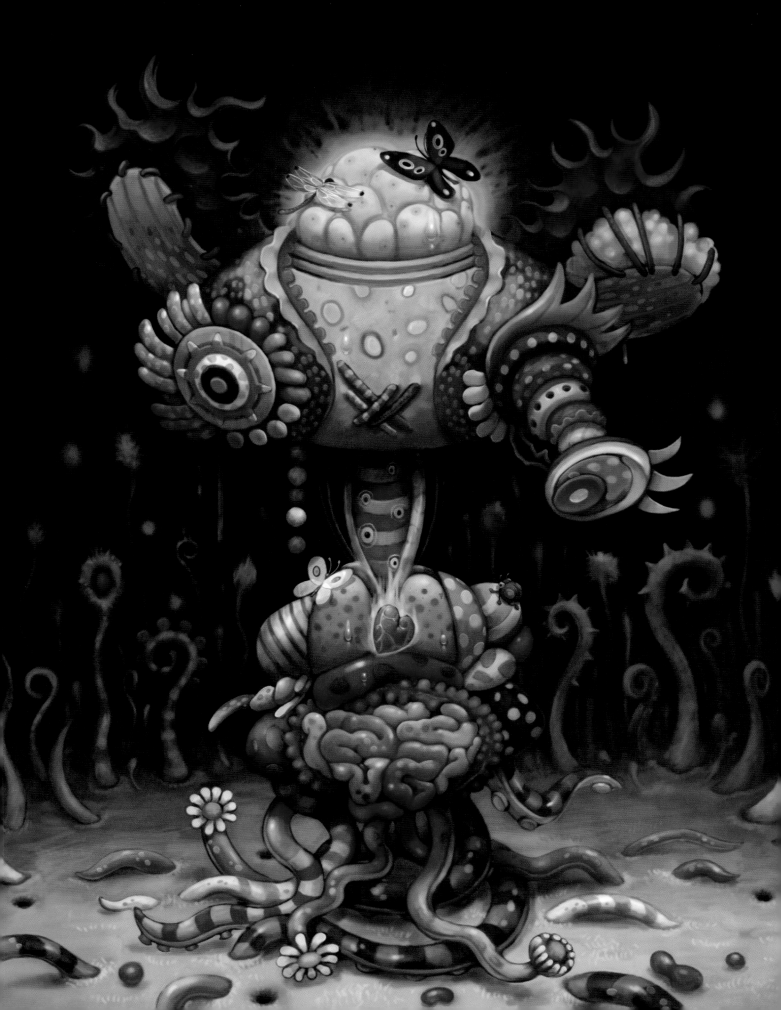

The eyes of Yoko d'Holbachie will send you. Just look at them, up to a half dozen at a time, and see a world not as simple or sweet as it might at first appear—decaying from surface cuteness into complex oddities of tentacle, barnacle and corpuscle. Revealing teeth and wing and toadstool, and a chromatic riot of mythological, biological and psychedelic implications.

"People often ask me, "Where do your images come from? Honestly I am not sure about it, either.

I guess that they existed at the same time when I was born. Most adults around called me 'weird' when I was a kid. Worrying about me because I was talking to imaginary invisible creatures or making strange stories."

Oh thank heavens for weird little girls. Yoko D'Holbachie is an-up-and-coming Japanese artist. Her style is striking—colorful, characterful and complex. At first glance her work can come across as cute. But the aftertaste is more complicated. There are strange things going on, odd growths, peculiar psychedelic mutations; her images seem to be a freeze-frame capturing an instant of a world in constant metamorphosis.

You can find precedents or points of comparison. Like if characters from Jim Woodring's dream work were given a Keane-eye transplant in Junko Mizuno's living room. But as fun as those cut-up reference games are, it oversimplifies the vision and effect of an artist who is clearly at an early point in what will hopefully be a long career.

The representation of eyes in d'Holbachie's work is a particularly telling and transporting feature, a microcosm of the hallucinatory dynamism you find throughout her paintings and illustrations. These eyes are windows beyond the soul, re-fractionated re-flections of an inner half-life, in synch to the strange transformations of her creatures and landscapes.

"I paint eyes asymmetrically because I contrast two factors—yin and yang—and because the right eye is not exactly the same as the left one. In fact, it is also true to my eyes. In addition, it works out that way partly because the pleasure of painting eyes makes me do it more intricately."

Turning pictures into words is a tragic and impossible endeavor, as the saying goes the conversion is 1000 per, in the favor of the image. But let's try anyway, shall we? To try to dive and divine into the biggest eyes of hers we've got today. Judge the artist by the cover to this very book.

Notice for starters, how cute our Volume Six cover girl is at a glance. Big green eyes and a lamb-y woolen face. A mild case of freckles plus whimsical curlycue antennae and sorta floppy ears complete the charming, delightfully pretty face. But wait now, look closer, and let the details of the image start to sink in. The face is not actually wooly, but bulbous, the ears are subtly dripping, and the eyes repeat twice in diminishing size to make a total of six ocular organs in all.

Closer still and see that the young-un in her clutches, held by hands with three thin rubbery fingers, has a mouth of pointed teeth. Born carnivore. A mouth that takes up a disproportionate chunk of real estate in the middle of the infant's face. A papoose with bite and three pairs of peepers like his mama.

Next the setting begins to dawn on you, a lifeboat or inner tube adrift on a sea besieged by big Space Invader jellyfish (maybe) who are shooting or pooping or raining or Yoko-knows-what down in the background. Meanwhile that raft has minor tentacles dangling from its sides and you realize it has a circumferential posse of unmatched pods that are blooming, puckering and oozing. Those maternal freckles seem to echo throughout, on the pods and the raft as well as across mama's ears and body.

I will not mention our lady's insect like wing or possible honeybee thorax. But I can't help but point out her noticeable and ample cleavage. And who is this mystery woman, you ask?

"I am glad for Kishibojin to be chosen the cover. Kishibojin is a goddess of the Buddhism."

Kishibojin (or "Hariti" in Sanskrit), is a Buddhist goddess of motherhood, family and abundance. The Buddhist website www.udumbarafoundation.org says: "Kishibojin is called the mother-of-devils because she symbolizes the selfish nature of mothers whose love for their children is so extreme they become devils."

In fact, d'Holbachie says she has always had a

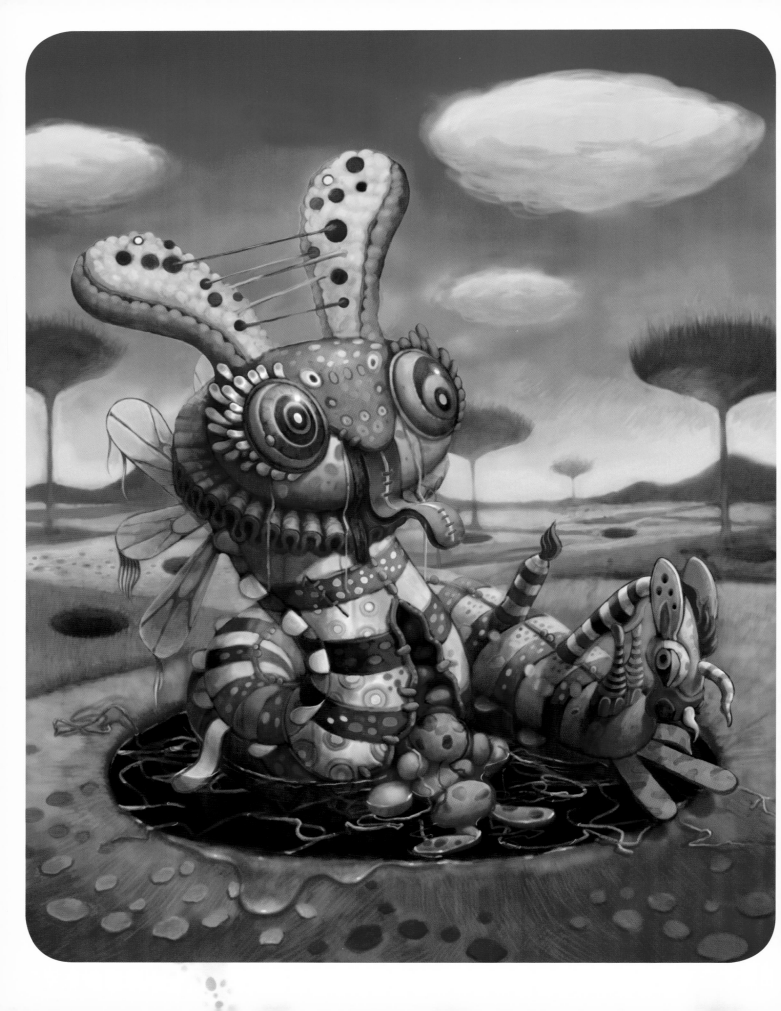

maternal feeling toward her images, that she thought of her creations as her children. But now her attitude seems to be changing...

"Now I take each of them for my twin brother in a sense because we have been ever together since we were born. Someone has told me, 'All of your pictures are your self-portraits.' It might be true in the sense that he is my twin brother."

Eyes can be mirrors as well, and like a fun house mirror d'Holbachie's creations reflect back a very different "twin" image than what you see of this 36th year on her website. There the artist is shown in her workspace, surrounded by sketches and toys, a colorful and evolving screensaver on her computer, a zebra-stripe-covered desk, wearing a busy multi-colored frock and with a complex expression on her face. Her face for the camera is not cute simplicity, but the opposite. Some amusement but not smiling, she's on a peculiar edge of stern. On her shoulder, also staring directly at the camera, is a handsome yellow bird with orange cheeks.

"This bird is a cockatiel, and her name is Vermilion. The whole studio is in her territory, so we are always together. We are getting along with each other except when she crashes into my oil paint in production. She is an excellent circus bird, and can play quoits or basketball."

D'Holbachie graduated from Tama Art University in Tokyo. She has worked for almost ten years as a freelance illustrator for advertisements, books and magazines, as well as doing design for entertainment and video games. She has lived in Yokohama, Japan for several years and teaches art in Tokyo a few days a week.

"I use both computer and oil painting methods. I use my PC when I make a rough sketch in order to expand the images of structure or color. I sometimes complete it by PC, and sometimes start to paint in oil on a canvas. One of the PC's merits is that you can quickly and easily lay down the image you have just had. In oil some accidents during my work could bring about an unexpected beautiful effect, and I feel that the final texture is intriguing.

"I love both means, but these days I am getting more interested in oil partly because I have had more opportunities to exhibit them."

She will be exhibiting next at Gallery 1988 in L.A. in the *Bitters and Sweets* show curated by *Hi-Fructose*, in conjunction with the release of this very issue of *Hi-Fructose* [November 2007].

Meanwhile, she has a somewhat surprising connection to psychedelic music in the poster she created for "jam band" The String Cheese Incident. That 2001 poster led to one of her more prominent publications, in *Art of Modern Rock: The Poster Explosion* (2004, Chronicle Books). She also has work in *Pictoplasma 2: Contemporary Character Design* (2003, Gestalten Verlag). Not quite making her a household name, these books did get her work in front of an appreciative

Those books and her website have helped to develop international interest in her work and the word continues to spread.

"I receive a lot of fan mail from various countries. I feel very happy, though now I feel sorry I can't reply to each mail."

I asked her, in the balance between "cute", "pretty" and "beautiful" what she would say she is most striving for in her work? Her answer...

"I am the most impressed with 'beautiful' of the three. There is a Japanese word 'kirei', which means similar to 'beautiful'. This Chinese letter 'ki' in it means extraordinary or enigmatic. Although I don't dislike 'cute' or 'pretty', I love something formidable as well as pretty. I will be very happy if I create beauty such as the bright orange patterns on venomous spiders, which must burn into your mind."

What you get from d'Holbachie's work is a kind of benign radiation, with, like the spider, an undercurrent of danger. Like an odd tone at the edge of a pop song, that when you listen closer is whispering profanity.

Not that her work is profane, in fact it is more that it goes beyond psychedelic to hallucinatory. Her subjects mutate and transmogrify. Visual echoes and trails, and mutation of the eyes before your eyes. Eyes that become as breasts as nodules or sphincters. All of this is quite natural in the worlds we window into with her. These tentacles are what grass is here. The 3rd, 4th, 5th, etcetera eyes are like stubble, 5 o'clock shadow in the plains of strange oceans and landscapes. It is as organic as any other aspect, and it makes me wish I could hear what they have on their ipods--I'm sure it's got melted beats, fine devolving lines of synthesizers, and would go great with the Wizard of Oz.

"My mother left me in the care of an American painter and his wife before I started elementary school. I hear that there was a residential area for American people in Yokohama in those days. My mother says that painting pictures of the images enabled my imagination to get a certain shape and I got settled at last."

Oh thank heavens for weird little girls... and American painters. And enigmatic transformations that just keep right on going. And the eyes that telegraph it all in glowing detail.✛

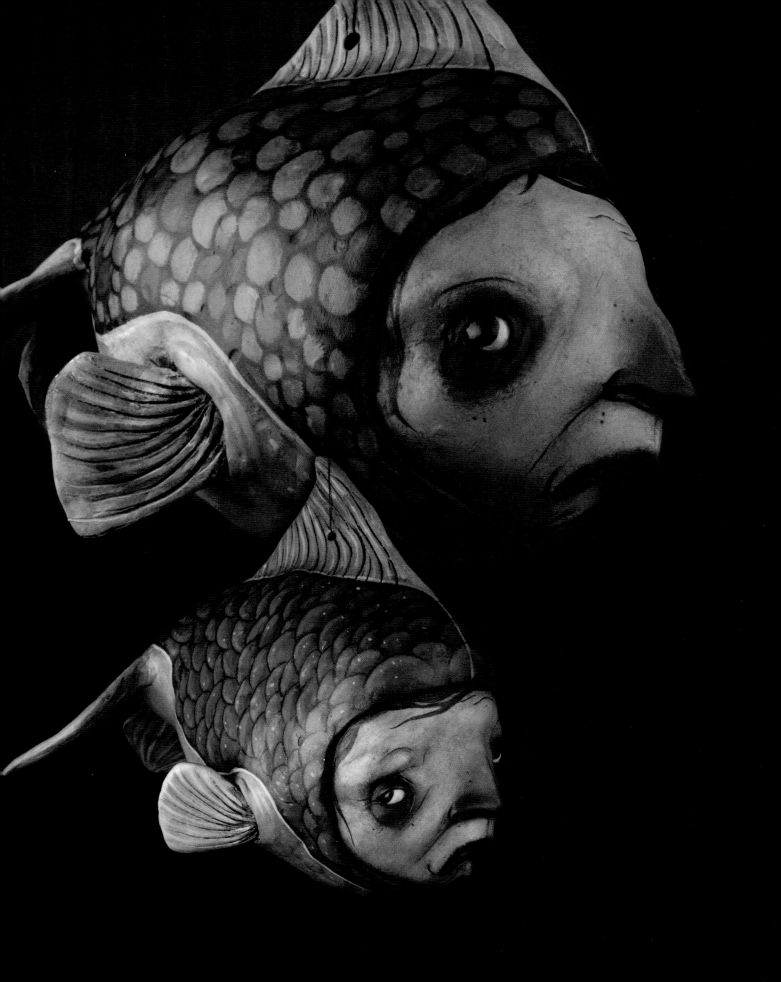

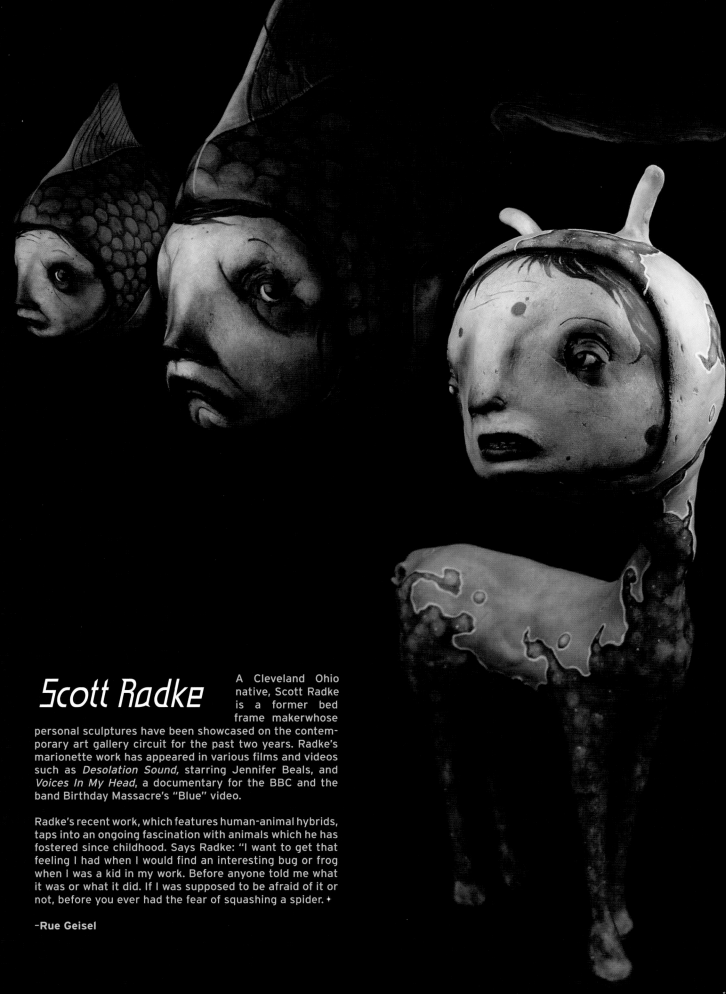

Scott Radke

A Cleveland Ohio native, Scott Radke is a former bed frame makerwhose personal sculptures have been showcased on the contemporary art gallery circuit for the past two years. Radke's marionette work has appeared in various films and videos such as *Desolation Sound,* starring Jennifer Beals, and *Voices In My Head*, a documentary for the BBC and the band Birthday Massacre's "Blue" video.

Radke's recent work, which features human-animal hybrids, taps into an ongoing fascination with animals which he has fostered since childhood. Says Radke: "I want to get that feeling I had when I would find an interesting bug or frog when I was a kid in my work. Before anyone told me what it was or what it did. If I was supposed to be afraid of it or not, before you ever had the fear of squashing a spider. ✦

−**Rue Geisel**

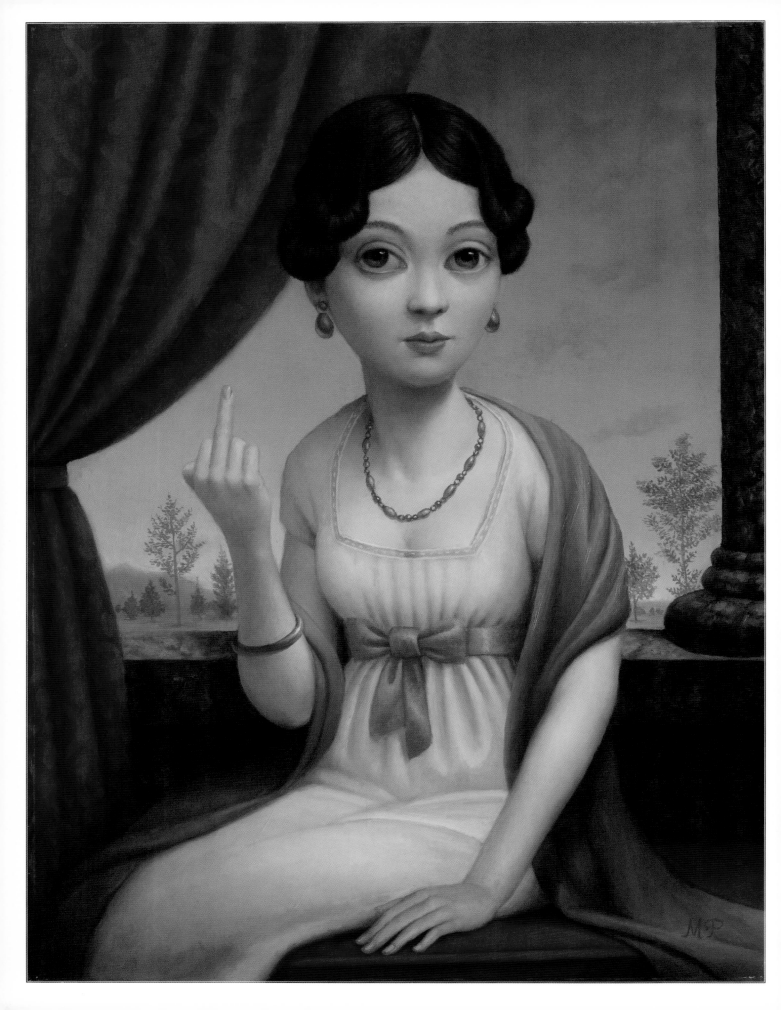

The Subterranean Art of Marion Peck

Interview by
Kirsten Anderson

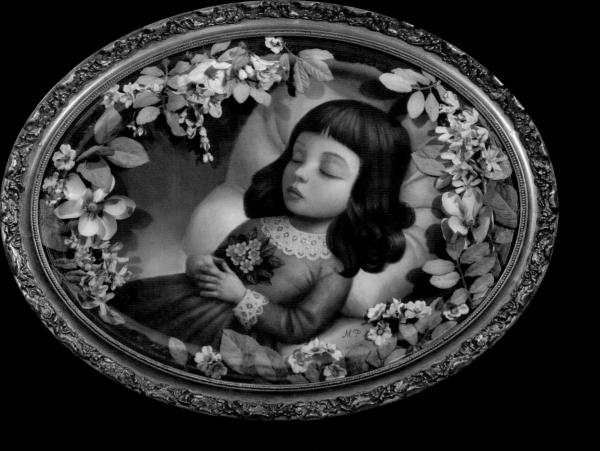

Painter Marion Peck has made her mark on the art world with a provocative blend of lush, dream inspired narratives shot through with both disquieting undercurrents as well as a vivacious dose of humor. Her latest works treat the viewer to a lush and truly surreal visual terrain featuring an array of characters dredged up from her dreams, such as chimerical beasts, expired children, flowers with human faces, evil snowmen, pink-eyed bunnies doing what bunnies are known for, as well as wall-eyed puppies, cross-eyed queens, and three-eyed kittens, all painted in luscious birthday cake colors.

I first met Marion when she stopped by my gallery in 2002 to show me her portfolio and ask about showing. I just about fell over myself saying yes. At the time, neither of us knew what a rich future lay ahead of her and her career, which has soared, with sold out shows in Seattle, Los Angeles and Rome. Not to mention her becoming half of a Pop Surrealism super couple with megawatt art star Mark Ryden, which led her away from Seattle and into the heart of Los Angeles pop art scene which embraced her immediately.

I recently sat down with Marion over salads and french fries and prodded the charming yet reticent artist into talking about herself for *Hi-Fructose.*

There are a ton of people familiar with your work since you entered the Pop Surrealism scene a few years ago, what people may not know is that you had been exhibiting and had been very successful for well over a decade before that. What is your background? How did you get started as a painter?

Well, I've been doing art since childhood; when I was little I had to do an essay in grade school called "All

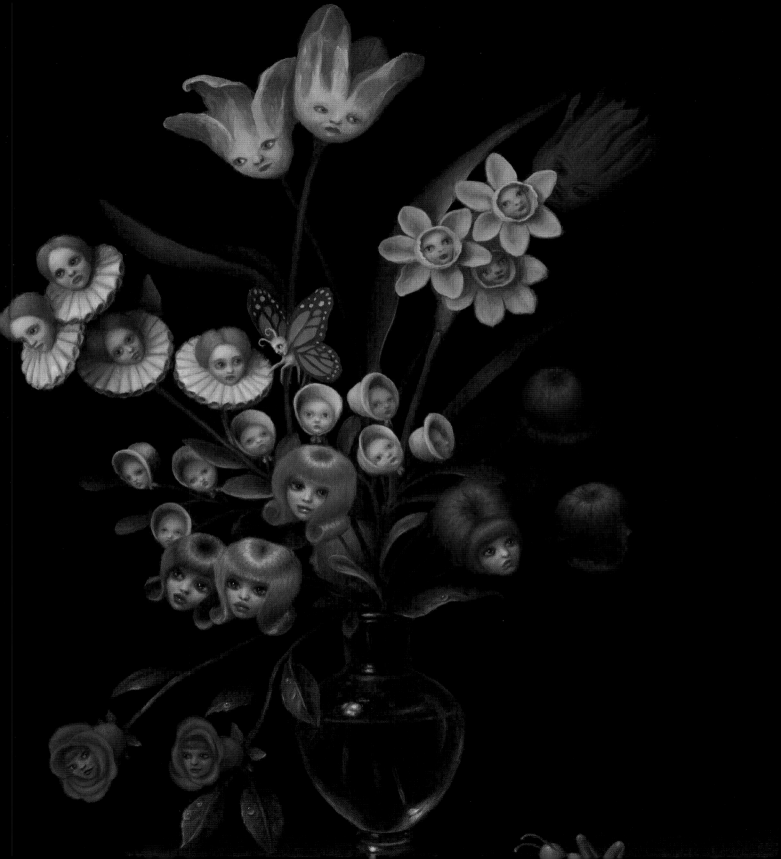

M. Peck

About Me" and I wrote, "I want to be an artist." So I always knew that that is what I would be. When I graduated from art school, I was really excited about being an artist and living that lifestyle... I was psyched to be poor! [laughs] I just worked and focused on art, and got a show in Olympia, Washington, which then led to Davidson Galleries in Seattle when I was 27 and from then on I had a show there every year or so. Pretty lucky actually.

I was aware of you during that time and I know you were highly regarded in the Northwest. I was surprised when you came to visit me at Roq la Rue to talk about showing...what was the thought there?

Well, Davidson was really supportive of me and really helped me... but at the same time I felt they were sort of conservative, and that they were more successful with "softer" works. I was attracted to the *Juxtapoz* scene and felt there were some elements of the Low Brow scene that I connected with and I wanted to explore that. I was in a rut at the time and wanted to explore a new direction.

Something else happened on the day we talked as well...

Yes, I met Mark Ryden that same day. He was in Seattle and I saw him getting into a limo with some guy... I thought he must be very "fancy." [Laughs] I met him later that night

"I'm very interested in the power of the subconscous; I think that is the source of power and meaning."

at an art opening and we clicked.

I guess the rest is history as you are now living with him in Pasadena! You seem very conscious of atmosphere and weather... how has the move from grey rainy Seattle to bright sunny Los Angeles affected your work?

The light and color changed, it soaks into you on that level. LA is much brighter than Seattle... less "moody." Also, I share a studio with Mark and of course that had an impact on me. We have a very deep relationship and work close together, as well as sharing influences and experiences.

I can see the influences, but I also see your influence in his work a bit. Actually, I find your work overall to be a bit "darker" and more erotically charged. What's going on there? Where do you cull these remarkable images from?

Mainly dreams... I'm fascinated by them and how they link to the subconscious. I'm very interested in the power of the subconscious; I think that is the source of power and meaning. All explanations for dreams seem inadequate, and the better you learn to remember them the more interesting and bizarre they are.

I don't consciously set out to use an image, they sort of spontaneously occur to me from a dream or a moment of inspiration.

When you are working with this dream imagery do you analyze what it might mean?

I don't really subscribe to any set established interpretations of what certain symbols in dreams mean. I don't use any particular image "on purpose"—I like to let them just arise. It's kind of interesting to let other people dissect them afterwards.

So, you've had this scene pop into your head, what then? How do you go about creating a painting from there?

I do loose preliminary sketches, but I notice that I always use the first one I do. I'll paint them thinly with

washes so I can work out what I want on the canvas, and then I tighten everything up.

Your last few shows had a definite macabre theme, what with the deceased children and pets and such. What inspired this particular series?

I became really interested in the concept of "Memento Mori"... I became fascinated with death, because, well... it's the big one isn't it? Who doesn't have a fascination with it? I liked to think about the concept of "those who had gone before," and had a wonderment that there are people who live their lives and they die as little kids... you can build a connection to people just by looking at a picture and seeing some dates... it makes me automatically create whole fates for them in my head.

The last show I did (at Billy Shire Fine Arts) was more about keepsakes and memorabilia... I used domes to cover the paintings for that reason. There is a romantic, nostalgic longing that mementos carry that is then tinged with dark stuff, because the person isn't there anymore. The first show led into the other.

What's next?

First I think I'll take a short break and then get back to work! I've been inspired by Neo Rausch lately. And of course, my dreams. I'm really excited to get back to the source. ✦

Family Record.

BIRTHS.

DEATHS.

Jason D'Aquino, who was once an illustrator for Christian children's books, is an artist whose deceptively innocent art is imbued with a bitter wit, sharply attuned to the wickedness in our midst and rendered in pencil, in astonishingly tiny detail.

D'Aquino's use of found objects as his drawing surface; from antique ledger pages, animal-skin vellum, match-books to aged Good Humor ice cream spoons, elevates the once discarded and forgotten object with a new yet altered or distorted value. Interview by Annie Owens.

Hunter S. Thompson makes frequent appearances in your work. You're a fan no doubt, what is it about his work that attracts you?

Hunter Thompson was the real deal. I first found him by way of Ralph Steadman—one of my favorite artists. Hunter was honest and fully immersed in his work. You have to respect that.

Speaking of Hunter S., do they still make Good Humor ice cream? Where'd you get that spoon? It's almost as if Thompson's likeness appeared on the spoon the way the Messiah's likeness appears in pancakes; Like a deity.

The old Good Humor spoon was in the top drawer of a broke-down roll-top desk. A real ancient thing, it was dumped at the curb for the garbage men. That desk held quite a few bizarre objects of mysterious origin. When I find something like that, I can't help but wonder who the owner of the desk was, why he kept all those things for so many years, and why they are now being so unceremoniously tossed aside. Maybe he died, and his story will never be told. Or many it's just a buncha junk—depends who you ask I guess.

Are all of your paintings done on found paper? Do you spend a lot of time in antique stores? Is there an ideal found object out there you've been looking for that you haven't found yet? Being fond of meandering through antique stores myself I always feel there's *something* really special waiting to be found, I just haven't found it yet.

All of my work is on "found canvases" whether they are documents, old matchbooks, or pages from some deceased person's diary. The surfaces are infused with their own history and they seem to resonate.

I actually don't spend much time in antique stores. I prefer outdoor markets and abandoned buildings. Places a bit creepier. I definitely have a problem collecting things. I have a large collection of antique blank books, (hard to explain). The Surrealists used to wander around the street bazaars and markets in search of strange, surreal objects. I definitely share that obsession.

There are many objects I covet. I would love to find a Mickey Mouse gas mask. Back in the Duck-and-Cover days of bomb shelters and air-raids, they actually made

those for the good little girls and boys. I think that's brilliant.

I'm intrigued by the image of the angel holding a little devil or centaur in her arms, would you mind talking about it? The creature in the angles arms has got arrows through his heart and it looks as if he's dying. I think I detect a sense of remorse from him; is that right? There's a message in the ribbon that cascades out of his hand and a barely perceptible swastika hidden in his wings.

That piece is called "Ahnenerbe." It refers to a Nazi-era study group and secret society started in 1935 under Heinrich Himmler. Aside from seeking objects of power such as the Holy Grail and the Ark of the Covenant (Hitler had already obtained the Spear of Destiny) the group used psychic divination to make military decisions.

One such task assigned to their team of psychics, was to uncover the hidden location of enemy submarines by dowsing with a pendulum over a map of the ocean. It was like a game of "Battleship," except with real bombs. If a psychic gave the wrong coordinates (as they often did), Himmler had them killed.

The drawing depicts an angel and a devil, representing Man's capacity for Good and Evil. And although the devil is defeated, there is a sense of remorse. Because for all the atrocities committed by the Nazis, the perpetrators, once captured, turned out not to be monsters, but mere men—no different than you or I.

Wow.

> *"No matter where I find myself, I can usually get my hands on a pencil and a scrap of paper, and create a piece of art."*

Are these pencil drawings? Not many artists will let pencil drawings be their finished pieces, but I love the detail that you've pulled out of the graphite. If I'm not wrong about this, what made you decide on this as your way of making finished work? Where does the sepia tone of your lines come from? Do you use magnifiers to draw so small?

My pieces are all done in pencil. The appearance of the sepia tone is a result of delicate shading over old discolored paper. Graphite as a medium seems simplistic but deceptively so. There are rich and impressive subtleties of effect, which can be achieved using only a pencil. This is part of why I embrace graphite as a medium. The other part is the accessibility. No matter where I find myself, I can usually get my hands on a pencil and a scrap of paper, and create a piece of art.

I often use high-magnification goggles to achieve the dense concentration of detail in my matchbook drawings.

"Writing Machine" and "La Pistola"–are they Thompson references?

The "Writing Machine" and "Pistola" matchbooks are not intentional references to Thompson, but I did complete them directly after a Hunter portrait, so I'm sure I had him in mind. The typewriter had me thinking of *Naked Lunch* as well.

What are some shows coming up?

I try to keep a pretty busy show schedule. I'm going to have a few pieces in Les Barany's *Carnivora* show, hosted by CPOP Detroit, Mark Murphy's *Green* at the Robert Berman gallery in Santa Monica this November, and I'm working toward a solo show in June 2008 at the FUSE Gallery NYC.

There is a nostalgic quality to your work but also a slight sense of the odd. Partly it's the crazed sweetness in the faces of your characters and partly the ambiguity of any specific point in time. I like this ambiguity. It's like how I'd feel watching old *Twilight Zone* episodes. Like everyone is really in hell. Have you heard that before?

I haven't heard it put quite that way, but I like it. My work is inherently anachronistic; the surfaces having been created long before I was even born. They were never intended to be drawn upon, so my creations are stuck in a sort of silent limbo, a foreign landscape out-of-time.

The smiles on the faces of my characters are like masks. They are not real. They are not expressions of joy. They are forced, and deliberately hiding something. The only ones in my drawings who are actually enjoying themselves are the wicked.+

23 ST. THOMAS ST.
TORONTO 924-3721

23 ST. THOMAS ST.
TORONTO 924-3721

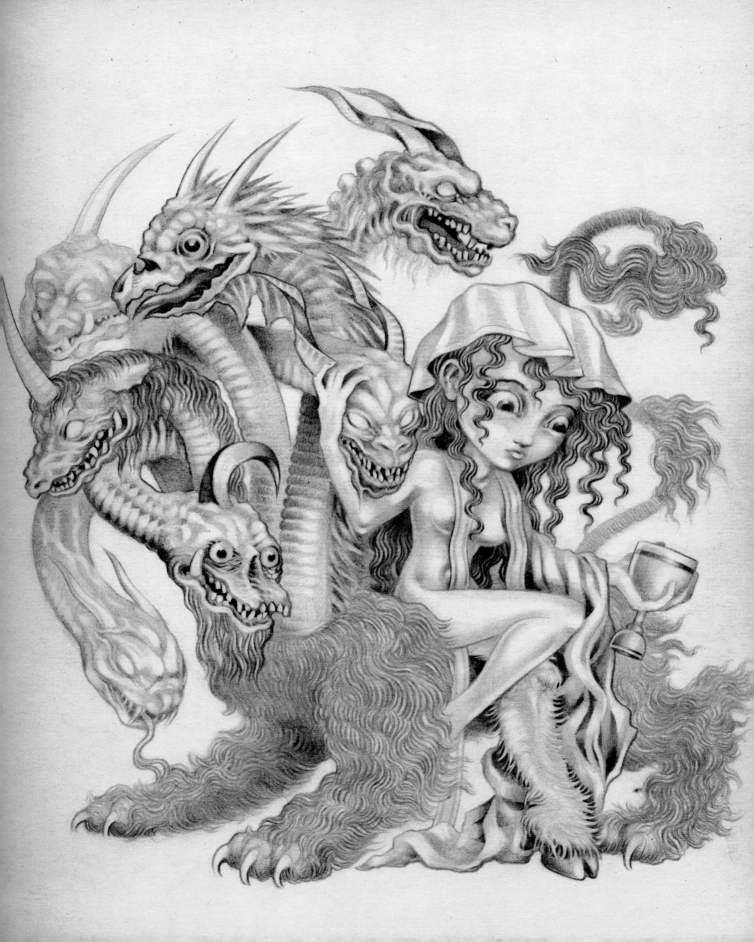

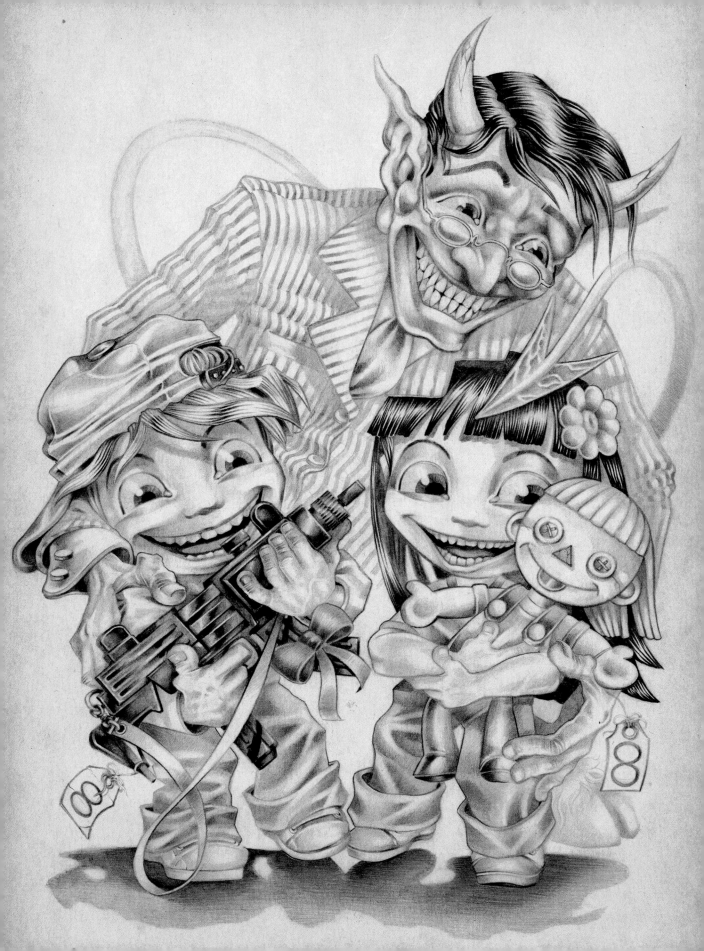

KEN KEIRNS

by Annie Owens

K2, also known as Ken Keirns, is a soft-spoken Chicago artist who recently relocated to Northern California. His gentle demeanor gives way to sly wit and droll humor, evident in his work as an artist as he talks to us about mob monkeys and feetless birds.

So very glad that we ran into you in Chicago. When Kirby showed me your work I was like, "Oh my gosh *that* guy is here?!" (Please don't be offended I referred to you as 'That Guy.' I'm horrible with names.)

No, That is very nice of you. You have interviewed some amazing artists; I really don't consider myself on the same level with... so it's very kind of you.

I'd really like to talk about monkeys and dinosaurs, do you mind? What's your connection with them?

Monkeys and dinosaurs are elements that I liked as a child, and are rather fun to paint. They also have a way of making paintings more fun. I have always tried to add a little humor to my work. Whether it's a hidden horned monkey hiding in the backseat or a ridiculous looking dinosaur approaching from behind. They are just a way to keep the work from getting too serious. At some point I started making them more prominent, and eventually they found their way to being the primary subjects. It changed the feel of the work to something

very different from what I was doing five or six years ago. Lately, though, I just like painting them.

Can you talk about what's happening in "The Business"? It calls to mind *Planet of the Apes* meets *Pulp Fiction*. The monkey takes on more of a protagonist role in your paintings. Even though he might have the smoking gun, we're on his side like in, "Surrender Dorothy You Bitch." We assume that whatever Dorothy did, she must've deserved it.

You are very close with the *Pulp Fiction* reference. For "The Business," I was shooting for a Harvey Keitel/*Reservoir Dogs* Chimp. I have painted the monkey in the suit before, but I wanted him to look more angry and jaded. I'd been mulling over ideas for the background for a bit. I have a good friend that is a truck driver who calls at night—we both keep odd hours. I asked him, "ok... I'm painting an angry looking mafia monkey in a suit. What is in the background?" Without hesitation, he said, "a burning car." So it was a collaboration of sorts, thanks Joe!

Speaking of Dorothy the bitch, did *The Wizard of Oz* not go over well with you? Was it the way she treated the Oompa Loompas?

I loved the *Wizard of Oz* as a kid, but the flying monkeys were a bit creepy. I figured that monkey must have gotten tired of being pushed around by the witch. So, he took care of business... his way.

Where was your first solo show?

My first solo show was in Lansing Michigan at the Otherwise Gallery in November 1999. It was called, *Sineaters and Eyesores*. It was a mixture of paintings, sculpture, mixed media and furniture. My work was a bit darker then, definitely not as colorful or humorous.

The turn out was great, but the build-up to it was hell.

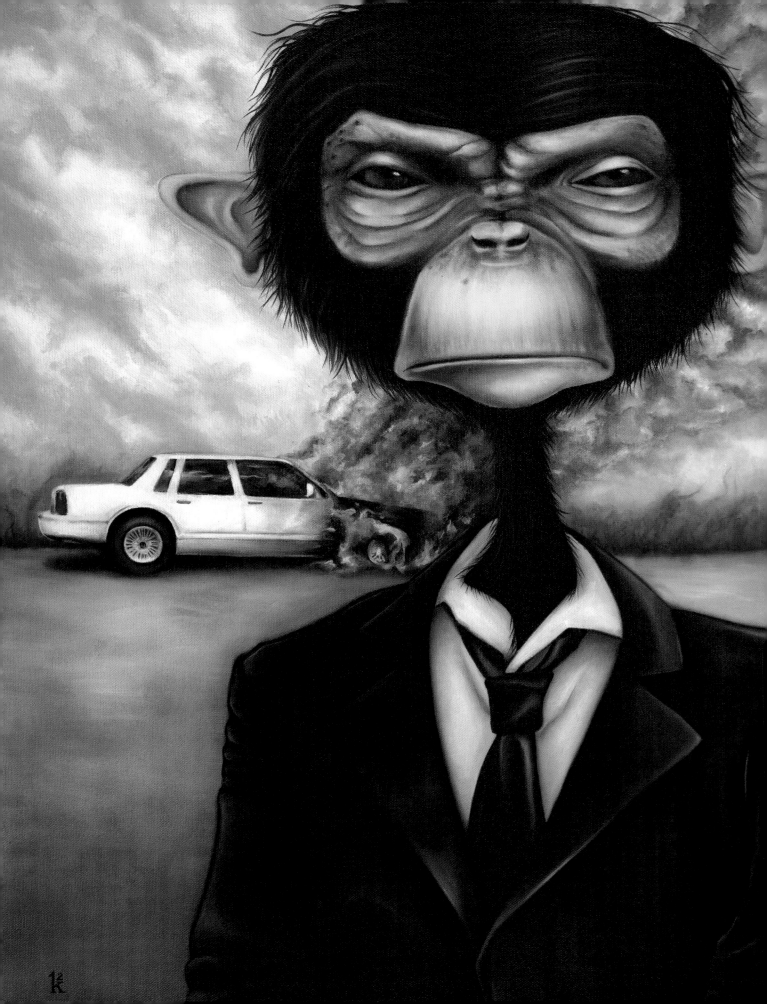

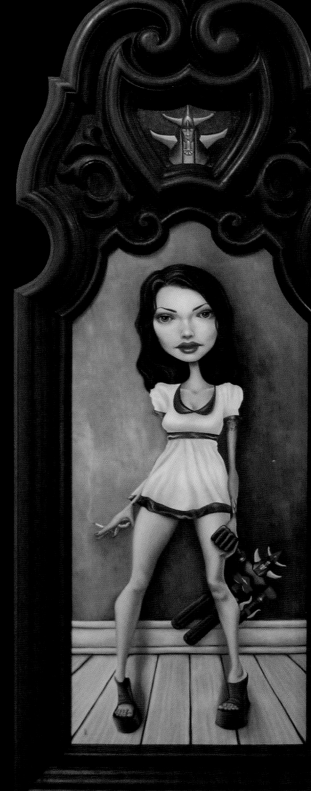

"I loved The Wizard of Oz as a kid, but the flying monkeys were a bit creepy"

Could you relay the story about the painting "Instant Message," featuring the bird with the invisible feet?

"Instant Message" is a painting that was created for the *Hot Babes in Toyland* show last May at Rotofugi. Whitney and Kirby (the owners of Rotofugi) are good friends of mine, and at the time I lived about a half mile from the store so I visited a lot. I would often show them pictures of pieces in progress to get an opinion.

When Kirby saw the in-progress photo of "Instant Message," he asked me why the bird was just floating, and if there was a special meaning behind it?

In this case, there really wasn't a good reason, other than bird feet kind of creep me out and I had been putting off painting them in. He suggested that it looked good and I could just leave them out... It wasn't hard to convince me.

I love the sense of humor in your work; even so, it's bittersweet. What does painting do for you personally? I mean, if you didn't get to do it, how would that affect you?

For me, having a sense of humor is necessary. I try and add a little humor or irony to build a sense of story or just to add a bit of fun. Something that might make you think for a few seconds beyond the actual composition, or amuse the viewer.

Painting is something that I love to do, I will always do, and I am always trying to improve. But, painting is a lifestyle in itself and a rather difficult one at that. I have a love/hate relationship with it. I was told once that my art wasn't fit to be on a t-shirt. Well, I showed him. I made t-shirts.

Art gives me a sense of purpose. There's nothing quite like the sense of accomplishment when you finish a new piece that you are really proud of, or when you sell a piece to someone who really loves it.✦

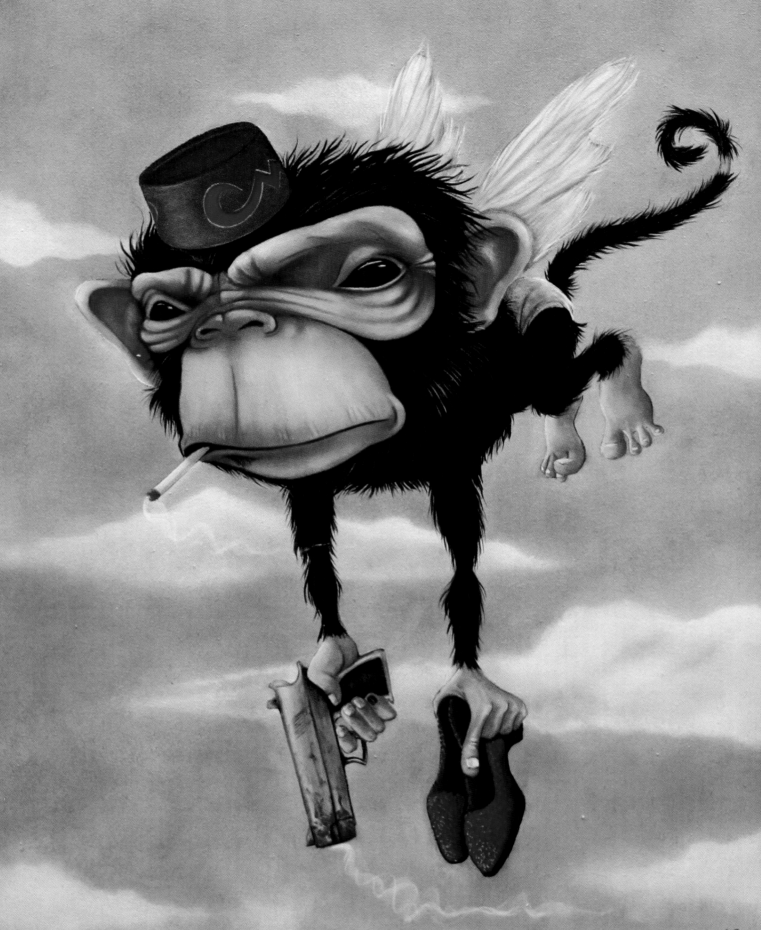

AMY CASEY

Amy Casey's latest collection of work in watercolor on paper aptly reflects the precarious state of affairs the world is currently in.

Houses on nightmarishly high rise stilts threaten to topple over at any moment. Hive-like clusters of more crumbling houses strung together like knotted pendulums swing from treacherously flimsy thread. Below, the ground is covered in a relentless swarm of plant-like creatures growing in suffocating profusion, and buses, cars and trains stop just short of the end of a broken highway, nauseatingly high above the increasing disaster below.

Even though this particular collection is born of a series of end-of-the-world nightmares, the sentiment behind the pictures are more optimistic than one would imagine.

> "I am fascinated by the resilience of life. Every disaster is followed by rebirth, where we hike up our boots, duct tape our lives back together and try to cobble together a "plan B" out of what remains."

Amy resides in Cleveland, OH and has recently shown at White Walls Gallery, ZG Gallery and is featured in Limited Addiction's anniversary group show February through March 2008.✦

Images courtesy of ZG Gallery, Chicago.

–Annie Owens

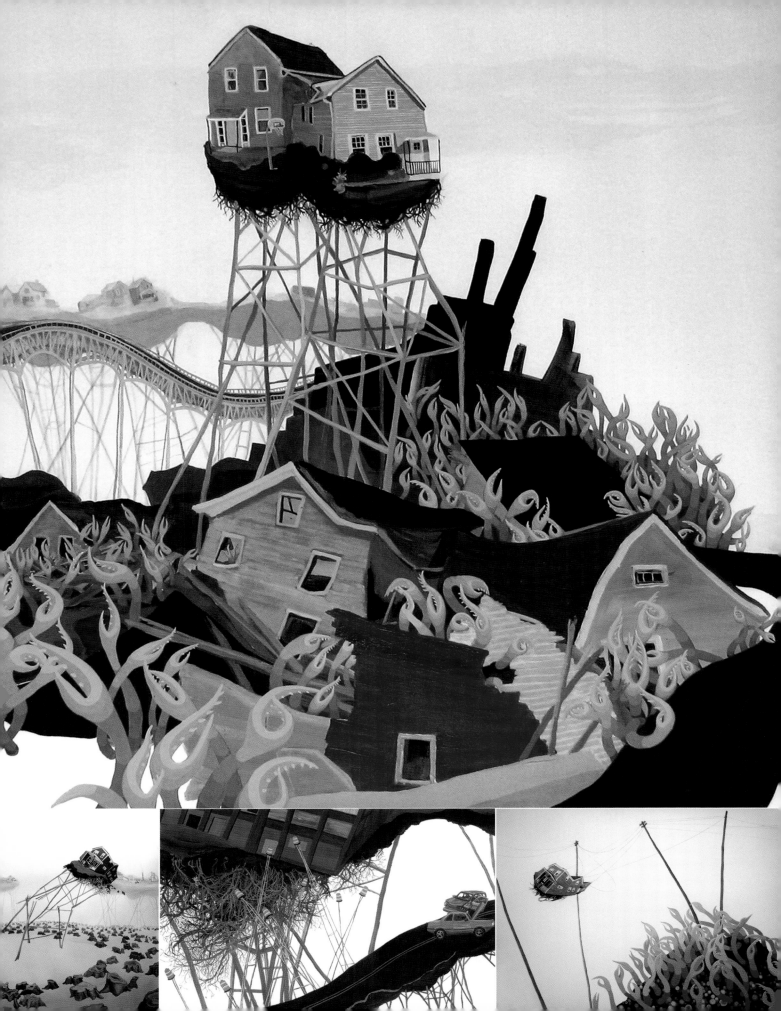

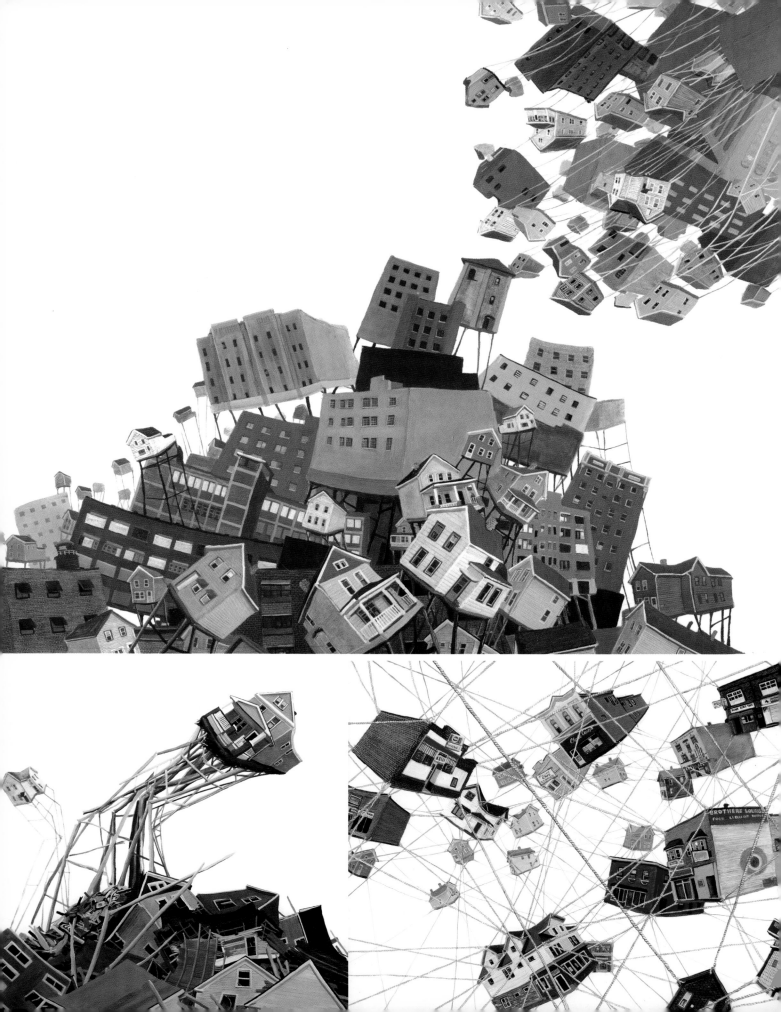

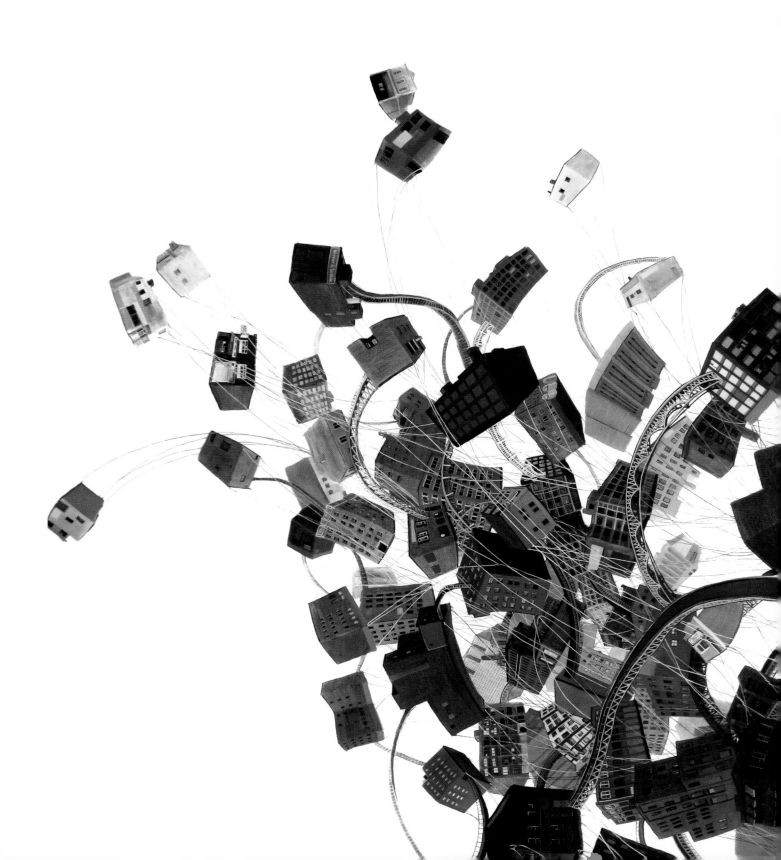

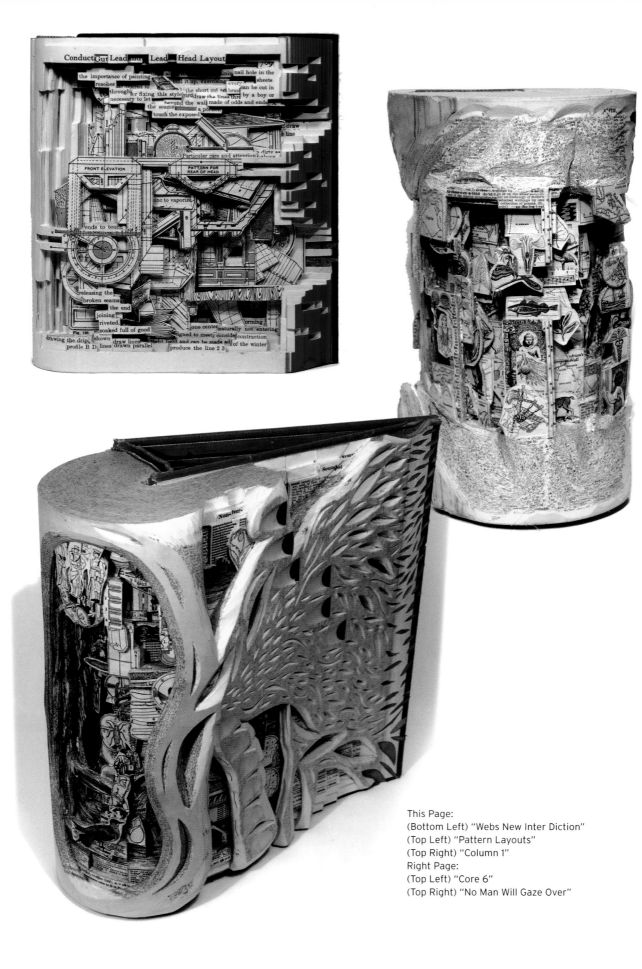

This Page:
(Bottom Left) "Webs New Inter Diction"
(Top Left) "Pattern Layouts"
(Top Right) "Column 1"
Right Page:
(Top Left) "Core 6"
(Top Right) "No Man Will Gaze Over"

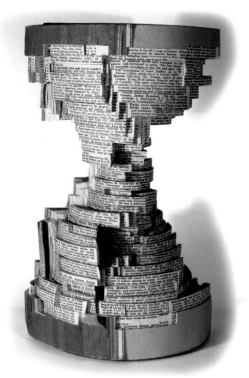

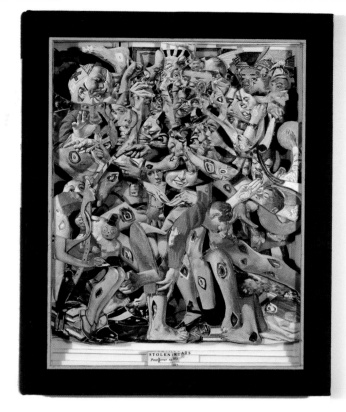

Brian Dettmer operates his meticulous operations out of Atlanta, Georgia. And instead of the common postmodern

Brian Dettmer

sampling, cutting, and pasting, and juxtaposition in most contemporary art, he presents us with something very much the opposite. It's a condensing, a digging.

Carving, cutting, and shaping layers of dead media, Dettmer disects old books, maps, cassette and VHS tapes. They are splayed out like Gray's Anatomy, another place where the once living are displayed in their dead entirety.

The pieces overwhelm us. This media that was originally made to be experienced in a well-behaved and linear fashion, page by page, note by note along magnetic tape, moving along through time, is now presented to us as a single entity. A big burst, straight to the brain, an overexaggerated *Cliff's Notes*, like staring at a stump and seeing all the rings of the tree's layers of growth.

Is this the soul of the book? Is this the spirit of the cassette tape? But then the rings of a cut log don't really tell us much other than the age of the tree, and maybe where it came from, do they?

In some of Dettmer's pieces it, seems that that is exactly what we are seeing. The dead media's spirit revealed. An old VHS of *The Godfather* has decayed into a single black rose. Like his cow skulls made of old audio tapes, melted down and reformed to represent maybe how old we see that technology to be. Thrown away books that have been carved up like logs, treated as the pure material resource that they always were. Yet in many of his pieces, there's much more going on: maps made into hands, old media taking on new forms, meanings, messages.

All the information, both original and new, is there both abstracted and condensed into one visual experience. With a single glance, you can see exactly what the book, map, or VHS was about. And yet we will never really know all the details or be able to read it or watch the tape again. We're seeing the whole picture at once, but can never actually know everything about it. And while we can see what it may have been about, and still is somewhat about, it's taken on a whole new meaning as well, a new form that simultaneously tells us more and less about the original object, more and less about the piece itself.✝

—Toast and Jillian Northrop

KUKULA

by Ert O'Hara

The last line of Israeli-born painter Kukula's bio says, "Kukula always five years old." This is when she believes she became her complete self, and in the two decades since, she has been trying to get back to it as age continually takes her away from that perfect existence. "When I was a child, I felt complete, I felt like a grown woman. Now I feel like a child, but obviously, I am a woman... I am in between."

That just might explain some of what is going on in her paintings. They are all of female characters; simultaneously childlike and womanly, partially exposed yet beautifully clad in period or designer clothes. Most of them also feature an assortment of childhood companions—dolls, teddy bears and tea parties. The sultry, sleepy eyes, bouyant breasts and come-hither expressions contrast sharply with the many infantile trappings. The huge head in relation to the adolescent body is probably the first thing you notice about her characters (clearly indicating they are dolls, not young girls), but in a hyper-sensitive world where children and sexuality are supposed to be mutually exclusive, any reference to youth combined with overt lust is going to get you in trouble.

Born Nataly Abramovitch in a not-so-wonderful small town outside of Tel Aviv, Kukula took on her moniker by modifying the name of a Japanimation character she was obsessed with. Where she grew up, confrontation is normal, and being polite is equated with being a hypocrite. She proudly effuses, "I embrace any emotion. I have no ability to ignore how I feel. I can't control it!" Always marching to her own song and dance brought teasing upon her as an adolescent. She dressed and behaved as she liked and couldn't understand why others would take issue. She never lost faith in herself, but did turn a bit inward, fixating on such super-cute totems of innocence and happiness as *My Little Pony, Strawberry Shortcake,* and particularly *Care Bears*—which she beseeched others to draw for her. This is where, she says, her interest in illustration was born.

After art school in Tel Aviv, she moved to the San Francisco Bay Area with her husband, Ariel, who is a graduate student at UC Berkeley. It was a major cultural adjustment. Kukula says that during the first year, she made many "enemies" because she didn't realize she wasn't supposed to just come right out and say her honest opinion about everything. After a venture of painting purses and making clothes, which were snapped up so quickly she could barely keep up with demand, she was "discovered" and asked to participate in a group show at the Shooting Gallery in San Francisco.

Working with galleries has taught her "American ways of dealing with people." And while she understands the value of being polite, she maintains a disarming honesty both in person and in her work. In response to pointed criticism of the content of her paintings, she laughs, "I was quite shocked. Nobody said I can't paint, they just said 'great, another doe-eyed skank!' And I want to know, who is this doe-eyed skank? I hope I can meet her and be her friend!"

Though a contented homebody, she is not immune to loneliness. Homesickness plagued her in 2007, and that sadness was reflected in the body of work she did titled *In Her Last Hour*, a series of paintings depicting the final hours of the characters lives. This past December, she and her husband went to visit her family and friends in Israel for a month. Though she had the concept of her next show, *Dreamcatcher* in mind before she left, the trip home rejuvenated her, and she now has more resolve than ever to embrace that which makes her happy.

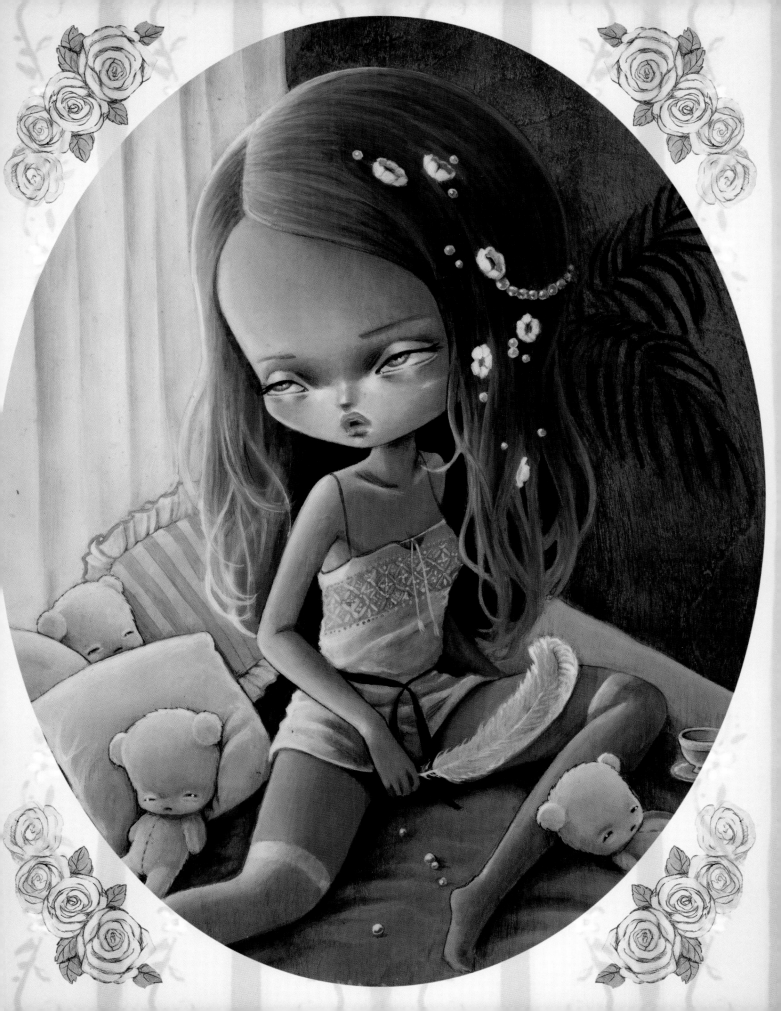

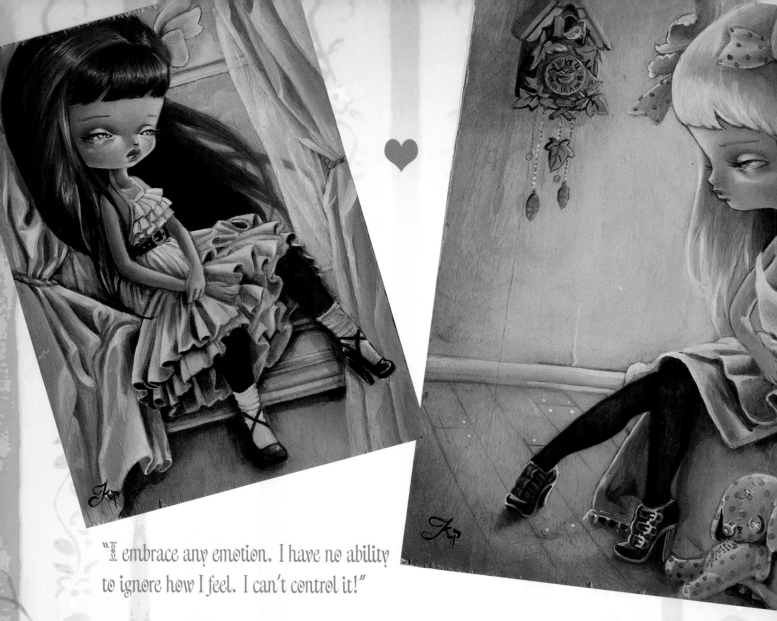

"I embrace any emotion. I have no ability to ignore how I feel. I can't control it!"

After painting several characters wearing a particularly expensive pair of shoes that she coveted (a steep Chloe wedge with a solid wood sole), she decided she'd earned the right to actually buy them. Kukula's love of decadent clothing is the other driving force in her paintings. The influence of Sofia Coppola's *Marie Antoinette* is obvious in more than a few pieces. She says, "I have this craving for aesthetics. I am trying to make everything in my life worthwhile. I don't like to waste my time, so I don't do much, but I do what I like. I like very good food, and very good music, and I don't care about underwear, but my shoes must be perfect!" When asked about the pain factor of very high heels, she doesn't hesitate, "The Chloe shoes are maybe a little uncomfortable, but it is more uncomfortable for me to feel like I am not dressed well." For Kukula, clothes are not so much transformative as they are representative. She feels they can tell more of the truth about us if we are honest and wear what we really like.

Kukula's attachment to the aesthetics of her girlhood is as solid now as then. She collects antique dolls, toys, and petticoats, and her studio could pass for the fairytale bedroom of a little bohemian princess. There, she is immersed in her youthful memorabilia, both bitter and sweet. As she prepares for her solo show at Thinkspace Gallery in Los Angeles in March 2008 (and another at Copro Nason in November), she is resolute, "I want to take my time. I don't want to create junk. If I do, it drives me nuts!"✛

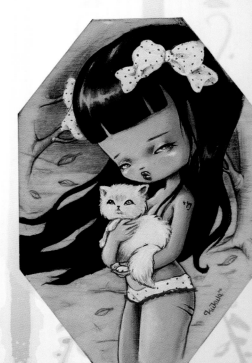

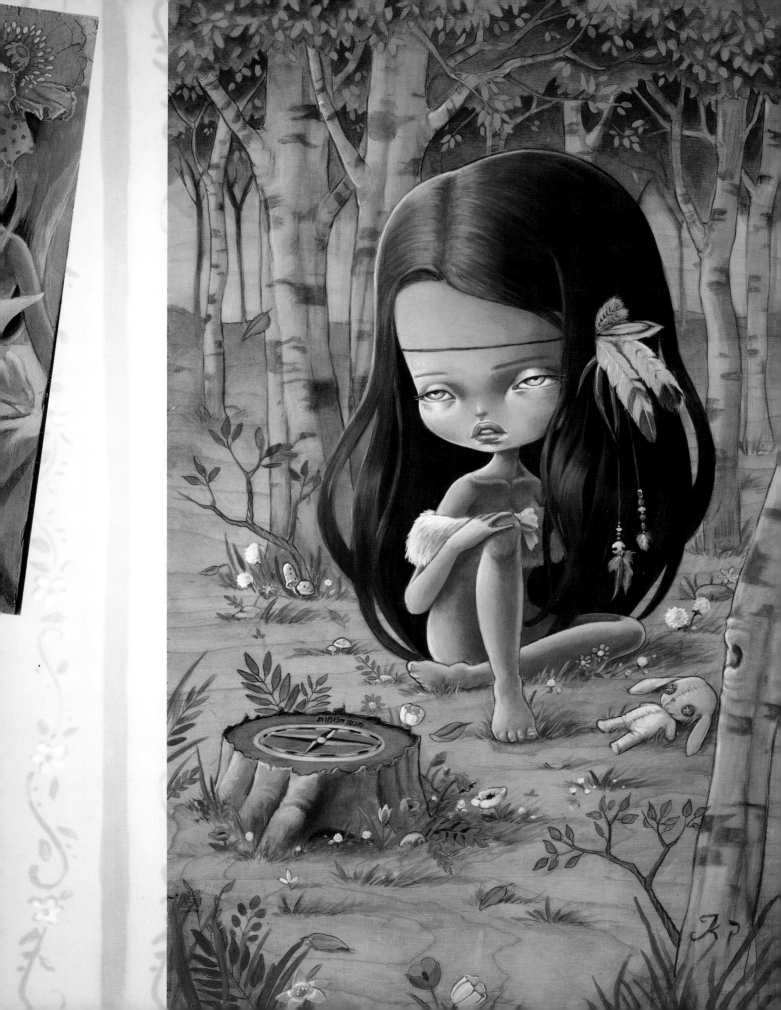

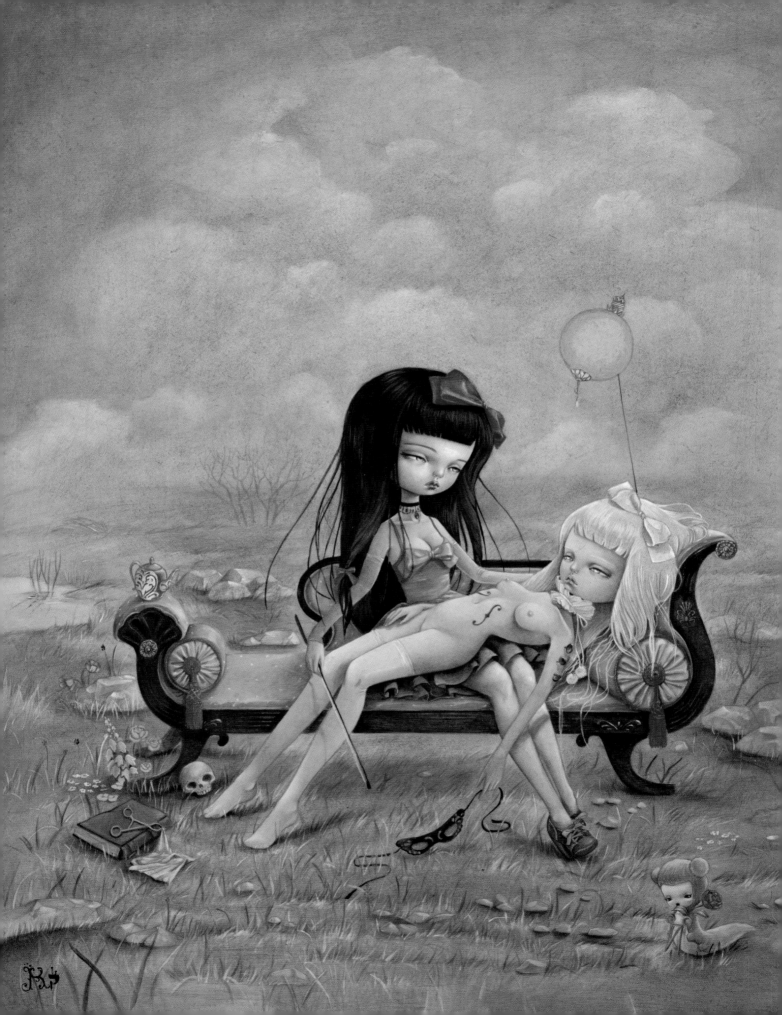

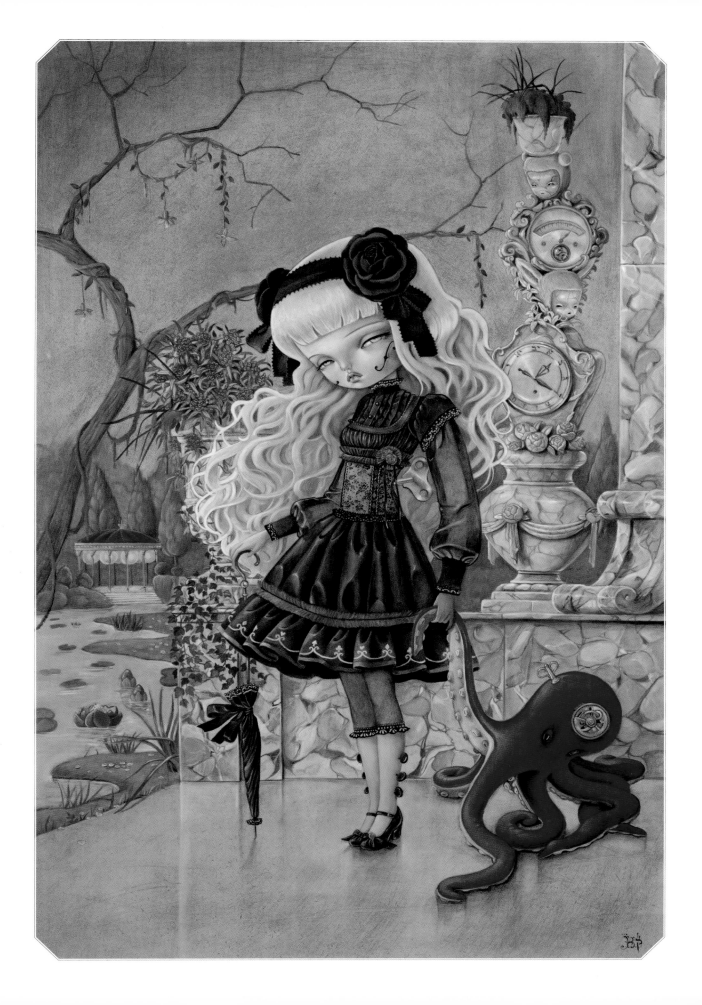

Substance:
The Art of KMNDZ

by Manuel Bello

Artist Johnny "KMNDZ" Rodriguez was born in South Central LA but relocated at a young age with his family to one of the rougher areas of Baldwin Park, the Los Angeles suburb where he grew up and still lives. His deep roots in the local culture flavor his work with a strong sense of family, religious reverence and iconic imagery.

As a child, he identified closely with the pop culture of the time, especially the mischievous art and writing of Bill Watterson, creator of *Calvin and Hobbes.* Later in his adolescent years, his interests included the usual boyish suspects like comic books and skateboarding while also dabbling in musical esoterica like the classical trumpet. Rodriguez used to tell his friends, "If I was a drunk, I would probably sit around and talk about how I could have been a pro skater." He may have seen some progression as a skater, but happily, he never made it as a drunk.

Taking his name from "Command Z" the Apple keyboard command combo for "undo," KMNDZ builds around the concept of the things in our lives that we all wish we could undo or change. In many cases, his art asks the bigger question of what could have been, as opposed to what is.

One thing that is clear is his all-around talent as an artist. KMNDZ has been making a name for himself in the graphic design field for many years doing projects for some of the biggest players in

commercial arts. However, he is relatively new to the fine art world, having completed his first painting just over three years ago. As a self-taught painter, he holds his own with the best of them, throwing off the expectations of consumer seduction, instead focusing on his personal experiences and those of his family and friends.

The cast he painted for the Keep-a-Breast project relates various elements of the story of an aunt whom he lost to cancer, including three drops of blood on the side of her body afflicted, the scripture John 14, which he read to her before she died, and a large center-placed bomb representing, "the power true love can have on a person."

Through Keep-a-Breast, KMNDZ met founder Shaney Jo Darden and became involved in another of her ventures, Lewsader, which she started with Robert Lusitana (former co-owner of the beach/surf line Redsand) to showcase six hand-picked fine artists each season in a crossover project fusing fine art with limited edition clothing lines. KMNDZ's line includes a bandana, t-shirt, hoodie and more.

In his painting titled "Pleasure to Burn," he depicts a robot smoking a cigarette. The concept is borrowed and reimagined from a classic 70s anti-smoking campaign which featured a middle-aged woman who, despite losing her larynx to the addiction, smokes a cigarette through the hole in her neck reserved for her robotic voice box, then rasps, "They said that nicotine wasn't addictive..."

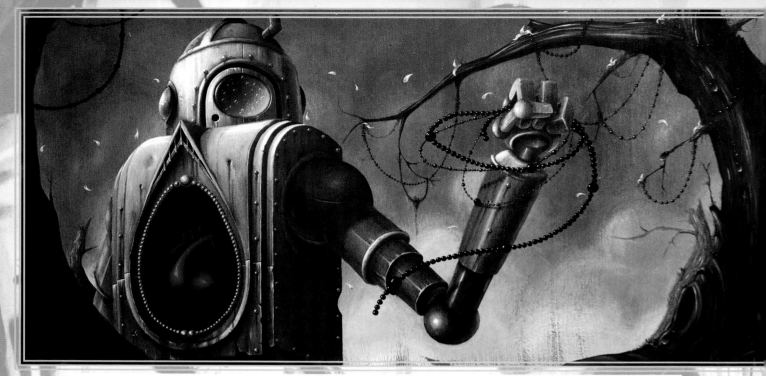

KMNDZ explains, "That piece is not so much a piece about the whole anti-smoking thing, but more about those things that we as humans all gravitate towards that are so destructive to us.". In another piece depicting two robot hands pressed together in prayer and set off by a vaguely star-like oval typically seen haloing the Virgin Mary, he simply says it refers to "fake people" and lets you fill in the rest of the sentiment.

Soft-spoken, politically and socially aware, Johnny "KMNDZ" Rodriguez has many things to say but lets his art do most of the talking. When asked what is important about his work, he replies, "Painting with substance. I did not start painting for financial benefit or fame. I started to paint because I felt I had important things to say." There is no question that his work is overflowing with substance and speaks volumes. In the words of KMNDZ, "*nvr frgt.*"✦

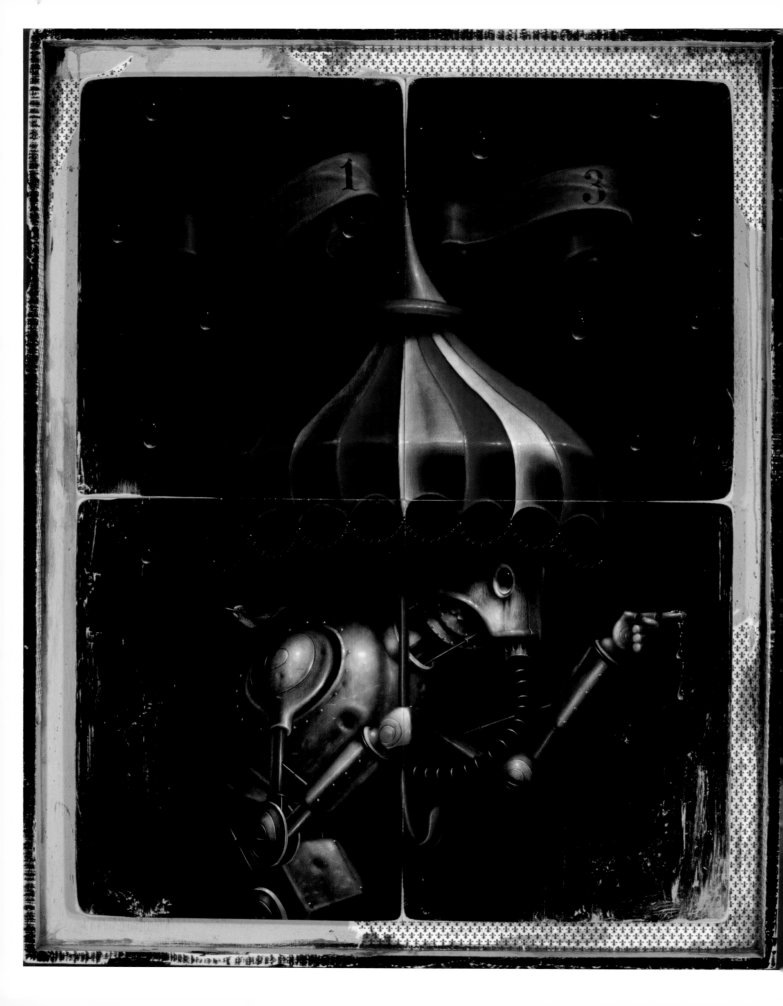

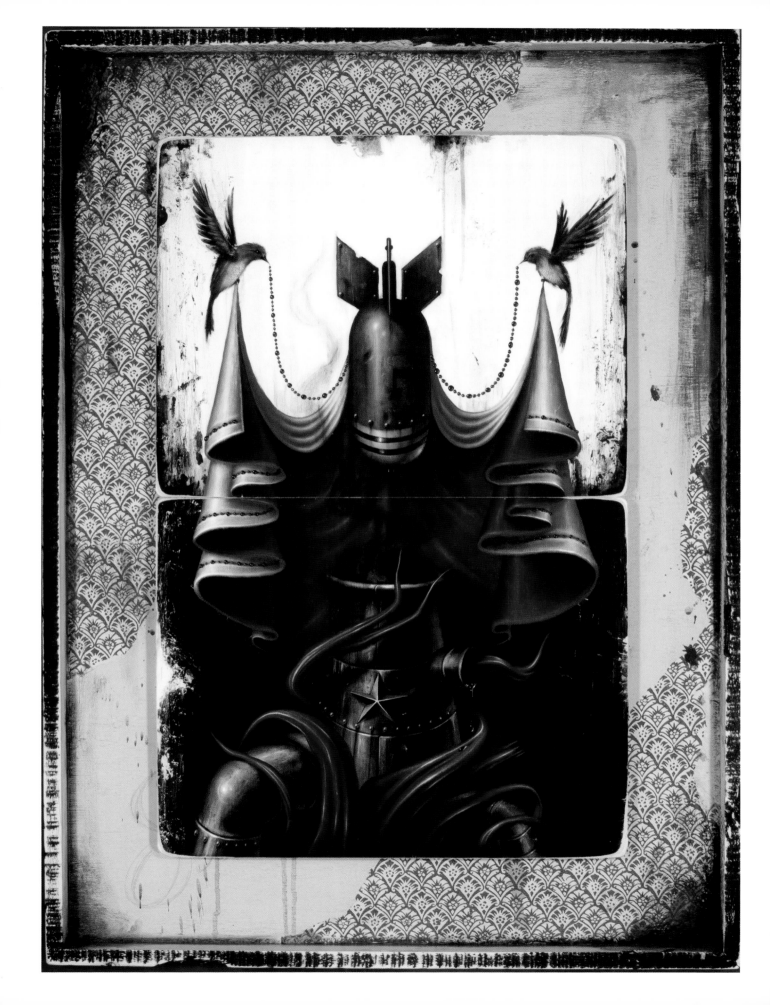

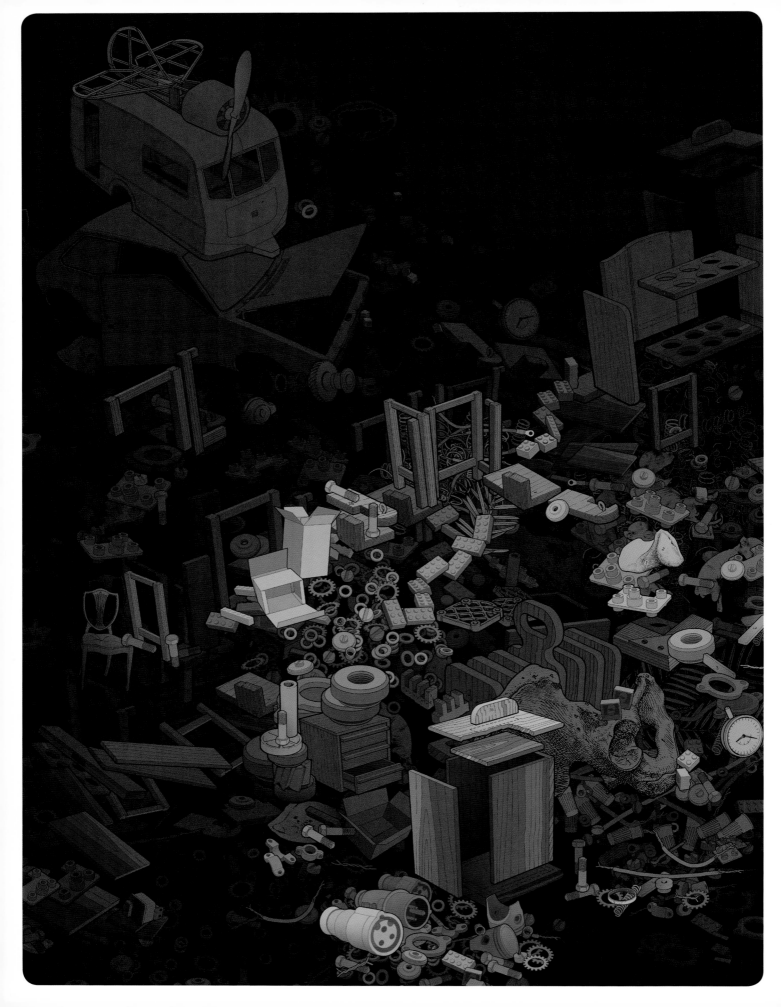

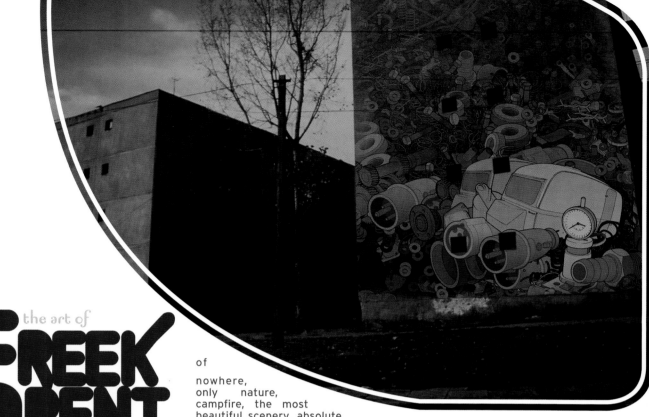

the art of
FREEK DRENT

by Ert O'Hara

For anyone who's ever dreamed of continent hopping while making art out of everything you see and do, it is wise to note the particular case of Dutch artist Freek Drent.

At 20 years old, he left Holland and spent a year in the United States—most of it in Colorado. He loved "the wide landscapes, mountains and impressive skies." Back in Rotterdam, he studied "all kinds of different media, photography, painting sculpting. [I] had a hard time to make a choice but finally [chose] TSO which means drawing, painting and design. This gave me possibilities to switch around. I was inspired the most by my colleague students. After four years, I quit and left Holland again. I even cancelled my house (didn't think about returning), and left for the south of Europe. There, I spent most of the time in Portugal where I made a living from selling drawings to local galleries. When I came back after a year, I finally finished my studies in Rotterdam."

Since then, travel has become a way of life and the major influence in his art. "I stayed for a few months in Iceland (artist residence). Most of the time I was traveling with my Volkswagen van all over the country, amazed by the scenery. Absolutely beautiful colored mountains, black lava fields, glaciers, clear rivers... but on the other hand [it was] so terribly empty and desolate that I often had the feeling that I had to run for something. I had to admit that I missed human presence in the endless landscapes. I was sitting in the middle of

nowhere,
only nature,
campfire, the most
beautiful scenery, absolute
quietness, but suddenly I had
to leave. At these times, I escaped to Reykyavik. Distance didn't matter, I just hoped I wasn't too late to find some nightlife, to be surrounded by some people."

Like a mountain range catching rays after a spring rain, each collage is both bright and shadowed, highlighting a theme particular to each piece. The cool, urban vibe that Drent's work evokes comes from the heaps of society's detritus that he compulsively amasses wherever he goes.

He became interested in the urban decay of Eastern Europe after visiting Romania. "This was the early 90s, not a long time after the revolution. What interested me the most was a bizarre, dark, gloomy atmosphere, the absence of Western (colorful) advertisements. I had been collecting objects varying from old vacuum cleaners, wooden organs, all sorts of mechanical and electrical parts and later serious loads of Eastern European plastic objects. Every time I moved, the problem became worse. After some different presentations with installations and video shows, I considered this as finished and wanted to make a new start."

To clear his mind, Drent embarked on a solo motorcycle trip across the United States from New York to Florence, Oregon. "The desolation of the states like North and South Dakota frightened me sometimes but also attracted me very much."

Since then, he has returned to Europe and spent the past four years concentrating on collage work that he assembles from a vast library of

small images that he's culled from various magazines, appliance manuals, and "exploded views"—those floating disassemblies of parts shown in technical diagrams. His *Where's Waldo* worlds are populated with mountains of memories and fields of fragments, but void of sentient beings, much like the barren terrain and abandoned industrial towns that he is so often drawn to.

Later in 2008, Drent will spend six months in Beijing, China in another artist residency, no doubt collecting more experiences, imagery and doodads, and creatively reassembling all of it as art.✦

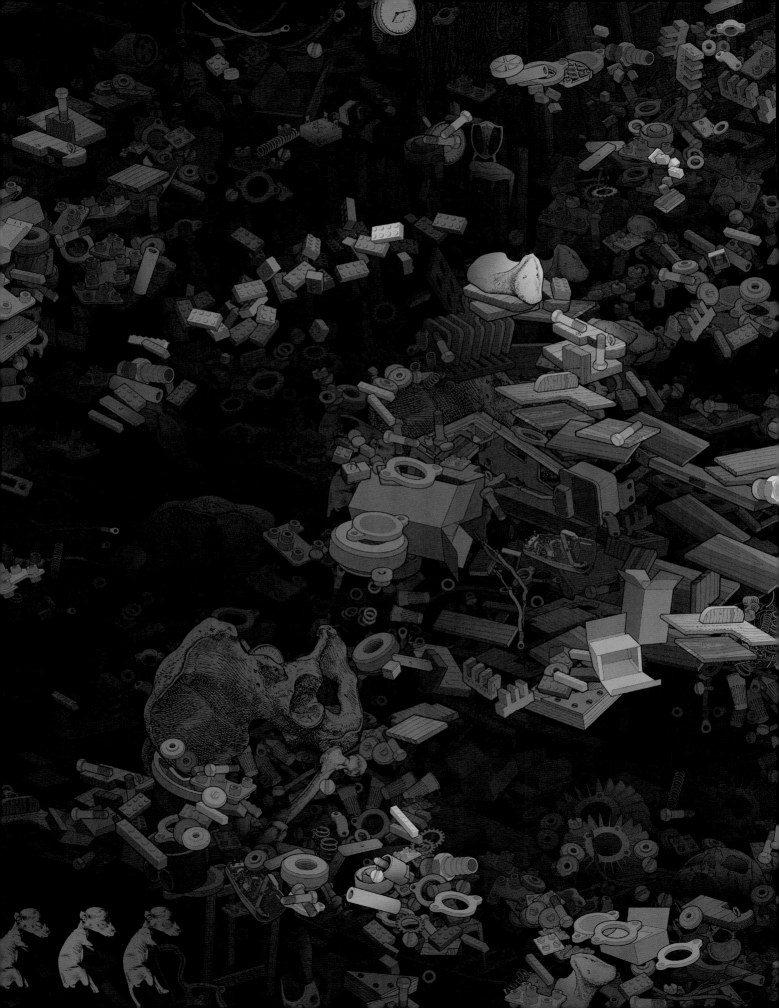

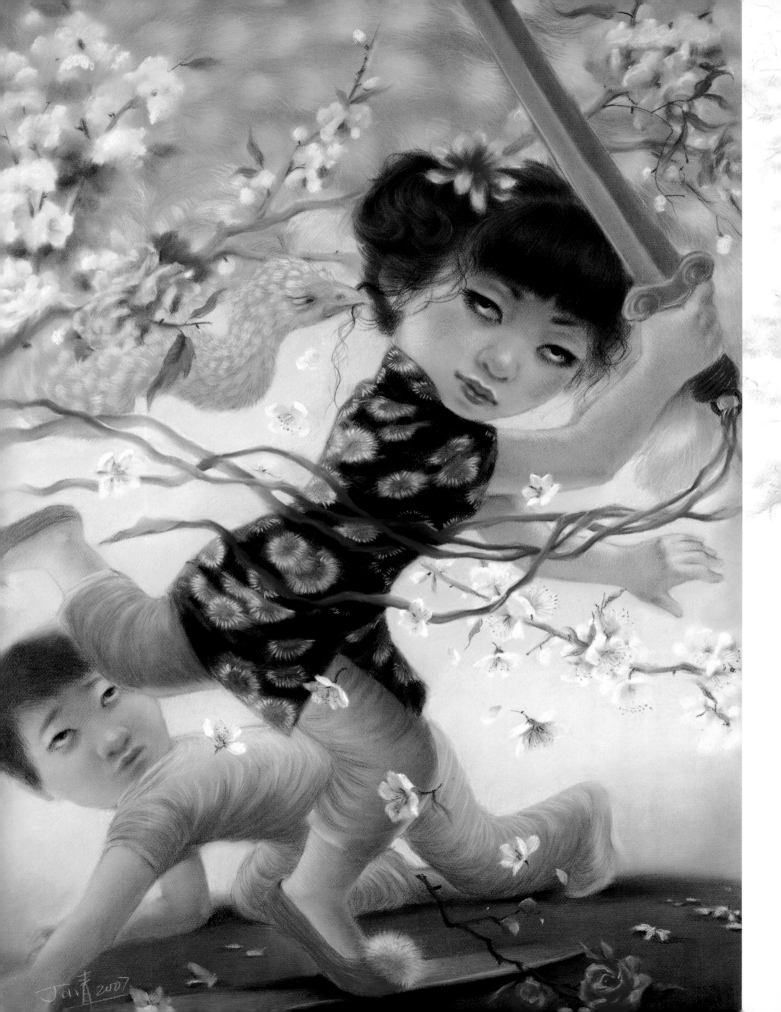

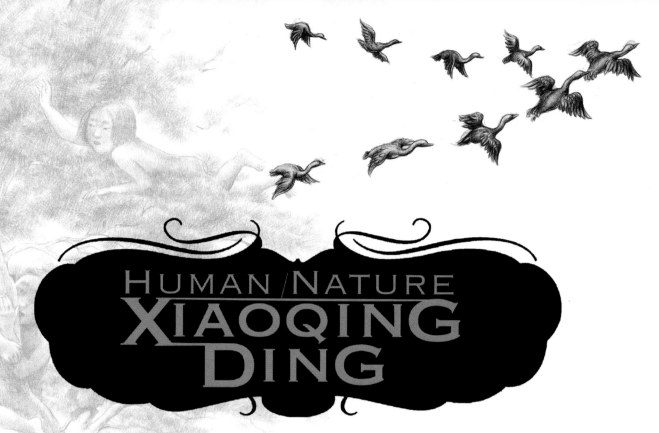

HUMAN / NATURE
XIAOQING DING

"Love is for fools and all fools are lovers. It's raining on my house and none of the others. Love is for fools and God knows I'm still one. The sidewalks are filled with love's ugly children..." — "Deep in the Woods", The Birthday Party.

Artist Xiaoqing Ding offered the above quote up when asked about the sentiment behind her provocative new series of works. Comprised mostly of large scale pieces in which love torn couples writhe, fight and have sex amongst images of mythical Chinese animals and verdant vegetation, the pieces are rendered in both lush, electrically vibrant pastels on paper, as well as delicate, tight enigmatic drawings. The theme is firmly focused on the eternal and painful quest for love and the melancholic battle between the sexes.

Xiaoqing (pronounced "Zheow-ching") hails from Beijing, where originally her choice of career was not enthusiastically supported (her parents wanted her to be a doctor), but thanks to the support of an art teacher and force of will, she was able to stay true to her dream. After studying traditional Asian arts for more than eight years in Beijing, (she is also skilled in egg tempera, embroidery, ink on silk painting, and silverpoint) she then traveled to and around the U.S., thanks in part to a series of grants, residencies, fellowships, and gallery exhibitions. Currently living in Brooklyn, her exposure to Western culture has allowed her work to adopt a twist that melds classic

Asian motifs with an edgy undercurrent of unabashed sexuality, gluttony and desire tied in together with a dose of magical realism. Her characters stop one step short of being cartoon-like, and her newer work has shed her original use of muted, classical tones to vibrate with a neon-like pop luminosity.

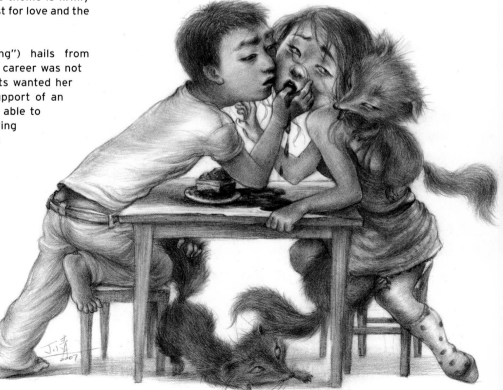

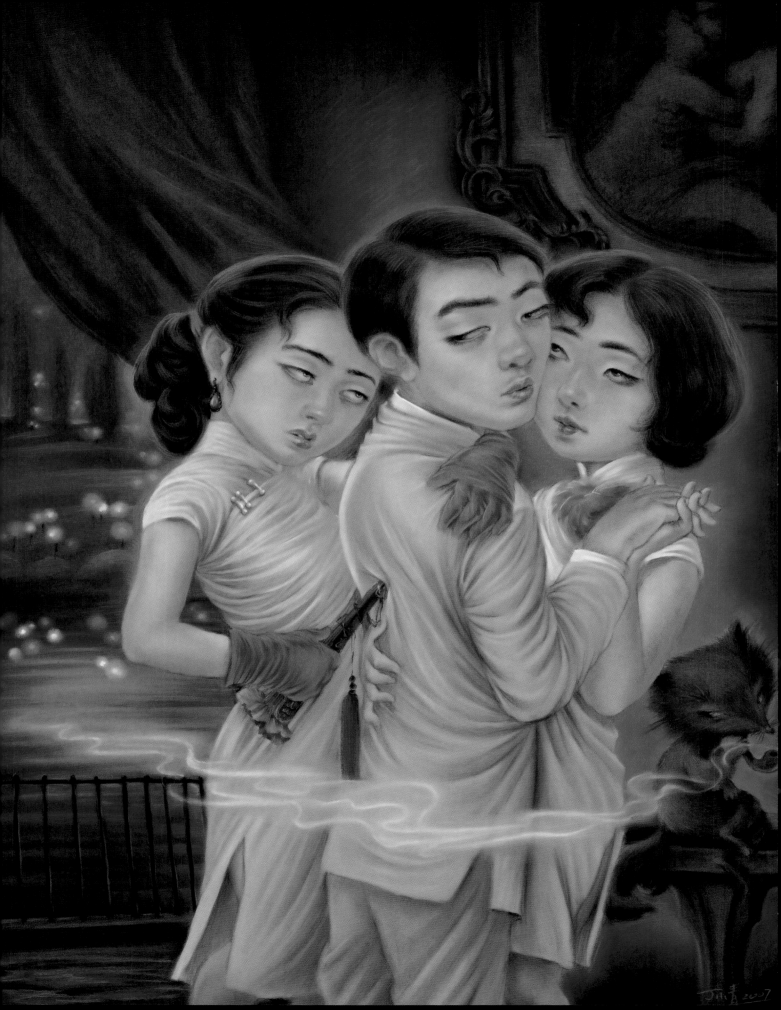

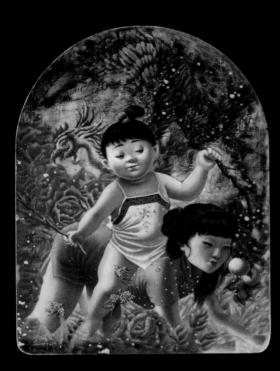

Often in her work, Xiaoqing depicts playful foxes as reccurring characters that reference the folkloric creature known as *kitsune* (a spirit in fox form) which in her work symbolize the provocative sexual female. These impish creatures serve as a foil against repressed sexual desires and sensuality. Peacocks also make an appearance as the *vain male* and other animals with clearly symbolic meaning make appearances as well. These characters swirl around and seemingly provoke the central human characters into revealing their true, if not socially polite, desires to each other. The seductive qualities of the *kitsune* have clearly bewitched Xiaoqing as well, as her work transitioned from focusing primarily on female imagery to predominantly documenting the anxious passions of couples.

"It's easy to paint cute girls, and it's easy to sell pretty faces, but I want to make my work complicated and close to my real feelings, not just pure fantasy and daydreams... so I [now] have added male images in order to tell a whole love story."

You can see more of love's lonely children at the Klaudia Marr gallery, Jonathan LeVine Gallery and Roq La Rue Gallery.✦

—Kirsten Anderson
photos by Duggal Visual Solutions

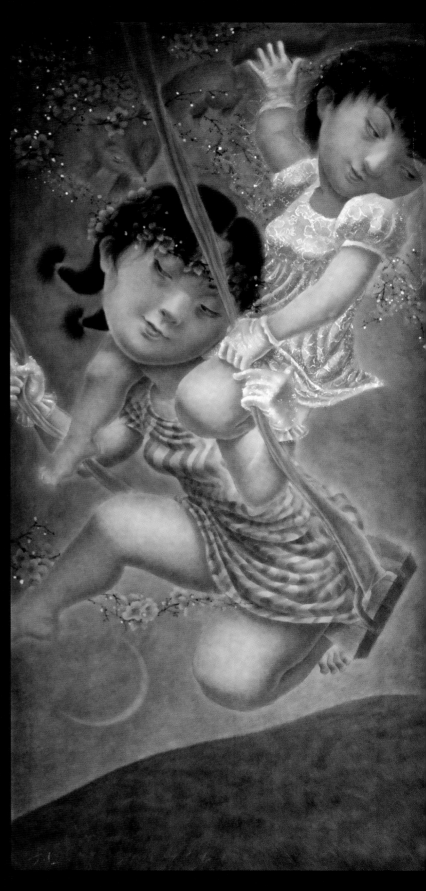

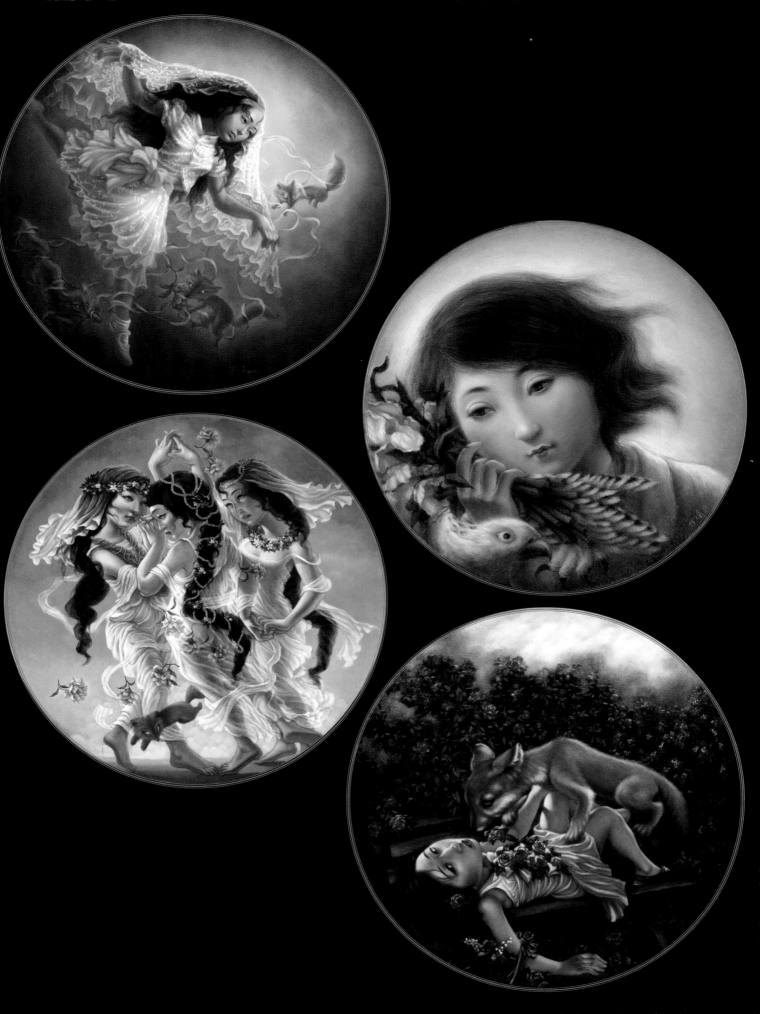

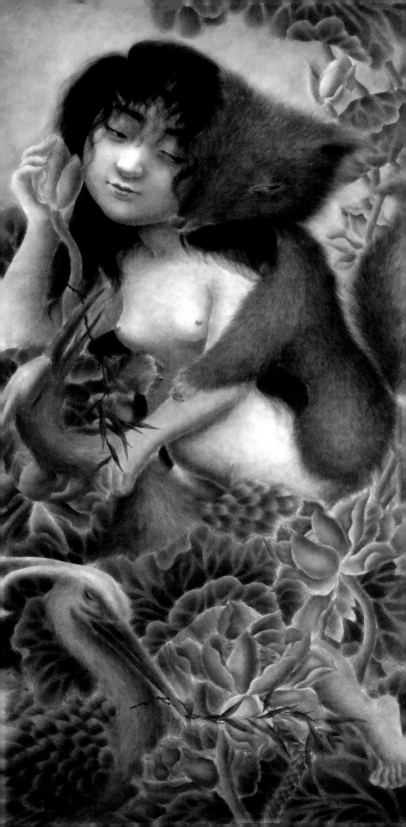

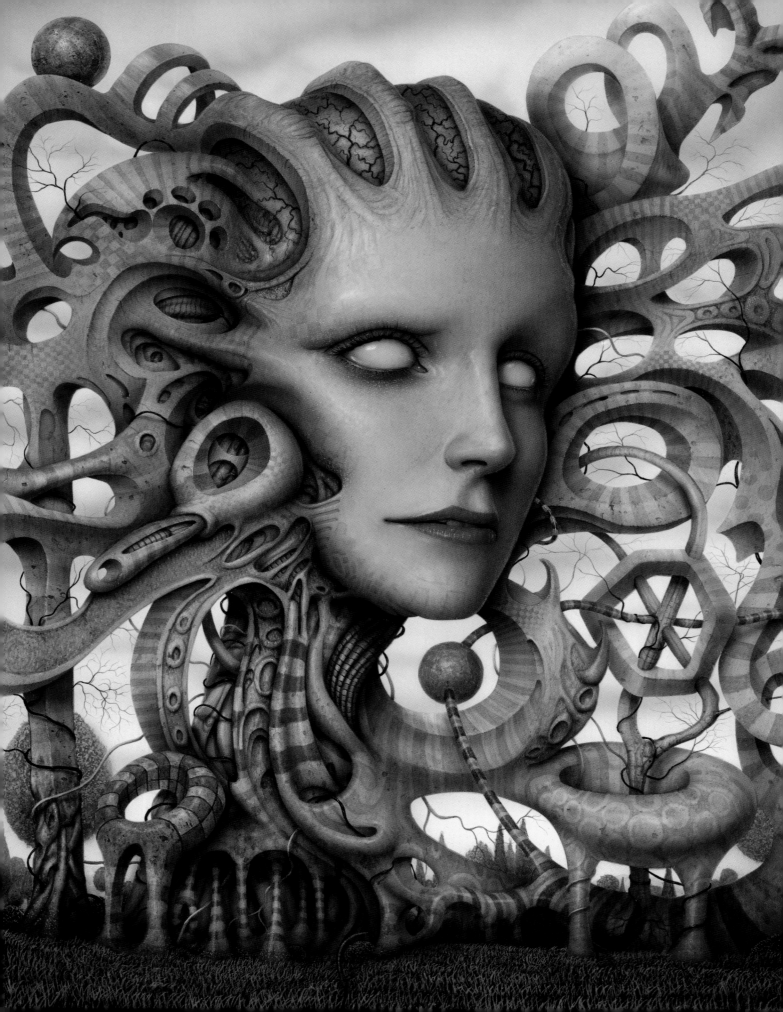

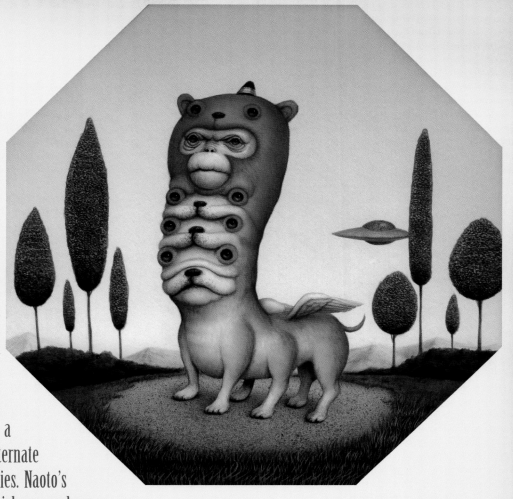

Naoto Hattori

by Kirsten Anderson

Naoto Hattori's paintings take the viewer on a hallucinatory ride to not only alternate worlds, but also alternate realities. Naoto's rich and meticulous paintings pick up on drug-fueled pop culture (rave culture imagery often makes an appearance) yet also tap into unexpected classical influences. A tripped out blend of cyber psychedelia and dark fantasy, his dream like melding, morphing, and melting of forms into one another take its cue from Surrealism. His landscapes could be straight out of traditional Renaissance paintings, and his demonic critters could rival the most fervent imaginings of Hieronymous Bosch.

Wildly prolific, Naoto manages to finish a new painting almost weekly, and is undeniably devoted to his vision without sacrificing quality. His rich color palette, heavy on greens, golds, and reds, emphasizes the alien fleshiness and exotic atmospheres of his creations. He is also able to jump between horror and humor with aplomb, whether he's reworking Da Vinci's "Mona Lisa" into a Basil Wolverton-worthy grotesquery, or creating a Lovecraftian nightmare vision seemingly straight from the worst acid trip imaginable.

Hi-Fructose **caught up with Naoto to find out what drives such a fertile mind.**

Raised in Japan, you have lived in New York for eight years now. How integral was your move to the U.S. for your art career?

The Japanese art scene is very limited. I feel they respect traditionalism and morality more than freedom of speech. Most artists' work there is same old stuff and I really wanted to start my art career where I could express anything I wanted, so decided to go to New York.

Your work seems to depict a near hallucinatory dream state. Do you record your dreams? Would you describe the world many of your paintings are set in as dreamlike?

I just try to express what's really going on in my mind. When I encounter some feelings, I try to visualize the feelings in my head and I start sketching what I really see.

"*I consider a painting finished when I see my character 'breathing...'*"

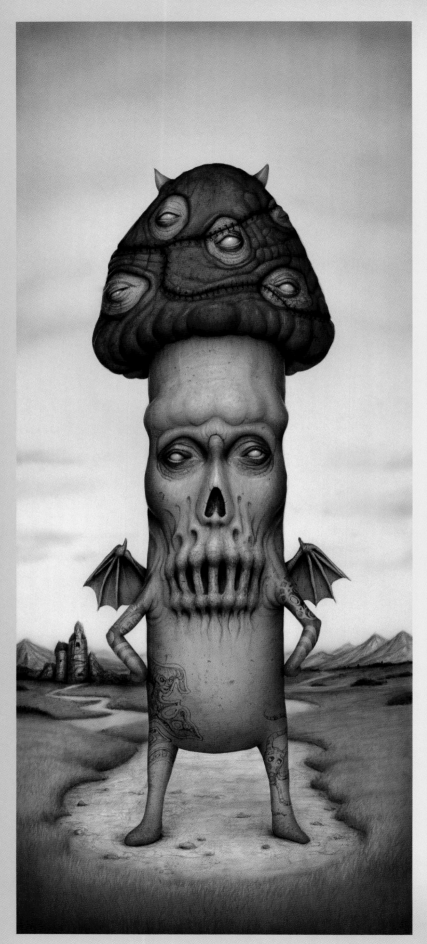

Most of time it comes out weird but that's the image that I want to paint. I try to express the reality in my mind.

You recently showed a piece in the *Hi-Fructose* curated art show *Bitters and Sweets,* and I was surprised on how small, yet immensely detailed and perfect your painting was! Do you work with a magnifying lens when you paint?

I don't use a magnifying lens but I use OO and OOO brushes for all the details. I was surprised when I first saw some of the masterpieces at the Metropolitan Museum of Art. There are so many details in small spaces. I like early Netherlandish paintings. I can feel the artist's passion by just seeing the amount of details.

It's very easy to paint a realistic painting in large scale and also easy to make strong impression at a show by doing that, but it doesn't stimulate me. Stepping back to see a large painting and stepping close to see a detailed small painting is the same thing to me. I'd rather spend the time painting details in a smaller piece than spending a week to fill the blank area on a large canvas. I just like to concentrate on every single brush stroke and put my whole attention on my painting.

I always wanted to paint my imagination but I didn't have a skill to paint it when I first started drawing. The image in my head is very realistic so it was clear that I needed to study art from scratch. I feel like I spent most of time at art college (School of Visual Arts) learning technical aspects and media options for my art. I tried to study everything that might help me meet my goal. I taught myself a lot and read lots of books about various drawing and painting techniques, anatomy and color theory. I tried out a lot of different media (oil, egg tempera, acrylic, watercolor, pastel, airbrush, scratch board...) and combine all those techniques into my artwork. I actually like the way I have to struggle and learn a lot of things for my art.

The world you paint seems like it is simultaneously turning in on itself. It seems like God's first attempt at creating Earth after an all-night bender; grass sprouts from foreheads, skulls provide shelter for multi-legged snake-like creatures... are we catching this world/ dimension/plane mid-evolution or between stages? Is it a parallel world to ours?

I started to create my own world ever since I was a child. I have a few worlds in my mind, and they all have their own living forms and ecosystems.

Sometimes I paint feelings which I can't express in words, but mostly I paint some kind of living form from my own world. It's kind of hard to explain what's going on in my mind, but I can paint anything without thinking too much about it. It

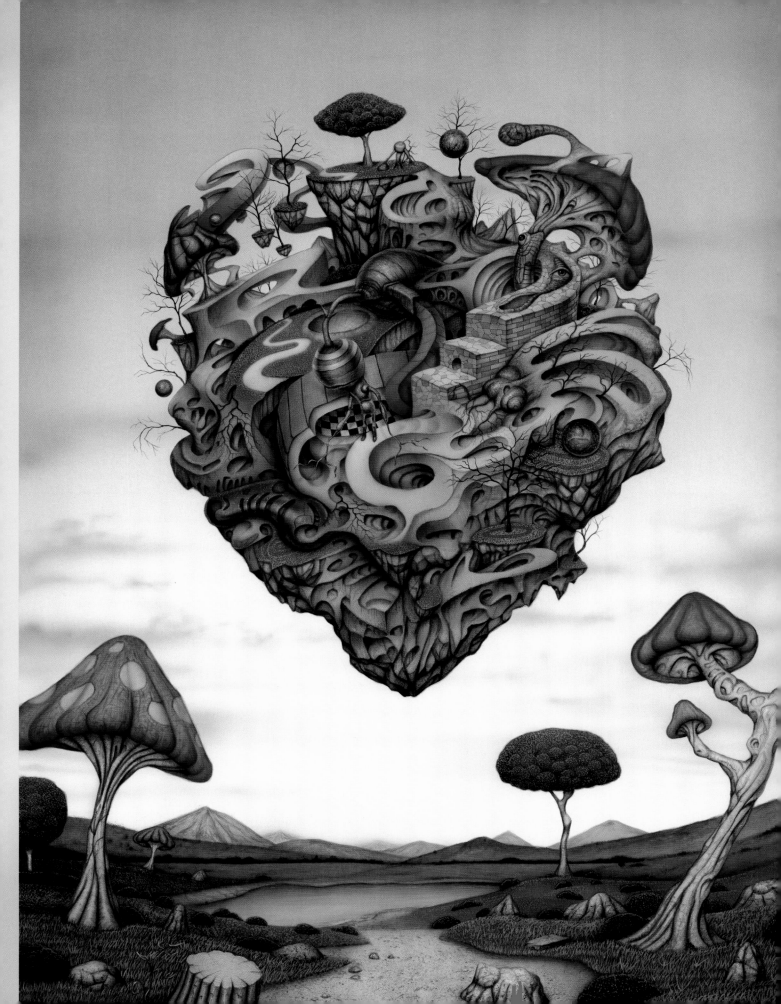

could be a parallel world to ours, where there are no rules and limitations, it's more like a dream.

If you were to pick a soundtrack for the world in your paintings, what would it be/sound like? (I imagine it sounds like Bjork on fire, in reverse.)

I'm into music, but its kind hard to pick a soundtrack for my art. My artwork might go well with psychedelic trip-hop.

How do you create a painting start to finish?

I sketch a lot. I do very rough sketches in a sketchbook but each image takes only a minute or less. I can see exactly what I want to paint fully formed in my head, so I don't take too much time sketching it out. I cut a board to a preferred size and do an under drawing with 2H pencil. Most people paint background first but I paint the main character first. Then I paint the background, and then paint the foreground again. It takes about ten days do do a painting that is 16" x 20"– larger might take up to month. Basically, I don't decide when to finish a painting though. Working on the smallest details make my character more lifelike so I take time for painting details. I consider a painting finished when I see my character "breathing" in the painting. +

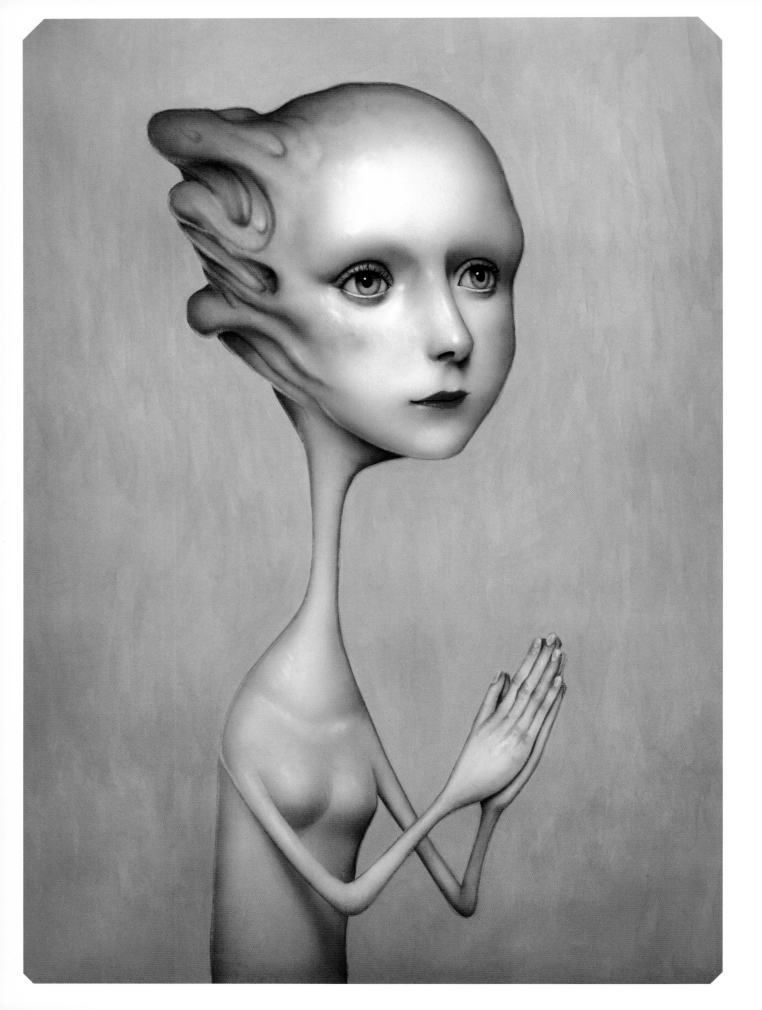

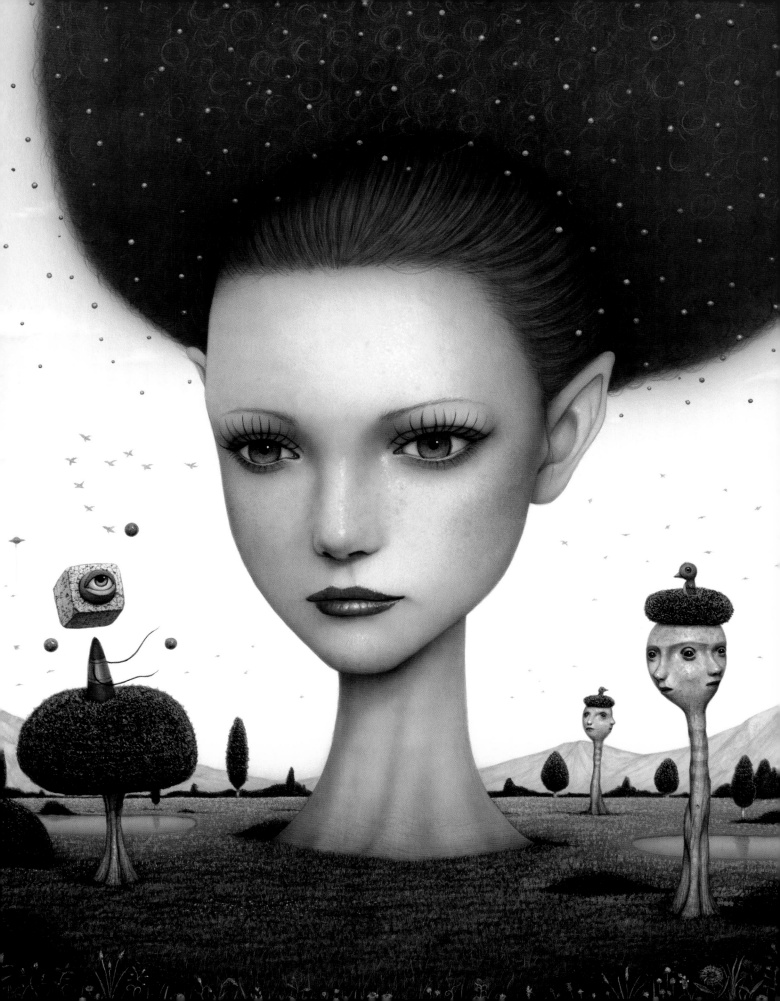

·BALL
IN
PLAY·

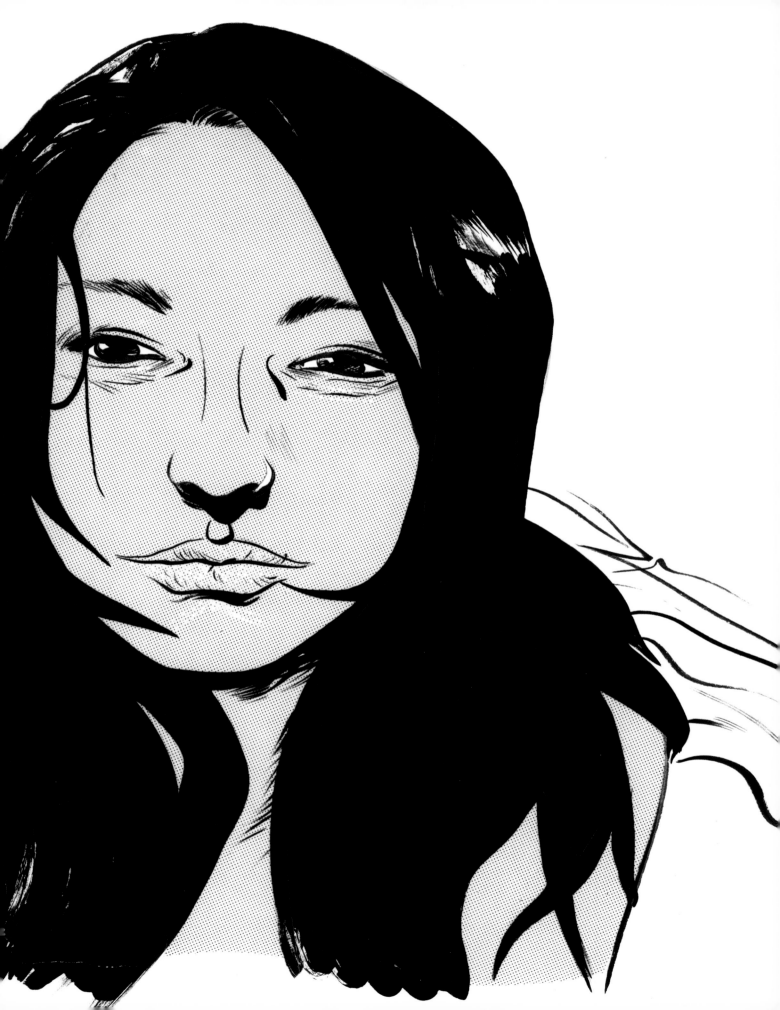

In his work, Paul Pope tells stories of irreverant cuties, body-gaurd genii, hot air balloons elephants, circus acrobats, and monsterous mecha-bicycles on Mars, which seem to move on their own. Even from the start, Pope's work spliced and diced genres, adding sci-fi wonderment to alternative comics and a much needed soul injection into the corpse of main stream graphic novels. His sought-after art prints, with fluid line work and huge dynamic compositions, seem to move on their own. Attaboy interviewed Paul, one stormy evening before Pope left for a trip to France.

I first saw your work in a bright pink *THB* book back in 1996 on a shelf of a gift shop at the now defunct Words and Pictures Museum and was floored. It was large format, huge and awkward to hold, and amazing...

Paul: The "B" sides book. The idea was to attack the idea of a comic book as a (necessarily) 7" x 10" pamphlet thing. Mind you, this was a world ago. Pre-internet shit. I wanted a single, not a 7-inch or a 12-inch. A kind of graphic LP. Today kids might not understand what that means—and it's only been ten years or so since they've gone to pasture. This was before iPods and MP3s. New machines speed everything up. No more dropping needles on vinyl. No more 7-inches.

Back then, underground comics were either focused on offbeat humor or felt like 60s residue, but *THB* and work in a tiny handful of books by people like Jordan Crane and friends burst the micro bubble open.

I'm closer to the Dave Sim/Chester Brown/ Mutant Turtles generation, actually. But I take your point there. I met Jordan early on, recognized the talent and the willingness to kill the opposition, so to speak.

Your book had such unusually long compositions and brimmed over with confidence. It was a narrative comic and even had sci-fi elements, but its feel was more like a bound together sophisticated story book of art prints. Were you conscious of this?

Yeah.

The work inside pointed to influences more

from Japanese woodblock prints than even *manga*, not from modern comics or even Robert Crumb, but from Jack Kirby and Tolouse Lautrec (feel free to answer, discuss influences, etc.)

Some people call this a metasynthesis, but it is really visual ambidextriousness. All those sources you cite are major influences on my style and approach. Whatever worked can and ought to work again. I wanted—and want—to find ways to keep suprising and entertaining the audience. To keep expressing through comics.

It seems that the feel has recently been adopted by more mainstream publications, who've hired on artists like yourself and James Jean...

James is a close friend, I trust and rely on him.

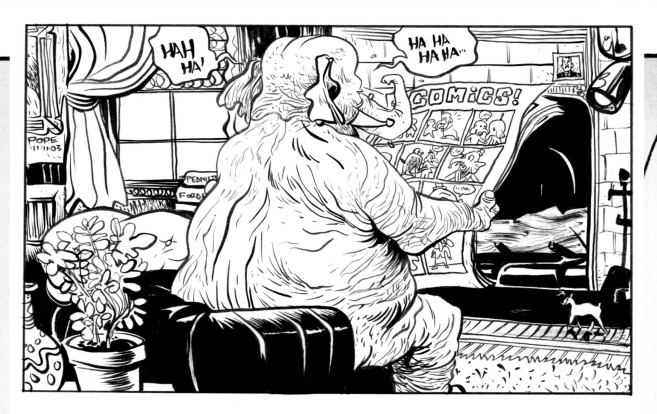

"Drawings cannot and have never been pornographic, that's my contention. Drawings are always fantasy."

Outside of that, I think there is a rough pendulum, on the one side is someone like Alex Ross—a talented artist (and coincidentally another friend), but an artist at any rate, who works in a very realistic style. And then there is me or the others in this vein who are more expressionistic. We are the Norman Rockwell/Hershfeld swing, between are the varieties. Not saying I am Hershfeld, just closer to his extreme than is Ross, and vise-versa. There are always the extremes, the photo-realists and the gesturalists. Alex and I have discussed this. It swings back and forth. What's important is, whoever you are, take it as far as you can.

Years ago, I read you discussing your work schedule, working three days, taking a day off; without any distraction, TV, phone calls, etc. Your work ethic seems quite militant, even conscious of your eating habits.

Yeah.

In an increasingly distracting world, has a focused work near-ritual become even more necessary?

Still working on it. I'm not satisfied. You catch me in mid-stream. Let's discuss this in 2010 or so once I figure it out.

I found that surprising, considering the insane amount of energy in your work, and how much out right fun it seems you were having.

But wouldn't it be fun to run a mile in four minutes? To reduce reality to just four minutes? It's the same thing.

Your drawings (even the ones not for rock posters for people like Jon Spencer or The White Stripes...) have a rock and roll sensibility to them...

I'm a rocker at heart for sure. Live it to give it. All that.

You spent years in Japan working

on *manga*, cranking out up to 70 pages a month!

80 was tops. 40 to 50 is most comfortable without the distractions. Now it is much lower-20 pages or so, sadly.

Did working in Japan change your approach to constructing compositions in your work?

Yes.

Your new book *PulpHope*, features

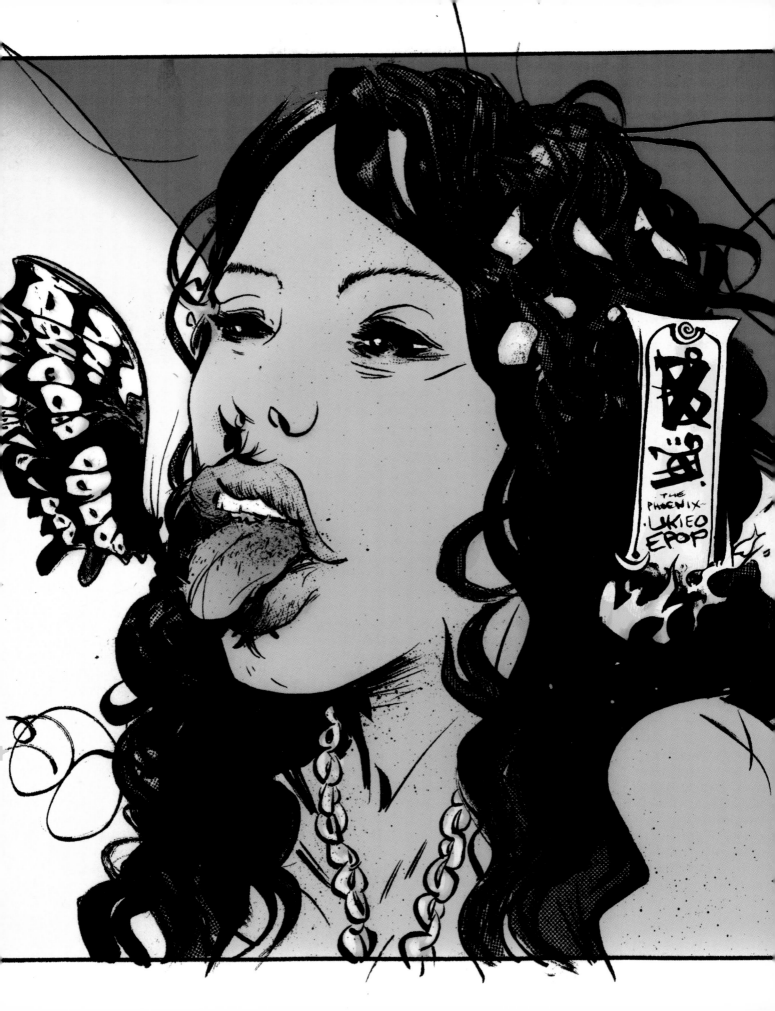

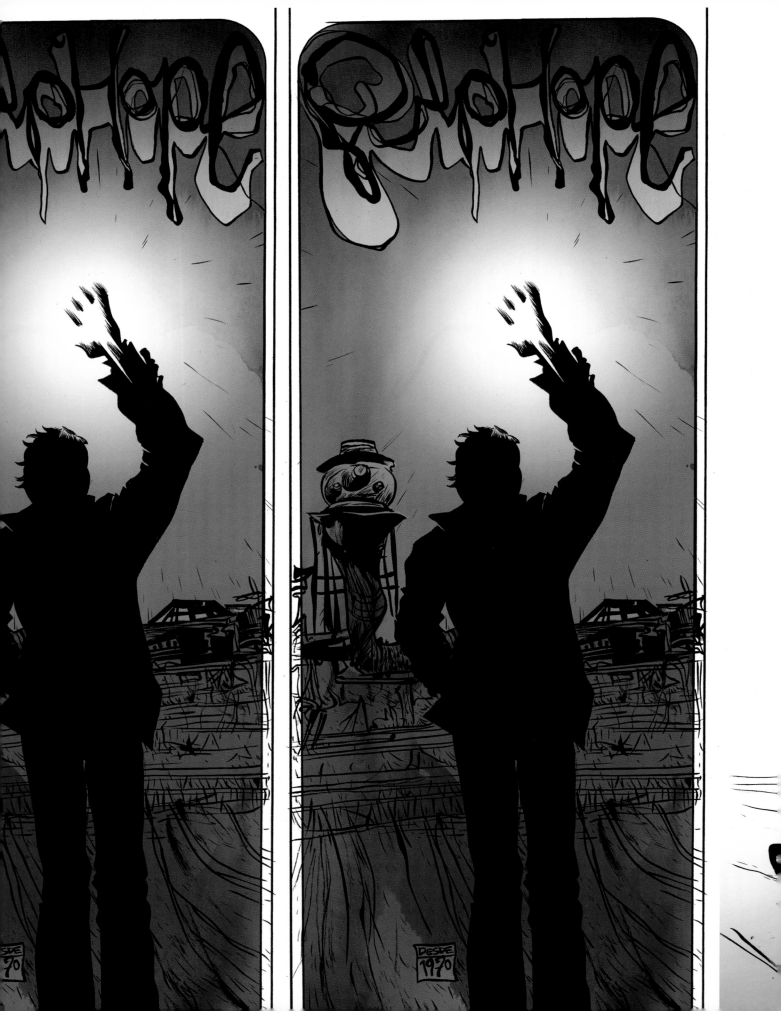

a wonderful retrospective of your art, comics, early drawings, and essays. Not to mention a few dirty drawings from your private sketchbook presented with unusual compositions.

You mention in the book that drawn porn taps into imagination more because the forms are abstract and tap into stored memory and experience, where a small detail like a scuffed shoe in a naughty photo serves as an unintended distraction sending the viewer into a sad place.

Yeah. And anybody who buys the book and reads the essay is free to draw their own opinions. Drawings cannot and have never been pornographic, that's my contention. Drawings are always fantasy.

I've read that you have an affinity for Mary Shelley's *Frankenstein*, any plans to illustrate a version of the horror-fiction masterpiece yourself?

No...

I'd love to see your ink drawings assembled together in an art show at actual size, Are there any plans for an exhibition we should know about?

Let's wait and see!

You're off to France in the morning for some sort of secret mission. Will there be fancy French cigarette cases involved?

I honestly don't know, man. I'll do my best. I'm more Buddha than Siddartha now. "Go like a desperado through the disparate disciplines," that's the idea. Just keeping alive.

Alive is good, but will the 70-year-old Paul Pope be a dirty old man?

Will I be a man who loves beautiful women and who will love to have orgasms and make love? Will I be a sensualist who will love to eat and fuck and listen to music and drink good wine and embrace snow and sunsets? Yes...✚

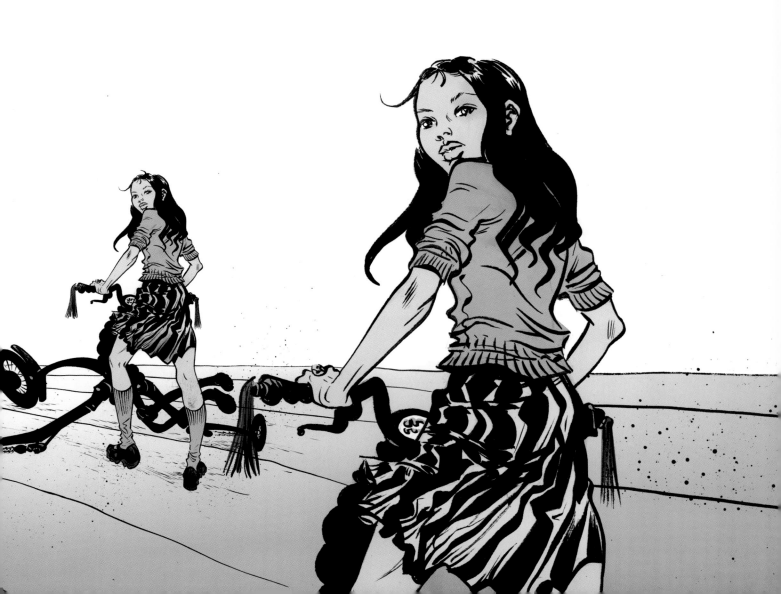

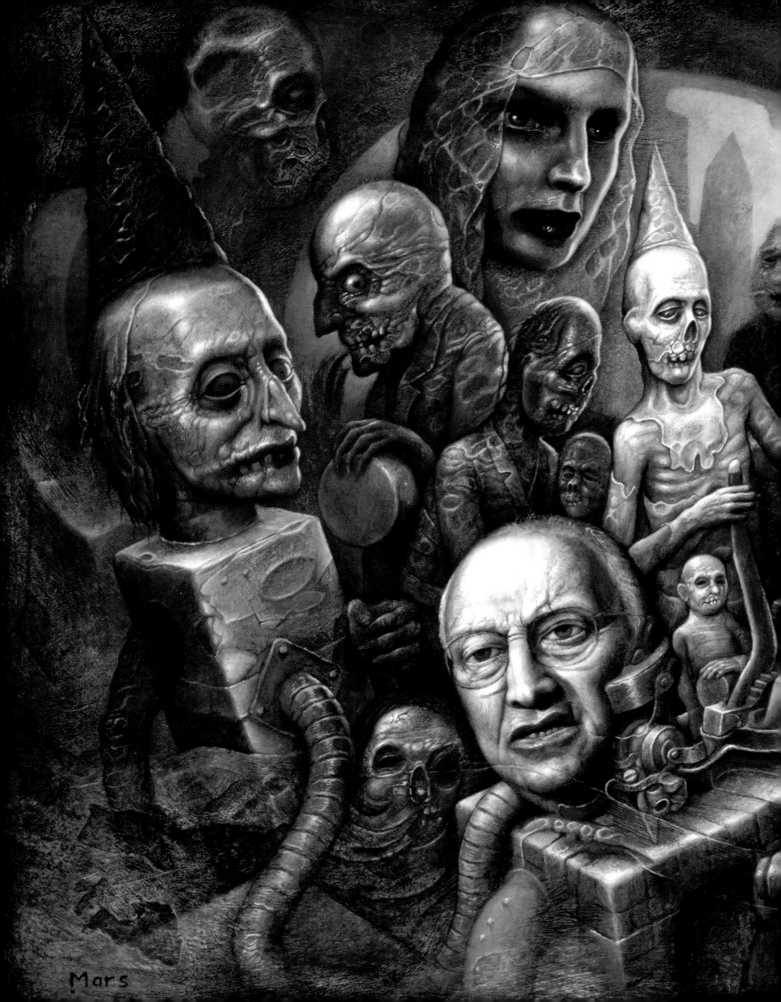

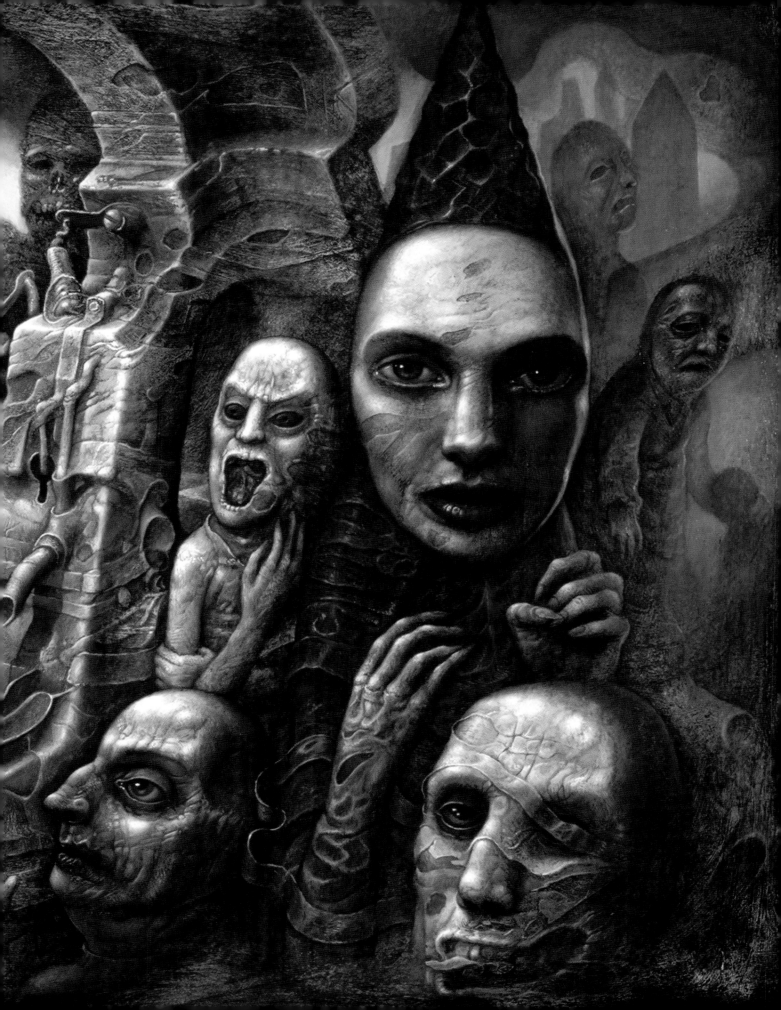

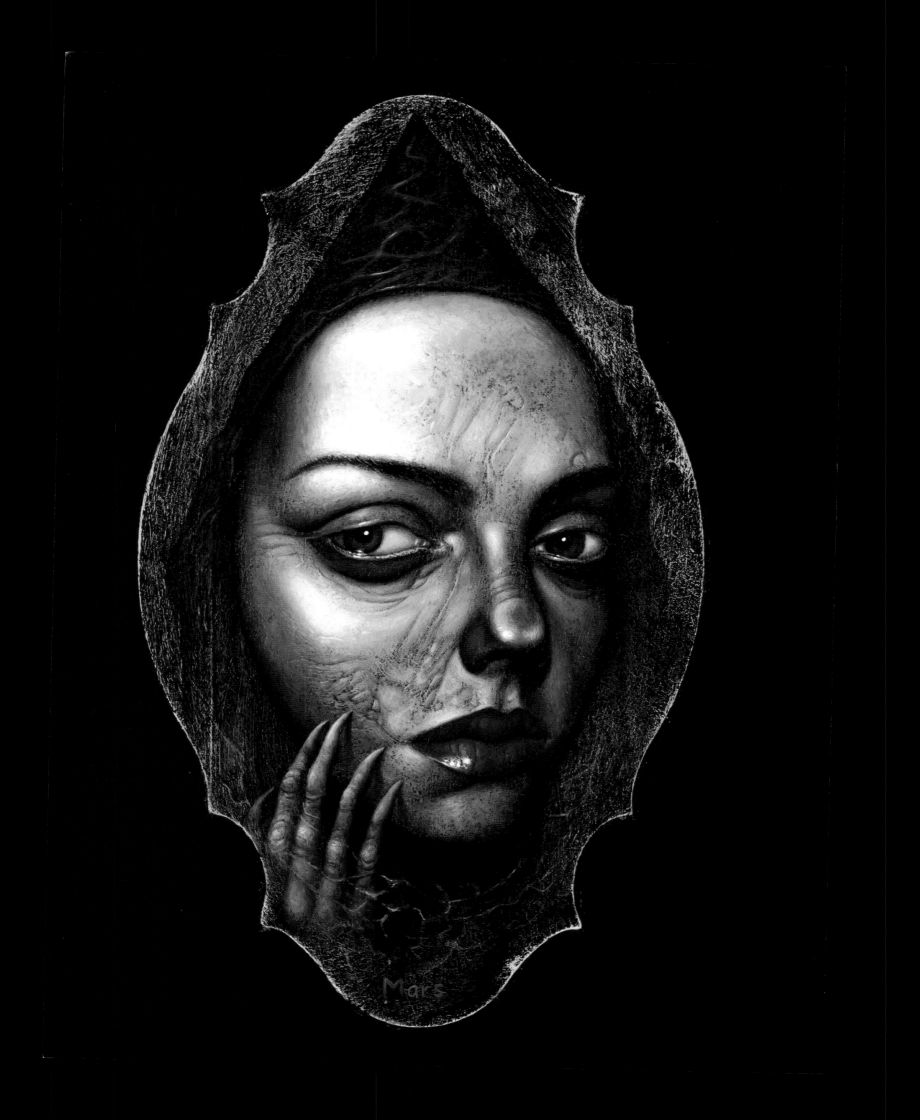

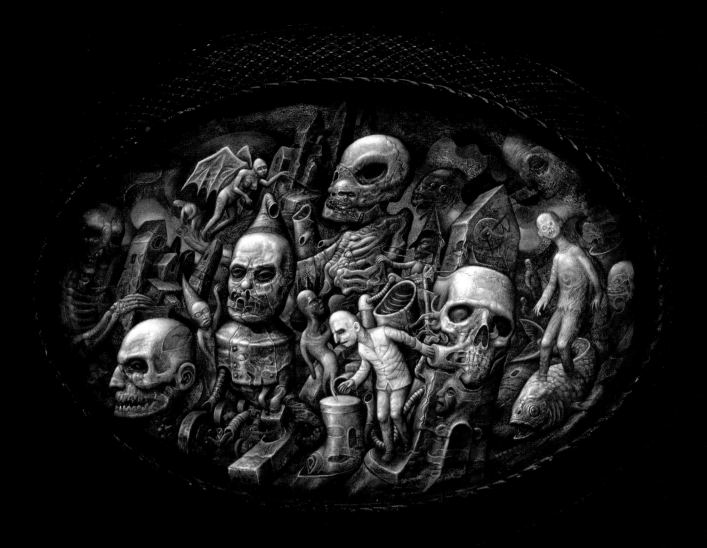

Tolerance
the art of ChrisMars

Written by Annie Owens

The work or Chris Mars has been featured in a long list of galleries and museum exhibitions across the United States. His works are included in many prestigious private and public collections, including the Minneapolis Institute of Arts (MIA) and The Minnesota History Center. To look upon his work, it's easy to become enamored with his classical portrayal of tortured souls and frightening medieval landscapes. Fantastically scary and awesomely rendered, this is art that reflects the darkness of the human soul. However, Mars' work is also representative of a much more positive attitude, coming more from a place of helpful enlightenment.

Chris' brother's mental illness what initially inspired his work and is intended to shed light on how we as a society could use a little more growth in our approach to the misfits, outsiders and the socially misunderstood. Rather than dwelling upon a message of criticism, the work suggests that we learn tolerance instead. As professed in his artist statement, "On my hands,

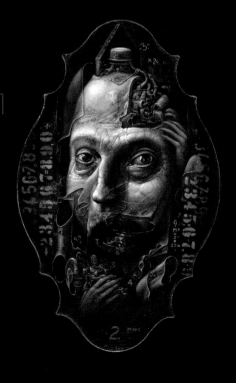

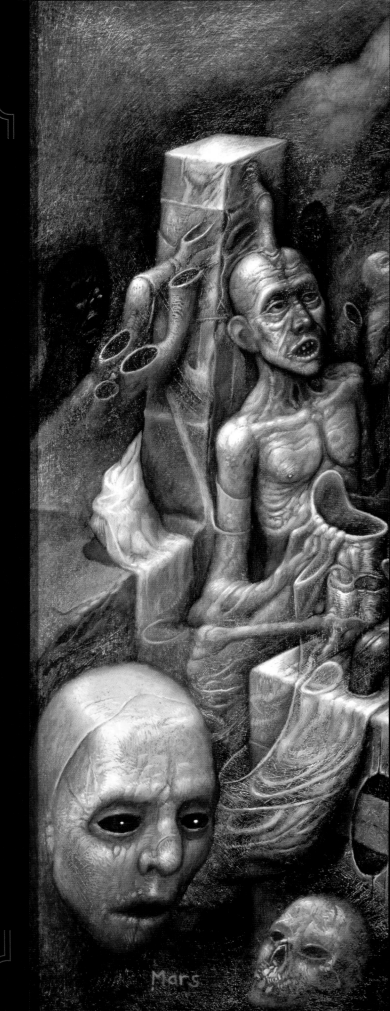

"As visual creatures,
I think it is our tendency to abruptly size
things up with our eyes before our minds
and hearts."

my mission: To free the oppressed; to champion the persecuted and the submissive; to liberate through revelation the actualized self in those proposed by some to have no self at all. It's in every single one of us, somewhere underneath that word on our chest."

In Mars' paintings, even though the representation of the central figure, the victim, is shown disfigured or misshapen in some way, it's often the "normal" characters representing the conventional, which have an even more disquieting aspect.

By switching the rolls of these figures, the normal one is displaced into the position of outsider whose affliction is intolerance. Conversely, the misfit is endowed with a kind of sympathy, and in turn, the viewer experiences this insider-outsider roll reversal as well.

As Mars' work continues to progress, he continues to hold true to his core intent of giving voice to the voiceless but on a broader level.

When asked about how his sociopolitical views have evolved over the years he responds, "My attitude is still positive, especially now that we are about to be rid of Bush. The pendulum swung quite hard towards fascism during his reign, but I'm lent hope by the many grassroots movements in the way of organic farming, sustainable energy, environmental awareness, election reform, etc. There is a circumventing of the federal government at the local level in Minnesota and other states and hopefully many more will follow. This silver lining is an example of humanity moving generally on a trajectory towards betterment. There are great dehumanizing horrors taking place as we speak, but at the same time I have hope that awareness of these horrors is increasing. I think we could be getting close to massive change away from present shameful state of things."

The dark and ominous tones in his work are analogous to the tendencies people have of disregarding what they don't immediately understand, casting the misfits into the dark. This initial perception can often betray what is in fact the very positive attitude Mars has toward humanity's ability to evolve and change for the better. In comment to this Chris says, "If the viewer feels unfamiliar and perhaps uncomfortable upon first glance, but then feels less so after learning about what my overall message is, it is analogous to how

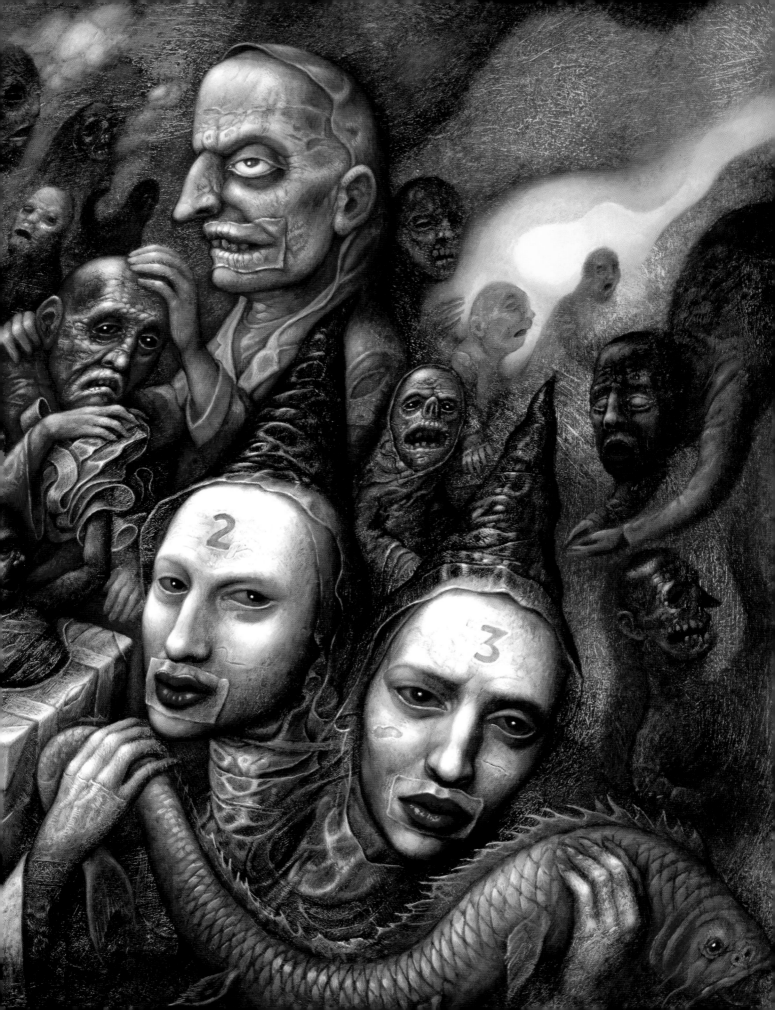

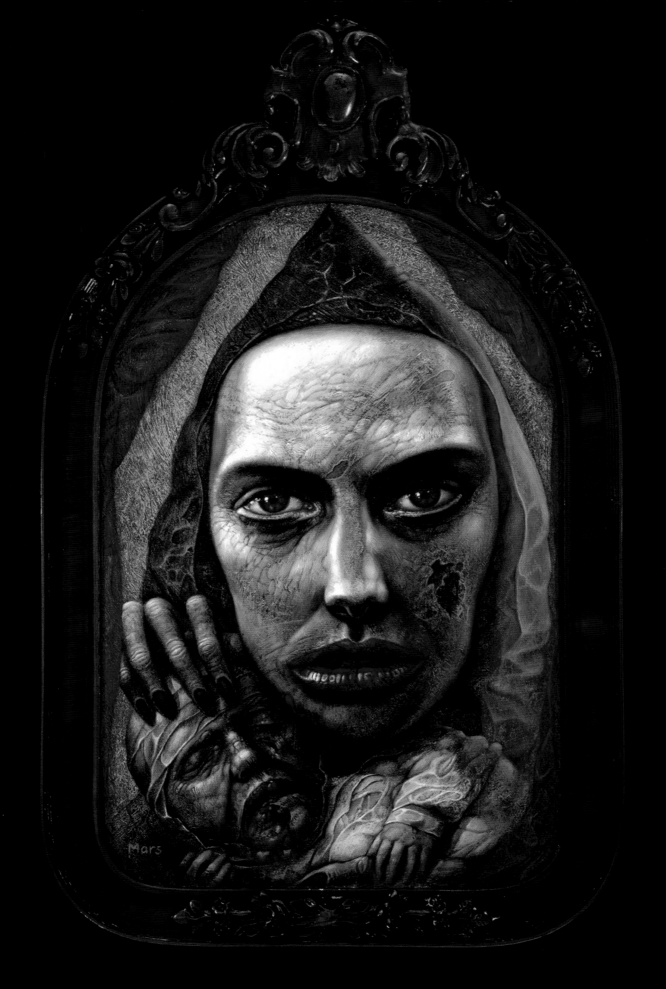

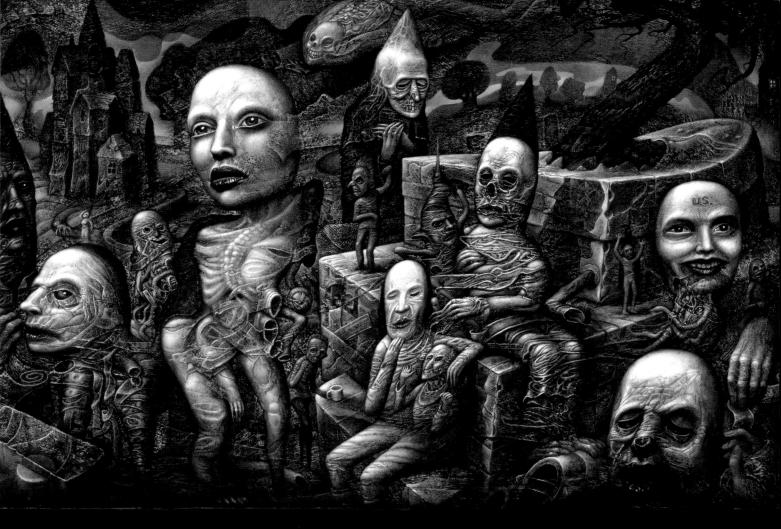

the mechanisms of prejudgment take place. As visual creatures, I think it is our tendency to abruptly size things up with our eyes before our minds and hearts. Hopefully, in the end, the harmlessness of the unusual trumps discomfort, fear, or xenophobia within my paintings and without."

As the former drummer of the Replacements, it's interesting to note that Mars spends little energy in the area of music nowadays. After recording four solo albums from 1993 to 1996, his musical endeavors have focused on creating soundtracks including the music for his personal animation projects "Severed Stream," "Bard's Moment," and the most recent, "Secondhand Loppo" or on film collaborations such as *Seeking Wellness*, with director Scott Ferril. "For me, it's much more enjoyable to make music and sounds in this format," Mars comments, "as it is less constrained than what I'd grown used to in the past.

Soundtracks, for me, are closer to painting, perhaps because sound is working to support visuals–different than say a music video where the music usually comes first. I don't do it all that often, but when I do, it is a good way to get out the musical bug in a manner that's in harmony with my visual orientation."

For this article, *Hi-Fructose* was given the exclusive opportunity to preview some of Mars' new work which will be featured in his upcoming solo show at Billy Shire Fine Arts in Los Angeles in September 2008. The last time he attended one of his own exhibits was a few years back at the MIA, but Mars plans to be in attendance for the BSFA show. "I grew to hate flying so much that it has gotten in the way of my attendance out of state." This will be his first flight in quite some time, but he is looking forward to this one, "My book, *Tolerance*, will be out by then, so it's my plan to do a signing.✦

"There are great dehumanizing horrors taking place as we speak, but at the same time I have hope that awareness of these horrors is increasing."

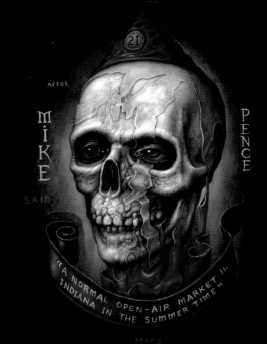

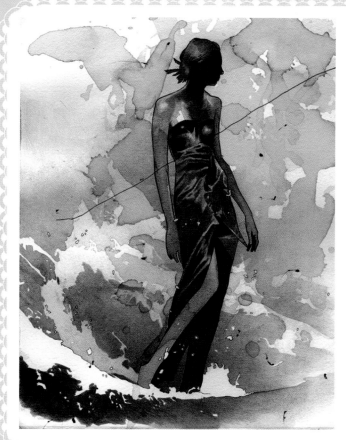

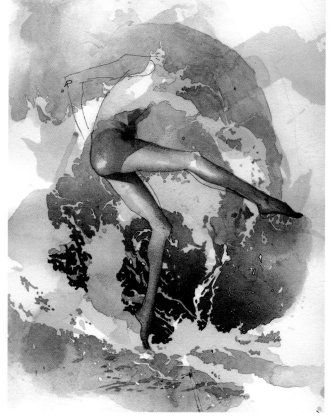

(Above Left) "The Longest Forever" Many places host a legend of the woman who waited for her husband to return back from war. Some men never returned and thus even after death she remained there, waiting an eternity for him to fall back into her arms.

(Above Right) "Wishing You Appearing Somewhere"

GHOST STORIES
THE ART OF EDWIN USHIRO

by Annie Owens

After several successful years of doing commercial work as a storyboard artist, concept designer and cinematographer in the entertainment industry, Edwin Ushiro got the urge to develop his own art with his own intentions.

His first group exhibit at Gallery Nucleus' *Unicorn* show in 2006 lead immediately to his first solo show at the same gallery. Currently, likely at this very moment, he is working on the pieces that will be shown at his second solo at Project Gallery in July 2008.

Whether his precarious beginnings as an infant misdiagnosed with a heart condition and given one month to live, has anything to do with the layers of introspection evident is his work, is too big a question to ask. However, big ups to Dr. Kathleen Poon and Dr. Caldwell. Thank goodness for second opinions.

Edwin's work reverberates with a strong sense of the past, reflecting that intangible sense of a memory that is just out of reach of 20/20 vision. Although he approaches his work with a light, methodical hand, the effect is strong and can stop you in your tracks.

Among other materials, Edwin incorporates iron transfer and fabric into his work. "My process is a fusion of digital and traditional. Most pieces usually start with a drawing on paper. This is scanned and colored in Photoshop then printed out and transferred onto another piece of material. I will later use paint, ink and sandpaper to achieve the desired mood."

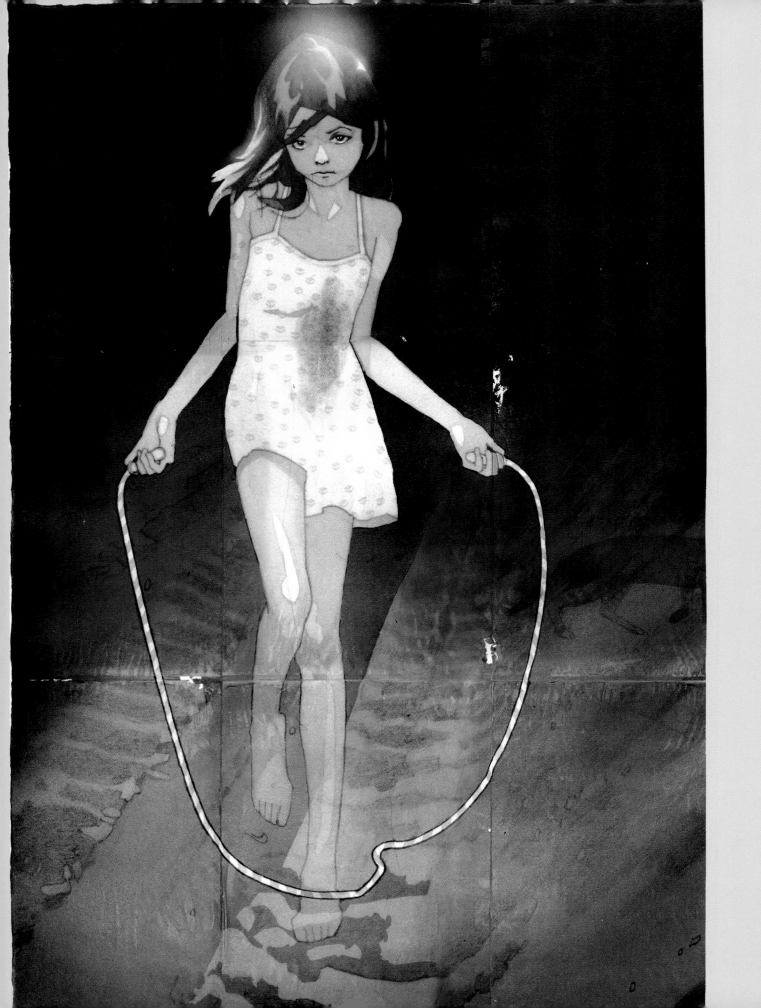

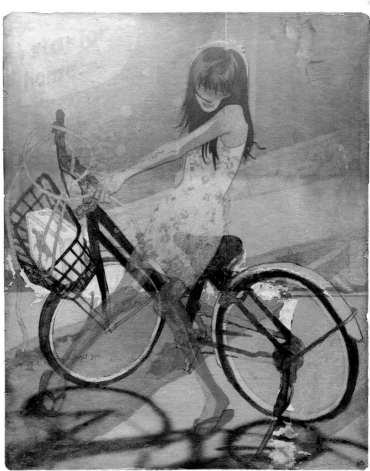

(Above Left) "When We Met" This is lightly based on a story my mother told me. As a baby in the ICU at Kaiser Permanente on Oahu, my mother had this nightmare where kids circled around her bed. She believed these children to be the dead waiting to take me away. Frozen stiff, she realized that her fingers were able to move. So she moved them until her arms could move and finally her entire body. By the time she got up, all the kids had vanished.

(Above Right) "Old Pali Girl"
(Opposite) "The Diligent Night"

When legends, myths or local lore come from our own hometown, they have a sneaky way of binding us to our roots.

Ever since he was a child, Edwin Ushiro has been fascinated by ghost, or *Obake*, stories. Not the *Casper* or *Ghostbuster* type, but the kind shared during the night at sleep-overs and campfires. These stories had actual locations, names, and cultural references. "In your mind [one] could see these stories, and it would be so disturbing, it would keep me up all night scanning around the darkness thinking somewhere out there, something is looking back at me."

"The Diligent Night," an ethereal painting of a young girl skipping rope seems innocent enough but conveys a strong feeling of something gone amiss. This was the first impression when I first saw the piece sans any additional information. The subtle application of color and soft reflected light conceals a terribly sad story. When asked about it, Edwin reveals that this was the first

personal piece he ever created and recounts the tale that prompted him to paint it. "Before I even knew this story," he begins, "one night my friends and I were cruising around Oahu and we passed by this really dark road. It looked spooky, and I suggested we drive down it since we were safe in the car's shell. My friend who drove decided it was a bad idea. The next day, another friend, a local to Honolulu told me the road was the Old Pali Road." The friend continued that driving down that road, especially at night, would have been the "stupidest t'ing you could have eva' done," further explaining that they "would have disturbed something that should have been left alone."

Apparently this was the murder site of a young girl at the hands of a family friend, who silenced her with her own jump rope. Nearby residents say the Old Pali Road is haunted by her presence. Legend has it that if you find this road at night, and turn off your engine, you'll notice a white mist forming, materializing into a girl skipping with her jump rope. She will venture near your vehicle and stare through the driver's window.

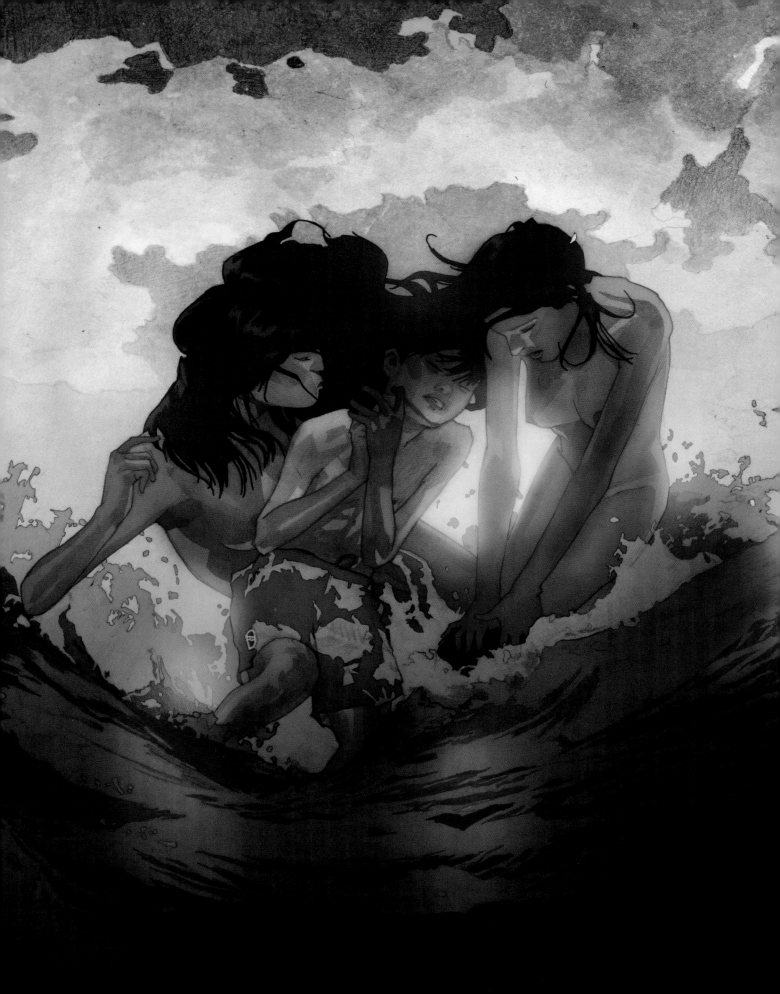

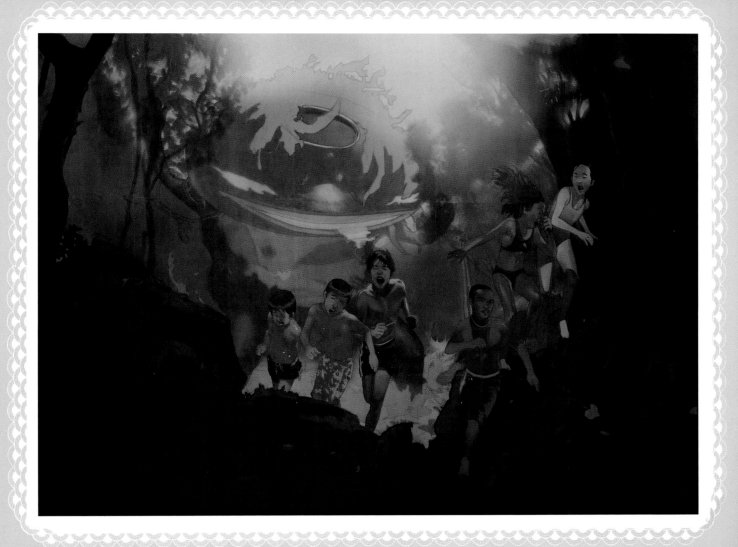

(Above) "Kappa," is a mythical creature from Japan that would rise from a pond to rape women, slaughter children and disassemble animals. A real life case of Kappa is actually recorded by the Hawaii Police Department in 1957. In this file, six children alleged to have witnessed a green lady with seaweed hair, claw-like hands, and many deformed features. The HPD and the Wahiwa Chamber of Commerce organized a search for this woman. Nothing was found. Only one other case of a Kappa sighting in Hawaii was reported since.

Other pieces such as "Wishing You Appearing Somewhere" or "The Longest Forever," rendered in watercolor and ink, are touching translations of his own childhood fascination with love, life and death. For example, grazing over the heartbreaking titles in the "Cardboard Symphony" collections can, alone, produce little knots of empathy to form in ones throat. One such painting, "From Sands I Could Have Trusted More," is dedicated to the honeymoon couple who lost their lives in the Pacific Ocean near Hawaii.

Edwin's work is rich with delicately insinuated meaning and unnamable

tension yet allows enough room for viewers to ruminate on our own impressions without forcing our hand. With the background stories generously provided by Edwin, we find that there really is more there than meets the eye. The written recounts enrich the perceptions of his work rather than detract from it.

The sensation experienced by taking in an image such as "When Everything Really Mattered," is very much the same feeling that inspired its creation. It could be that it's this connection between artist and viewer that is the real draw of Edwin's work.✛

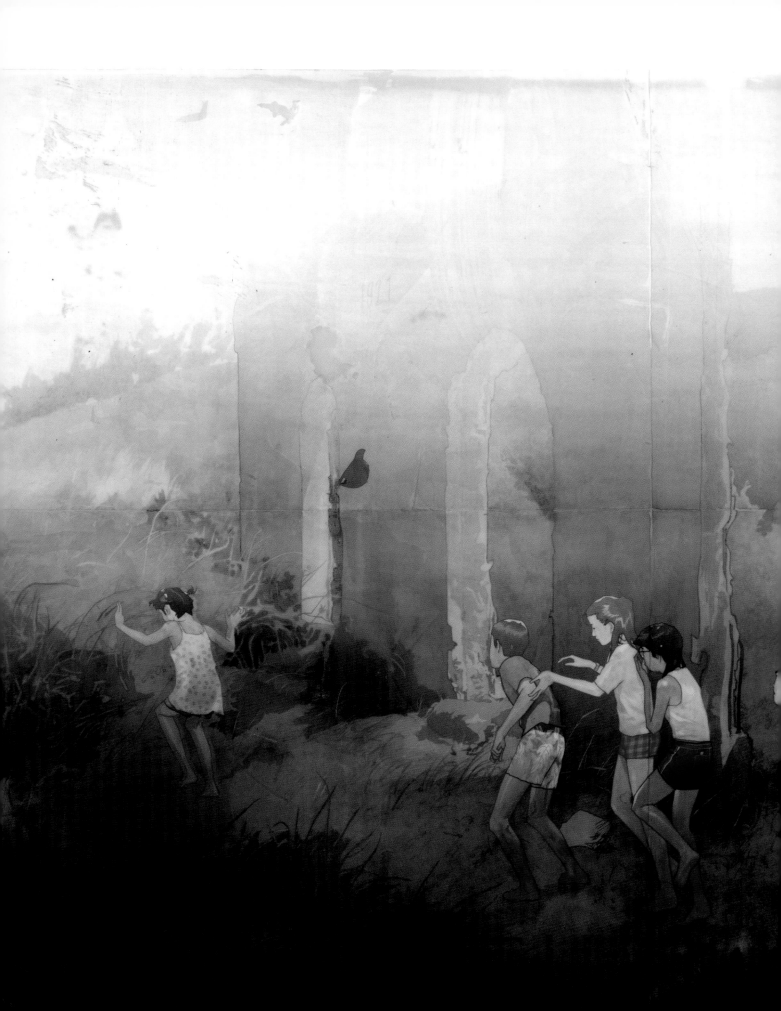

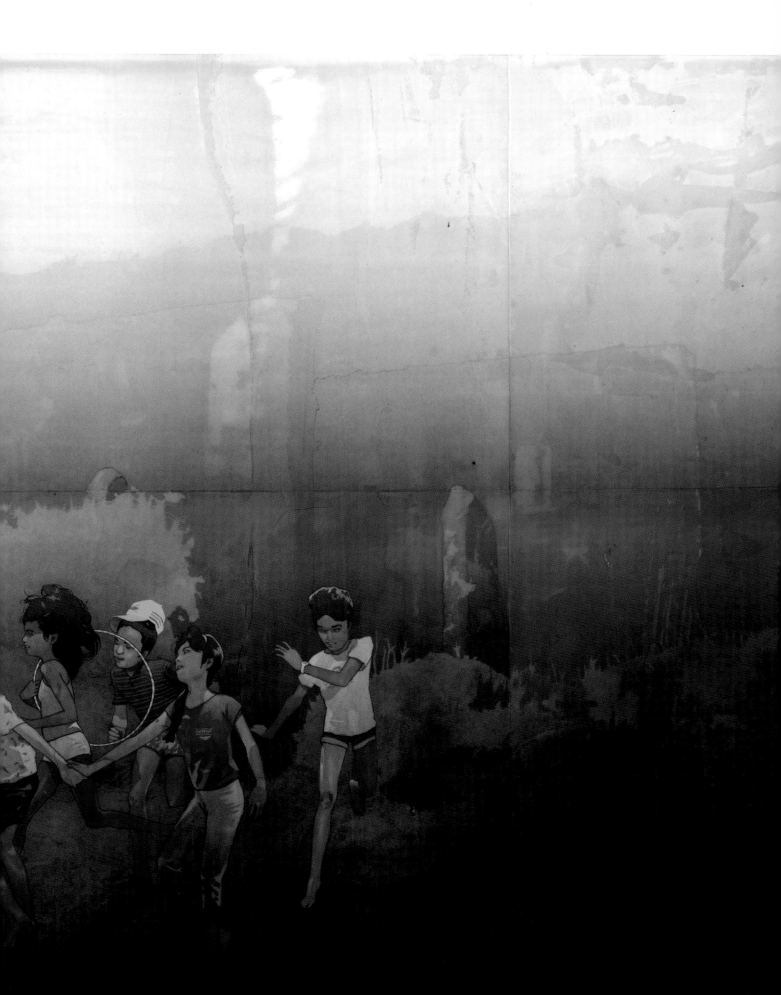

WAY$HAK

by ERt O'HARA

It might seem pretty safe to assume that comic, commercial and fine artist Jonathan Wayshak has a pretty dim view of this world. If you judged him by his book covers, and the insides as well, he might seem scary, disturbed and just a little bit unhappy. After all, his ink drawings and oil paintings are rife with stretched and torn realities, bulging and bloody narratives, nothing appropriate for a hotel lobby... well, maybe Hotel Hell.

You would be half-wrong about Wayshak. He is negative and nihilistic in some ways. Not a fan of the gallery scene, he no longer sells his paintings. He hates his own work, and can't imagine being satisfied with it. When his girlfriend tells him she doesn't like it either, "She hates it. She thinks I have some kind of drawing skill, but the final product is just ugly to her," it doesn't bring him down. It validates him. He was right. It sucks. It is god awful, disgusting and hideous... exquisitely so.

Wayshak spends hours upon hours crosshatching tiny precise lines in a clearly comic-influenced style of illustration that results in the graphic zines he has faithfully self-produced and sold at comic-cons and indie zine stores over the past six years. His spacious loft-style apartment in San Jose is barely lived in except for the studio upstairs, a space littered with work you'll never see.

His studio is where anything goes. "It's just a way of killing time, and it's not all that intellectual. Just sit, make a mark on the paper, and make another, and see if you can develop it into something. This isn't science, so rational thought has no place in the process. My mind will wander..." In his work, you will see murder, dismemberment, molestation, torture, loneliness, and other scathing indictments of humanity. However, if your sensibilities allow, you can also see the fruition of his imagination and a keen aesthetic sparked at a young age by Todd McFarlane's *Spiderman* then honed through an art school education spent mainly in the computer lab with the other art geeks. Wayshak's art is delicate and intense to look at objectively. When you start reading the scene or the story, it's brutal and ridiculous in its honesty. He says, "I'm not trying to shock people. I'm just a man. I try to be honest, but how honest can you really be with yourself?"

> "I try to be honest, but how honest can you really be with yourself?"

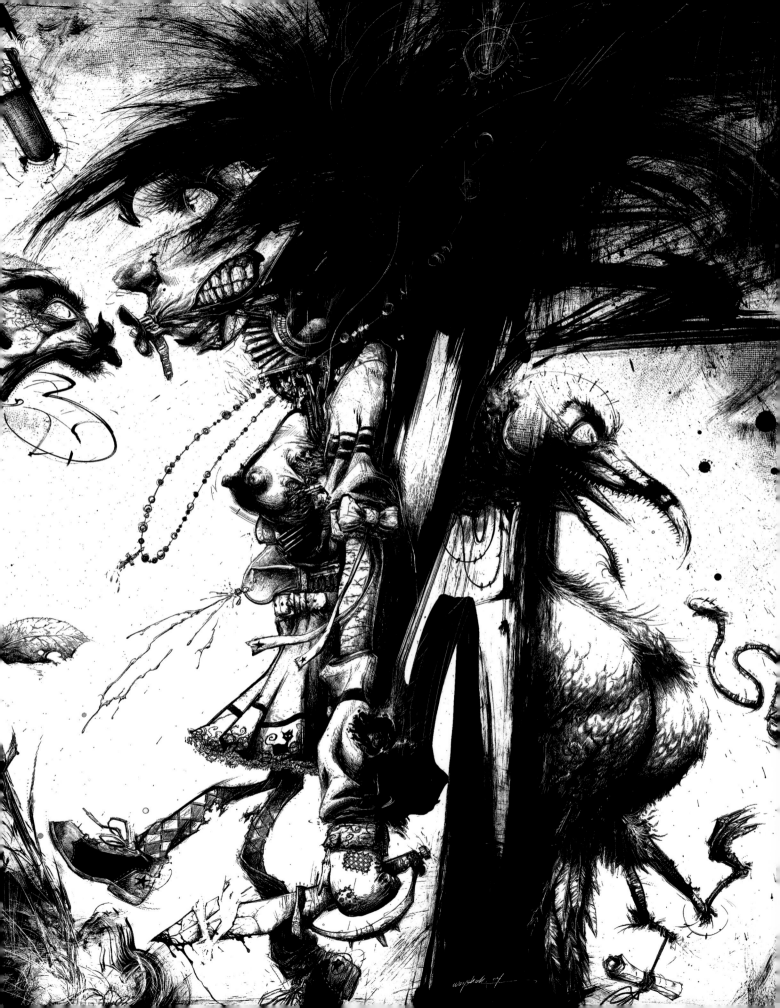

Wayshak has been supporting himself with his commercial art and easy affinity for technology since he was 19. After giving Target a try for six months, he took his skills to the internet-rich streets of San Francisco, and never looked back. He hasn't had to bother with a commercial portfolio, ever. His work speaks for itself, and things just keep working out.

Over the years, he has shown in galleries, but he's withdrawn from that world. "I don't get invited to shows any more," he says without lament. His non-commercial work is truly personal. It takes however long it takes and turns into whatever it happens to turn into after countless re-drawings and re-paintings. The vertigo of so many options seems to strangle him a bit. Hesitation doesn't suffer his commerical work. He does a lot of storyboarding these days or design for video games, projects where he's given a general concept that he fleshes out yet reserves judgment. The comics and paintings he does as "a way of killing time" are labor intensive and he admits, totally self-indulgent. Somewhere in the mix of being compelled to experiment and produce a lot of art, he has misplaced the "normal" desire to commodify it.

His desire is to tell stories. As much as it might follow that someone who stays home reading comic books, watching cartoons and science fiction, and scratching out bleak ink scenes, caking them with white out, and purposefully exploding the lines of narrative panels must be some kind of anti-social hermit who lives in an escapist fantasy world, that's not who Jonathan Wayshak is. He spent "two months in Europe being a

bum," and has a two-week trip to New Zealand coming up this Spring. "Nothing is more interesting than real life experience. You can't make that shit up. The stories are a way to translate that experience into something people can relate to. At its best, it's something unique, like Ernest Hemmingway. At its worst, its Steven Spielberg... something clichéd and ordinary."

In July 2008, Wayshak has a 96-page book coming out through Baby Tattoo Books. The book will be a rare glimpse at his private paintings and illustrations, and possibly include a sketchbook section as well as a sampling of his comics. "I really wanted to reprint all of that shit, but the page count is too small. 96 pages would just be comics."

When I ask him if he thinks it's unfair to characterize him as a nihilist, he clears the air with this, "Well, I'm only passionate about a few things in life, and to hate something requires a great amount of energy and passion. I'd rather direct that energy to other things that I find a little more worthwhile... My work is not as dark as people believe it to be. The subjects of my work show no winners or losers, it's more about the conflict."

Conflict is something everyone can relate to and a revealing aspect of Jonathan Wayshak's art, as much about himself as others. He is a constant contradiction, driven to render ugliness in a beautiful way but waxing dispassionate at its potency.✦

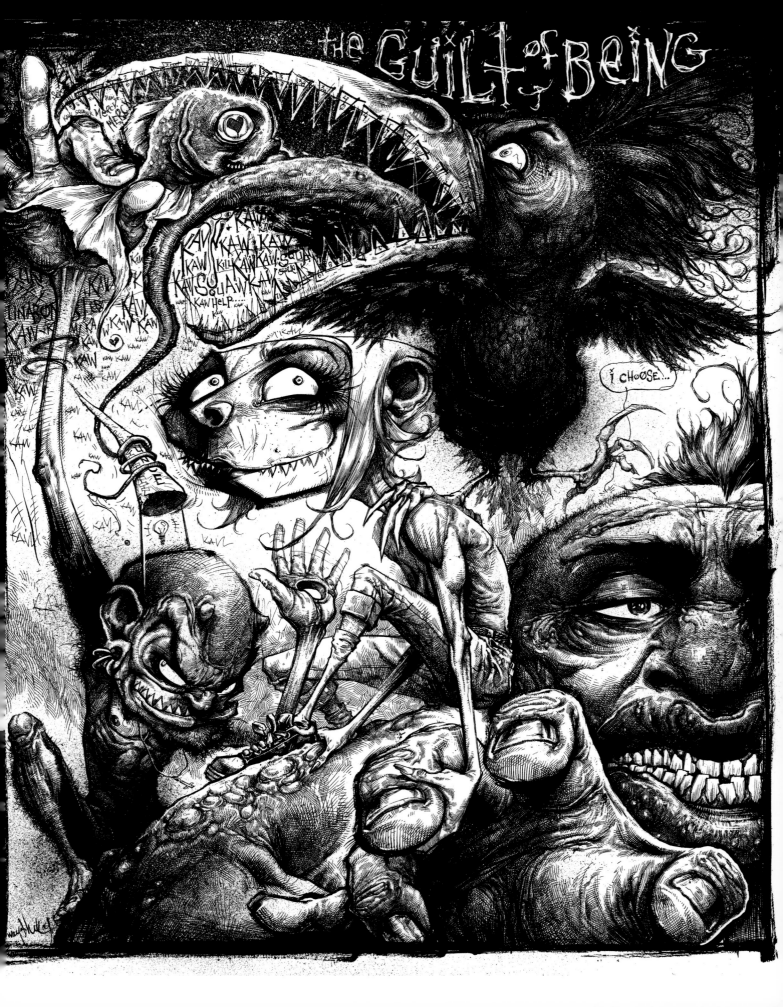

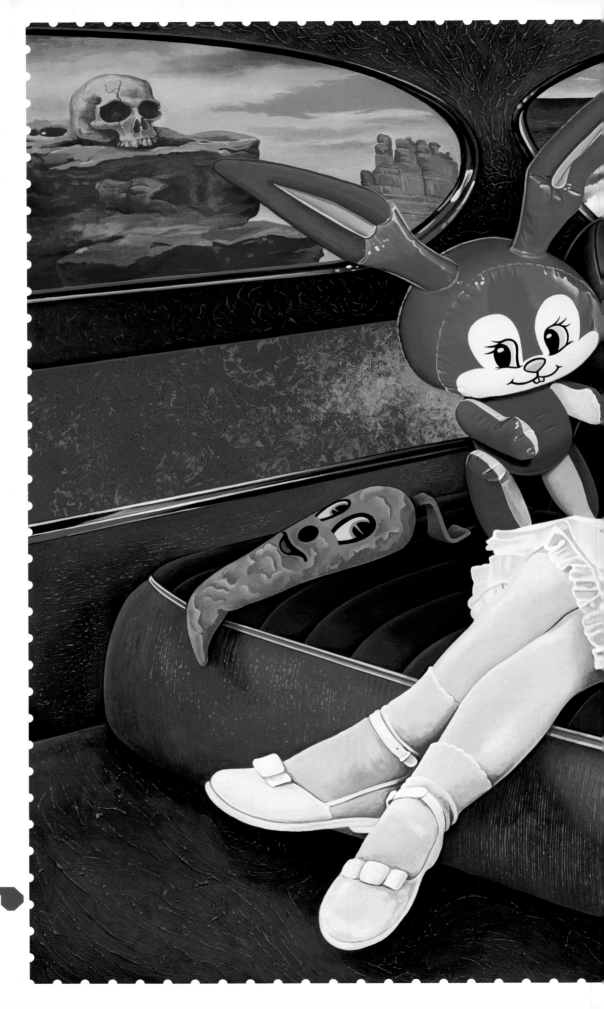

KRK
Ryden In Blob We Trust

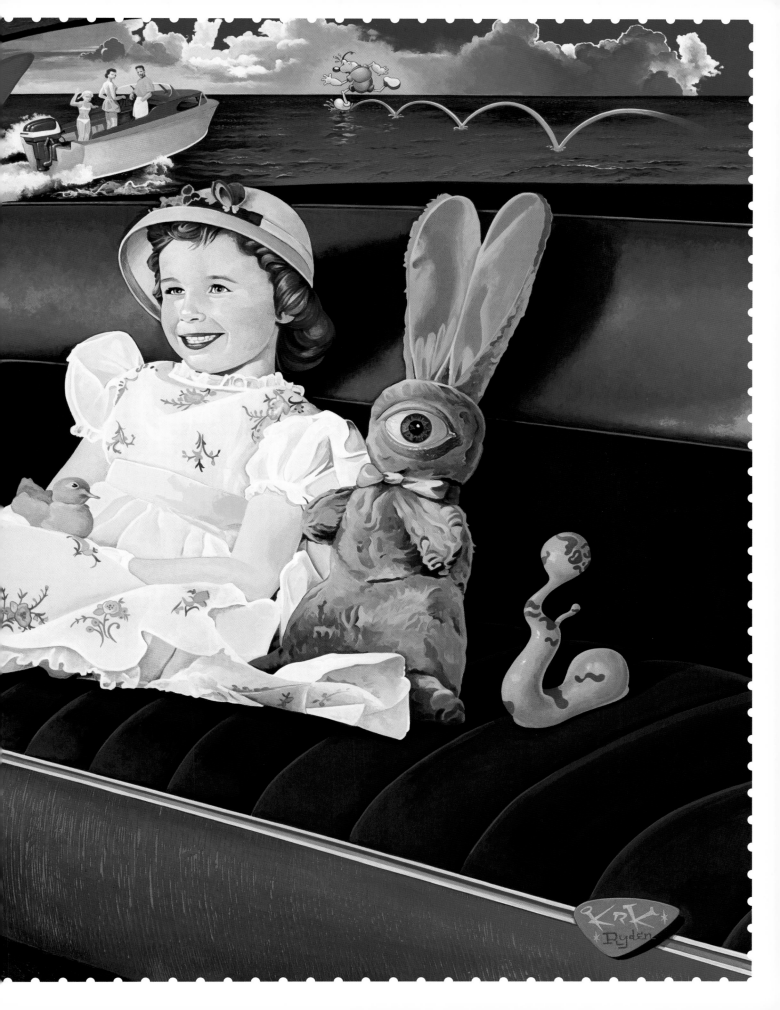

Interview by Attaboy
Art Photos by Quang Le
Portrait and Interior Photos by Joe Reifer

Even KRK Ryden's bathroom walls are hand-painted in comic book panels. Elsewhere, a collection of convenience store-bought novelty lighters are positioned like circling sharks has invded a brightly colored coffee table.

The kitchen refrigerator, long removed from the premises to make room for the wall of mousetraps; each room, nay, each exposed surface or wall trimming is painted its own distinct color. Alone, the colors are obnoxiously garish, but together, they compliment each other like a neon bouquet in Paris. Windows and curtains always drawn, the conductor KRK Ryden creates his work surrounded by a kaleidoscope symphony of his own choosing. The odd ephemera, expertly placed knick knacks, and spectrum-colored walls would appear as the ultimate distraction for a meditating Zen Buddhist, but for KRK, it makes the coziest of homes.

KRK's paintings are like his house/studio. Experiments in controlled chaos, bursts of expertly displayed clutter, arranged by color, pattern, size, and theme. Each has its own push and pull on your eye and brain.

I sat down with KRK to interview him for *Hi-Fructose* as we ate a bowl of fresh popcorn, heavy on the butter. We were in a room crammed top to bottom with Sharpie labeled VHS cassettes and DVDs of titles like: *Hot Rod Girl, Fiend of Dope Island,* and *The World of Tomorrow.* (It's been a dream of KRK's to host a Saturday night Creature-Feature TV show). There are stacks of cartoons too: "Gigantor," "Colonel Bleep," and old "Betty Boop" when she still sported a dog's head. Some have handwritten reviews by KRK on them, "cutting edge animation, but the music score ruined this flick!" Or like the review for *The Return*: "like watching grass grow while having prickly heat, but not as exciting."

[Pointing to one of the DVDs] A few months back you leant me a DVD collection of the badly animated (but in hindsight, surreal) *Klutch Cargo* series. It's insane that to cut corners on animating the dialog, they inset clips of an actual human mouth! This reminds me of your paintings, where you place elements completely out of context, and even, in completely different styles/realities into the same painting.

Badly animated!? Klutch would be insulted. It was actually cutting-edge television animation, the predecessor of limited animation years before *The Flintstones.* It just looked funky because of their little

experiment with lips. Sometimes the cell vinyl color didn't come close to matching the flesh tone of the people actually doing the voice-overs. Klutch made it into the film *Pulp Fiction*; it was used in a scene that needed a choice example (albeit odd) of an early 60s kid's show.

My art does have a layered, cut-and-paste look to be sure. Years ago, I thought the "dropping in" of cartoon or comic book art and the occasional ad art illustration in a realistically painted piece wouldn't work. Sometimes it's vice-versa; a realistic image like a portrait in the foreground is superimposed on a comic book panel. As I forced the images together in time, I developed a technique that fused them together in a way that made visual and artistic sense. I experimented with paint application and style so that the overlapping welded together. For example, a comic book figure will be outlined with a color that conforms with a color of the field behind it. Real clever stuff like that.

Each piece, when gathered together, seems to provide evidence for the bigger story...

It is evidence. Puzzling evidence. You've got to put all the paintings in a big room to get the picture. That's how you can

see the story unfold. I'll lose track of the tale myself unless I can see everything together like that. Da Vinci said that when an artist's imagination soars far beyond his ability to create that vision, it's a good thing. I've got far-flung ideas that in time will come to fruition. With time and lots of money, those dreams will be turned into reality.

A major KRK Ryden piece wouldn't be complete without your handmade, fantasy, fur-wrapped frames, with surprise shadow boxes with recessed areas often silhouetted in a skylark blobbed shape. On paper that sounds horrible but in actuality, the frames are wonderful and I couldn't imagine the paintings presented any other way.

Allow me to reveal to the world how I make fur frames. To begin, I should explain the source of the fur frame concept. I was in SF MOMA looking at beat art from the 50s. There was a smallish piece that had its frame coated with a dark brown fur—it might have been rabbit. I can't remember the artist or what the art looked like, but I'll never forget that totally unreal and ultra-cool frame. It reminded me of Duchamp's fur-lined teacup. I had thought of doing something like that before, but seeing the thing crystallized that way encouraged me to pursue and develop it.

I start by drawing and cutting out a paper template. The shape is usually googie style, like an elephant ear. The template is used to create a plywood form. The edges of the wood are sanded and made round. I get most of my material from a humongous fabric store in the Mission district in SF. They've got a lot of rare and bizarre fabrics. The material is layed on a large flat area (like a floor) face down and sprayed with a cancer-causing and ozone-destroying 3M adhesive spray. The plywood cutout is deftly dropped on the fabric and pressure is applied. I cut away the excess fur about an inch from the wood, like shearing sheep. The material is flapped around the edge and stapled upholstery style. If the fur is long it needs to be combed out with a toothbrush before it's hung up. All the fur I use is fake, because real fur is murder to clean.

A complicated form might be rendered in monotones while a simple shape, when approached from the left or right side, will reveal an odd sanded texture or a literal hole in the picture plane, inhabited by the eyes of a Peeping Tom.

I paint almost exclusively on masonite. That gives me the freedom to cut out shapes and create multi-leveled art. They're reliefs. I'll cut a hole out of a piece from the picture surface, and back it up with another painting behind. That's something that can't be done with canvas easily.

There's a painting technique that my brother Mark turned me onto about 15 years ago. Paint an area with a thick coat of paint, being conscious of the brush strokes, controlling their direction and pattern. After that primary coat is bone dry, the image you initially planned to do is painted over it, basically ignoring the undercoat, which is usually of a lighter value. After that part is done and dry, fine sandpaper is used to sand and reveal the first layer of pigment.

Another trick is to backlight or electrify the art. Behind the cut out masonite pieces white lights are arranged and attached to illuminate glass or plexi. As the construction of these pieces evolve, I hope to introduce more complex technology. I want to use flat screen TVs with CGI that integrate with the painting. For example, a scene that portrays a window in a room may have clouds moving by with an occasional bird in flight via a monitor built into the painting. This is a future goal. I'd like to build in motion-activated software that produces sounds and programmed lighting emitting from the art.

In 1977, you changed your name from Keith to Keyth, and now use the name KRK for numerology reasons... How does numerology integrate into your day-to-day life?

I've got OCD when it comes to numerology. I'll look at a hotel room number, quickly add up the number on the door like 428, get a 5, and say, "Shit, it's going to suck in there." I changed my name from Keith to Keyth in '71, around the same time Dionne Warwick added the "e" to her first name for the same reason: numerology. In '82 I changed my name to KRK because the band Manifest Destiny would come in my studio and call me that, referring to the initials on my sign, which stood for Keyth Ryden Kreations.

For quite a while, I signed my art with a simple "KRK" until I found out about someone who had the same number, Norma Jean. Marilyn Monroe's life pretty much sucked when she was Norma. I added Ryden to the paintings that previously had KRK and they sold. It changed the numerogical vibrations by doing that, yo. Girls like me to do their numerology; it's almost as good as having a cute dog.

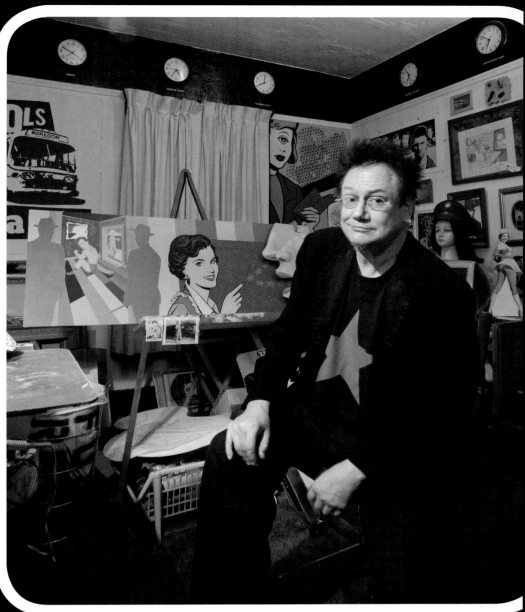

Portrait and Interior Photos by **Joe Reifer**

You've had a long relationship with Devo and their front man Mark Mothersbaugh, Your work also encapsulates Devo's core, with ideas of De-Evolution and the failed promises of the 1950s America...

I've known Mark for almost 25 years. How we met was Devine Devonian intervention. He saw a litho printed poster I did that a friend of mine, Karin Hansen, brought to a party. This poster portrays a quartet of scientists whipping a sexy girl who has been miniaturized via high-tech machinery. When you look at her through traditional red-blue 3-D glasses, she becomes naked. Her red dress gets filtered away by looking through the red lens. Mark called me and I went to Hollywood from Encinitas, a small south cal beach town. I met him at Larraine Newman's house (of *Saturday Night Live*'s Conehead fame) who Mark was going with at the time. He set me to work on *The Brainwasher* and dubbed me the editor-in-cheese. The BW was meant to be made for Devo fans but would eventually turn into a slick monthly on-the-racks mag. At the time you could only get "The BW" by joining Club Devo, and you could only join by buying the record and ordering something through the Devo Surplus catalog that was printed on the inner sleeve. This was back when people would spin flat black disks on things called "record players" to produce sounds. Unfortunately, it never made it to issue two, even though I made a some art for it that kicked ass compared to the first one.

Thanks to the zealous efforts of my good friend and manager, Michael Pilmar, *The Brainwasher* is now an interactive magazine accessible through Club Devo on line. The original graphics from the first *Brainwasher* are used throughout.

MM's art has influenced my art through the years. You can see the similarity in composition, in the placement of elements.

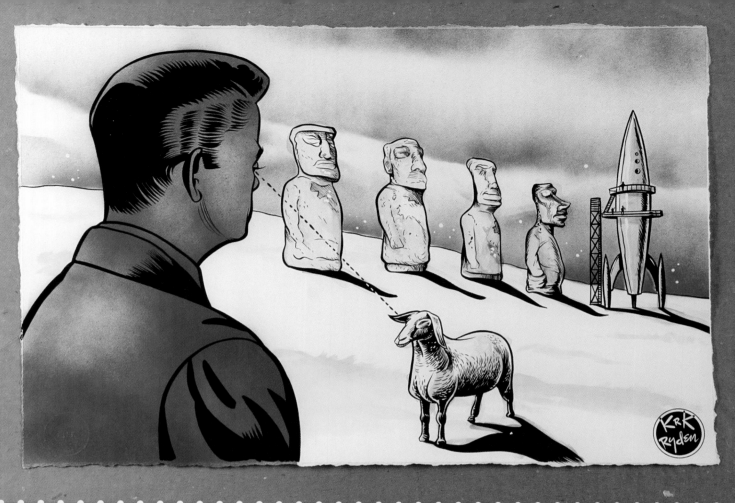

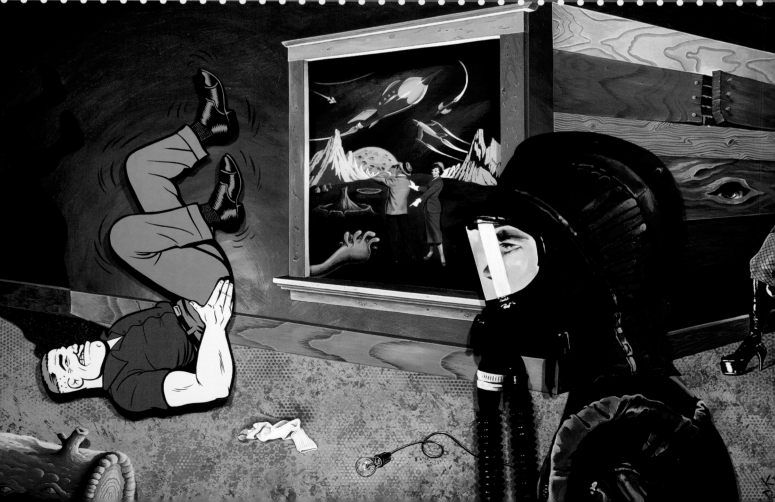

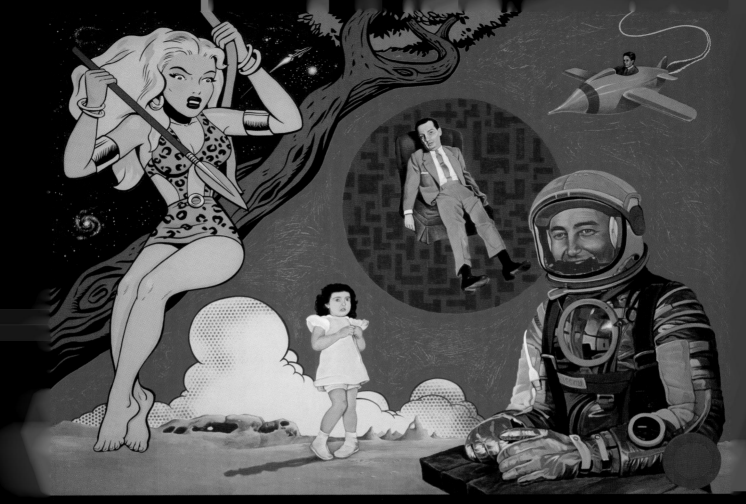

"So now, when you scratch the smoke coming out of the house that's in place of a human head on the print, it really smells like lime."

Occasionally I'll even stick a profile of a face in the upper corner, peering down diagonally. I've thrown in the occasional potato, too. I'm a devolutionary artist. I was raised in the 50s, and some of those images haunt my paintings in a positive way. The stereotype and simplicity of a guy in a monkey suit wearing a Stetson has a charming appeal to me. The use of these scenes, like that of a woman ironing, often in black and white, are surreal. They are surreal by virtue of being thrust in today's world. They're out of sync, and get laughs.

Let's talk about your family a bit here...

I'm the oldest of five. Got two brothers and two sisters. My pop's name is Keith, his middle name is Harold. My given name is Keith as well, but my middle name is Lawrence so I'm not "Keith Ryden the Second." Sometimes I call dad Harry and he calls me Larry. He insists that Harry is not short for Harold, and that Harry S. Truman's name could have never been Harold. He's right actually, but Harry was short for Harrison, Truman's uncle. Pop's a tough son-of-a-bitch. The leftist views and Yippie persuasion I have may be to

do with the influence of his inherent anti-establishment attitude.

Mom, God bless her soul, died over a decade ago from lung cancer. I look at people who smoke nowadays and just figure that they're either retarded or suicidal. My sisters Jay Air and Lori are both purty enough to be models. My brother Steven is the archivist, and currently owns the biggest collection of my original art. Markie can draw pictures too, he can paint real good. He lived in a castle once.

Did you really meet Walt Disney as a boy?

When I was four, I visited Disneyland for perhaps the second time. The year was 1957 and the park was fresh, clean, and new. My uncle Al, one of the managers, introduced me to Walt and he took me to his little office at the corner of Main St., the one that's been rebuilt for prosperity and history's sake. I just barely remember Walt sitting at his desk and asking me if I liked Donald Duck. I then rejoined my folks and we continued down Main St. It was so beautiful, so perfect, and I was so excited that I hurled my guts out all over the cobbled street. It's one of my earliest, if not first, childhood memories.

Your recent prints through Pressure

Printing are in 3D and, uhm, infused with the scent of lime?!

These fine art prints come with custom made 3-D chromadepth glasses. They aren't red and blue. They're something new. They make cool colors recede and warm ones (especially red) pop out about an inch above the picture plane. If the art is executed correctly, an orange bagel will appear to float on a sky-blue sky. Viewing the print or painting without the glasses does not give the viewer a distorted picture however, like with the old school red and blue shift technique. The prints smell too.

I'm the first spud on the block to put scratch-and-sniff in fine art prints. I had done a piece called Lime Scent and a fan from Oregon by the name of John Barley suggested that I try scratch-and-sniff. I collaborated with Brad Keech of Pressure Printing and I started to investigate the process. Much to my surprise, it was much easier to do than I had thought. It basically involved purchasing a special order of something called slurry. So now when you scratch the smoke coming out of the house that's in place of a human head on the print, it really smells like lime.

My next print will portray someone smoking a joint somewhere in a surreal scenario. Scratching it will make it smell like cannabis.✦

Convulsive Beauties
The exquisite compulsions of
Gregory Jacobsen
—by Nathan Spoor

Entering into Chicago-based artist Gregory Jacobsen's visual forum is a fascinating and beguiling experience. The effects of his self-ascribed "pile paintings" are nothing short of viewing a perilously crafted ballet of grotesques—each one set on view for an unsuspecting voyeur and would-be lover. These obsessive creations portray a sensual dynamic of macabre making love to truth, resulting in a rare and passionate vulnerability.

Gregory Jacobsen, now 31, has the effect of one accepting life as each moment is presented. He is pragmatic, with heavy doses of existentialism and nihilism.

Although very sexual in nature, his works are not so easily classified as the dime store mainstreams of psychology one might assume. While the artist claims to subscribe to no one school of thought, his views of Freudian theories on repression and sexuality, as well as the mystical nature of Jung's archetype (an integration of spirituality and appreciation for the collective unconscious) are of equal importance.

Jacobsen rarely works from sketches. These paintings are more immediate, though he's reluctant to write them off as merely "automatic" and reject any simple-minded "symbol" reading of his work. Therein lies the enigma of the artist's struggle. That amazing creative impetus being eternally locked in the conflict of the ritualistic deflowering of the surface in a grand performance of vulnerability and dignified ambivalence.

The limitations of Jacobsen's work are not evident in the final products of his efforts, but they're there. In his eyes, the laborious prcedure of drafting, sketching and planning a piece is a confining yet integral to develop a piece. "I don't plan these paintings so much as feel them through the growth process," he begins. "There are months of work under each surface. The failures of the past are all built up in this glorious movement of flesh. I'm fascinated with making flesh look more realistic. I tend to sand over months of work, several versions of a single painting even, to achieve a glimpse of what I'm attempting to paint. It's the layers, though, those layers and layers of work that give the paintings their depth. I need more movement, more dynamic compositions. Compositions need the most work. While working in sketches the compositions have to be erased and reworked. But in paintings I can simply sand the surface smooth and have the added effect of the previous layers of mistakes to eventually lead me to the right place."

Jacobsen's paintings reflect a certain understanding of life structure within a constantly evolving landscape. As a youth playing in the fields of the New Jersey riverbanks, his curious nature took him on a particularly remarkable series of adventures. The haphazardly covered piles of waste dirt seen around the town made quite an impact. As he grew more inquisitive of the changing cityscape, he stumbled upon a place that would change his life forever—the ruins of an outlying community of vagrants and societal outcasts in the nearby woods. Being just beyond the fence of his backyard, Gregory found himself in this new playground constantly. A forest of piles of everything. Piles of trash, magazines, toys, appliances. Just piles and piles of discarded and unwanted objects.

These were the coming-of-age times of hope in a place of abandoned dreams and discarded fortunes. Fires were erected, offerings made, fluids exchanged. This was a new day and a new stage. Gone were the inhibitions of the outside forum. Here, no one imposed on him any opposition born of someone else's agenda. This new drama would stay with Gregory as an ongoing fascination, culminating in the frenzied realizations of his paintings as well as its natural courtesan-music. "A lot of my work comes from music," he states, "especially the newer pile paintings. With the more tableaux-orientated pieces—I would say they come from Musique Concrete—creating a scene with disparate elements to create something new and jarring. This could be applied to sampling and such but Musique Concrete is much more theatrical with using everyday sounds that become animated and take on a life of their own. The pile paintings are influenced by people like Xenakis and Stockhausen who created massive architectures out of compositional structures. The piles may look like masses of chaotic shit, but there was a lot of planning and trial and error to get them to their monolithic forms."

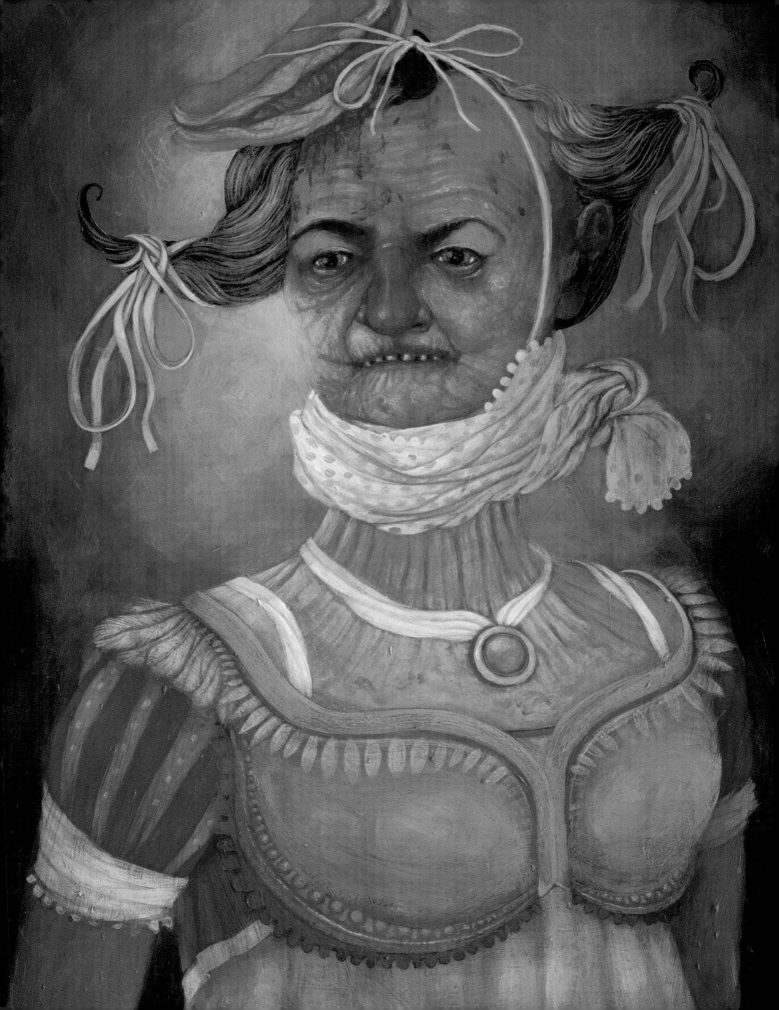

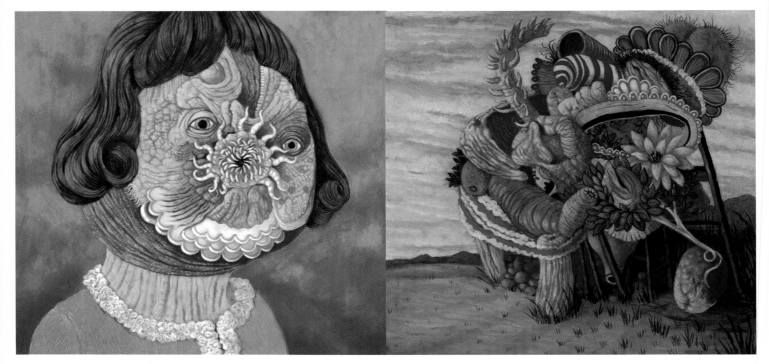

"Sally with Doily"

"Jacobsen Stromboli Chateau"

That's not to say that these challenging pictorials are too far beyond reasonable definition. The term bandied about most in Jacobsen's world these days to describe such artwork is "Magical Realism." This realm of painting presents artworks where the scientific and physical and spiritual andhuman realities are fused. Here, the illogical can safely exist with the knowledge that it is the viewer's task to decode the texts hidden within each piece of art.

Jacobsen has been able to unleash his childhood torments of growing up with fetishes attached to food and sex. Growing up with an unsatisfied desire for the readily available Hamburger Helper-style fare with sides of potato chips and Ding Dongs made for one gregariously rotund individual. "I was a fatty for a number of years," he confesses. "I eat pretty healthy these days and my diet doesn't deviate much. I love trying new foods but rarely go out to restaurants because of the social fanfare that goes with it. My loss though. I have been a vegetarian for many years and obsess over meat, daring myself to eat it... something disgusting like McDonald's... but can never bring myself to do it. There's a little bit of sexual titillation in it because it is so taboo for me. This is where the food and sex come into the paintings."

Jacobsen's earliest childhood memory is attached to falling down the cellar stairs, but the next is possibly a more potent, if not more fascinating view into the course of his journey. "The 'art and sex' memory is from the day I was out painting the driveway gravel with the girls next door who I always had crushes on. I always envied the girls because they were always so much better looking, more interesting looking and got to wear better clothes."

These memories are sandwiched together in a mind that could only chew on them in the most polemic manner besides painting: music. "I wish I had more time to truly develop the performance end of things as I feel I am capable of a lot more. In the past it used to be a sort of freak-out, a cathartic

experience on stage... but as my painting has gotten more disciplined and thought out, the music/performance followed suit. Right now we as a band, Lovely Little Girls, are working hard at creating something new that is very theatrical and somewhat ritualistic (in a disciplined manner rather than hippy-dippy soupy drones and chants) while also retaining a dark humor... which is how I would describe my paintings at times. One of our big influences is Magma, a French Zuehl group who created their own language and mythology and who (at least in their early work) had a malevolent sound and stage presence that resembled a Catholic church ceremony."

Gregory eloquently speaks at length about his dual-natured persona and its effects on his nature, laughingly enough. "This of course is filtered through my innate goofiness. No matter how hard I try to fight it... I have always been pretty fucking goofy. But I have always approached everything (painting, performance) with utter seriousness... like Buster Keaton or Peter Sellers. I often find myself getting too damn serious about things and I have to whip out a bunch of drawings with spurting cocks and laughing animals (like right now)."

Besides pursuing his performances with his band, his fascination with the internet and collecting avant-garde and outsider music, Jacobsen is most influenced by his surroundings in his Chicago habisphere. More specifically, the downfall of the old beautifully built but decaying buildings for the new gentry of yuppified living situations and nouveau riche neighbors. Even now, his beloved neighborhoods of Chicago, which have provided a home base for his 13 year occupation, are suffering the prefabricated affrontery of progress. The historic 1929 "atmospheric"-styled movie theater in which he finds his gainful employment lies tense but untouched. "It's the last remaining old building on the street," he coos softly, "and I always wonder what it was like 70 years ago, and am conscious of how many people have passed through."

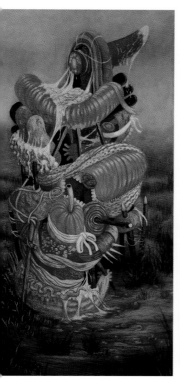
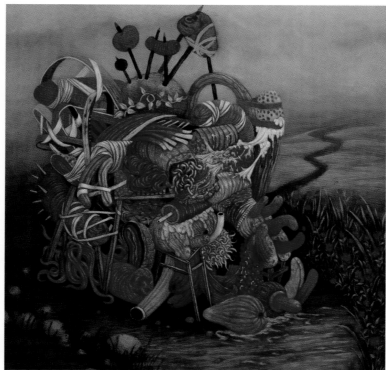
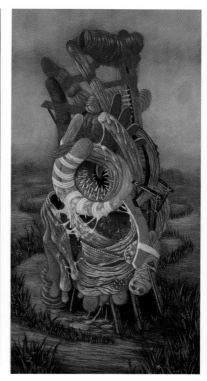

"Hoagie Hut"

"...I can simply sand the surface smooth and have the added effect of the previous layers of mistakes to eventually lead me to the right place."

With these thoughts demanding all precious and relevant soapbox momentum in his ongoing realm of the bizarre and intimate, Gregory Jacobsen maintains focus. He holds fast to the belief that the personal as well as the larger world issues deserve equal footing. "I think these pieces are some of the most personal," he begins. "It has a lot to do with growing up in New Jersey and hanging out in the dumps and the woods where there was always shit washing up downstream from the river, there were always piles of garbage. Also, there was always the 'lesser than' feeling of being 'the shithole next to New York' (which can be extended to my current living situation in Chicago where Mayor Daley seems to be inviting a terrorist attack just to validate it as an important city).

The works have been his imminent aggravation and eventual salvation, echoing his needs for an effective and safe respite from the daily chaos of life. The current pile paintings are found to contain immense thought as well as the tender and passionate hand of immediacy. "They actually came out of severe frustration with painting, sanding down, taking a chisel to the masonite and finding a form from there," he comments. "I have always been drawn to monolithic architecture, food photography and scientific drawings and these mistakes developed into something that was a combination of all three. I often get frustrated with the human form because it has been taken in so many different directions by people who have done it so well. I want to paint figures like Ingres, but I know I will never be able to. So these piles are a bit liberating."

These are works for the faint of life, for the uncommon, unseen and unheard. Out of the basest elements of recollection and the severe natures of creation come the images of Gregory Jacobsen's sweet lament for the idiotic and the obscure. His is not a question of choices, or of becoming another version of some distant puzzle. These are the glorious obsessions of mystery and wonder.

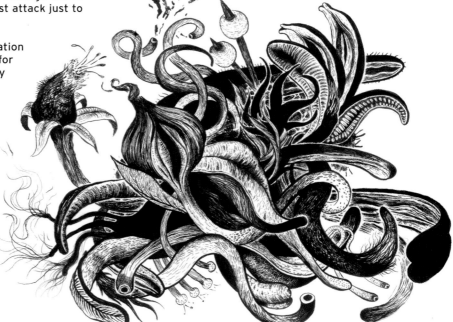

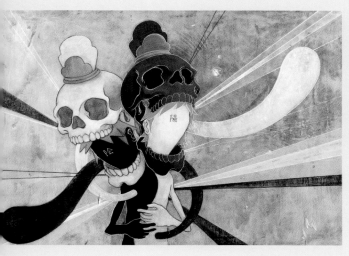

Yoskay Yamamoto

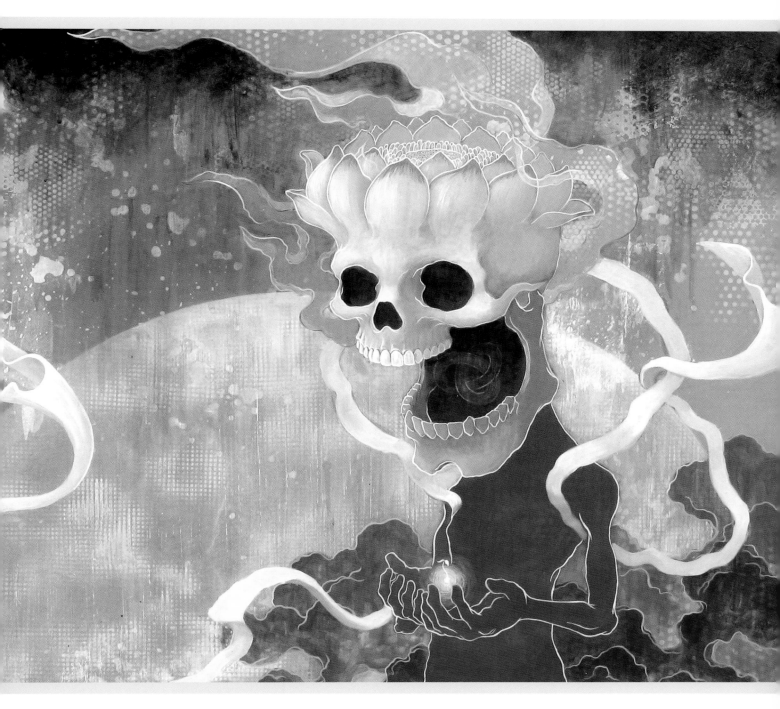

by Heather Yurko

Yoskay Yamamoto, a Japanese-born resident of Los Angeles who has managed to successfully blend Western icons and graffiti culture with the traditional and mythical elements of his native land.

Yoskay, a self-trained artist, began his artistic career in the United States while interning under David Flores at Shorty's Skateboards Inc. in 2004. Since then, he has been showing at various galleries including Thinkspace, Blu 82 and Canvas Gallery. Yoskay's first solo show, *The Upside of Down,* recently sold out at project:gallery, a contemporary art space which represents the artist.

The current show combines Yoskay's recurring themes: single figures in nature but not of nature, coupled with the battle of contrast between light and dark. The juxtaposition of these modern characters in ephemeral settings replete with clouds, rain, waves, flowers and smoke evoke feelings of floating into another dimension—where dragons, skulls, and fish-headed boys are the norm.

Yamamoto's artistic efforts are getting him noticed throughout the United States. He is currently booked into 2010 with shows in New York, Los Angeles, and Miami, and was recently one of the featured artists in *Scion's Installation Tour 4* at Art Basel.

To round out his rapidly rising up-and-comer status, Yoskay has a designer vinyl piece based on his work "Fish Head" in production with Munky King. ✦

(clockwise from bottom left):"Inskay+Yoskay" "Kizuna,"
"As the Day Ends the Future Begins" (left to right)
"Do You Mind if I Stay for a Bit?" "Screaming for Sunrise"

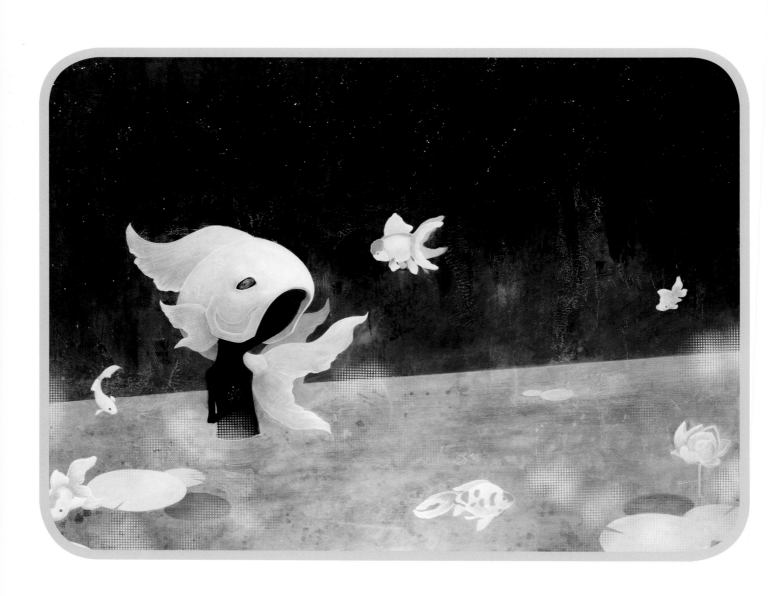

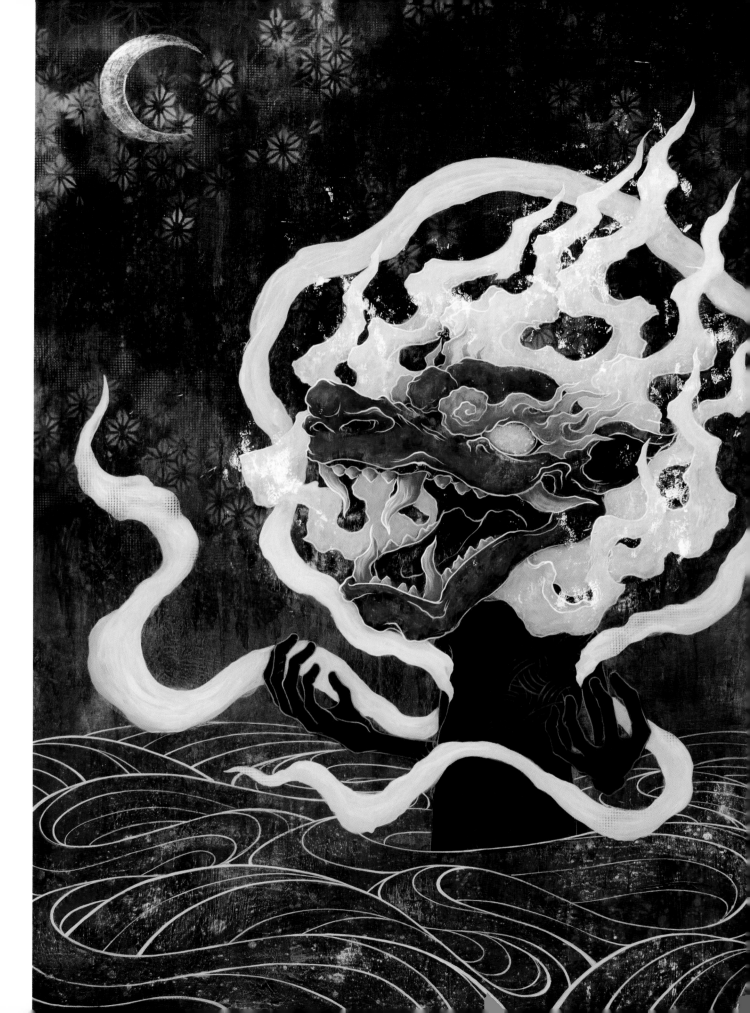

by Attaboy

Legend has it that the ten-year-old Eyvind Earle was given an ultimatum from his dad: either read 50 pages of a book or paint a painting each day. Serious business for such a youngin', but four years later Earle had a one-man (or should that be "boy"?) show in France.

A nature-loving imaginary-scape painter forced to live and work in cities, Earle would travel ten to thirty miles on his bike to find new scenes to paint, or rather inspire, his paintings. That is, until he realized that instead of traveling back and forth home each evening, he would cross the U.S. looking for scenes on his bike.

At the age of 21, with a $21 commission from a portrait painting in his pocket, a wood board as an easel, some food and a pot to cook in, and a tent, Earle set off on his bicycle to draw and paint each day—just as the creatively-possessed overachiever was accustomed to. "I painted 42 watercolors in the 42 days it took to cross the country and I wrote a ten thousand word diary of the trip," says Earle in an exhibition biography. He traveled 3,000 miles from Hollywood, California to Monroe, New York, soaking in his muse through the elements along the way.

Then came showings in New York, and at the age of 23 the Metropolitan bought their first Earle for their permanent collection. In 1951 he joined Walt Disney Studios, where he was a key stylist and background painter for *Sleeping Beauty.* Earle left soon after to do independent animation and greeting cards, but thankfully ended up back where he belonged, painting what I'll affectionately call "metaphysical landscapes from Planet Holy-Hell"!

What followed is an amazing body of work from a soul-searching, prolific artist. In 1998, Earle was honored with the Winsor McCay Award of lifetime achievement for his contribution to the art of animation. Since Earle's death in 2000, his personal paintings have grown in popularity, especially in Japan.

In his paintings, Earle picked up where God (or evolution, or the Looney Tune God of Evolution) left off. Magical, pristine, yet dynamic as all hell, his oil landscapes capture his reverence and wonderment for the chaotic and beautiful forces of our terra firma. But Earle knew better than to try to capture his ever-evolving subject itself, instead he bears witness and goes somewhere else—with us in the backseat, along for the ride.✦

Special Thanks to Tom and Excellent Virtu and the Van Eaton Gallery for assistance with this article.

Eyvind Earle

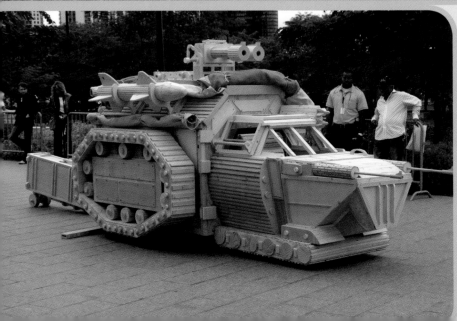

Mike Rea

Happiness is a Wood Gun

by Matt Holdaway

The best thing to happen when I took shop class was when one of the metal shop students heated up a piece of iron and dropped it into another student's pocket.

Had I the vision of Mike Rae, I would have listened more closely on how to use a table saw. Rae works with wood the way I worked with margins on math tests. The rocket ships and machine guns I created with ballpoint pale in comparison to the life-size time machines, M-16's, and mech suits Rae builds from wood. Measuring not twice (or not at all sometimes) and cutting once, Rae uses standard construction lumber to bring into this world what was once only imagination. Space capsules, sea monsters, jet skis, weapons of destruction, time machines, and even the highly searched-for Ark of the Covenant are all within Rae's grasp. Almost. The semblances bring the image into the hands but the true function remains fantasy.

Hailing from the Midwest, Rae brings an honest and earnest approach to his work and isn't shy about building large. I spoke with Mike about his work.

Were you sculpting in high school?

My school had one art class. I made a ceramic gargoyle and carved something out of balsa. It wasn't very good.

Did you sculpt in college?

Originally I was painting. During an art investigation phase I surveyed other things. Some of it was pointless. Weaving. It was a pain in the ass; I had to load a loom up with thread. And it's built one thread at a time.

Yeah, like don't we have a robot that can do this? At this time you were working on your Bachelor's in Art Education. How did you transition into sculpture?

The Art Ed worked out with the survey because I did stone carving and welding. I liked building stretchers and was getting finicky about getting them to square up. I started doing lap joints. I liked it. Everything came out of the first little table saw. After seeing a Charles Ray retrospective and some of H.C. Westerman's work I decided I wanted to sculpt instead of paint.

At your shows are all of your works available for purchase?

I've sold some of the small stuff but not the jet skis or things like that.

It seems after such hard work, it would be hard to part with them .

Yeah it is, but once you've lifted it up the stairs a few times you feel that you've had your time together. Especially when I consider how much space these things take and I want to keep creating new work.

Is your home covered in space suits, wood bullet casings, and fire extinguishers?

I just built a loft. I have the bed from *Diff'rent Strokes*.

Awesome!
Yeah, it's awesome except for there's no Willis. Or Abraham.

Are you enjoying doing larger installation shows?

It is fun and the curators have been really nice. I got there to set up and there were people there to help wearing white gloves. I was like, "I'm not wearing them." One nice thing about larger shows is people helping you carry everything and set up. Sometimes the wood expands in the move so

people seem nervous when setting it up but I tell them, "Just kick it. It will fit."

I love the wookie piece.

For that I was thinking about Mayonnaise Olympia with a wookie. I was thining hairy body. When you see it in real life you can see the little bald spots on the knees.

Many of your pieces show an affinity for Science Fiction and pop culture while paying homage to the classics. What are you currently working on?

I've been working on myself in carbonite. I was thinking of Robert Morris with the overall shape. I have my hands behind my head kind of relaxed. I kind of made my gut a little bigger that it is. Well maybe it is that big. I made my penis huge. You've got to take them when you can, you don't get paid a lot with this job.

With each work Rae completes, he learns more techniques that enable him to bring larger and more elaborate works to life. His latest solo show is now at the Contemporary Art Center of Virginia and he is preparing for the touring silent auction show/party *Baby Robot.*✛

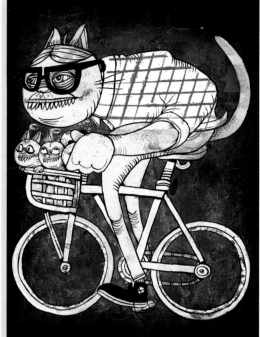

"I feel like I deal better with two gigantic invisible gorillas in the room. They keep each other company."

by Ert O'Hara

Hi-Fructose spoke with gentle conjurer of whimsical monsters and silly animals, illustrator Ferris Plock, in the days following the opening of *Circus,* a two-person show he produced with his fiancée, artist Kelly Tunstall. Two days after the opening of the show, the pair was married in a low-key ceremony at the gallery with their artwork as a backdrop and testament to their compatibility.

"My mind is still kind of running a mile a minute. It always does after an opening. I have been lurking around the dungeon [the garage turned studio that the two have shared for the past two years—Ed.] kind of replaying the show and the

last couple of days. I haven't really been on my regular routine this past week. I like my routines. I am an old man that way, so it's kind of weird to not be in the studio working on the show. Man, I had a great time at our opening though. Lots of good people there to share the celebration."

For all it matters, Plock is a Bay Area native. Though he was born in New Jersey, he grew up in various outlying suburban cities near San Francisco, where he now lives and works nearly non-stop. "I feel like I deal better with two gigantic invisible gorillas in the room. They keep each other company," he says of the mania surrounding producing *Circus* while also planning their wedding to coincide with the opening of the show. "I can be more functional and aware. I just obsess about stuff if I am left to my own devices, and when there are two projects, there is little to no time for pausing." When he needed a break from the gorillas, he worked on other smaller projects—one, a series of "clown cones" that were displayed at the show, but not listed for sale [nevertheless, they were

Ferris Plock

The Gorilla in the Room

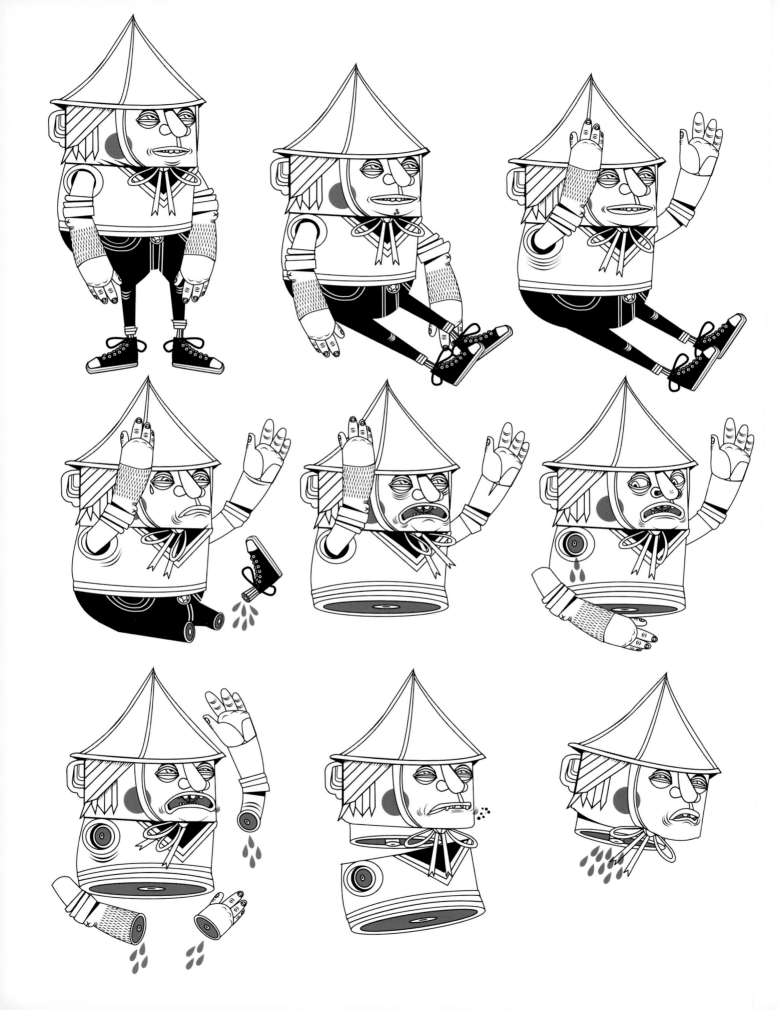

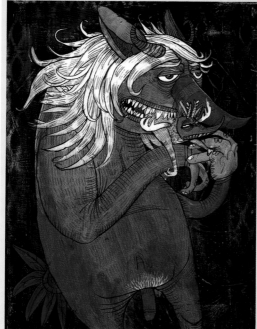
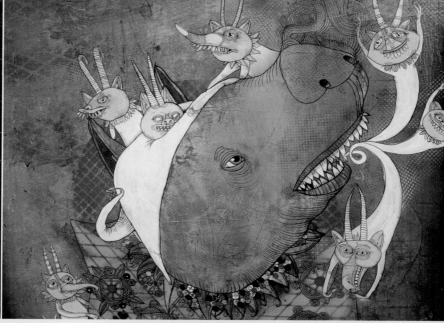

scooped up by a local collector—Ed.]. "I was like, '*wait I should be doing stuff!!!*' Those were my oasis within the show; a fun project within the project."

Plock elaborates on *Circus*' origin and underlying themes: "We both have a fascination with the different characters that made up the depression-era traveling circus. We were really interested in how these different circuses traveled from city to city. All the stories are about 'when the circus came to town.' I was just interested in, 'How does the circus get there?' I feel like the circus is the perfect metaphor of what has been going on in our country the past eight years. You will see the number eight in multiple pieces and you will also see the number eight on its side, which I meant as the infinity sign. In other words, the last eight years of our country being run by clowns has felt like forever.

"Most of my paintings depict animal parents teaching their young how to escape the circus, or juggling clown heads, or tossing exploding bananas. I really feel like the circus allowed me to explore my feelings about how our country has been run (thus the decapitated clown heads hanging in the front). I tried to make it tongue-in-cheek so that a viewer could enjoy the work, but also maybe pick up on some of my ideas."

The circus might also be an apt metaphor for the zany cast of characters who make up the population of San Francisco. Plock is particularly enamored with the city. "I love it here. I like that it's okay to be unpolished. You can figure your shit out here because the climate is forgiving and understanding, and then you take your shit on the road."✛

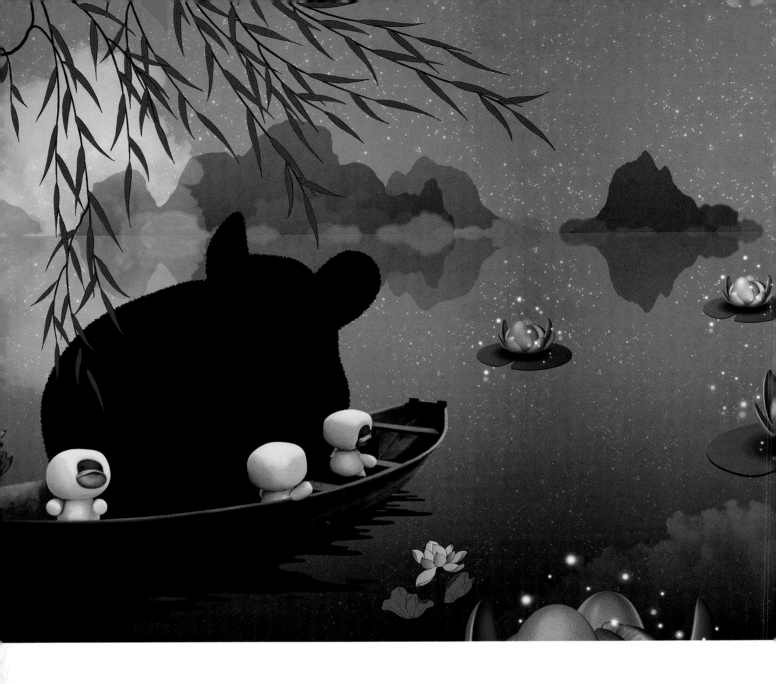

OKSANA BADRACK
MOON OVER DRIFTERS

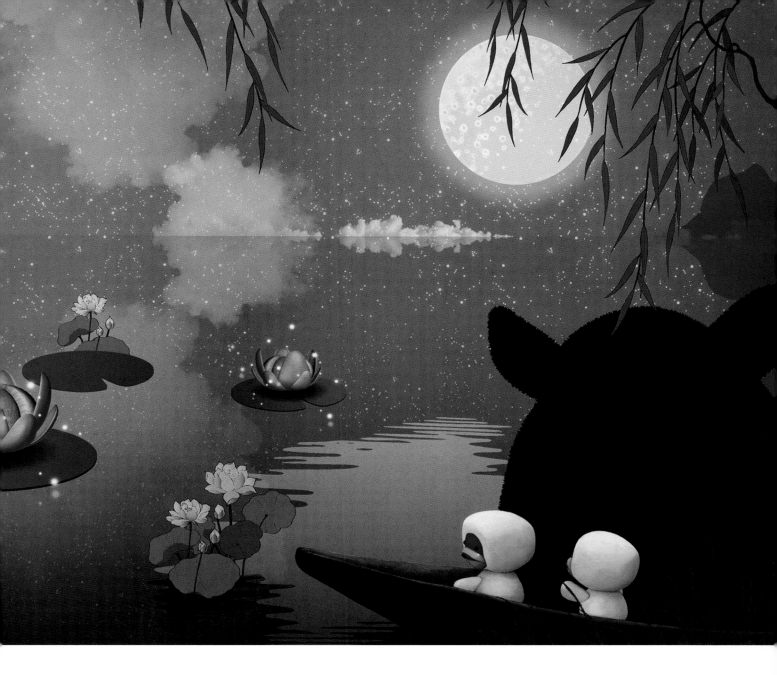

Interview by Annie Owens

Oksana Badrak's solo show at the Black Maria Gallery in Los Angeles (June 2008), exhibited a new body of work reflecting "weathered evidence of fantastical worlds that remind us of our own, although many surprises await."

As a graphic illustrator by trade, Badrak's personal work is naturally informed by her editorial projects, but her style can't be fully explained so simply; it's much more layered than that. It reverberates with warm sensitivity to the way she creates her own personal universes—parallel to the one to which we are bound.

Her work shows a variety of animals as the dwellers of richly textured environments, unrestricted by the usual rules that govern the mundane real world.

The sense of a warm dewy atmosphere, or the chilliness of a wide-open expanse of ice and snow, is amplified more by the use of mixed mediums. Elements such as digital renderings,

vintage papers, ink, photography, and paint extend the paintings' sense of wonder and spirituality right off the edge of the paper.

Badrak has been featured in numerous exhibitions in the U.S. and abroad, including galleries such as Art Prostitute, Roq La Rue, OX-OP, Strychnin and Junc. She's been published in magazines such as *The New Yorker*, *Playboy*, *Entertainment Weekly*, and *American Illustration 24* to name a few, and maintains an impressive client roster, which includes Nike and Warner Brothers.

Oksana moved to California at the age of 15 from her homeland in Moscow. She developed her unique style in illustration during her education at ArtCenter, from which she graduated with distinction.

I had the fortune to run into her at the Fusion 5 Festival in Cannes, France this past spring, and was happy to finally put a face—and a warm and endearing personality—to her art. Here she takes some time to speak with me about her work.

Annie O. (AO): Can you talk about the animals in your work, like "Winder Fox"? Why do we only see his back end walking out of the scene? And would you comment on the two "Great Flood" paintings?

Oksana Badrak (OB): It's funny that you ask about the Winter Fox. I remember seeing a seemingly typical child's drawing of a shiny sun and grass with an orange scribble off to the very edge of the paper. What excited me to no end was the title, "Fox Leaving." I thought it was genius. When I decided to make a painting of a fox, I couldn't help but remember that kid's drawing and marvel at the sensitivity with which he captured the fleeting nature of that very elusive animal. So, I guess I kinda ripped him off.

The Great Flood paintings came around the same time as all of those horrible tsunamis and floods that afflicted our world. Whenever I think of floods I remember a piece of Russian schoolbook text about an old man named Mozai, who lived alone in a small log house on a hill on the very edge of a forest. Every spring when the melting snow flooded the woods, rabbits would seek refuge on stumps or fallen trees, going without food for days. Year after year, old Mozai took out his row boat into the flooded forest to collect poor rabbits by the hundreds. He brought them to his house to wait until summer, when the water had subsided. The imagery that story evoked always moved me

as a child. So the Flood paintings are a weird reflection of those things.

AO: The Triptych of the bears, "Moon Over Drifters."

OB: The bears in the triptych are very special to me and I know their shape very well. One of the dwellers in our house is a chinchilla named Guinness. Sometimes I wake up in the middle of the night and see his very graphic magical, black silhouette against a wall, which always gives me pleasure. I guess I wanted him to make an appearance as a very mysterious, larger-than-life character in the "Moon Over Drifters" piece.

AO: "West" shows a pretty dark, but charming sense of humor. What's happening there?

OB: The piece started out as a sketch for *The New Republic* magazine cover. The issue focused on the topic "Television in the Era of Bush." It was rejected, as it felt overly dark; a brighter, weirder version of the piece ended up being printed on the cover. I felt a strange attachment to the darker piece and eventually painted it for a show that was coming up at the time. And actually, a lot of pieces I show in galleries are editorial rejects.✦

Femke Hiemstra

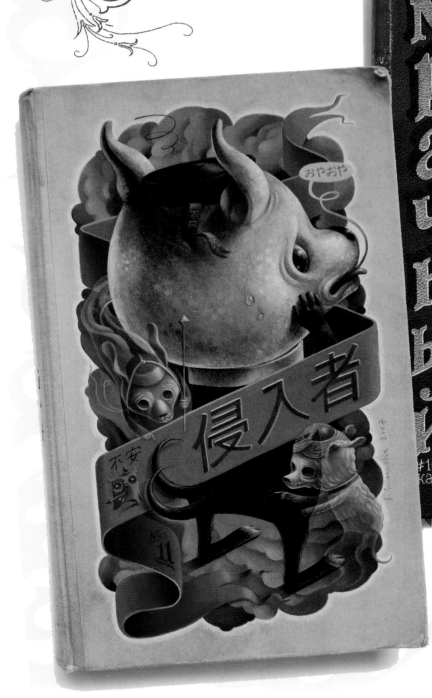

(left to right)
"Intruder," "Mr. Macabre,"
"Chat Domestique,"
"Ursus Astronomia"

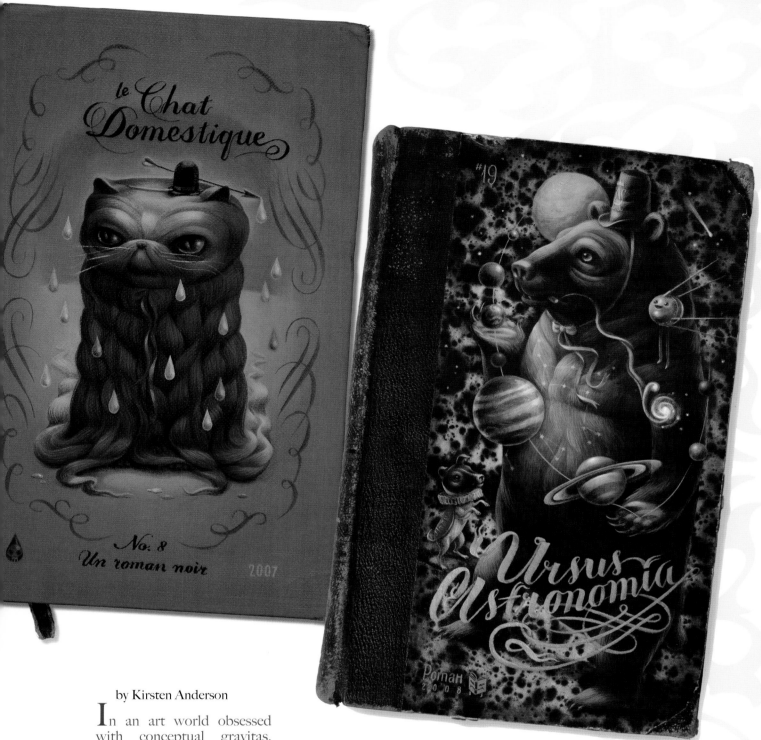

by Kirsten Anderson

In an art world obsessed with conceptual gravitas, it is refreshing to find artists who happily work within their own framework, academic seriousness be damned. Sometimes eschewing the critically accepted standards of art-making brings forward a truer kind of art, which, despite its easy palatability due to refined technique and whimsical humor, actually speaks deeply to the human psyche's need for talismanic symbolism and the timeless desire for mystery and wonder.

Femke Hiemstra is just such an artist. Hailing from Amsterdam, Femke brings the concept of the magical object to full force. Her immaculately rendered drawings and small, jewel-colored paintings are reminiscent of the more fantastical works of Alan Aldridge and Mark Ryden, a opulent mélange of fantastical flora and fauna, fairy tale and folklore, albeit with a darker bent and more ebullient humor. As I became more exposed to her work I found that while she maintains the rigorous technical standards of Pop Surrealism, her work has a twist that differentiates it from the usual hallmarks of the genre.

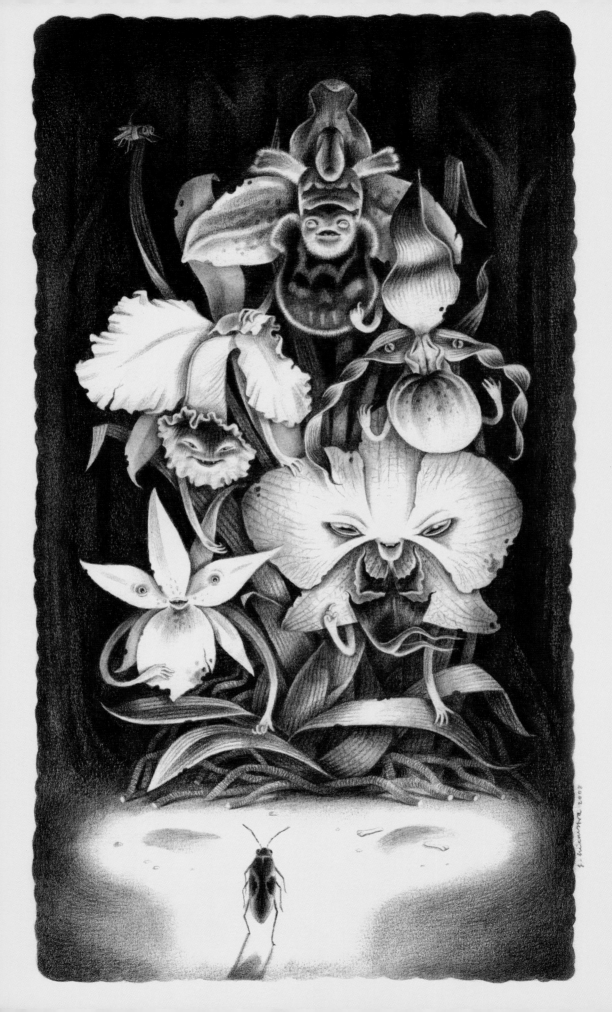

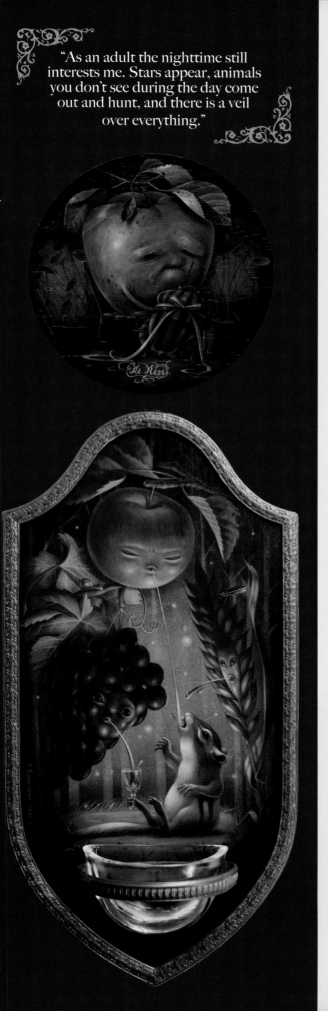

Her works are almost always painted on found objects, which are endlessly sought via trips through thrift stores, flea markets, and antique malls. The original object must have it's own peculiar aura... something that sets it aside from its companions in the crap piles. Recently I went with Femke on a search for objects at a flea market in Seattle. As piles of strange items went unhappily discarded, she finally found a treasure, a teeny vintage flashlight in the shape of a red puppy, that as Femke held up with a victorious smile, suddenly took on a strange importance, a tired piece of battered plastic rescued to become a pop talisman.

These found items are then painted on, transformed from the mundane into wondrous objects seemingly from a fairy tale land. An old box of matches becomes a box of magical flying jellybeans, meant for consumption by a sinister looking radish. Orchids with sinister bat faces turn the tables on wayward beetles. A cookie tin becomes the frame for a painting about a "Fortune Cookie Hunter" (Femke's work is heavy on the puns) who must search out and fulfill his sick, cannibalistic addictions.

Multiple phrases from various languages are worked into each painting as well, usually alluding to the title or adding a secret joke to the image.
Books are favorite canvases, with the covers repainted with fanciful and wonderful narratives. These objects are locked up tight in frames that keep the works behind glass and sealed up, which only enhances their mystique. In addition, Femke sometimes adds things to the works and doesn't tell anyone, sometimes tucking secret notes in the glued-shut books but never telling which ones have them and which don't.

After a week-long trip in Seattle scouring antique shops, I made Femke finally sit down and reveal some of her secrets to *Hi-Fructose*.

How long have you been painting? How did you get started and ultimately decide that you wanted to make a living doing art?

I kind of rolled into doing art. I was an illustrator for about nine years, doing mostly editorial stuff about kids with cell phone addictions for example, or mortgages and pensions. Then in 2006 I was offered a spot on a group show at MF Gallery in New York City. I did not have that much personal pieces so I sent in a couple of prints. When they asked me back a second time I created some new paintings. Then Roq la Rue Gallery crossed my path and offered me a shared show with David Ho and Ronald Kurniawan. Serious stuff! I felt like I found a new creative goal and I decided to switch to making solely art and try it for at least a year. I wasn't fed up with illustration or anything but creating my own stories in paint was just much more fun. And it still is.

Why do you choose to work with found objects rather than traditional canvas?

I'm a big fan of old packaging and book designs with dramatic typography. Something modern with Helvetica often doesn't do it for me. I like the older stuff because it's damaged and those cuts and scratches tell a story of their own, they breathe life and uniqueness. When I paint on those surfaces the story continues, so to speak. It also gives the objects a new life.

When I go out to search for new old books I usually go to secondhand bookshops. Sometimes a shop owner—often an older man—wants to know why a (relatively) young woman buys such old books. One time I explained I use them to paint on and that I cut a big hole in the pages to make the book less heavy. I never forgot the look of horror on the shop owner's face; he went completely silent and I slinked off. Ever since then, when asked, I lie and tell them the books are a gift.

What is influencing your current series of works?

Influences are all around me; in a single word or a song, a rusty Coke can, or the stuff my silly cat does. Anything can lead to a story in paint. Pictures and photos always work for me like the Hulton Getty Picture Collection or my collection of scrapbooks with old foreign matchbook designs. The written word also gives me inspiration. My latest work was partly influenced by *The Devil's Picnic* by Taras Grescoe, a book on the forbidden fruits of this world like Absinthe, Cuban cigars and Hjemmebrent (Norwegian moonshine); an amusing and very informative travelogue with sharp observations and lively descriptions.

Many of your scenes look like they are happening at night... why is that?

Kids can have a huge imagination, and as a sensitive, creative kid I was perhaps a bit over the top. My thoughts often ran off with me and especially during the nighttime I could lose track of reality. As an adult the nighttime still interests me.

"When I paint on those surfaces
the story continues, so to speak.
It also gives the objects a new life."

Stars appear, animals you don't see during the day come out and hunt, and there is a veil over everything. Secret meetings or creepy stuff in movies practically never happen during the daytime. Darker characters in movies appeal more to me than heroes. The dark triggers the mystery. I love it.

I like to have a feeling of mystery in my work as well; I can play with strokes of light and show bit and pieces of what's going on in my universe. I feel it adds to the story and the emotion of my characters.

Can you talk about your technique? Your painting is so refined, the tiniest of objects are rendered so perfectly. How do you start a painting?

I start with making tiny thumbnail-sized sketches. They are easy and fast to make and it takes little time to see if something works or not. Also, I'm not comfortable with making sketches right on the surface. My handwriting (at this moment) is small so I'd like to stay close to that. I enlarge the sketch digitally to keep the right composition and 'swing' in the lines. Then I print the sketch and color the back of the paper with chalk or pencil. Next I put the sketch on the surface I want to paint on, trace the sketch lines and by doing so transfer the lines on the surface.

There's no regular order when I paint. Often I begin with the background but I sometimes start with the most interesting thing: the subject I've been looking forward to painting, like the expression of a creature or a character in my head that's dying to get out. Then I simply can't wait. I build it up out of multiple transparent layers of acrylic paint and it can be sheer fun to see it come to life.

Do you use any kind of magnification or just sit very close to the work as you are painting? Do you listen to music when you paint?

I don't use a magnifying glass, no. I don't wear glasses either. I still have good eyes I guess! It depends on my mood but most of the times I listen to music when I paint. I dig anything from alternative and indie to rock, post punk/British bands, (freak) folk, (baroque) pop, or music from motion pictures... I work at home, which works out well as I often like to sing along and do an occasional drum solo with my Wacom pen.

Are there artists you would cite as inspiration?

The Clayton Brothers are two of my favorites. I especially love their tattoo-influenced works with animals from some years ago. What appeals to me in general is that they dare to take it over the edge. It's wild and weird, both in style and story, and therefore full of emotion to me. I sense the energy and that's really inspiring. I'm also fond of early Renaissance works like the paintings of Giotto—with the first use of perspective—or the fantastical creations of hell that Hieronymus Bosch made. All the skulls by J.G. Posada... the art of Max Ernst... In a perfect world "The Elephant Celebes" (by Max Ernst) would hang in my living room next to an original Clayton Brothers, like the *Carl and His Dog Snowball* series.

Your work has a certain "lightness" to it, a fantastical element and a lot of humor. Many artists seem obsessed with their work being "serious" and ideologically heavy. Do you ever worry about that as you are entering the "fine art" realm?

No, not really. Maybe those artists should sing and drum along with music more. ✦

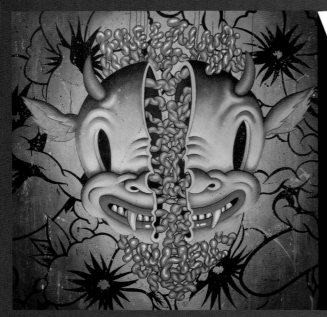

Victor Castillo's
Appetite for Destruction
by Kirsten Anderson

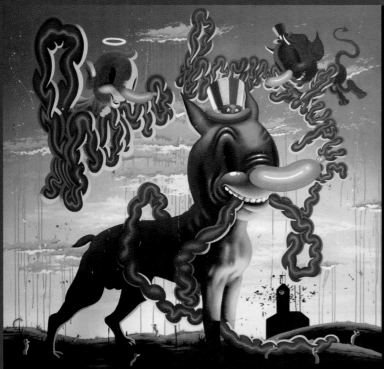

*L*ooking at the dark pop of Chilean born artist Victor Castillo breeds a certain sense of uneasiness.

A brutal darkness emanates from each canvas beyond the initial reaction to the cartoon grotesquery and goofy over-the-top-ness of sausage-nosed, hollow-eyed characters with a penchant for gleeful violence, writing out words in juicy entrails and carrying the cross. This uneasiness stems from the realization that although we initially think we are just shocked by the brightly colored (and well-executed) ghoulish images engaged in vicious shenanigans, we realize that we are familiar with these worlds in ways most of us would rather not think about. And that's just the way Victor wants it.

When asked about what effect he hopes his work has on a viewer, he says: "First a sense of amusement, then anxiety. The idea is to seduce the viewer in and then provoke varied thoughts beyond the initial reaction. There is a very dark and seriocomic vision of the world behind my work."

This vision is prompted by the injustices and hypocrisy perpetuated by the questionable promises of capitalism,

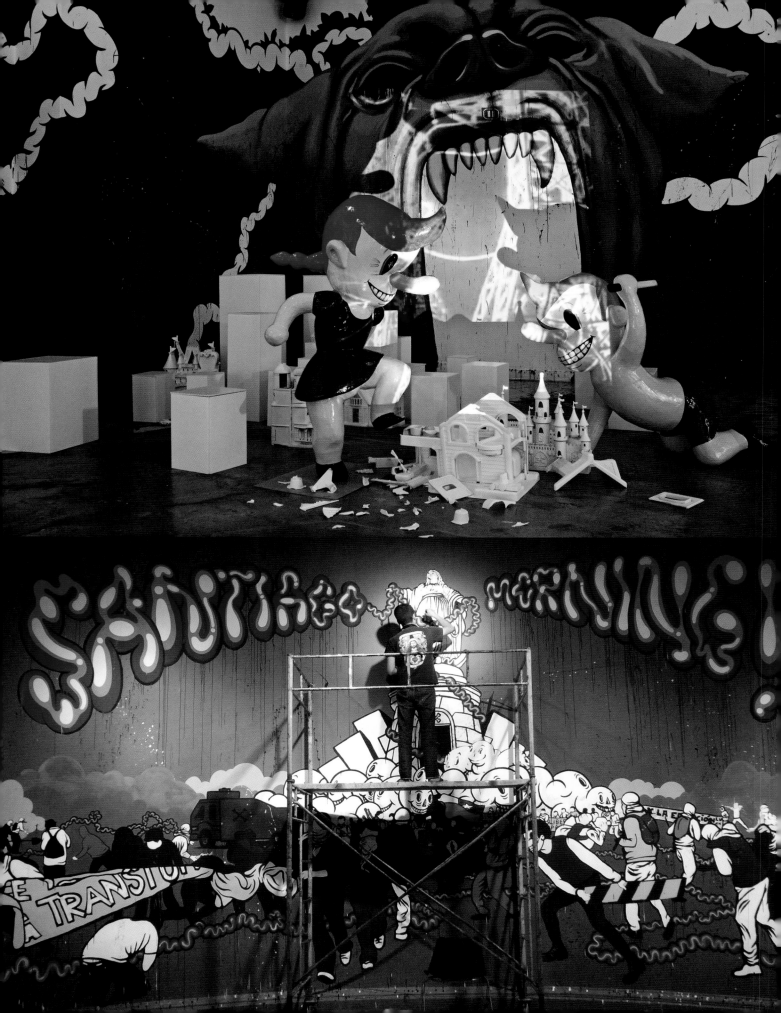

global politics, and religion rampant in the world today. He states, "I don't adopt any political militancy. I try to have a wide and critical approach to politics in general, paying attention to the opinions at different social levels, but always from an apolitical position. I deeply mistrust both politics and religion." But clearly his work is influenced by much introspection and investigation into the workings of human interaction and power plays through history, as references to societal disasters (including everything from illuminating the darkest church controversies to making fun of white power ideology) attest.

Castillo's work adopts the use of comic characters that are reminiscent of the early days of cartoons, but he has altered them: grins become leers and happy smiles only reinforce the inhumane. He feels that cartoons have a bigger impact on young minds than usually considered.

Victor explains, "(As a kid growing up in Chile,) I was fascinated by the classic cartoons that I saw on television and magazines. I learned to read with the Hispanic American spelling book which had drawings very similar to Walt Disney and similar (artists)... and so that aesthetic was very present in Chilean children's

literature. Many of those early cartoons were very racist, and have since been censored or re-edited, but to me it all points to an external influence on a postcolonial continent in which we are indoctrinated unknowingly by the centers of power with caricatures. We still have those hegemonic models."

In Victor's narratives the cast of characters usually feature hot dog noses and hollowed out eyes. This is to represent excitement, arrogance, desire, and the thought of cannibalism (given the obviously phallic noses) juxtaposed with unconsciousness, blindness, insanity and dehumanization represented by the empty eye sockets. Additional common traits to his paintings are the use of lighting (characters are often tellingly lit as if from flames from below) and children in Victorian finery often doing horrible things. "The Victorian children in my paintings represent the old Europe, (which was) ethnocentric, imperialist, and deeply Catholic and puritanical, and the influences that had. I am interested in showing that contradiction of cruel innocence and hypocritical indoctrination as a metaphor for the origins of the current capitalist, postcolonial society and all its attendant brutalities. Hypocrisy is very intact in this age of globalization, where in the name of "peace and

freedom" countries are invaded and bombarded for economic reasons, but those reasons are hidden behind proclamations of good intentions in the name of God and the Truth."

This is not to say that Victor's work is not without its humor, albeit black. Victor's work shares the same darkly comic viewpoint as his influences who he cites as Gary Baseman, Ron English, Mark Ryden, as well as the unapologetic gross-out joys of Spumco (most notably the *Ren and Stimpy* cartoons). He says that while he has been drawing his whole life, he has only been seriously painting for about five years, inspired by the artists just mentioned, and his oeuvre includes mixed media work and large-scale murals as well as canvases.

In addition, Victor is a rare breed of artist who enjoys working in multiple disciplines... wildly prolific, recently he has been exploring performance-based pieces. "To work in a space using experimental and ephemeral materials is something I have always been attracted to, but I haven't done anything

yet that I feel really stands out. In recent years I have concentrated more on drawing and painting, however I would still like to go back and stage more performance pieces, and I'd like to really extend the complexity and visual elements of them. For example, reinforcing the playfulness and humor in my work by using more disposable materials like toys in conjunction with wall painting."

In addition to pushing the envelope both artistically and discipline-wise, Victor has a head-spinning itinerary ahead of him as galleries all over the world clamor for his work. Represented in his current hometown of Barcelona by Iguapop Gallery, he has shows and works appearing in art fairs booked for the rest of the year in Los Angeles, New York, Shanghai, Tokyo, Barcelona, Santigo de Chile, Seattle and Berlin.+

Translation assistance for this article was provided by Inigo Martinez Moller and Gillian Hanington.

The Unorthodox Taxidermy of Dr. Seuss

by Attaboy

Theodore "Ted" Geisel, better known to adult children as Dr. Seuss, wrote and illustrated 44 books for children under the Seuss name, as well as several other books for kids using the pen name, Theo LeSieg ("Geisel" backwards). Giesel left his indelible Sneech stamp on society as the famed kids' book author (read: revolutionary) who planted his irreverent seeds in conformity's garden, just when society needed it the most. However, Geisel also lived a full and surprising life that many aren't familiar with.

From the start, Seuss thumbed his nose at authority and its many shape-shifting forms, through political cartoons, instructional animations created with Chuck Jones and company during World War II for the G.I.'s, and even co-wrote/directed an Academy Award winning documentary/post-war scare film with his first wife called *Design for Death*. Once asked to give a college commencement address, Geisel spent a year honing his speech down to 78 words. Seuss found ways of stating his mind without the constant blathering he was so against.

The good doctor also left us a plethora of unconventional personal work to rediscover—the kind that won't be translated into a Mike Meyers-starring popcorn movie any time soon. This secret art of Dr. Seuss includes a collection of Spooky Seuss-scapes, bizarre cat paintings, unfinished introspective books, and these bizarre and ingenious sculptures made in the early 1930s.

Seuss created his Collection of Unorthodox Taxidermy in a cramped New York City apartment. The "Two Horned Drouberhannis," "Andulovian Grackler," and "Semi-Normal Green-Lidded Fawn." and other beheaded beasts were not mere hunting trophies of defeated animals proclaiming humans as food chain master. Seuss' goal was to create the animals' own fantasy version of themselves. He used real animal parts, including beaks, antlers, and horns from deceased animals, all given to him by the Forest Park Zoo where Geisel's father was a warden. They hang with beaming smiles, painted in bright colors, and exhibit their horns and plumage with pride. In these sculptures, a bizarre Shinto meets a... uh, Seussian spirit of the animal—lived on happily, with eyes wide open, proud.

As more and more contemporary artists like Scott Musgrove, Liz McGrath, and the new wave of roadkill-searching Rogue Taxidermists build in popularity, it's nice to look back on our beloved friend to free thinking, Dr. Seuss. Always ahead of the mental curve—even 70 years ago.✛

The Collection of Unorthodox Taxidermy *is now available in limited edition, hand-painted resin-cast reproductions through authorized Dr. Seuss dealers.*

The Art of Dr. Seuss collections are created in an exclusive publishing arrangement with Dr. Seuss Enterprises and with the approval of Audrey Geisel. A special thanks to The Chase Group for providing images for Hi-Fructose.
All images ©Dr. Seuss Enterprises, L.P.

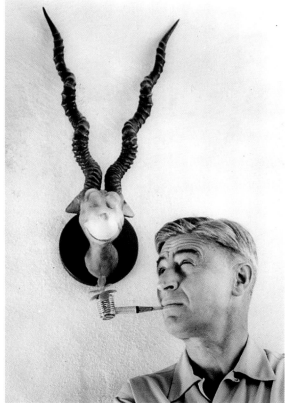

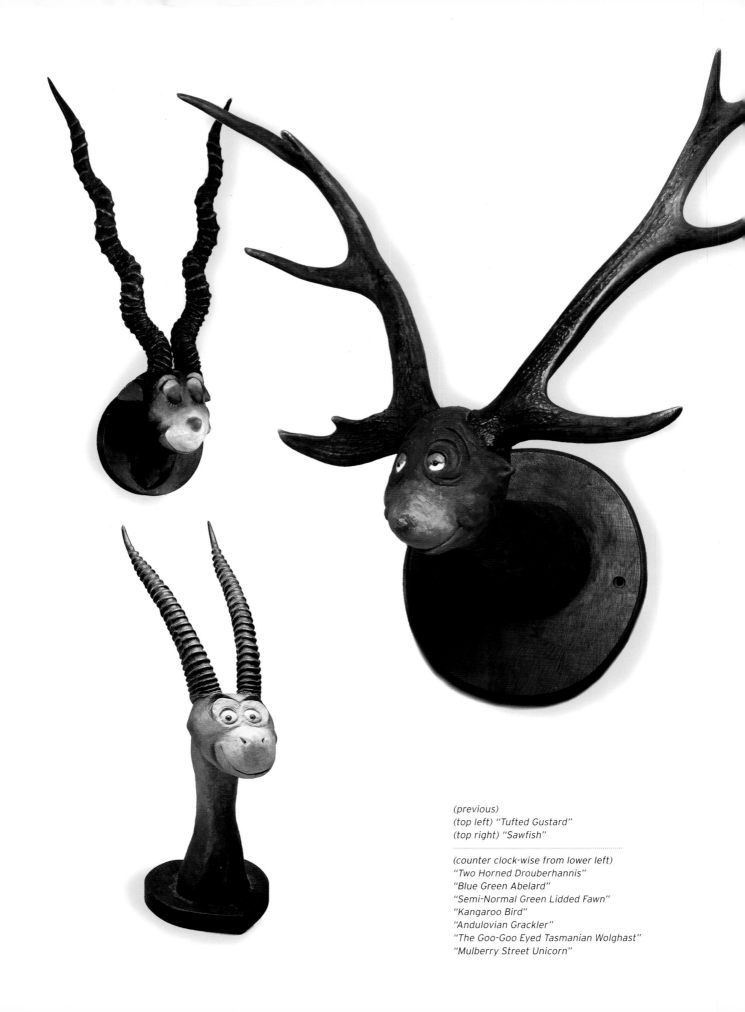

(previous)
(top left) "Tufted Gustard"
(top right) "Sawfish"

(counter clock-wise from lower left)
"Two Horned Drouberhannis"
"Blue Green Abelard"
"Semi-Normal Green Lidded Fawn"
"Kangaroo Bird"
"Andulovian Grackler"
"The Goo-Goo Eyed Tasmanian Wolghast"
"Mulberry Street Unicorn"

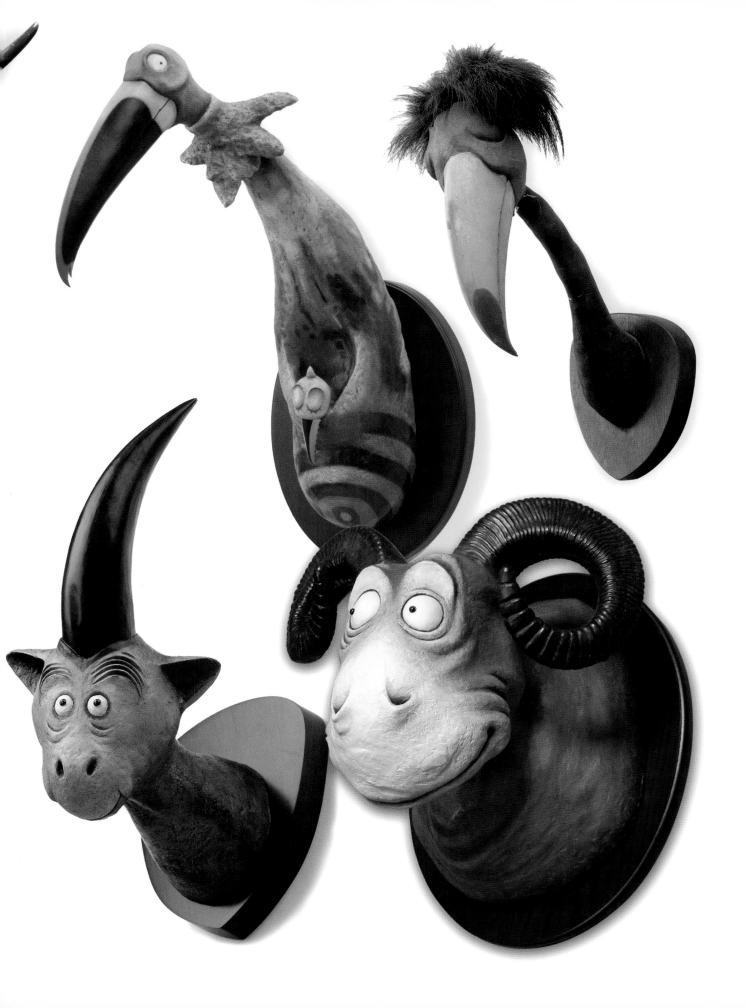

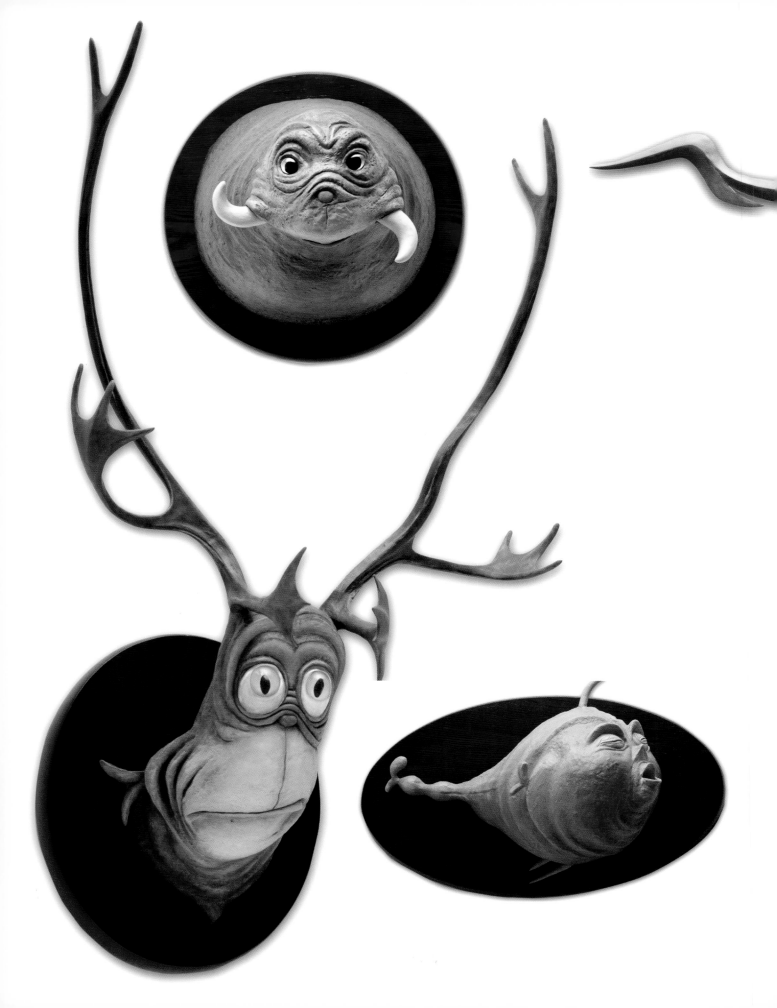

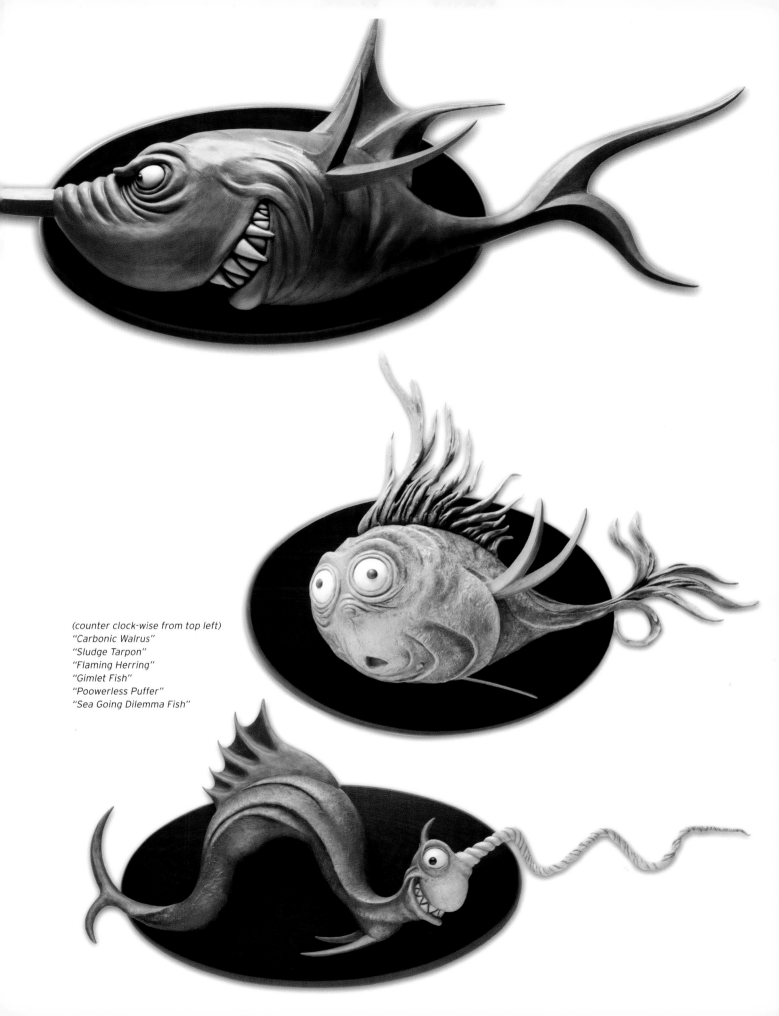

(counter clock-wise from top left)
"Carbonic Walrus"
"Sludge Tarpon"
"Flaming Herring"
"Gimlet Fish"
"Poowerless Puffer"
"Sea Going Dilemma Fish"

ESAO ANDREWS
The Nervous Giggle Alibi

Introduction by Ert O'Hara **Interview by Annie Owens**

The presence of Esao Andrews' work in gallery exhibits has been sorely missed over the last few years, but the re-emergence of this genre-bending artist has been wholeheartedly embraced as entire collections of his work have been snatched up from the two major exhibits he's already had this year—at Roq la Rue in Seattle and Jonathan LeVine Gallery in New York City.

Since we last saw him in 2004 Andrews' surreal narratives have evolved significantly. What were once simple portraits, mainly of solitary, female characters within sparse environments, and heavy on mood, have now become more finely rendered snapshots of dreams and nightmares, rife with symbolism, unreal characters, and unexpected details.

Andrews spent his young life in Mesa, Arizona watching it grow from a nearly a desolate desert into a suburban neighborhood with all the trappings. Being one of the only Japanese kids around led to being bullied a bit, but he got into skateboarding, and had always been an inventive kid, so drawing and creating became more and more a part of his identity. By high school, he knew he wanted to go on to study art in college, which he did by attending one of the most well respected institutions in the field, New York City's School of Visual Arts. There he became friends with such illustrious peers as James Jean and Tomer Hanuka.

After graduating with a BFA in Illustration in 1996, he launched a successful career as a notable Flash animator while developing his painting chops on the side. His first oil paintings were shown at coffee shops and group shows in New York, where he still lives. In 2003, he was asked to do a two-person show with John John Jesse at Fuse Gallery and he's been in demand ever since.

Annie Owens (AO:) Your work has been absent from the gallery exhibit circuit for some time. Where have you been?

Esao Andrews (EA:) Yeah 2008 is kind of a come back for me; at least I think it is. The last full shows I had were in 2004. I'd only been in a hand full of group shows 'til this year. There were four full shows in 2004 for me as well as several group shows, and I completely got burnt out and frustrated. It's just not possible to do that and have anything good. Took some time to question what I was doing and should be doing. I'm still trying to figure that out.

AO: What were some of the things you came up with when you asked yourself that question?

EA: Art making is something I've loved doing since the beginning of time. While working at regular jobs, art was something that was about pushing personal limits. When doing shows and freelance illustration became a main source of income, it started to feel like regular work having to force inspiration for deadlines. Approaching ideas started to be based on if whether they might sell. I need to

take breaks from commitments in order to re-find love in what I do. Art-making is all I have, so if I lose interest in that, it's over.

AO: What have you been up to?

EA: I was painting that whole time trying to get better. Most of those paintings went to L'Imagerie Gallery in Los Angeles sort of on a consignment basis. There wasn't pressure with deadlines so I was able to concentrate and grow. At the time it wasn't a regular gallery and didn't hold shows—only selling to private collectors. That was a downside. I disappeared from the public.

AO: Your show at Roq La Rue this past May sold out even before the opening—that must feel great. The hiatus served you well; your new work has definitely evolved and is very strong. Was it hard to take that step back though? Were there any thoughts of being forgotten? I ask because it seems, from what I can see, many artists get caught up in things and feel they can't turn down group show after show.

EA: Yeah, it feels good to be out in the public. I was definitely scared of being forgotten because I had only just begun my career. I'm still not concerned about constantly

showing though. I don't want to have any more duds circulating out there in the void.

AO: After being away for a while, what was it like stepping back in and how did that come about? What made you say, "okay, now"?

EA: Since I had been painting that whole time, stepping back in wasn't a big deal. After doing a couple of interviews and not doing shows to follow up any hype, I felt it was time to finally start making commitments again. I had grown comfortable and needed a bit of pressure.

AO: One of the many things that stands out about your work is that it avoids trend. In the prevalence of pop(ular) art, there are a several, almost universal "gimmicks" or approaches to art that can get tiresome and cliché. How do you not fall into that trap?

EA: Thanks Annie. I have my stable of subjects that I fall back on just like everyone else. There's always a battle to find a new scene in the painted world I've been creating over the years. I'm constantly brainstorming different ways to express some vague mood because I like to have images stand by themselves without the support of a series. I've never liked doing series, nor do I want to have

a specific icon that encompasses the idea of what I'm about, as if remaking a logo over and over. In the end a painting is a piece of merchandise, but it doesn't have to be approached that way while thinking it up and making it. I just get bored very easily and don't like being repetitive. And since I do representational work, it's hard not to appear to step on other peoples' toes when it comes to imagery, so I do my best not to. If you say my work avoids trends, I appreciate that since I try (not too hard though—I still like painting dark, surreal stuff and girls). I'm aware of gimmicks out there, and uncomfortably aware of my own as well.

AO: In a past interview I read you were asked about the black humor that reverberates in your work. You said it could be a way to avoid being too corny and mentioned that you may be trying to work through that. I'd like to ask how that is working for you? To me, that sentiment reflects an endearing level of self-consciousness. The nervous giggle before saying what you really want to say.

EA: This is true. For me, I kept adding humor to an idea in order to be able to withstand criticism—by already saying, "Hey, but I'm not even serious if you think it's corny." Sort of like an alibi or a nervous giggle. At some

point I figured that it had nothing to do with what I wanted to make, but just being self-conscious. Looking around at my contemporaries I started to wonder if deep down some thought the same thing. That's why I brought it up. Eventually I'm sure I'll get the Goth moodiness out of my system as well, and then move on to something else. Even saying that seems weird though.

AO: What is "Separate Lives" about?

EA: Hmm... I made the drawing at the end of a long relationship and even though it's just a painting of a creepy house, what I'd like to believe is that it's about the end of the relationship. I only say "believe" because it was a friend who pointed out that the house had two chimneys and it looked like two people living separate lives in the same house. I thought nothing of the chimneys before, but like a horoscope, made perfect sense of what it represented. We're friends still. It's all good.

AO: The painting "Orange" has always grabbed me. It's not her nudity alone that is compelling but certainly adds to the mystique. It's her face that is unnerving. I wondered if it would be different if she weren't nude. I'm sure it's different case by case, but what do you think the roll nudity plays in your work? You use it sparingly but deliberately. It's not like "Here's a hot naked girl."

EA: Wow, I never really thought about who I choose to be nude and why. Maybe I use nakedness as a way to enhance confidence and comfortableness in a girl. You got me going through my work trying to find a reason. Seems like most clothed girls are pretty bummed; yet the nudes are just about always happy. Since being nude makes a person usually a bit vulnerable, a comfortable expression implies uber-confidence. That's the best sense I can make.

AO: This next question sounds so trite but what are you most looking forward to this coming year in terms of shows?

EA: I'm not thinking about any full shows yet, but there are two group shows I'll be in. After doing the Jonathan LeVine and Roq La Rue shows, it's time for me to rein-vent myself again. I want to work on some sculptures and other outlets besides oil painting.

AO: Your work always leaves me with the sense of being in a slow-moving dream, where you're not sure if the ending will be bad or good.

EA: Even though most of my work is dark, I rarely show actual pain or horrible anguish in an expression. I like them to be "quiet" if that makes sense, to leave the "action" in a painting left to the imagination of the viewer. I've realized this is also a crutch that I've devel-oped where I like to have the image as a still moment in whatever may be happening, or about to happen. To be sort of iconic. I don't think its bad though, but the concern is there.✦

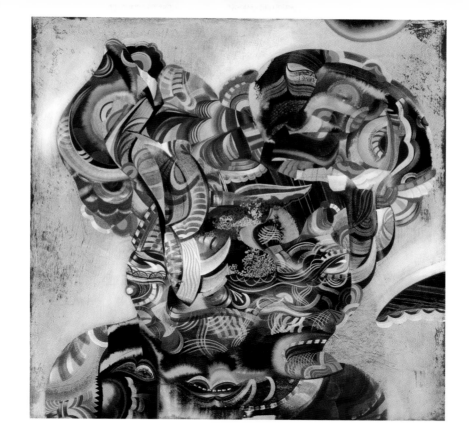

THE ART OF ROBERT HARDGRAVE

by Ert O'Hara

Farmer Bob had cancer. Let's get that out of the way right now, because for the past four years, it has prefaced nearly all that has been written about him. Frankly, he's tired of talking about it.

In 2003, his newly transplanted kidney developed lymphoma, which meant undergoing six hellish months of chemotherapy. The happy reality for Seattle-based painter Robert Hardgrave, known to his fans and friends as Farmer Bob, is that he lived through it and continues to inspire those who are lucky enough to know him. Though he'll be on anti-rejection meds indefinitely, Hardgrave is ready to seize the days ahead of him. "I continue to worry about it, and things do come up, but I am confident in living with my current kidney for at least ten more years. I was sick for a long time. It is

hard to get complacent when I think back to when I couldn't work at all. I am a workaholic and having to step back and stop was a real challenge."

After things settled down medically, Hardgrave and his wife of eight years, Stephanie, decided together that he would devote himself entirely to his art while she worked the stable, regular-paycheck-and-health-insurance-providing job. "I am really lucky in that aspect. Stephanie has been a strong support from the start. I guess she saw the potential even before I did. Having been through the medical ringer was sort of what decided some issues. I wasn't able to hold a job for a long time for health reasons, and it was just sort of how we lived. Then when I was able to work, she supported my decision to make art full time."

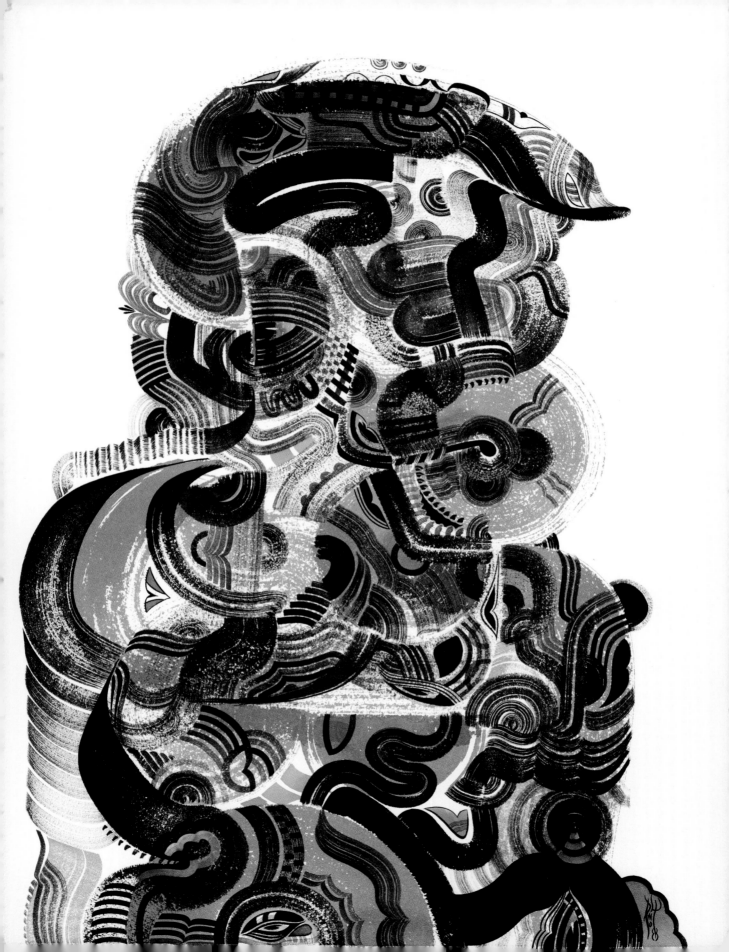

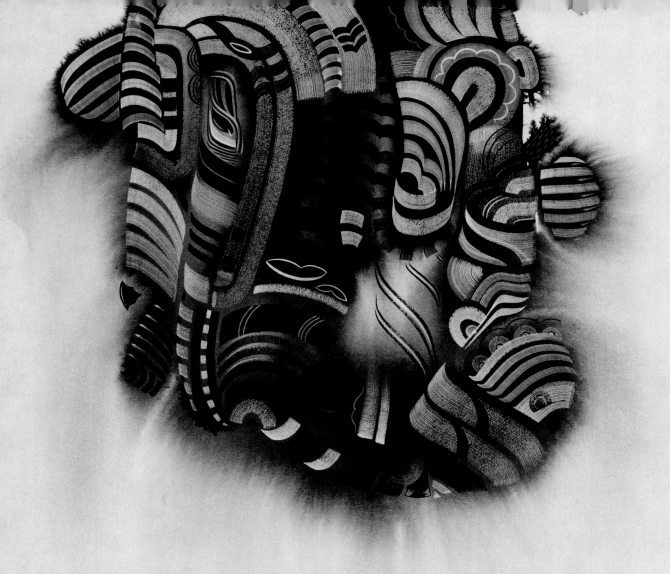

"I have a hard time sleeping because I am always thinking about painting. I'm obsessed. Possessed. Something... I feel the best when it is happening."

Hardgrave's paintings are the result of complete immersion in the process, most of the time with unintelligible death metal blaring non-stop. To meet Hardgrave in person, you wouldn't suspect this soft-spoken 39-year old with a Zen-like countenance to be a die-hard fan of such cacophonous music, but it turns out that it's an integral part of his creative process. "One of the main reasons I listen to what I do is because of all the syncopated rhythms and dynamic nature of metal. It is pretty organic hence, organic works. There is a certain point in working where you reach a sort of automaticness and it comes from something inexplicable. With music, I can arrive there much sooner because of the way it makes me feel. It's a beautiful thing." He freely admits to being in love with painting: "I have a hard time sleeping because I am always thinking about painting. I'm obsessed. Possessed. Something... I feel the best when it is happening."

Hardgrave's work has continued to steadily evolve as he tries new media and techniques. "I've been doing a ton of collage, which is really fun and different, yet has some limitations. It creates a closed-off effect not leaving it to open up like a painting can. I like this direction although I have been playing around with a bunch of other ideas as well." Along with being an inspiration to his peers, he steps out of the studio on occasion to observe. "I have been exploring some local Seattle artists who have been around for a while: Gaylen Hansen and Faye Jones. My new work has a more narrative aspect directly relating to these other artists. Format as well. But I get inspired by more than

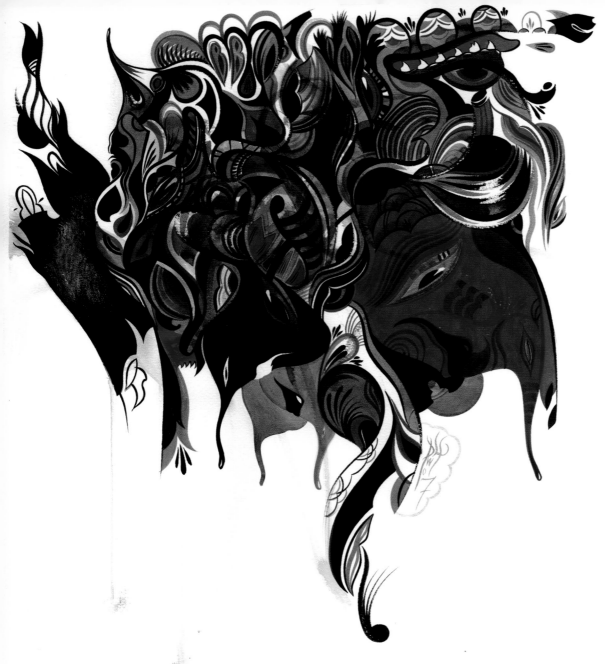

just art: life struggles, music, and moving through my own processes to find gems to work with... I once read a quote from Pushead that you won't really see who you inspired until ten years later."

Speaking in depth about his current work, he says, "It's colored inks on rice paper. I made my own patterns and just cut them up and found what I found: my normal method, just a different format. I had been working on some pieces for the BLK/MKT show that had some collage in them, but I ended up not sending them. About a week before that exhibit, I participated in a 24-hour painting marathon. That was where I just let loose and did some works that were all collage, and they were invigorating, so I decided then that I was going to explore it and see what happened. I've been making these round pieces, and friend of mine is fabricating metal hoops for frames."

The recently opened Joshua Liner Gallery in New York City (eponymously spearheaded by Liner, formerly of Lineage Gallery in Philadelphia) hosted Hardgrave's first major show of the year in May 2008. "I have a show in August at Limited Addiction in Denver [a duo show with Matthew Curry—Ed.]. I've already started with a batch of new pieces. I have been bubbling with new ideas lately and I want to get them out before they disappear. This has been the busiest, best time thus far in my life. It will be empowering to look back on. I feel good and am excited for what's next." He enthuses, "Next year we're throwing a black metal birthday party for my 40th. You should come and wear black metal garb, corpse paint, and all that. [We'll have] a big upside down cross cake!! It's going to be evil. And fun!!" We'll be there with hell's bells on. Wouldn't miss it for anything.✦

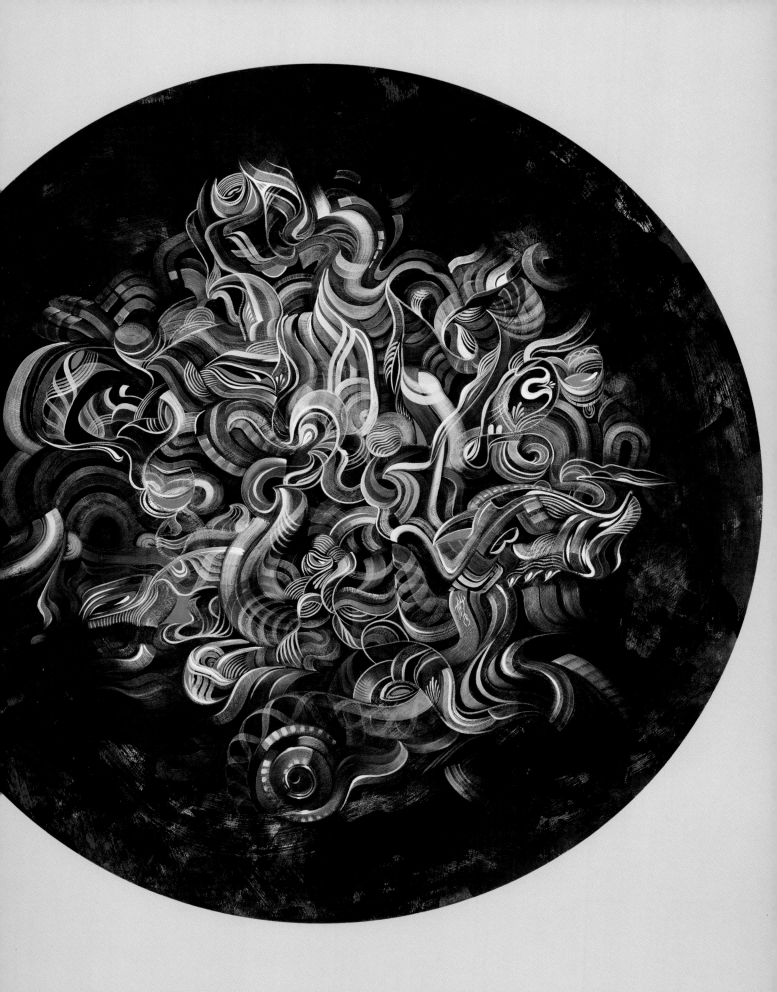

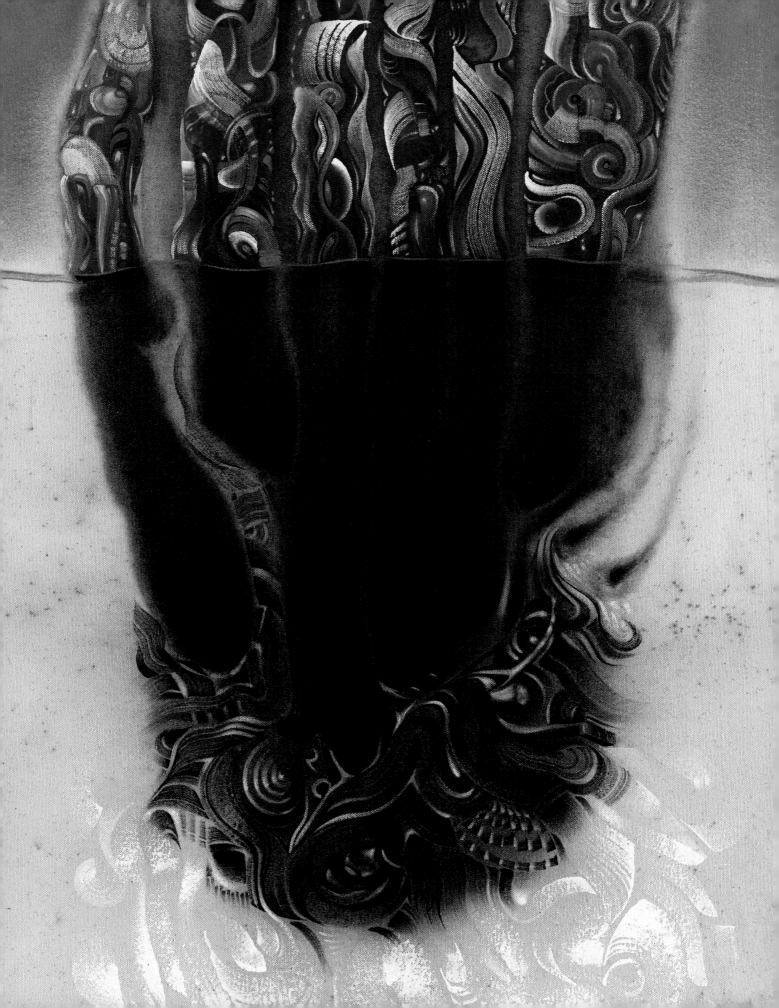

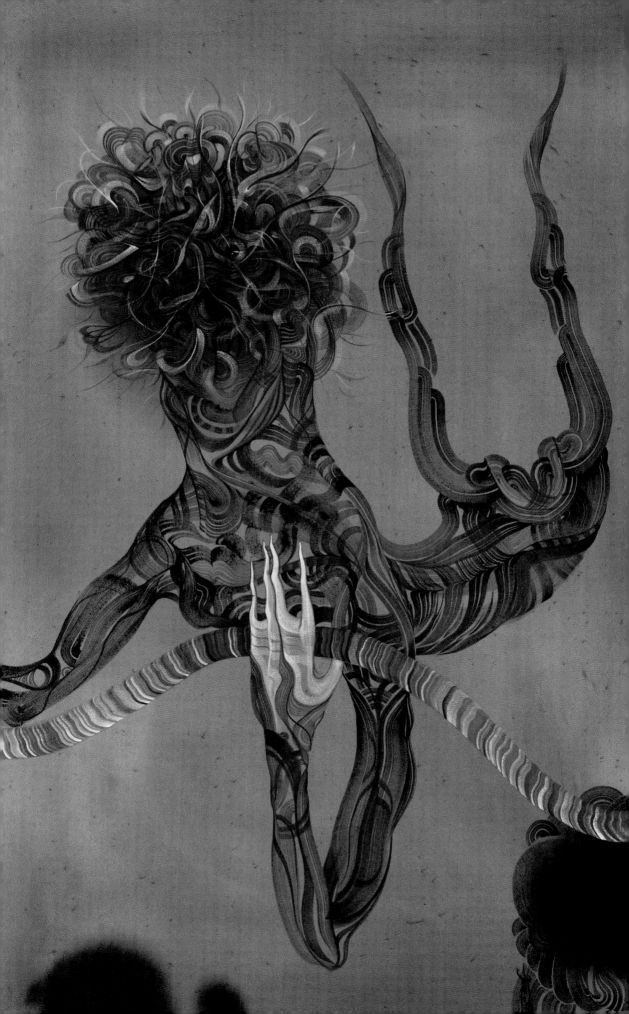

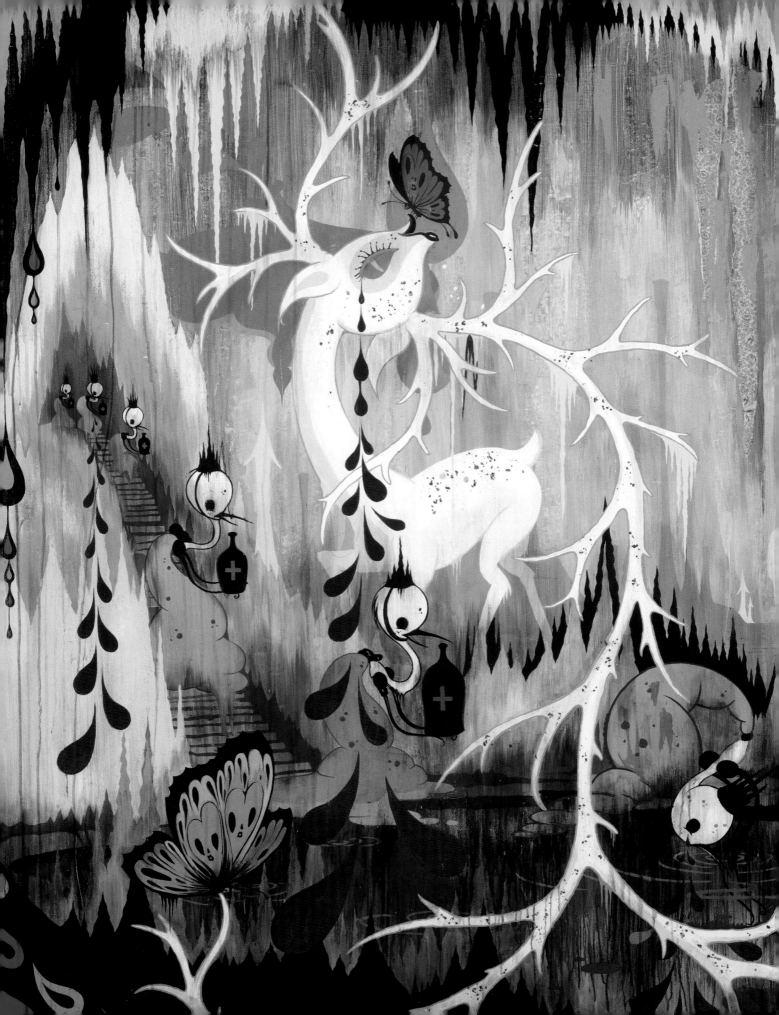

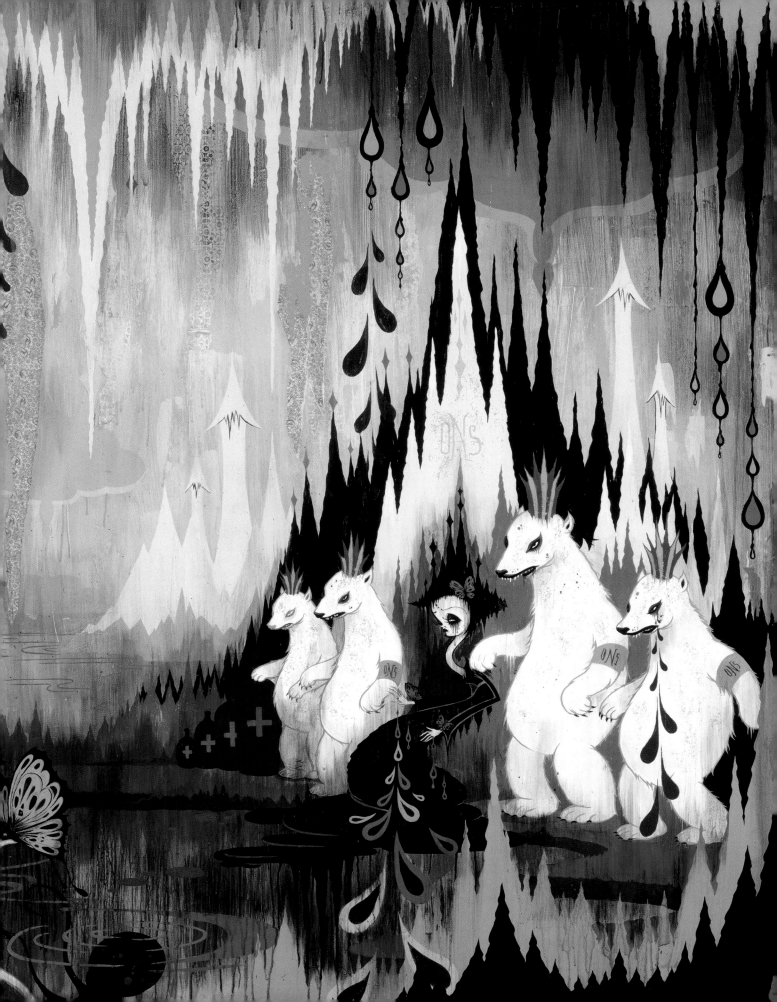

Black Mirror the work of Camille Rose Garcia

by Kirsten Anderson

Camille Rose Garcia paintings offer a doorway into a parallel dimension. A cartoon dystopia painted in aurora borealis colors, they teem with elegantly sinister witches brandishing sharp knives and bad intentions, punk anarchist girls raging against the machine, and weeping wildlife whose tears fall as thickly as oil from a geyser.

In fact, oil seems to cover most of Camille's paintings, a black, dripping sludge prettied up with a dash of black glitter. Side by side like rain on spider webs run glittering gold and silver drops that shimmer along the layered glazes of thick candy colors and decaying wallpaper, simultaneously drowning and revealing the tableaus floating across the canvas.

This world mirrors our own, a sickly sweet and darkly glimmering version of the very real horrors we perpetuate on our planet and among ourselves. The fairy tale-like characters in Camille's paintings are often desperately seeking sanctuary, or even an escape hatch, but they never seem to truly find one, reflecting the condition we find ourselves in with the ever-present threats of global war and global warming.

Raised on a diet of Disneyland and punk rock while growing up in Southern California, Camille became disenchanted with art school and the hypocrisy and limitations often found within, and turned to reading about creative outsiders such as William S. Burroughs and Philip K. Dick. These influences inspired her to follow her own vision in the mid-1990s, to create works about things important to her, regardless of art world propriety. The timing was perfect as the Lowbrow/Pop Surrealism scene was beginning to take off, and Camille has ridden the ever-cresting wave to become one of the movement's top stars. Placed there by her talent, vision and a series of well-thought-out, gorgeous shows (including a recent retrospective at the San Jose Museum of Art and her most recent knockout show *Escape to Darlingtonia* at Merry Karnowsky Gallery in 2007) Camille has proven herself well worthy of her success, showing that she will be a talent to be reckoned with in years to come.

Hi-Fructose tracked down Camille at her secret hidden lair and plied her with questions.

First of all, what and where is Darlingtonia?

Darlingtonia is a reference to the Cobra Lily [*Darlingtonia californica*–Ed.], which grows wild all around the area that I just moved to, and which used to be called Darlingtonia ages ago. I used to come here every summer as a child, to a cabin my Grandpa built. So Darlingtona is kind of like a mythical place in my own personal history, except that it is also real. Now I live here, and we're building a cabin.

Your most recent shows (*Escape to Darlingtonia, Subterranean Death Clash*) seemingly center on animals more than human characters. Can you speak to that? I'm also curious whether your recent move to Northern California from Los Angeles has caused a change in your subject matter.

One of the side effects of having gained a certain amount of popularity is that now everywhere I go I see cute little girl faces with black hair and drippy bangs! So I think I was reassessing some elements of my work. Do I need humans in there to tell a story? Also, being in an area now with abundant nature and way less humans, I wanted to focus more on the mystery and beauty of animals in this area. Anyway, the humans in my paintings were always drinking poison or running, and at some point

they either have to cheer up, or lie down and die. I'm not sure yet what their plan is.

Your work reflects global disorder, war, disease, and the human response (or lack of one), which includes self-medicating into a stupor. Can we know more of your thoughts on what you think humans would need to do in order to not destroy ourselves, taking everything else living with us? Do you think it is even possible to make those changes at this point in time?

Wow, these are questions I ask of myself every day! There is a danger in having too much time to think about the big questions, because it always leads to the same one. Are we here on this Earth to learn something and evolve? Or did some sick god just dump us here to ruin everything for no reason? One really gets into the theological questions here, thinking about fate, the order of the universe, patterns in nature. I think what humans need to do in order not to destroy ourselves is realize that the world was not made for man, but man was made for the world.

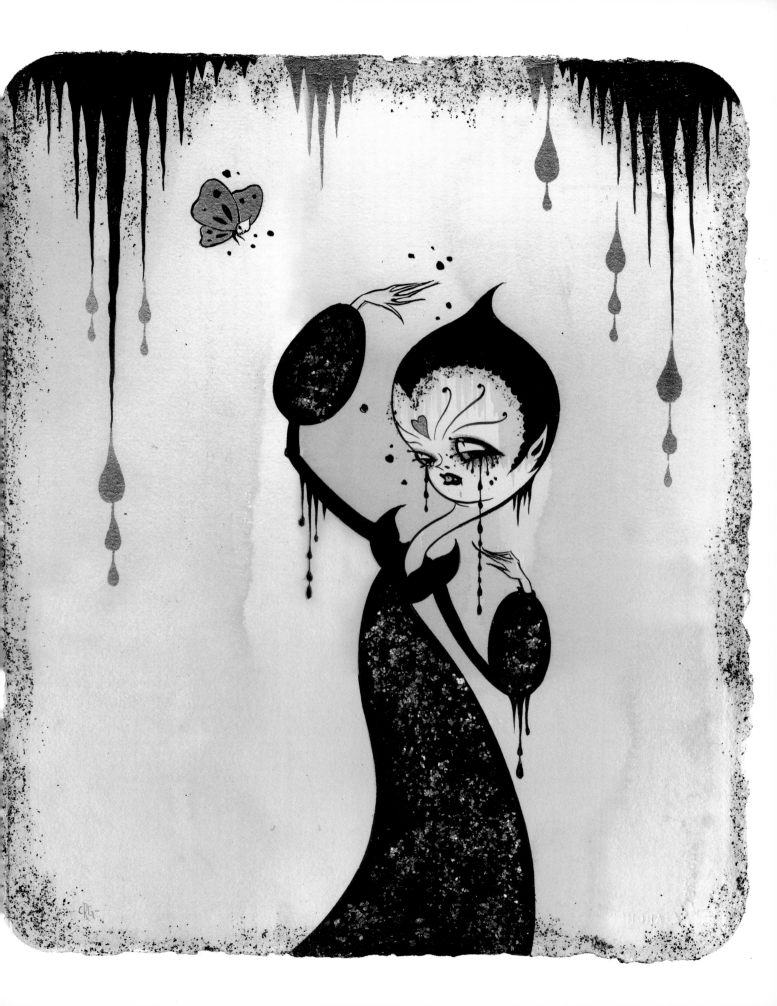

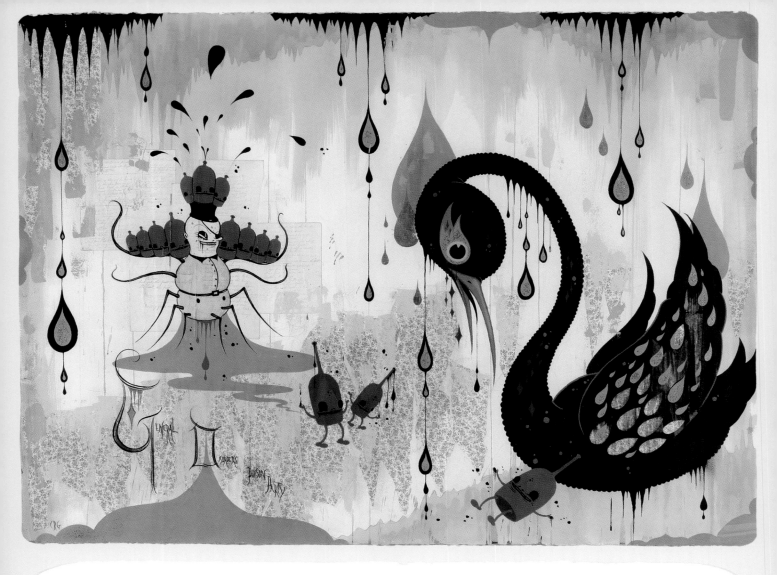

I think it is possible for people on an individual level to make a change in their own consciousness and attitudes toward the world. But there will still be a four billion-person die-off when we enter the age of energy scarcity (which we are entering now). Also super scary are all the converging prophesies about December 21, 2012. If we all just get flung off the earth because the magnetic poles realign, then what is the point of thinking about the future at all? So then I find I'm in existentialist, nihilist territory, which never leads anywhere good. There has to be a future for people to have hope and to strive for things.

You have become an extremely successful and sought-after contemporary artist, who must now produce work almost on demand for galleries and collectors. How do you deal with that? Do you mind it? Do you ever feel like people now have expectations on your work?

Yes, again, another question that plagues me every waking moment! I try not to think about what other people want or will like while I'm painting. The only thing I can do is try to make things that intrigue me, that I would want to look at and think about. I am increasingly finding that the concepts that I think about and want to express are too great and overwhelming to be "drawn out" and designed in a little picture. Most of the time I feel like I am a blind person grappling in the woods by myself, and once in a while I come to a clearing and I can feel the sun on my face. As far as the gallery shows, they are just arbitrary dates on a calendar that mark a segment of time, and that

show's paintings are what I was doing at the time. I have to think about it that way, or else I'll start to hyperventilate, because yes, there is a tremendous pressure to be "great." I put a lot of that pressure on myself.

As your work deals with these issues that are so relevant to our time, it has an emotional pull accompanying a socio-political statement. Does it surprise you that your work speaks to people on so many different levels?

It does, because sometimes I don't know if I'm making any sense at all, or being too cryptic, or being too obvious. I am truly amazed and grateful that I can communicate with so many different people. But I do think that some concepts are universal. What is the nature of beauty? What is the nature of man? Why are we, collectively as a species, so fucked up? I think everyone around the world thinks about these things subconsciously when they have a moment between working and buying things. Why are we always working and buying things? What is the point of capitalism? Why is there such a disconnect between the world we are "shown" and how the world really is?

Your work is so highly imaginative and evolved thematically. I watched your San Jose Museum of Art interviews on YouTube as you discussed each show you've had; it was great listening to you explain the stories behind each one, like hearing fairy tales by a campfire! Clearly the ideas in your work have been important to you for a long time. Is the mythology in your work something

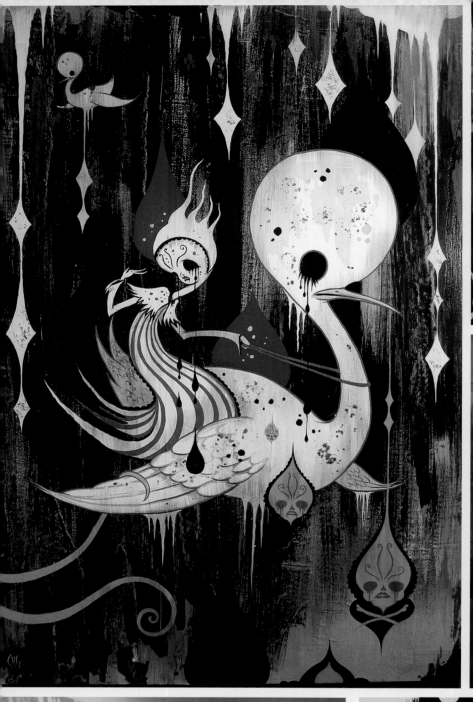
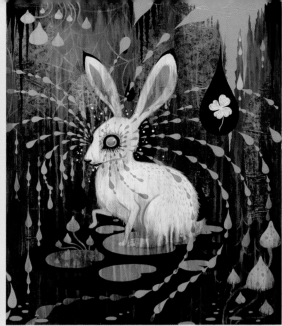
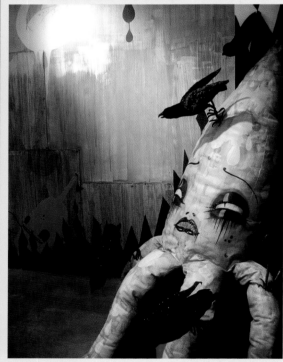

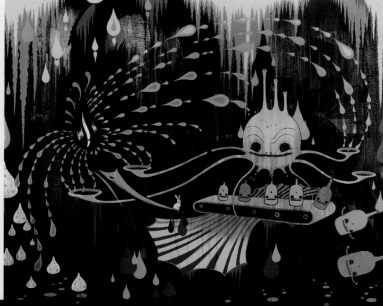

that was with you when you were a small child? How did these worlds start developing?

It's funny, I just recently watched *Bambi* again, which I saw when I was a little person. It sounds cheesy, but rent it—I swear—it's a beautiful movie! Anyway, I realized again, how many of these same stories and motifs have been with me since I was a child, never really changing that much. Walt Disney, making those early films, took stories that were already fairy tales: *Snow White* was a Brothers Grimm story that was passed on to them from an oral tradition, *Pinocchio* was an Italian story originally, and *Bambi* was also taken from a book [*Bambi: A Life in the Woods*, by Felix Salten–Ed.]. My point being is that these were already ancient stories by the time I got to them, and I got them from animated movies and books. So now I am retelling the same stories, and people that are inspired by me are also retelling ancient stories that go back probably thousands of years. The tattoo a 17-year-old gets on his arm of one of my paintings has a part of history much larger on there than he can even imagine, and he becomes part of the story as well.

What is your vision of utopia? Do you think it can be achieved? Does utopia even contain any people in it?

My vision of utopia is this planet with about four billion less people on it. This will be achieved, whether we like it or not. Shit, now it sounds like I am a nihilist! I'm not—I swear—it's just that this planet was already a utopia pretty much until the industrial revolution. I'm not saying everyone was happy, but you could live off of the land, and what else could anyone possibly want but to watch the stars move and change with the seasons eat around a big fire with your family, and to be outside working in the sun during the day. My point is the current human population—nine billion?—can't exist without displacing everything in its place, which pretty much means extinction for us as well. So the choice is really, four billion people die off, or nine billion people die off. I'm just a romantic at heart; I choose four billion!

I think people might be surprised to find when they meet you that you often seem to be a fairly upbeat person. You mentioned that you "have to have hope." What gives you hope?

Lately it's been harder, with bad news spewing forth every minute in some kind of black-hole spiral. Usually, if I unplug from the matrix, quit looking at the internet or TV, and go out and take a hike that gives me a bit of hope. But I am lucky to live in an area surrounded by natural beauty. I moved here for that reason. I was afraid if I stayed in Los Angeles I would turn into a nihilist, seeing really no hope for mankind. I mean, there's something about seeing an entire row of mature trees on the street spray-painted with gang graffiti to really pull your day down into a dark, dark hole. We might as well just tar and feather all the plants and animals in the world and throw them into a big pit, laughing. These are the things I think about. But yes, I am hopeful! Again, four billion people die off. On the hope end of the doom-hope scale, I would say, "Grandmas and spring." Grandmas and spring give me hope. And puppies.

What do you do to chill out and not go nuts, after spending time thinking about depressing subject matter?

Usually I have to go into my "I'm not really here" mode, where I go into the studio and imagine better worlds for myself and others. The world that has been created for us out of the industrial age is not very conducive to happiness; it's really only designed for consumption and production, with no other activities very highly encouraged or they are even criminalized. I really look around me sometimes and wonder, "My God, what kind of sick mind has created all of these horrible ugly structures filled with horrible, ugly people, who are either plain unhappy, unhappy but hopped up on pharmaceuticals so they can function, or clinically crazy." If this is the best man can do,

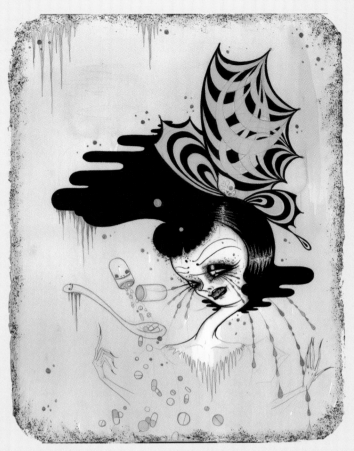

then I say just let the sun fall into the earth already and end this horrible mistake. Uh oh! Maybe I am a nihilist after all! It's good I am in the woods.

You are an anomaly in the Pop Surrealism scene in that you have a very close relationship with your primary dealer, Merry Karnowsky. What is it about that type of relationship you find fulfilling?

Well, there are two main things. One, I truly enjoy her company. I would not work for so long with someone that I didn't fundamentally have a good time with. So on a personal level that makes my life better and less annoying. On a business level, she sells everything I have ever given her, and she is very positive about what I do, and is always very excited about the work.

Which living (or dead!) artists do you find inspiring? Do you feel connected to the Lowbrow/Pop Surrealism scene? Or do you personally see your work in a different light?

Wow, living or dead that is a big, long list. I do feel connected to the Lowbrow/Pop Surrealism scene, but my work definitely has a lot more social political criticism woven into it. I think because the scene is so popular, it's a great platform to inform people, and to maybe inspire change. There is so much opportunity there, but I think a lot of artists maybe don't know what they want to say about the world. I think The Clayton Brothers and Mark Ryden have always had that something extra in their work; the Claytons have an empathy for the human condition, and with Mark Ryden there is a genuine interest in the mysteries of the universe.

What is next for you?

Well, I will be building the doom bunker, of course! But next, I will be showing at Merry Karnowsky's new Berlin location then a New York show in the fall. Oh, and learning to fish. We live right on a river. I'm not telling you which one.+

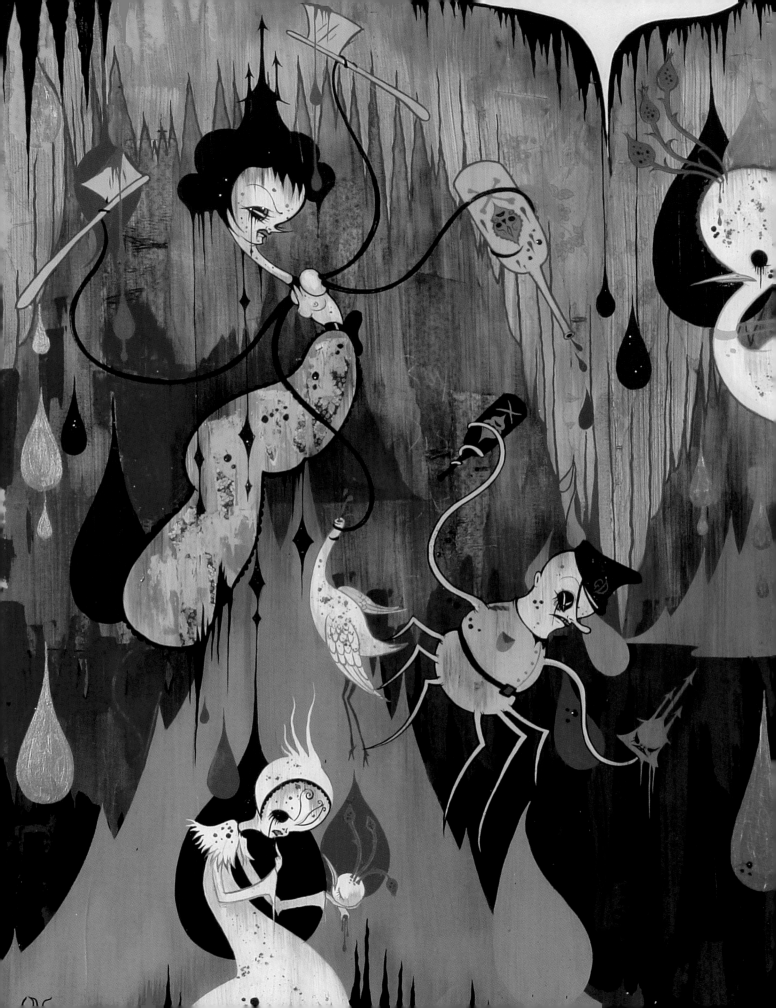

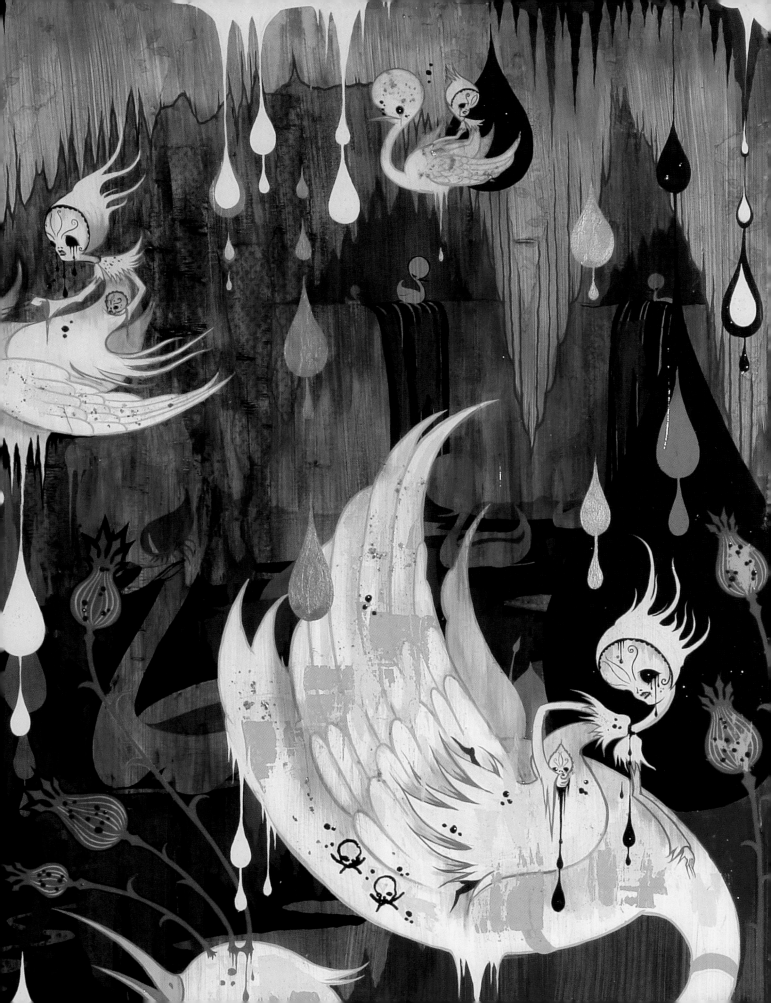

BARNABY BARFORD

Picture if you will, a cute baby lamb grazing obliviously upon a serene grassy meadow. A small child skips happily along nearby—scythe in hand—(of course) stopping briefly to pet the tiny tufted little lamb on the head. Her hand slips (accidentally... wink, wink) and—Woopsie!—off with its head!

"Oh Shit Daddy's Going to Kill Me!" So might go the narrative upon which the figure on page four of this feature, part of the *Private Lives,* collection, is aptly named.

Barnaby Barford lives in London and transforms found ceramic figures, both mass-produced and antique, into elegant and delicately re-arranged sculptures that are tragic, hilarious and always tell a story. The beatific becomes barbaric and the cute becomes sinister in his gleefully irreverent narratives. Although the angelic white ceramic gleams with innocence, lending some semblance of purity to the masterfully defiled figures, it ultimately serves more to amplify the vulgarity of the finished piece. The more you look, the more explicit it becomes.

Currently, Barford is working on his animated film *Damaged Goods*, a tragic love story performed by found ceramic figures using the oldie-but-goodie technique of stop-frame animation. The project, commissioned by Animate Projects in association with the Arts Council England (ahem... when does America get to have one of those?) will premier as part of England's *Animate! TV* this winter.

Barford has shown in prestigious museums and galleries, such as Sotheby's in London and Gynn Vivian Art Gallery in Swansea, and has designed for upper tier companies like Nymphenburg and Thorsten Van Elten. Although accustomed to running around the fine art and design circuit, it is apparent that he enjoys examining the dynamics between high and lowbrow culture, as well as challenging the traditionally quaint, preconceived notions around ceramics.✦

—**Annie O.**

(opposite page) clockwise from upper left)
"Anything You Can Do I Can Do Better CCCP"
"Anything You Can Do I Can Do Better USA"
"We Are Hoping We Will Grow Out oF It"
"Dear Lord for What We Are About to Receive Make
Us Truly Thankful"
"Dream On"

(this page)
"Oh Shit Daddy's Going To Kill Me!"

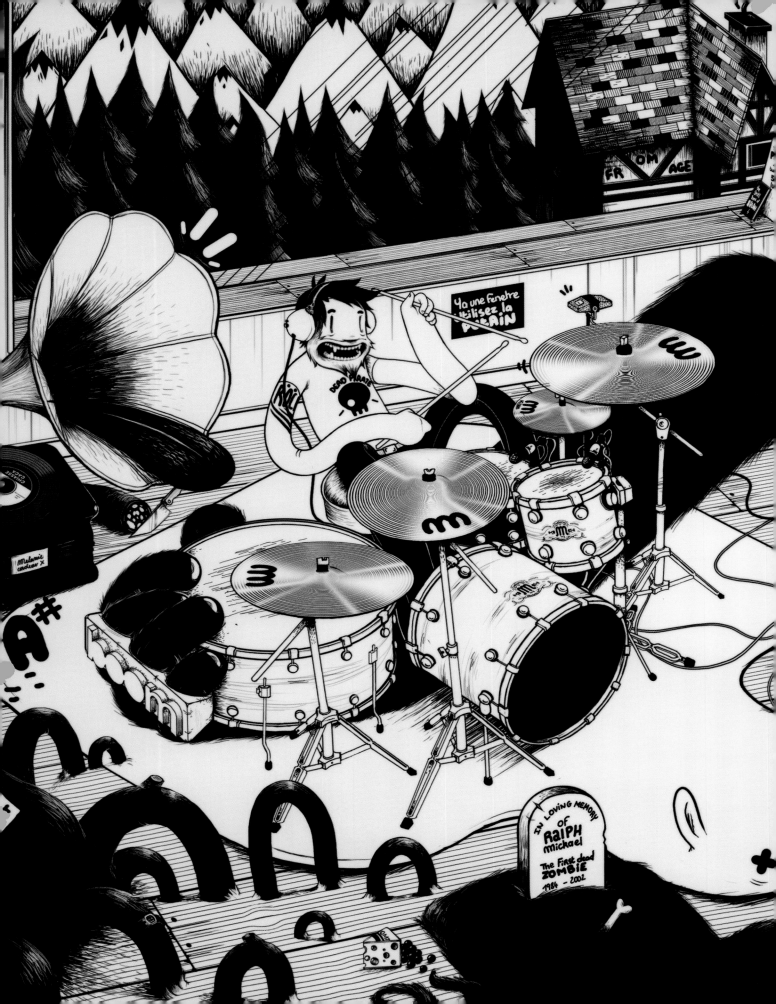

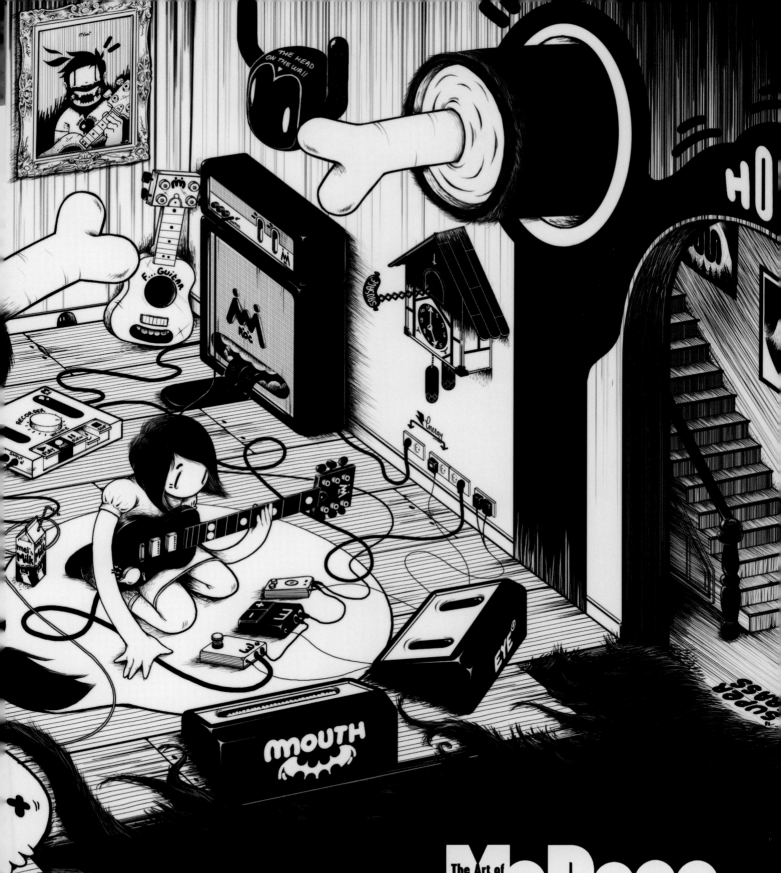

The Art of **McBess**

Interview by Attaboy

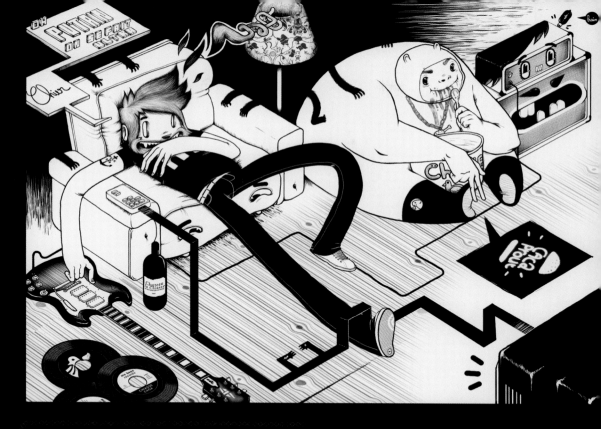

The first time I saw one of Matthieu Bessudo's drawings it opened these jaundice-glazed eyes baby wide. Their high-contrast colors, spaghetti-armed forms, and elaborate line work pulsed; ringing out like the waves of a migraine halo. You can almost hear the soundtrack that accompanies them.

I've become a bit of a surly fuck of late, but seeing Bessudo's work unbunched my panties just enough to let a shaft of light through the quintessential crack. A 23-year-old French native now living in England, McBess is at the start of his art career with upcoming group and solo exhibits in Japan and Chicago's DVA gallery. I was pleased to interview him for *Hi-Fructose*.

You just completed an exhibition in Kassel Germany at Rotopol, which included gigantic mouths, handmade records, prints, painted AC wall outlets, and a warning sign by the cheese. Can you tell us a bit about how you planned the exhibition and why we should "respect the cheese!"?

Why should we "respect the cheese!"???? Aha, well it is quite simple, it's one of the best thing in the world, I'm not talking about tasteless creamy crap for people who wants to do a diet, I'm talking about the one that smells like your feet after summer afternoon in the park. We need to respect the cheese in order to save it from all these hygiene regulations; plus it was my show, so my rules! Hahaha!

For the exhibition, my friend Michael Meier from Rotopol asked me if I was up for the show, I said yes, then I asked Simon Floriant and Guillaume if they would fancy going to Germany to have some sausages, they said yes and found themselves slaving for me in the Rotopol Gallerie. The guys from Rotopol planned

lots of stuff that we could use to decorate the shop. There was a big part of improvisation and it was really fun.

Did you sell some of your beard hairs there? Is you beard a sign of your creative independence or just o abject laziness. Is it morally right to sell your very own beard hairs?

I thought I kept this idea for me, how do you know that?! Okay first of all, I don't have a beard because of any clever sign of creative independence, and don't believe anyone who would tell you that their beard means something; how would that work? Hitting people in the face with your beard won't give you any artistic freedom, believe me I've tried. I have a beard because I need a big chin to impress people, and selling some part of it is not immoral. On the other hand, buying it is kind of weird.

Your work seems effortless, like it spills directly from your brain. It makes me want to draw or bake a cake. It seems like you are having the best time.. are you?

Oh oh, I'm so happy to have such a positive effect Yes indeed, I'm having the best time, it has not always been like that though. I started drawing seriously when I was really frustrated, I drew all the things I wanted to have... [laughs] now I got them, so I don' know. I guess I'm a lucky guy; I'm surrounded by incredible people who are really supportive, I should thank them but I won't, they're going to get cock afterward.

Your art seems to revolve around playing music amidst chaotic environments, shark toothed females, pirate libidos and stories of picking out jus

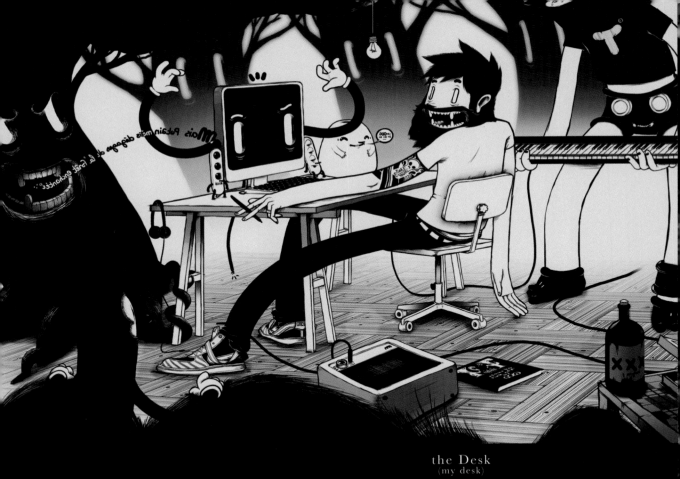

the Desk
(my desk)

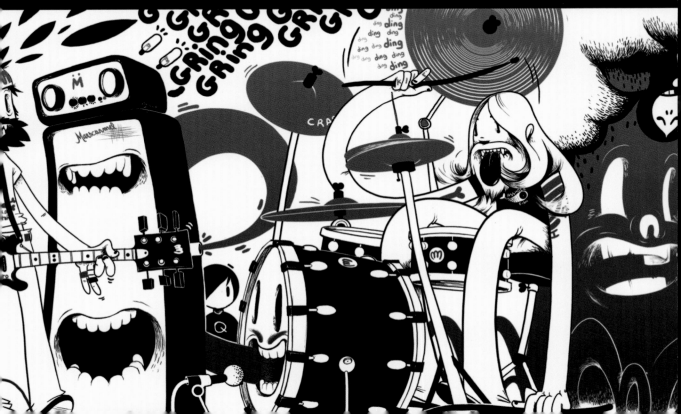

mcbess.com

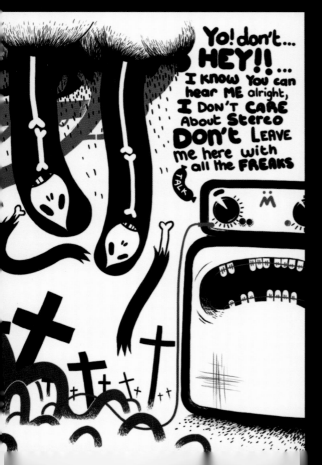

the right guitar, with hand written notes and messages spew[ed]
sorts of fantastic orifices. Are you chronicling your day-to-da[y]
and hurdling blocks in your work? How closely does your work [follow]
real world life?

I draw about things that I'm touched by, some stuff that I live, [some I]
aspire to. The main character is myself, kind of. I think it's my w[ay to give]
more credibility to how I would like things to be. I'm crazy ab[out]
music, I would spend most of my time doing it if I could. So in a [way]
it's kind of a journal; yes, I'm playing a lot with my fantastic [guitar, I]
spend a week looking for records and watching *Ghostbusters* [while eating]
grapes and cheese there's a big chance that it's going to be in m[y drawings,]
but I don't really pay attention to that, I know what I want to draw [like]
what I want to eat when I'm hungry, there's nothing special a[nd]
clever, I'm doing primitive art... [laughs]

What little I've seen of the animation you've been invol[ved in is]
amazing. You've really brought your drawings to life. We see [a man]
pound on the drums, epic battles are fought over sneakers, an[d]
socketed box men line dance for our pleasure. You were origin[ally trained]
as an animator, right?

Yep, I've been to a school called Supinfocom, where actuall[y I learnt]
nothing because the teachers out there got their heads up the[ir ass,]
they actually can't read this or any 3-D manual, but I found a l[ot of people]
in my class who taught me a lot.

So I did four years of 2-D and 3-D studies. The last year we m[ade a film]
for Sigg Jones along with Douglas Lassance and Jonathan Vui[llemin as]
part of the Salle Polyvalente, it was painful but I learned a lo[t from the]
experience. 3-D is an excellent tool, even if you want to anima[te in]
two dimensions. I'm happy to be able to use it, and actually I use [it]
for my illustration as a reference.

What is the Salle Polyvalente collective? Are you or have you [ever been a]
member of the Communist party?

Haha... no, I've never been a member of the Communist party, [why you]
ask? The beard? I don't know what's the point of view of the A[mericans on]
the European politics, anyway. I'm pretty bad with this kind of s[tuff.]

Salle Polyvalente is a collective, it's not French exclusive any[more,]
now we're 23 illustrators working on the same theme, the la[st was]
delicatessen the next one is "obey!" (not the artist, the verb). T[he idea was]
to push my fellow friends to show what they were doing since the[y are so]
good, and to create something big that would leads us to do bi[g things,]
parties, books... It's really the beginning but I've good hope for [it.]
I want my friends to be rich so I can be invited to their ridic[ulous]
mansion.

There's a classic golden age of animation look to much of you[r work]
fused with Modern themes. I see references to Ub Iwerks, [Max Fleischer]
and more. You're just 23 years old! Have you seen a lot of "[golden age"]
animation?

My dad is a big fan of jazz, the old Disney cartoons, and p[retty much]
everything that is in black and white, so I grew up with Betty B[oop]
and Mickey. I've been inspired by a lot of recent people, but it[']s never as
strong and deep as what you can get when you think about [things that]
forged you as a child. I've been serious for about tree lines, I'm [too lazy]
right now.

We've managed to track down videos of what appears to be [you playing]
guitar like a possessed wolverine and there seems to be a mu[sical current]
going on in many of the images How integral is music to your [work?]

Ideally for each of my illustrations there's a song, but I'm still [working on]
it. It takes a lot of time to record music in a decent way, and [even harder]
when most of your instruments are analog, plus you don't a[lways draw on]
the same music, so I should draw and play music at the same [time, which]
I'm sometime doing but then I've got no time left to eat or [do other]
"interesting" stuff. Anyway the music is nearly the main thing [that makes]
me draw; I've done illustrations just because I was listening to [the song]
"Mary" by Supergrass. For example, when a music gives me the s[hivers I need]
to put it on paper to keep a trace. I would love to make music th[at gives you]
an image and then gets the power of the sound and visual, so I [think that's]
the next step for me, but first I need to finish *Grand Theft Auto*[.]

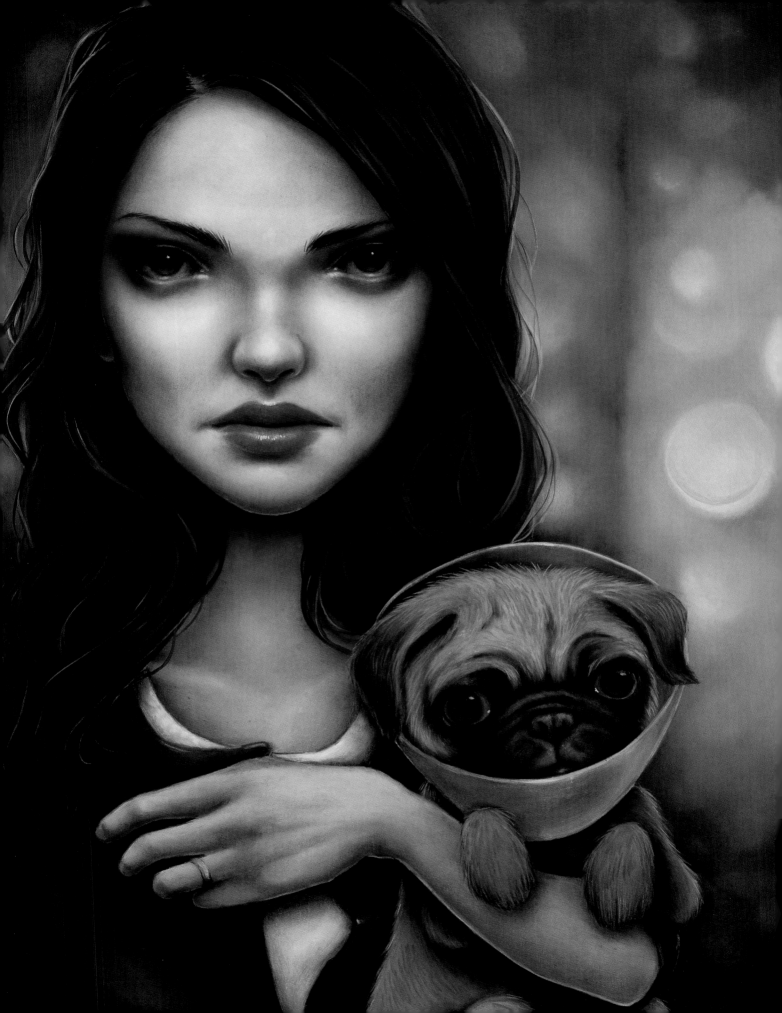

Contributors:

Kirsten Anderson *Having dipped her toes into the Lowbrow art scene in the mid 90s, Kirsten Anderson opened Roq la Rue Gallery in 1998 after curating several group art shows in various locations in Seattle. In addition to running the gallery, she edited and co-published the book "Pop Surrealism: The Rise of Underground Art" in 2004, which was the first comprehensive survey of the burgeoning scene and gave it a new moniker. She is the Editor-at-Large at Hi-Fructose where she writes about art and artists related to the Pop Surrealism/ Lowbrow scene. She occasionally writes for other publications about art and lectures about Pop Surrealism and the artists affiliated with the genre.*

Mikl-Em *is a writer, actor, and event producer in San Francisco. His writing includes articles, poetry, assorted theatrical works and various bloggery. Most frequently he appears as a guest blogger on LaughingSquid.com covering music, comedy, pop culture, and other forms of creative deviance. Mikl's theater work includes performing, directing and writing. On stage he has played Griffey in a stage version of Zippy the Pinhead, re-created Cesar Romero's version of The Joker, and walked in Peter Boyle's large footsteps as The Monster in a stage production of Young Frankenstein. He can often be seen performing at San Francisco's Dark Room Theater, where he also lends a voice to the heckling comedy of the weekly Bad Movie Night series. He would not be possible without the existence of numerous SF Bay Area institutions including: The EXIT, 21 Grand, The Dark Room, SOMARTS, Stagewerx, and his beloved Danielle. Not to mention Attaboy, Annie and the wonderful publication you hold in your sweaty claws. You can also find Mikl on his own blog http://miklem.com or follow him on twitter @mikl_em.*

Ert O'Hara *is a writer, artist and death metal-loving, freight train-obsessed geek girl who lives in an art-strewn non-stop party nest in the uber-hip Mission District of San Francisco where she hosts other artists for epic paint sessions, tea and radical thinking. She has written for Fecal Face Dot Com, Juxtapoz, and Hi-Fructose. Art is her favorite thing ever; to see, do, learn about and explore. Her greatest inspiration is Margaret Kilgallen, who said, "I like things that are handmade and I like to see people's hand in the world... in my own work, I do everything by hand... even though I do spend a lot of time trying to perfect my line work and my hand, my hand will always be imperfect because it's human... you can always see the line waver. And I think that's where the beauty is."*

Matt Holdaway *is an American writer. He wrote stories with pictures until he learned to write. He began self-publishing at age 11. He became Editor-In-Chief of his High School newspaper at age 15. After schooling he published the zine A Multitude of Voices for over a decade. In 2001 he entered the professional writing world in Buzziyk #16 (an off-shoot of The White Buffalo Gazette). Since that time his writing has appeared in over 80 publications internationally. He lectures on the history of publishing and how to make a zine at institutions such as Yerba Buena Center for the Arts, The Cartoon Art Museum and The University of California, Berkeley. He now resides in the Oakland Bay area where he is the lead vocalist of the story-rock band Matt Holdaway's Army.*

Jillian Northrop and Jeffrey (Toast) McGrew *run a Design-Build Studio in Oakland called, Because We Can, LLC. What do they do? Well... just about anything! What do you need?!? They run a small crew of people with multi-disiplinary backgrounds including architecture, design, photography, construction, computer programing, and fashion. Quite a mash-up indeed. They even have a huge in-house robot that helps them make things (they named him Frank). With a focus on furniture design and commercial interiors, Jeffrey and Jillian keep their business focused on sustainability, art and eco-friendliness. Oh, and they like to write for Hi-Fructose in their spare time. www. becausewecan.org*

Manuel Bello *Originally from Lowell Massachusetts, Manuel Bello relocated at an early age to the Southwest, eventually settling in Los Alamos, New Mexico. In his adolescent years he became heavily influenced by skateboarding, punk rock and most things fast. Like many skateboard enthusiasts of his generation he was easily brainwashed by the 'skateboard art' revolution happening during the late 80s and early 90s. Around the turn of the century many of those once counter-culture skateboard artists began showing up less on skateboards and more in galleries and as a result, so did he. In addition to writing for Hi-Fructose Manuel Bello is also a regular contributor to Fecal Face Dot Com, and various other magazines and websites. He has spent the last decade running around New York City documenting skateboarding, street art, contemporary and pop surrealism, as well as the artists who have been making it happen.*

Rue Geisel *has written for Hi-Fructose since its start back in 2005, filling in the gaps, gapping up the fillings, filing gaping maws, mowing down the files, in an organized way for the organism of dis organinization that is Hi-Fructose. She is a trans angered trans-fat -filled fillet living in a Trans-Am listening to AM radio.*

Joe Reifer *is a fine art photographer who specializes in night photography of abandoned places. His favorite place to photograph is the desert under the full moon, with exposures typically ranging from five to 45 minutes. He also enjoys picturing mundane suburban neighborhoods in the daytime with toy cameras, and photographing artists for Hi-Fructose. Type the following into your internet device to see falling down things in the middle of nowhere under the stars: www.joereifer.com*

Heather Yurko, *a sometimes writer, constant lover of all things shiny and vinyl, spends her days striking a balance between her desires and the demands of the day. She's worked in the Financial, IT and Toy Industries and dreams of getting corporate cash to make awesome art. Heather is a freelance writer for several print mags, and she tweets and yammers and makes jewelry in her spare time.*

Nathan Spoor *is an artist and writer living in Los Angeles, CA. His work is highly regarded by several prestigious collections and publications worldwide. Spoor's paintings involve images of transition and growth; fluid narratives that chronicle a world rich with the mystery, joy, pain, and delicate balance of personal and spiritual evolution. He beleives that continuous study of technique and process are critical to his own growth as an artist. No image or canvas is too precious to wipe, repaint, and even burn on his own journey to discovery and expression. In this way, Spoor makes a personal and transformative connection with each piece that for him lives on beyond the finished works. With a writing style that shows an impressive passion and understanding of the arts in context, Spoor continues to bring challenging and informative text to readers of such internationally acclaimed publications as Hi-Fructose, BL!SSS, Juxtapoz, Grand Central Press, and The Surfer's Journal in an intelligent and educated fashion.*

(left) "Isolation"
Ken Keirns

About the Editors:
Annie Owens

Making, appreciating and understanding art and where it comes from or at least helping to create a forum where these things can be explored is what I do. This is directly in opposition with my grandmother and mother's loving advice to me as a child that in order to survive "you must do what you need to do, and not what you want to do." For now this feels right, but I am restless by nature and some day I might decide to go back to school to finally study forensic psychology.

In between curating content, writing articles, managing advertising, subscriptions, sales and distribution for Hi-Fructose I like to hang out in the garden with our dog Donut and our rabbit named Gigi.

Sometimes I draw and paint in watercolors and now and then I'll show that work in galleries. Among such galleries I've shown in are Rivet Gallery in Columbus Ohio, Gallery 1988 and Copro Gallery in Los Angeles where I will have a solo exhibit in March of 2011.

Serial killer documentaries are a guilty pleasure of mine as are watching, cataloging and critiquing horror movies; Horror movies being a life long obsession and one to which I intent to contribute in the nearish future. "Let Your Love Flow" by the Bellamy Brothers will be the opening song.

Attaboy

Attaboy is an internationally shown artist and toy designing word herder who creates in numerous mediums. The end result has appeared in books, museum shows, galleries, boutiques, junk yards, toy stores, rock clubs, movie theatres, mass transit, and on cable television. It looks like his upcoming kids book will also be adapted for the stage, but we'll see how that works out.

In 2005, he co-founded *Hi-Fructose* with his now fiancé Annie Owens on a whim. Five years later, it has many thousands of enthusiastic readers and is distributed world-wide.

Attaboy lives in a house in Richmond California with Ms. Owens, a dog named Donut, and a rabbit he pretends not to like, but instead will continue to feed as "an investment for a future dinner."

Attaboy would like to thank everyone who has supported *Hi-Fructose,* especially his brother Charlie, without whom *Hi-Fructose* would not have been possible.

Extra Thanks To:

Charles Surmazweiz, Van Eaton Gallery, Gary Pressman, Erica Miller, Mei Mei Everson, Long Gone John, Colin and Ron Turner, Brian McCarty, Yves Laroche, Kirsten Anderson, Ken Harman, Evan Rosa, Howard and Leilani Denn, Grandpa Driscoll, the Seifert Family, Diane Turner, Die Gestalten Verlag, Ert O'hara, Evan Rosa, Scott Beale, David Pescovitz.

(below)
"Hydrant"
Mark Jenkins